IN MEMORY OF

IN MEMORY OF

DESIGNING CONTEMPORARY MEMORIALS
SPENCER BAILEY

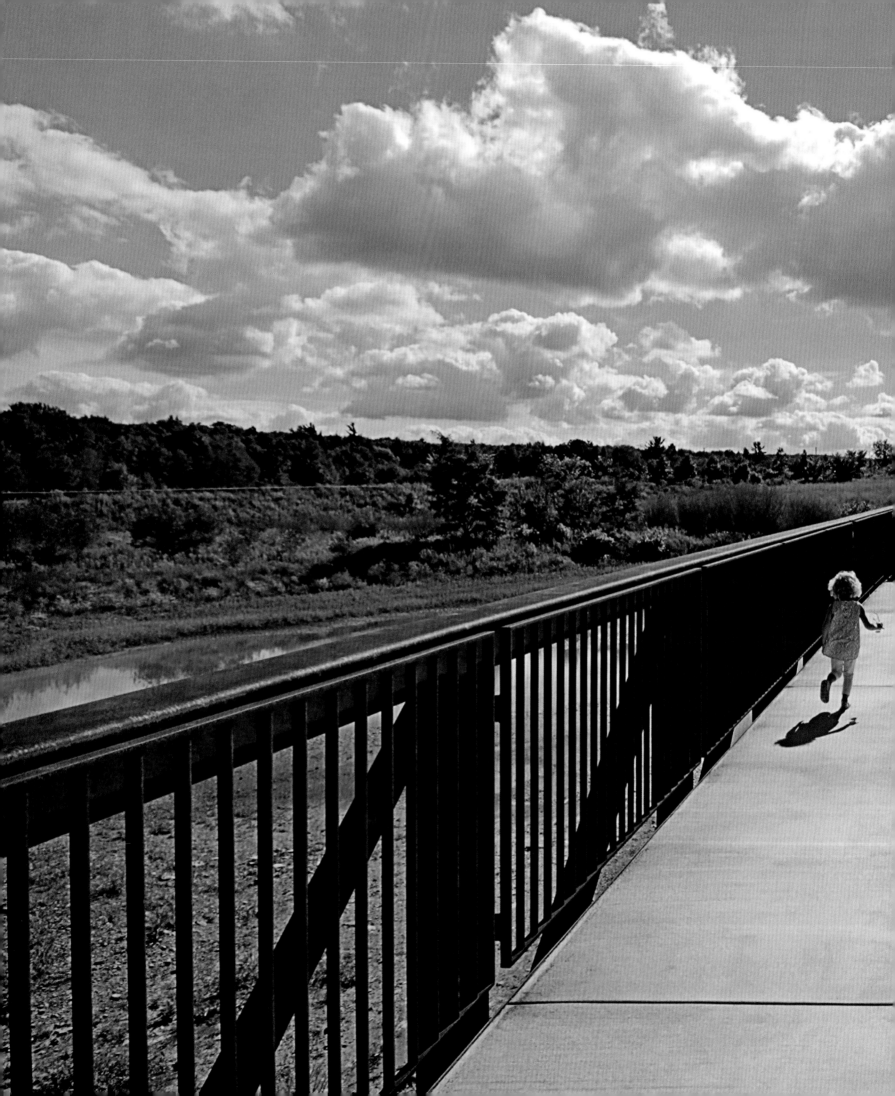

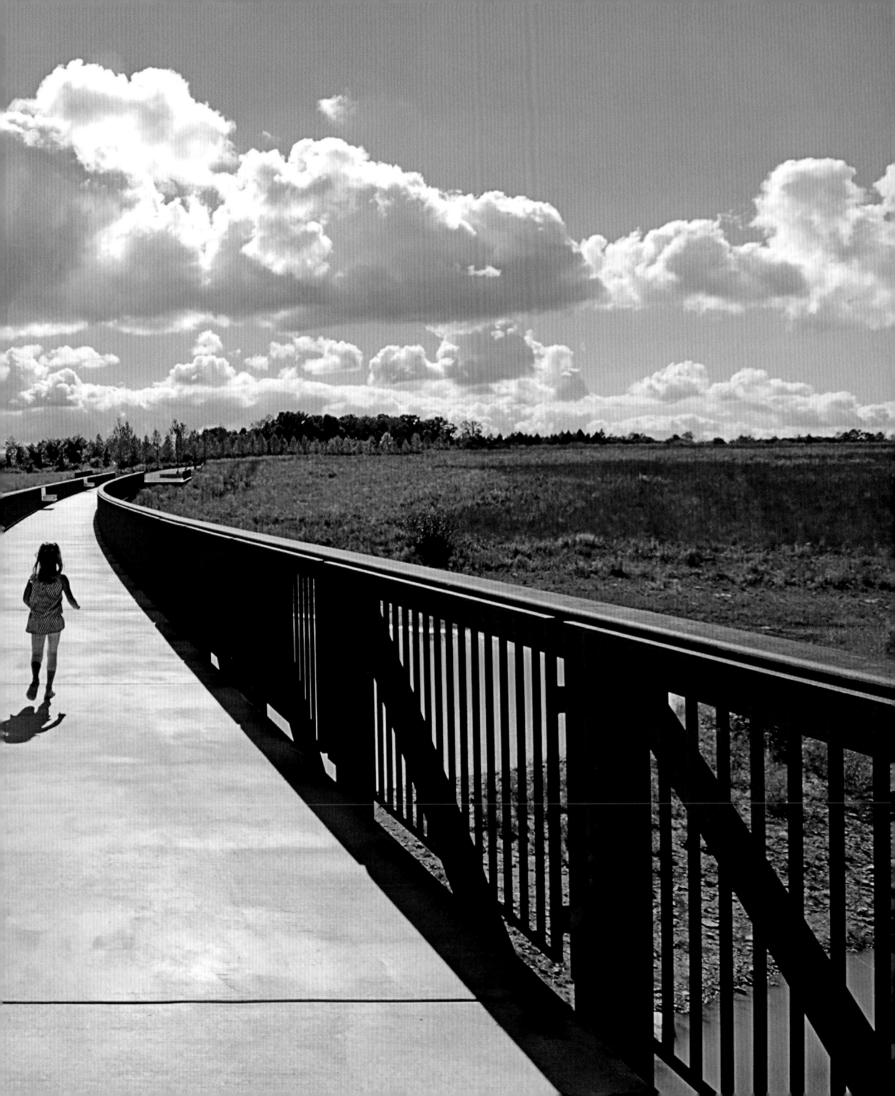

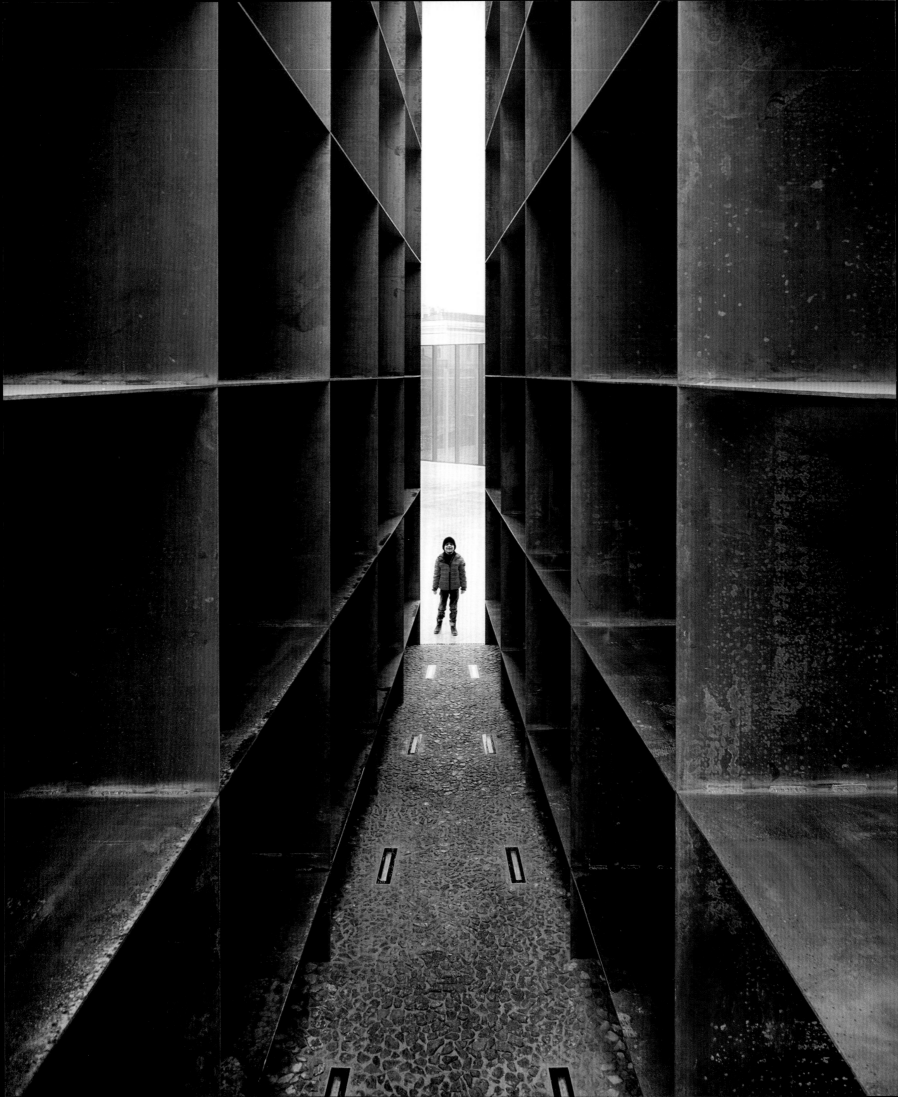

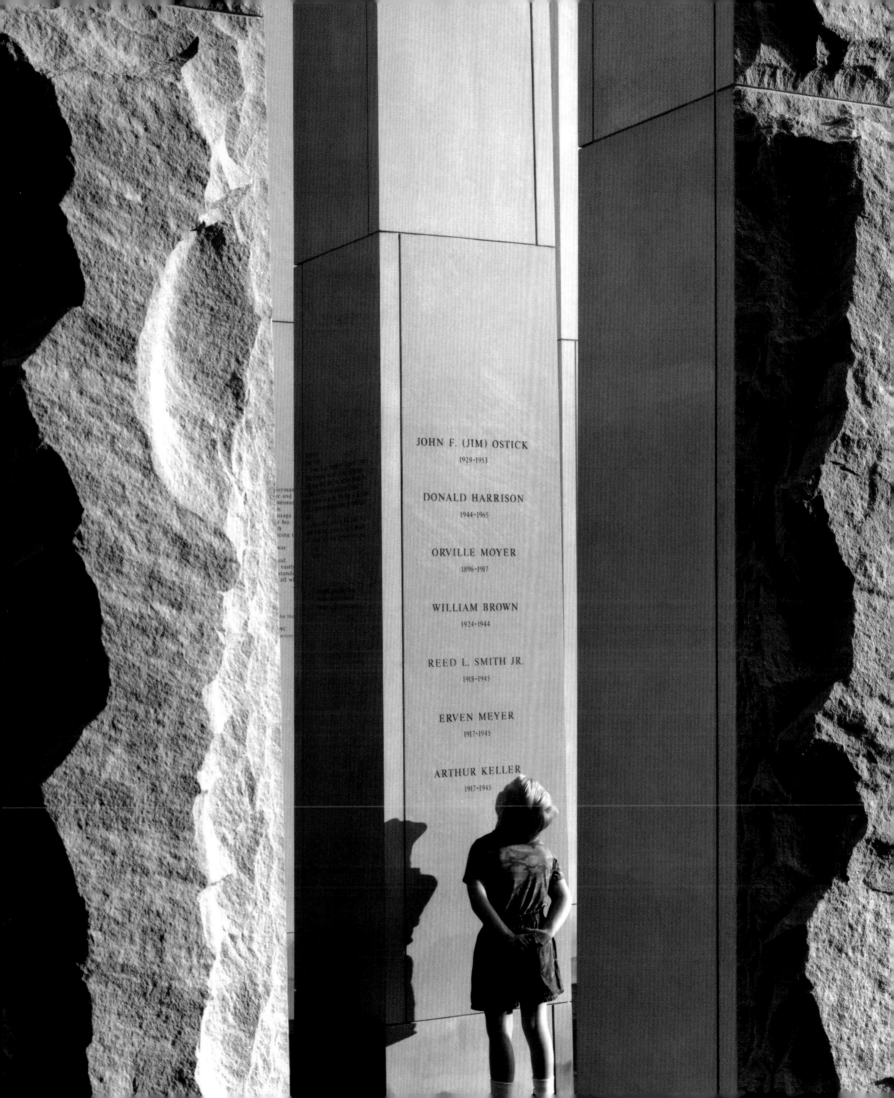

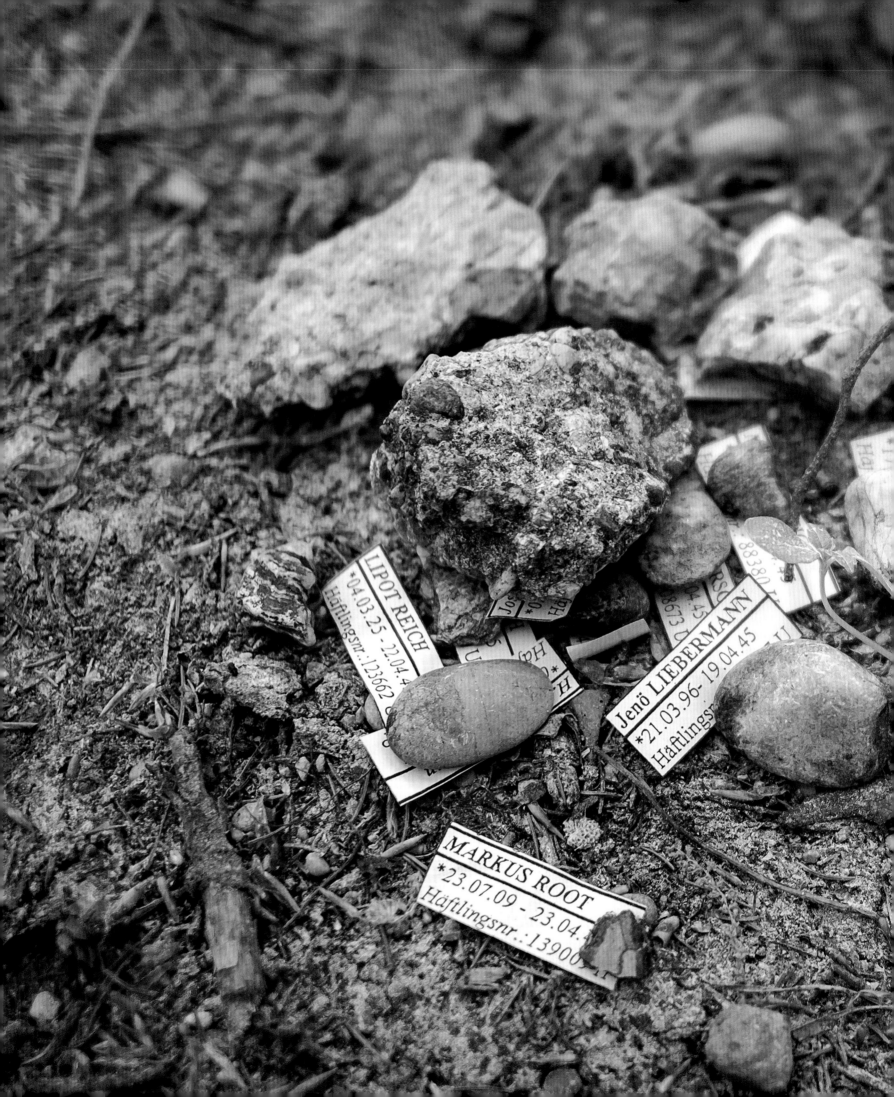

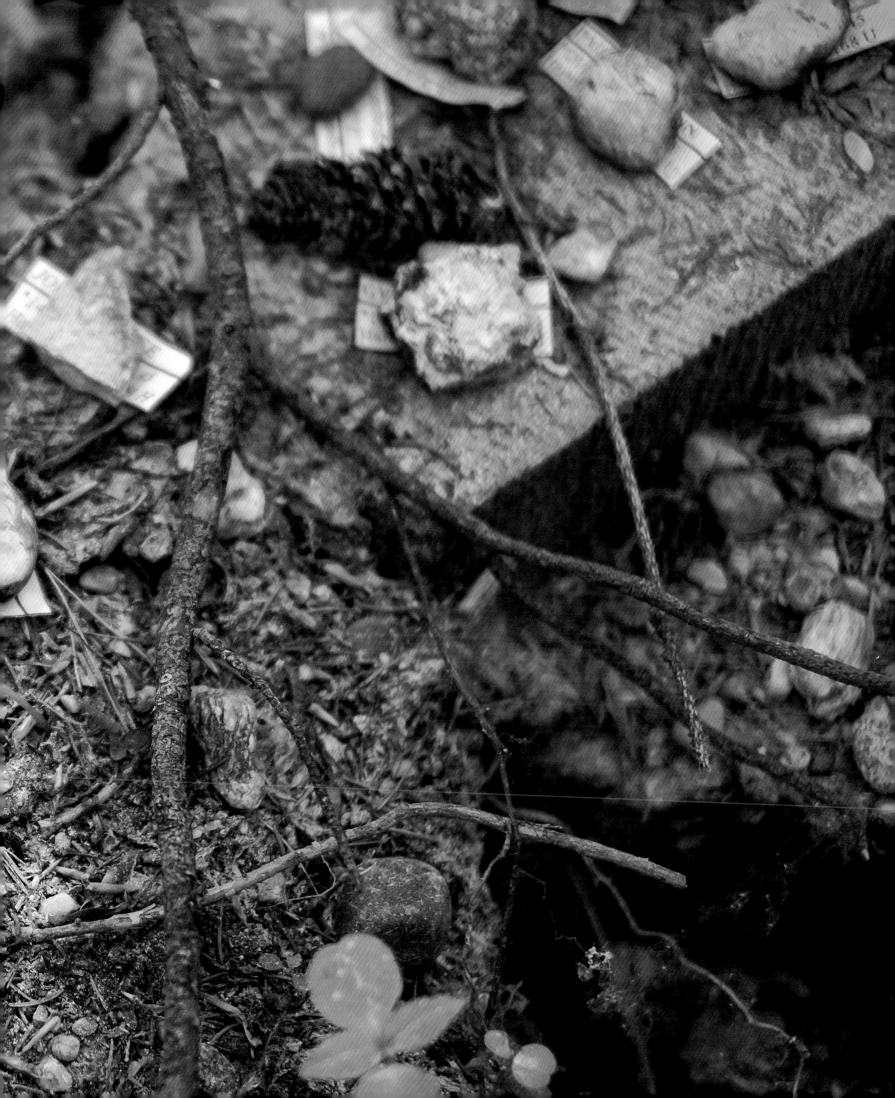

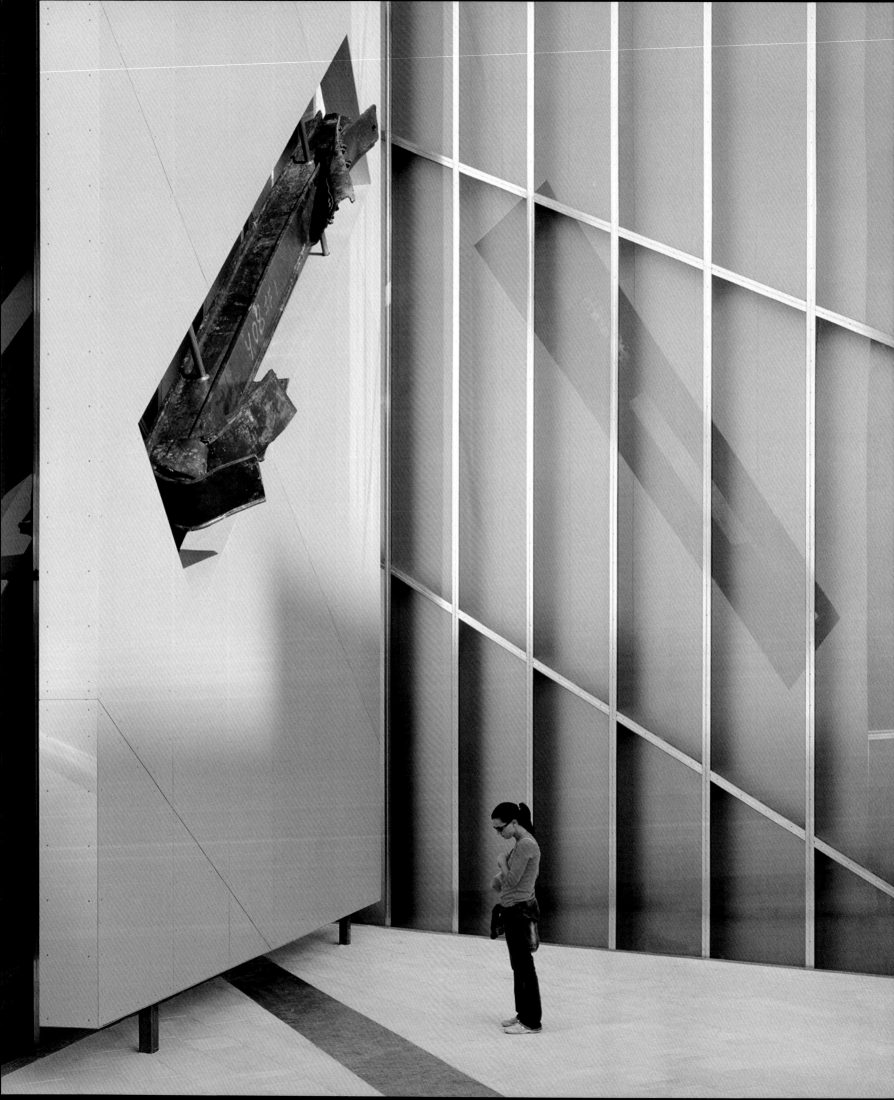

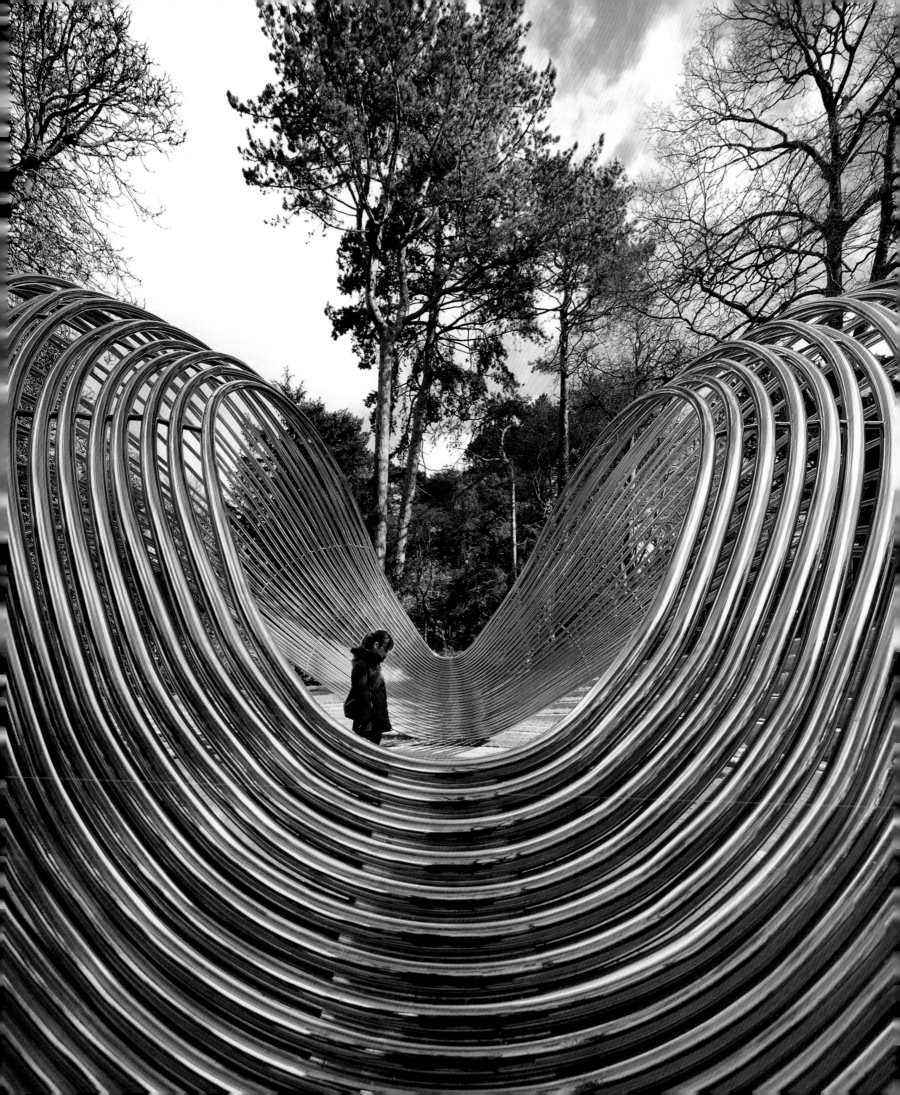

FOREWORD

This book comes at a time of rethinking spatial storytelling. It is encouraging us to look more critically at the memorials we've made in the past, and question the relevance of memorials in the twenty-first century. Rather than the imperialist idea of enshrining a singular view, I am interested in exploring the democratization of the memorial. As narratives unfold and splinter, there's almost a fracture—or even a certain failure—in the very idea of making memorials.

Given the fragility of this terrain, designing monuments and memorials should be borne out of a desire to make architecture that represents our collective consciousness. Personally, I believe in remaking the role of memorials from static objects to dynamic spaces. Architecture always has the potential to reflect an experience of time and place.

My design for the Smithsonian National Museum of African American History and Culture was about creating a living memorial to black life, but also about forming a new urban room for the city so that the building becomes a monument to everyday life within a charged landscape. In the notion of the memorial, the monument is being made.

My provocatively titled 2019 exhibition *Making Memory*, which opened at the Design Museum in London, allowed me to think about the form of memorialization and to explore some of the deeper meanings behind a series of my projects. The focus of my work is not about the changing of space through an object, but about the way in which we can adjust the context and landscape to encourage a more open form of engagement. Spencer's writing shares this sensibility.

Right now, I feel a call to action about visibility and form. The consciousness, nature, and implication of form is profoundly important for architects to understand. With this, the narrative of memorials is a device to project the many things facing people across the planet: nationhood, citizen rights, human rights, climate action. Memorial form is an important act of un-forgetting.

I believe this book makes a valuable contribution to the debate about the form of memorialization and the shape that it can take in the future.

—*Sir David Adjaye OBE*

PHYSICAL ACTS OF MEMORY

For my mom,
Frances Louise Lockwood Bailey.
1953—89

Just off Interstate 29 in Sioux City, Iowa, situated in a park along the banks of the Missouri River, there's a contemplative, tree-lined memorial. The sort of beautiful but still semi-nondescript place you might find in most any small or mid-sized American city. A quiet spot at which to reflect and remember. On the approach, seven large stones, each affixed with a cast brass plaque, narrate the tragic event that the site commemorates:

"The whole city of Sioux City reached inside itself and found resources it didn't know it had . . . found that this is who we really are."

"Let no one go unmentioned. Yet once again, we say, we're very proud of Siouxland and all who helped that day."

"There are certain moments in life you simply have to enter . . ."

"There was no hesitation, we did what we had to do . . ."

"Remember, I love you . . . I care about you . . ."

"There was always someone there . . ."

"I didn't save him . . . God saved the child . . . I just carried him, sir . . ."

Beyond them, an eighth plaque, dated from the memorial's dedication ceremony on June 5, 1994, reads: "Rarely will an event define its people as did the community response to this challenge. Thousands of citizens were involved in saving lives, caring for survivors, and comforting relatives and friends. The image of a man carrying a child became our symbol of strength, compassion, and unselfish commitment. Fittingly, the sculpture is entitled *The Spirit of Siouxland*."

Further in, centered in a colonnaded semicircle and surrounded by rocks and plantings, there's a 6-foot (1.8-meter) bronze statue portraying a military man carrying that young boy to safety. Next to it, a more recently made bronze sign, paid for by the Greater Sioux City Press Club, clarifies: "This sculpture commemorates Siouxland's extraordinary response to the crash of United Flight 232 on July 19, 1989. It depicts the rescue of three-year-old Spencer Bailey by Lt. Col. Dennis Nielsen of the Iowa Air National Guard's 185th Tactical Fighter Group, one of the many who answered the call that day. The work was created by artist Dale Lamphere and was inspired by a photograph shot by *Sioux City Journal* photographer Gary Anderson."

I was that child.

I had boarded the aircraft—a DC-10 carrying 296 people from Denver to Chicago—with my thirty-six-year-old mom, Frances, and six-year-old brother Brandon. We sat in Row 33. (My dad and twin brother were thankfully not on board.) At 37,000 feet (11,300 meters) in the air, the titanium fan disk in the tail-mounted engine exploded, the debris puncturing the plane and cutting all of its hydraulics lines, making the jet extremely difficult to steer. Eventually, it was determined that the flight would make an emergency landing at Sioux Gateway Airport. The captain, Al Haynes, miraculously maneuvered the vessel, its crew, and the passengers to the ground.

After a harrowing forty-four minutes of nearly uncontrollable turbulence, Flight 232 made contact with Runway 22. The tip of the right wing hit the ground, instantly igniting and quickly tearing off. The aircraft's tail section ripped off, too, ejecting the bank of seats where my mom, Brandon, and I sat. The rest of the plane broke into several pieces. The main section of the fuselage slowed to a stop, upside-down, in a cornfield.

One hundred twelve people, including my mom, died; 184, including Brandon and me, survived.

Ever since that day and Anderson's capturing of that image—which appeared on the front pages of newspapers and on newscasts around the world, as well as on the cover of *Time* magazine—I've had to contend with the trauma of that event. And the power of that picture, which, five years after the accident, became a memorial statue. I didn't know it then, but beyond the traumatic Flight 232 event itself, the taking of that mass-mediated image would change my life—and the lives of many others—forever. Indeed, that Anderson photograph took on a life of its own.

It's still odd—and, in truth, probably always will be—to see my tiny body as a cast-bronze figure. When a reporter from the *Sioux City Journal* asked me in 2008 about the experience of being memorialized, I told him, "It's strange being twenty-two years old and seeing yourself in a metal statue. It's something so permanent. And I'm sure oftentimes people go and look at it and they think that I probably passed away. I don't think they probably realize that I'm still alive."

Seeing myself in a statue remains a strange, out-of-body feeling, despite my being able to look at—and

think about—that memorial and *every* memorial within a much larger context. How a second in time in 1989 became a widely circulated photograph and, just five years later, a memorial statue; how a single image became a source of hope for so many, even with so much darkness and death underlying it; how my body came to represent something far greater than an individual life; how I got publicly tagged a "survivor" and struggled for years and years to come to terms with that—I've been dealing with and unpacking these questions of memorialization for three–plus decades and will be for the rest of my life. Putting this book together, they've gained even greater focus and meaning.

I've come to know that the haunting photograph by Anderson, as well as Lamphere's statue based on it, though potent and powerful and a source of positivity for many, have created considerable confusion, too. Hence the newer Flight 232 Memorial plaque that attempts but still fails to identify the memorial's intent. The child–being–carried motif—as striking as it is confounding—is, in actuality, not so clear–cut in its message.

Every memorial comes with its own series of questions about how, why, what, and/or whom to remember. But in the case of the Flight 232 Memorial, they're not just big social and cultural questions; they're also, for me, deeply personal ones. Questions I had zero control over: why are Anderson's, Lamphere's, Nielsen's, and my names included at the site, yet no other crew, passengers, or rescue workers' names are featured? What about Captain Haynes? What about my mom, my brother, and all of the others? Do visitors to the site know I'm still alive, or do they assume I passed away (because memorial statues rarely depict the living)? What makes Anderson's image worthy, above all options, of being Flight 232's "symbol of strength, compassion, and unselfish commitment"? Would a more abstract memorial design have been a better metaphor for capturing the emotional weight and detritus of the crash?

It should be noted that the image of Nielsen and me is eerily similar to the famous photograph of Baylee Almon, who died at age one in the April 19, 1995, Oklahoma City bombing, being carried by firefighter Chris Fields. And though the two pictures bear a strong resemblance, they carry very different meanings. The Almon–Fields image was—rightly, in my opinion—never turned into a memorial centerpiece. On display

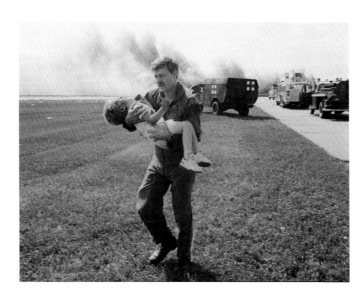

ABOVE GARY ANDERSON'S PHOTO OF THE AUTHOR, BEING CARRIED AFTER THE 1989 CRASH-LANDING OF UNITED FLIGHT 232 IN SIOUX CITY, IOWA.

RIGHT A BRONZE STATUE BY DALE LAMPHERE BASED ON ANDERSON'S PHOTO, THE CENTERPIECE OF THE *SPIRIT OF SIOUXLAND* FLIGHT 232 MEMORIAL.

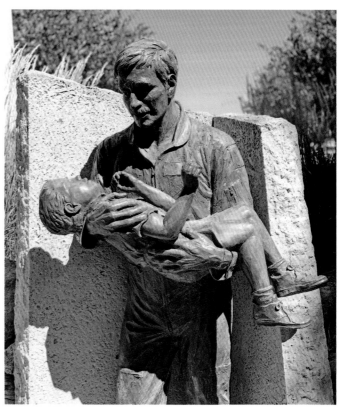

inside the Oklahoma City National Memorial Museum, there's a white Italian marble statue based on the image, by the sculptor Miles Slater, but it's treated more as one residual artifact among many. Adjacent to it, the wall text notes that the image came to "symbolize the tragedy for many people all over the world." The picture earned its photographer, Charles H. Porter IV, then a banker in his mid-twenties, a Pulitzer Prize.

Another Flight 232–related memorial I'm connected to is a hut, located in the Arapaho National Forest, about four miles south of Breckenridge, Colorado. Completed in 1994 and called Francie's Cabin, the three-story timber hut, which sleeps twenty, is a straightforward tribute to my mom's life. (Next door to it is a wood-burning sauna dedicated to her brother Herb, who died in a tragic woodworking accident in 1987, at age twenty-seven.) Paid for through family gifts, private donations, and community and foundation grants, the hut is operated by the non-profit Summit Huts Association, which maintains a system of backcountry cabins. If it weren't for a donor plaque, some basic signage, and a couple of portraits of my mom in the place, one would never know it's a memorial. But it's exactly that simple gesture—it's just a cabin where visitors can stay overnight and experience nature—that makes it, in my mind, such a potent tribute. The connection I feel to that cabin far exceeds the one I do to the Sioux City statue. It's a building to be enjoyed; there aren't any mixed readings about it. Its purpose and intent are clear.

A third Flight 232 memorial exists in the form of a permanent exhibition at the Mid America Museum of Aviation and Transportation (MAMAT). Included in the presentation is the damaged cockpit seat of Capt. Al Haynes, various newspaper clippings with images of the event and its aftermath, a blood-stained crew member's uniform, United Airlines signage, and rescue workers' utilitarian outfits. It is a literal historical interpretation of the event, told through objects and artifacts from, about, or related to the crash.

The museum, which was established in 1989, moved in 2010 to its current location inside a 30,000-square-foot (2,800-square-meter) warehouse on the northern edge of Sioux Gateway Airport, next to what remains of Runway 22. That small,

unmanicured runway section is, in its own unintentional way, yet another memorial, a site at once haunting and beautiful in its abstraction. On my most recent visit to Sioux City, in the late summer of 2019, weeds had pushed their way through cracks in the asphalt, which I viewed as a fitting metaphor, if ever there was one, for growing past lingering trauma. In one of the more surreal and grounding experiences of my life, Brandon and I slowly walked down and back the length of the runway. I will never forget it.

These four memorials—the *Spirit of Siouxland* statue, Francie's Cabin, the MAMAT exhibition, and Runway 22—indicate how remembrance and memorialization are complicated and fraught with decisions (or not) about what to include (or not), decided by a wide range of forces, private and public, and various people in power or control. Memorials are never straightforward; they serve different parties' wants and needs and almost always attempt (rightly) to tell multiple narratives. The results depend on the circumstances, making each site, building, or sculpture its own living, breathing, emotion-filled construction. No structure is static or on a plinth, but when it comes to creating a memorial, they gain even greater complexity. They yield feeling and meaning. With good reason, many memorials are often considered "sacred ground."

Being memorialized from a young age myself in both a photo and statue, I was practically reborn into a highly unusual vantage point from which to look at and think about memorial making. For me, the notion of a memorial is deeply personal because it has long been a literal, cast-in-bronze fact of my life.

Memorials carry a multitude of meanings, and each is in the eye of the beholder. Because of this fact, in addition to this Introduction and the texts for the sixty-three memorials featured in this book, interspersed throughout are five short first-person essays, each related to a different emotion: Hope, Strength, Grief, Loss, and Fear. Consider them alternate "readings." Like the memorials featured, this book is intended to be experienced, felt, looked at, interpreted, and read in a variety of ways.

On the whole, the book is my effort to better understand what contemporary memorials—in particular, the most architecturally and artistically significant

memorials built internationally since the early 1980s—mean, represent, and tell us about ourselves and our world. The *Spirit of Siouxland* is but one small example—and, in my opinion, not a particularly stand-out one—amid a large global memorial culture that has morphed over the past few decades, beginning most notably and importantly with Maya Lin's Vietnam Veterans Memorial (page 54), completed in 1982 on the National Mall in Washington, D.C.

Because of the Flight 232 Memorial, I've long been interested—and invested—in unpacking memorial culture and understanding how memory works. But my engagement also stems from a fortuitous career path as an editor and journalist. (This is to say nothing of several adult years of therapy, starting in 2016, which have proved enormously life-giving and tremendously helpful.) In 2010, I joined the staff of the American design magazine *Surface* as an assistant editor and in mid-2013 was, quite unexpectedly, promoted to editor-in-chief, a position I held for five years. Through that transformative experience and in the two years since, I've been able to meet or interview some of the world's most notable architects, artists, and designers—many of whom have designed memorials and given signifi-cant thought to memorial making—including Sir David Adjaye, Brad Cloepfil, Elizabeth Diller, Craig Dykers, Daniel Libeskind, Michael Murphy, David Rockwell, and Peter Zumthor. The conversations I've had with them have helped provide a framework to better comprehend not only the complexity of the Flight 232 Memorial, but also what it means, in today's world, to commemorate something through architecture and art.

I'll never forget the day, in 2015, when Adjaye and I met in Washington, D.C., and walked together through the Smithsonian National Museum of African American History and Culture (NMAAHC, page 192), then a hard-hat site, under construction. I can't think of many other buildings that carry such profound meaning, and to be there with him, seeing history and memory in the making, was awe-inspiring. The build-ing's patterned aluminum facade was nearly complete and its insides were still raw. The massive void that this 5-acre (2-hectare) site of memory—within 800 feet (240 meters) of the Washington Monument—would

fill in American culture was palpable even then. Upon opening in 2016, the NMAAHC averaged 8,000 visi-tors a day—double what it initially expected.[1] That was no surprise to me.

In the spring of 2013, another fortuitous thing happened: I visited the Noguchi Museum in Long Island City, New York, for the first time. Discovering the inven-tive, playful work of artist and designer Isamu Noguchi, I became obsessed—maybe even *beyond* obsessed. The serenity of his sculptures spoke to me, and made me calmer. It was fascination by osmosis. And though I didn't comprehend it at the time, I also sensed a deep resonance of memory, loss, and void in his work. Eventually, in 2015, I joined the museum's board. Since then, I've studied Noguchi's life and work even more, realizing there was much truth to my initial feelings.

Throughout his life, Noguchi thought deeply about memory and memorials. In fact, he devised ten abstract memorial designs, three of which were completed prior to his death in 1988: the Monument to Heroes (1943), a sculpture in the museum's permanent collection; Bolt of Lightning . . . Memorial to Benjamin Franklin (1933/1985) in Philadelphia; and the Challenger Memorial (1988) in Miami's Bayfront Park. (The latter appear on pages 70 and 206.) Among his projects that remained on the drawing board were Monument to the Plow (1933), Sculpture to Be Seen From Mars (1947), the Hiroshima Memorial (1952), and the Memorial to Buddha (1957).

What made Noguchi special, or even spectacular, as a memorial maker—as the Noguchi Museum's senior curator, Dakin Hart, pointed out to me—was his aim of celebrating "the spirit of things" through physical abstraction. His memorials were made to be *experienced*. Singular in his approach, and in line with twentieth-century artists like Constantin Brancusi and Alberto Giacometti, Noguchi understood how to create ambitious works that are evocative exactly because of their vagueness. Their power and strength lies in their abstraction.

Maya Lin's Vietnam memorial connects, if tangen-tially, to the Minimalist language and thinking that Noguchi helped pioneer. A masterfully designed "negative form," her memorial offers an emotional representa-tion of loss and absence through, as memory studies scholar James E. Young has put it, "the visitor's descent

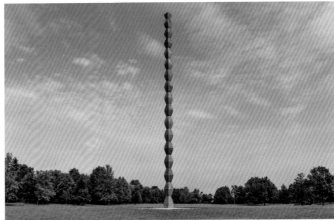

downward (and inward) into memory."[2] Inspired, in part, by Sir Edwin Lutyens's Memorial to the Missing of the Somme (1924) in Thiepval, France,[3] and George–Henri Pingusson's Memorial to the Martyrs of the Deportation (1962) in Paris,[4] the Vietnam memorial was an early example of an abstract spatial design—neither straight sculpture nor landscape.

The diversity of the shape and style of memorial designs, as well as the subject matter, has evolved greatly since the 1980s. Stanley Saitowitz's 1995 New England Holocaust Memorial (page 208) in Boston, Hans and Torrey Butzer's 2000 Oklahoma City National Memorial Museum (page 50), Peter Eisenman's 2005 Memorial to the Murdered Jews of Europe (page 28) in Berlin, Michael Arad's 2011 Reflecting Absence (page 118) at the World Trade Center, and MASS Design Group's 2018 National Memorial for Peace and Justice (page 88) in Montgomery, Alabama, are all in some way linked to this approach. Exceptional in their execution and powerful in their abstraction and Minimalism, these projects stand out in a world awash with memorials.

The path to today's memorial craze has been more than a century in the making. In an insightful 2002 essay in *The New York Times*, Michael Kimmelman, then the paper's art critic (now its architecture critic), outlines the progression of what he calls the "common–man memorial," dating it to Auguste Rodin's 1884 commission to create a monument to the burghers of Calais. Rodin's resulting piece comprises six figures grouped together and "looking gaunt, not heroic. The expressions suggested doubt or fear."[5] A few decades later, this common–man memorial evolution continued with Brancusi's decidedly abstract Endless Column memorial in Târgu Jiu, Romania, completed in 1938 and dedicated to the soldiers who died fighting off the Germans from that town during World War I. It was "a thoroughly modern monument," Kimmelman writes, "encapsulating the radical idea that a modern memorial could be, first of all, modern and not necessarily explicit."[6] Noguchi's memorials fall squarely into this category, too.

The same year that Brancusi completed his Târgu Jiu memorial, Lewis Mumford wrote a provocative, much–referenced essay titled "The Death of the Monument," declaring exactly that. While Mumford may have been a bit hyperbolic—and more than half a century ahead of his time—his argument was prescient. "The notion of a modern monument is a contradiction in terms," he wrote. "If it is a monument, it is not modern, and if it is modern, it cannot be a monument."

What Mumford hadn't necessarily considered was the evolving distinction between a monument (a more

figurative interpretation) and a memorial (something with an abstract bent)—a distinction that many scholars have since made and that I also make in this book. As Quentin Stevens and Karen A. Franck write in *Memorials as Spaces of Engagement,* "Before Mumford's essay, architects and artists, particularly in Europe, had begun exploring . . . abstract forms rather than figurative sculptures."[7] As examples, Stevens and Franck note Heinrich Tessenow's Neue Wache (1931) in Berlin and Giuseppe Terragni's Monument to Roberto Sarfatti (1934) in Asiago, Italy, as well as some unbuilt postwar projects, including Louis Kahn's proposed Memorial to Six Million Jewish Martyrs (1972) in New York.

In the wake of World War II, architects and artists experimented increasingly with nonfigurative forms—perhaps the most notable example being Eero Saarinen's towering, now-iconic Jefferson National Expansion Memorial Arch (1965) in St. Louis, Missouri that celebrates the United States's expansion to the west. Another notable postwar project is the USS *Arizona* Memorial (1962) at Pearl Harbor, in Honolulu, Hawaii; by Alfred Preis. Forming a floating bridge on the water, it establishes a serene, if somewhat clunky, presence.

During the mid-twentieth century, the former Yugoslavia became a potent place of memorial making. Between the 1950s and '70s, the artist, urbanist, writer, and politician Bogdan Bogdanović built nearly twenty memorial structures, most of them abstract Brutalist concrete designs. These included Flower of Stone (1966), a memorial for the victims of the concentration camp in Jasenovac, Croatia, and the Dudik Memorial Park for the Victims of Fascism (1980) in Vukovar, Croatia. Standout abstract memorials built elsewhere during these decades include Kenzo Tange's Cenotaph for the A-Bomb Victims (1952) in Hiroshima, Japan (see Tange's 2002 Hiroshima National Peace Memorial Hall on page 212); artist Dani Karavan's undulating concrete Monument to the Negev Brigade (1968) in Beer Sheva, Israel; and Jan van Wijk's sinuous, cathedral-like Afrikaans Language Monument (1975) in Paarl, South Africa.

Amid the social unrest and counterculture of the 1960s and '70s, a growing distrust of monuments took hold, leading to new, more radical thinking, such as Claes Oldenburg's Pop Art monuments.[8] By the 1980s, the idea of the "victim" memorial began to proliferate

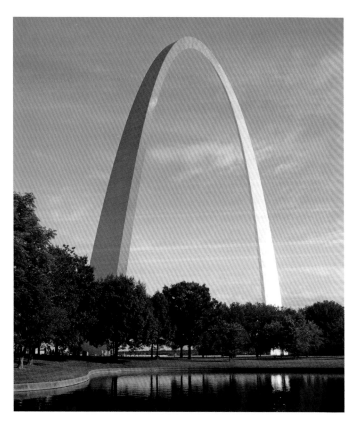

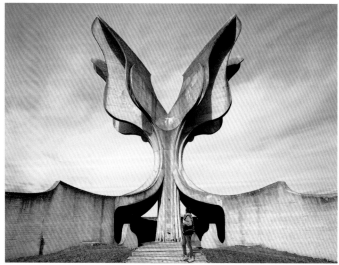

ABOVE BOGDAN BOGDANOVIĆ'S FLOWER OF STONE (1966), A MEMORIAL FOR VICTIMS OF THE CONCENTRATION CAMP IN JASENOVAC, CROATIA.

LEFT EERO SAARINEN'S JEFFERSON NATIONAL EXPANSION MEMORIAL ARCH (1965) IN ST. LOUIS, MISSOURI.

(for example, the Flight 232 Memorial), following a transition that occurred in the early to mid-twentieth century, particularly during and after the Vietnam War.[9] "Monuments"—typically statues related to war and politics, celebrating victory or valor, and often depicting soldiers and statesmen—were largely replaced by "memorials." These tended to be spatial and abstract, recognizing collective hardship and sacrifice, as well as trauma, tragedy, survival, violent death, and terrorism.

This shift also came at a time when the psychiatry community was beginning to better understand—and look more closely at—trauma. "The Vietnam War inspired numerous studies, the formation of scholarly organizations, and the inclusion of a trauma diagnosis, PTSD, in professional literature," writes the doctor and trauma expert Bessel van der Kolk in his revelatory 2014 book *The Body Keeps the Score*, adding that public interest in trauma was "exploding" during this time.[10]

A Minimalist approach to memorials began to take over. "Of all improbable art movements of the last fifty years," Kimmelman writes in that 2002 essay, Minimalism became the "unofficial language of memorial art. What used to be men on horses with thrusting swords has morphed more or less into plain walls and boxes." Referencing Lin's Vietnam memorial, Eisenman's Berlin memorial (then a proposal), and Rachel Whiteread's Holocaust memorial in Vienna (page 48), he continues, "Minimalism has gradually, almost *sub rosa*, made its way into the public's heart."[11]

When it comes to memorial making, it seems that, over the twentieth century, artists and designers realized that abstraction carries power that a figurative statue or literal-minded sculpture rarely, if ever, achieves. Vagueness, when done carefully, with intent and a desired effect, creates a vast array of connections between cultures, individuals, and emotions. Each visitor to an abstract memorial can have their own reading and response. Abstract metaphors allow for messiness, complexity, and contradiction. They embrace chaos. They are, as author Rebecca Solnit has written, "bridges across categories and differences."[12] Artist Jochen Gerz—who, from 1990 to 1993, with a group of university students, created The Invisible Monument (page 220) in Saarbrücken, Germany— said, "If you are representing absence, you should

create absence. The same absence also permits each person to become the author of his/her own memorial work."[13] At their best, abstract memorials serve multiple constituents while telling challenging stories. They invite visitors to enter and experience them, to slow down and *feel* something.

MASS Design Group's Michael Murphy, describing the power of abstraction, told me, "It allows you to bring your own biases." But, he warned, "If it's *too* abstract, it allows you to bring biases that are out of place." Hans Butzer, who with his wife and partner, Torrey, designed the Oklahoma City National Memorial Museum, similarly said, "You're on dangerous ground if you design something so abstract that nowhere in the project is there really a foothold for people to begin engaging."[14]

Because memories are abstract, so too must memorials be. Religious studies professor Edward T. Linenthal has written, "The more volatile the memory, the more difficult a task to reach a consensual vision of how the memory should be appropriately expressed, and the more intense becomes the struggles to shape, to 'own' the memory's public presence."[15] This is why abstract memorials so often work.

In the pages that follow, from Lin's memorial onwards, there are a myriad of typologies, from sculptures and statues to museums and art installations. Admittedly, I could have gone even deeper to include the AIDS Memorial Quilt, unbuilt or cancelled memorials (there are many of note, such as Swedish artist Jonas Dahlberg's Memory Wound, for Norway's Utøya massacre), counter-memorials, impromptu temporary memorials, highways and bridges and tunnels, *tchotchkes*, sports arenas, university buildings, and more. But I felt it was important to focus the book on the most extraordinary examples in architecture and art—ones that were intentionally and thoughtfully built to evoke and capture memory.

That said, many impressive memorials, for one reason or another, do not appear here. Two examples in particular I was pained to cut, and I wish were featured. One is Elyn Zimmerman's 1995 World Trade Center Memorial, which honored those who were killed in the 1993 truck bombing. Because it was destroyed

in the 9/11 terrorist attacks, the available imagery was limited. (It's one of the more haunting examples of memorialization I've come across: a shattered remnant of the memorial, found in the Ground Zero rubble, is now displayed in a velvet-lined, casket-like wood box in the 9/11 Memorial Museum—a memorial within yet another memorial.) The other is James I. Freed's 1992 United States Holocaust Memorial Museum in Washington, D.C., a striking, category-defining project.

Other standout projects not featured are Karin Daan's 1987 Homomonument in Amsterdam; Maya Lin's 1989 Civil Rights Memorial in Montgomery, Alabama; Tree Memorial of a Concentration Camp (2006), for which artist Sebastian Errazuriz planted a magnolia tree, for one week, in the middle of Chile's National Stadium, where Augusto Pinochet had tortured and killed thousands of political prisoners in 1973; Dani Karavan's 1994 Passages in Portbou, Spain, dedicated to Walter Benjamin, and his 2014 Harel Brigade Memorial in Jerusalem (Karavan's 2012 memorial in Berlin is on page 44); and the 2007 Atocha Station Memorial in Madrid, designed by Estudio FAM.

I gave significant thought to the subjects and typologies of the memorials included: there are hundreds of Holocaust memorials around the world, for example, and surely many should feature in this book, so which ones stand out? This book presents a wide-ranging selection of memorials, but it does not attempt to be a be-all-end-all retrospective of work built in the past forty years.

It was my aim to explore each project's evolution, showing them as *living* and, from a cultural and social perspective, ever-changing. Memories, like memorials, are multifaceted, open to varying interpretations, recollections, and readings. Kendall R. Phillips describes our "slippery relationship" with memory best: "Memories refuse to remain stable and immutable. Their appearance, often unbidden, within our cultural experience is like a mirage: vivid and poignant but impermanent and fluid. No matter their importance or revered place in our collective lives, we cannot grasp them fully nor fix them permanently."[16]

The complexity, contradiction, and turbulence of public life the past few decades is tricky to pin down in this context. As the world itself becomes more

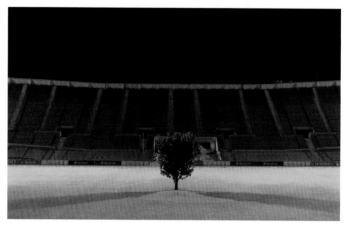

TOP ELYN ZIMMERMAN'S 1995 WORLD TRADE CENTER MEMORIAL, DESTROYED IN 9/11, HONORING THOSE KILLED IN THE 1993 TRUCK BOMBING.

BOTTOM SEBASTIAN ERRAZURIZ'S TEMPORARY TREE MEMORIAL OF A CONCENTRATION CAMP (2006) IN CHILE'S NATIONAL STADIUM.

interconnected and diverse—and, at times, partly because of this, polarizing—so too does the world of memorials and our interpretations of them. The contemporary memorial is, as Erika Doss writes, "often equivocal, unresolved, and ambivalent. Its meaning is neither inherent nor eternal but *processual*—dependent on a variety of social relations and subject to the volatile intangibles of the nation's multiple publics and their fluctuating interests and feelings."[17]

The speed at which we memorialize—like the speed at which we now communicate and do so much else—has increased, too, with memorials appearing almost as soon as a tragedy is over. The Oklahoma City memorial, for example, was completed within five years

of the bombing. The Flight 232 Memorial and Francie's Cabin were also built only five years after the crash. Arad's Reflecting Absence was completed ten years after 9/11, despite needing to satisfy countless constituents and a drawn-out selection process. As many of the memorials in this book indicate, humans seek to heal quickly. (There are exceptions, of course: the NMAAHC took a century to realize, overcoming slews of hurdles, and Peter Zumthor's Steilneset Memorial, on page 148, was built more than 300 years after the people it commemorates perished.)

What makes memorials fascinating is that, no matter how you look at them, they're loaded. Various social, cultural, financial, and political powers bring them into this world and, once built, such powers continue to shift their meanings and interpretations throughout time. There's essentially nothing fixed, constant, or consistent about them. Perceptions shift. Regardless of who's steering the narratives, from Berlin to Washington, D.C., from Montgomery to Mexico City, one thing underlies every single memorial: the urge we have to never forget. And even if not everyone agrees, abstraction may well provide the soundest solution for achieving this. As Paul Murdoch, architect of the Flight 93 Memorial (page 156), told me:

> The discourse of architectural critics and art professionals, etc., is: Maya [Lin] did her thing in an abstract language, can't we move on from that? First of all, Maya wasn't the first person to do that. Second of all, if you just do some realistic sculpture or narrative-laden memorial, you're starting to narrow down what kind of interpretations are possible. This abstract language is important. It allows a diversity of viewpoints while still expressing something fundamental.

Abstract and typically minimalist in language, the memorials featured in this book are visually affecting and open to multiple interpretations. They are indelibly, *physically*, ingrained in the minds of those who experience them. Visit these constructions in person and they're likely to become embedded in your memory. It's my hope that holding this book in your hands will have a similar, grounding impact.

1 Lonnie G. Bunch III, *A Fool's Errand: Creating the National Museum of African American History and Culture in the Age of Bush, Obama, and Trump* (Washington, D.C.: Smithsonian Books, 2019), 242.

2 James E. Young, *The Stages of Memory: Reflections of Memorial Art, Loss, and the Spaces In Between* (Boston: University of Massachusetts Press, 2016), 3.

3 Maya Lin, *Boundaries* (New York: Simon & Schuster, 2000), 4:09–4:11.

4 Young, ibid.

5 Michael Kimmelman, *The New York Times*, "Out of Minimalism, Monuments to Memory," Jan. 13, 2002.

6 Kimmelman, ibid.

7 Quentin Stevens and Karen A. Franck, *Memorials as Spaces of Engagement: Design, Use, and Meaning* (New York: Routledge, 2016), 17.

8 Kimmelman, ibid.

9 Stevens and Franck, ibid, 37.

10 Bessel van der Kolk, M.D. *The Body Keeps the Score: Brain, Mind, and Body in the Healing of Trauma* (New York: Penguin Books, 2015), 190.

11 Kimmelman, ibid.

12 Rebecca Solnit, *Whose Story Is This? Old Conflicts, New Chapters* (Chicago: Haymarket Books, 2019), 130.

13 Stevens and Franck, ibid, 49.

14 Suzette Grillot, Rebecca Cruise, and Brian Hardzinski, kgou.org, "Memorial Designer Reflects on Commemorating Tragedy Through Architecture," April 19, 2013.

15 Edward T. Linenthal, *Preserving Memory: The Struggle to Create America's Holocaust Museum* (New York: Columbia University Press, 2001), 52.

16 Kendall R. Phillips, *Framing Public Memory* (Tuscaloosa: The University of Alabama Press, 2004), 2.

17 Erika Doss, *Memorial Mania: Public Feeling in America* (Chicago: The University of Chicago Press, 2010), 45.

MEMORIAL TO THE MURDERED JEWS OF EUROPE

Peter Eisenman's Memorial to the Murdered Jews of Europe may be the most-debated site in a city full of contested grounds. It lies just near the Brandenburg Gate and Germany's parliament building, and is built over a bunker once used by Nazi propaganda chief Joseph Goebbels. Yet nowhere are the tensions around how to remember the Holocaust in the city more palpable than on this austere 200,000-square-foot (19,000-square-meter) square. Comprising 2,711 concrete slabs, or stelae, arranged in a rigid, undulating grid structure, the memorial continues to be both derided and celebrated, the focus of ongoing philosophical and political battles.

The memorial's inception dates back to 1988, when a group began petitioning the government to honor the six million Jews killed in the Holocaust. In 1993, a plot of land for the memorial was determined, and a year later a design competition was announced, although no winner was selected. In 1997, a second competition was launched, with a scheme by architect Peter Eisenman and sculptor Richard Serra chosen, although Serra soon quit the project. In 1999, a proposal designed by Eisenman was at last approved.

Upon its opening in 2005, the site, which includes an underground information center, quickly became central to the city's life. Its vast scale and solemn design feels, on one level, like a graveyard, but it invites other interpretations and responses. It serves not just as a space for reflection, but also as a park-like hangout for bicyclists, skateboarders, picnickers, and sunbathers; it has become a go-to destination for selfie-takers. In 2017, Shahak Shapira, a Berlin-based Israeli artist-satirist, created a provocative project that juxtaposed found selfies taken at the memorial with archival images from concentration camps, a clear criticism of the ambiguous design and the public's use of it.

As long as Eisenman's Holocaust memorial exists, the debates around it will continue to abound, as disorienting as walking through its towering, tilting pillars.

RIGHT THE GRID OF CONCRETE STELAE AT THE MEMORIAL CONFOUNDS IN ITS MEANING, AND THIS WAS THE ARCHITECT'S INTENT.

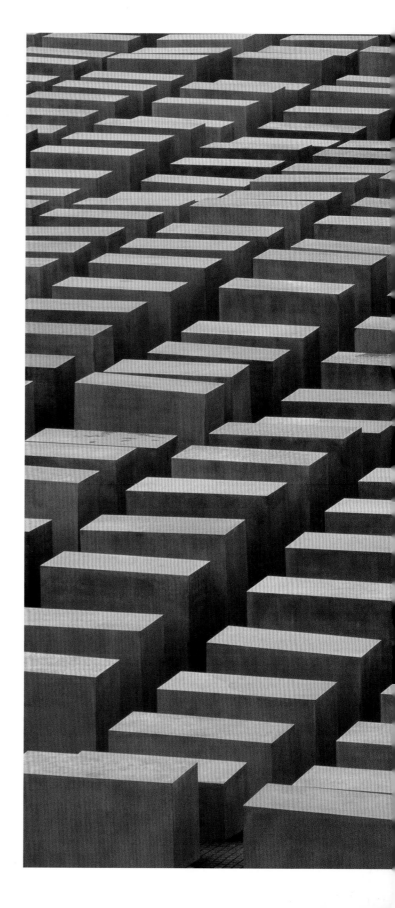

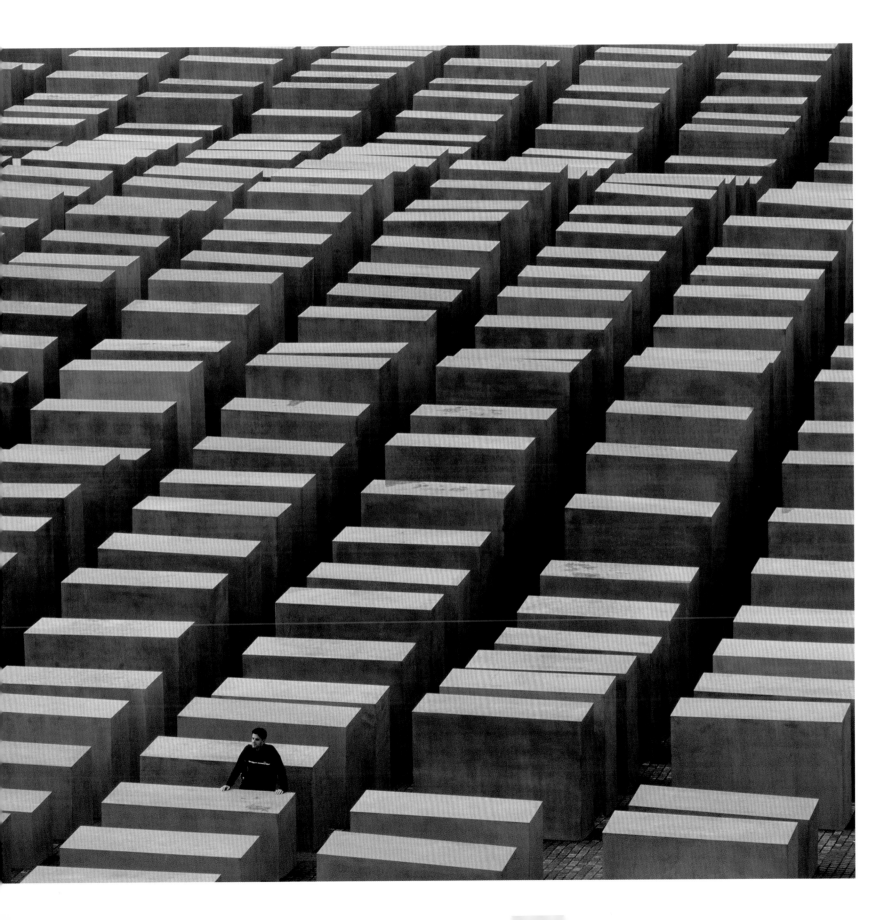

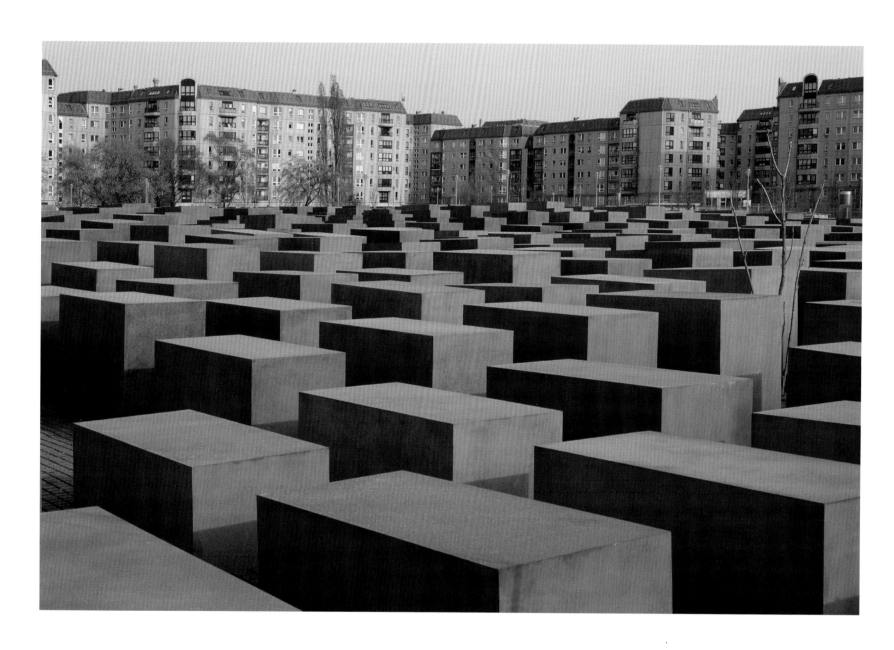

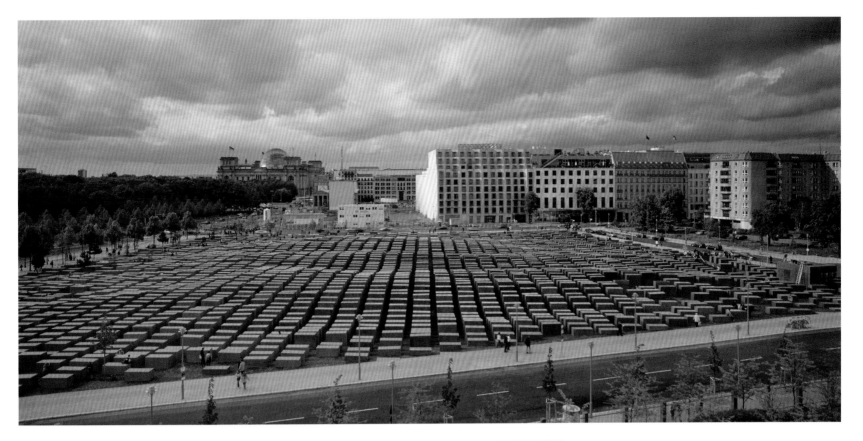

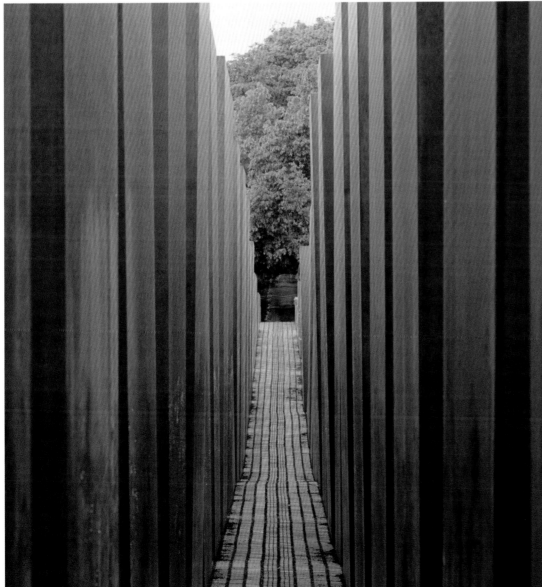

TOP SEEN FROM ABOVE, THE MEMORIAL WITH THE U.S. EMBASSY (THEN UNDER CONSTRUCTION), THE BRANDENBURG GATE, AND THE REICHSTAG BEYOND IT.

LEFT A VIEW FROM INSIDE THE MEMORIAL.

OPPOSITE SEEN FROM THE PERIPHERY, THE MEMORIAL'S TOWERING, TILTING PILLARS CARRY AN IMPOSING, WEIGHTY PRESENCE ON THE SITE.

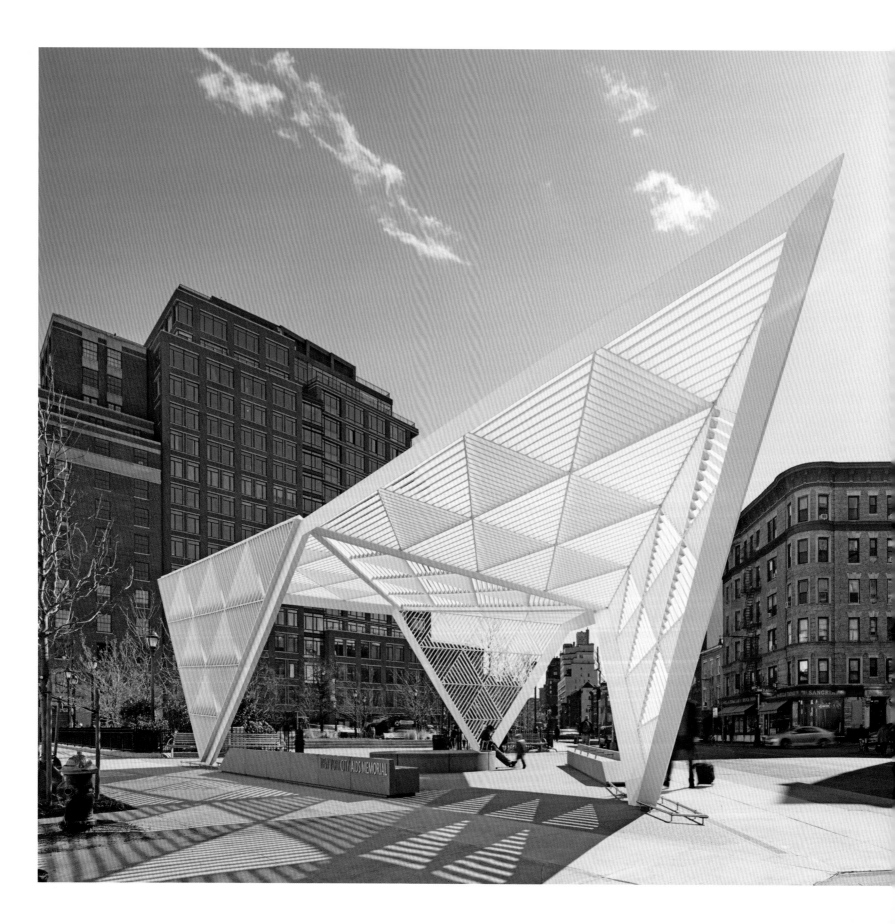

After St. Vincent's Hospital—a ground zero of the AIDS epidemic—announced its closure in 2010, two urban planners, Paul Kelterborn and Christopher Tepper, rallied to create an AIDS memorial in the park next to the former hospital in Manhattan. They formed a board (chaired by Phaidon CEO Keith Fox), pitched to politicians, and launched a design competition, which attracted 475 entries. The competition's judges—who included architect Elizabeth Diller; actress, comedian, and activist Whoopi Goldberg; Studio Museum director Themla Golden; and Michael Arad, architect of the 9/11 Reflecting Absence memorial (page 118)—chose Studio AI Architects for its Infinite Forest concept, a triangular, mirror-lined space surrounding a thick grouping of slender birch trees; slate walls on the exterior were to invite passersby to leave tributes in chalk.

The final memorial turned out decidedly different, but was a comparably potent design with a clear message: to remember the 100,000-plus residents of the city who have died of AIDS, and to recognize the many activists and caregivers who have helped them. The memorial comprises an 18-foot (5.5-meter), tent-like white steel and aluminum pavilion that hovers over a central fountain, benches, and an installation by the artist Jenny Holzer, who inscribed Walt Whitman's "Song of Myself" into Minnesota granite pavers.

Built on the site of St. Vincent's Materials Handling Center, an ugly loading-dock building that resembled a utilities plant, where both medical supplies and corpses were sent in and out through tunnels, the memorial carries significant historical weight (St. Vincent's opened the U.S.'s second AIDS ward in 1984). Yet its transparent form appears to have an ethereal, floating presence. An apt honoring of the tremendous loss, the memorial offers a sense of hope.

LEFT THE MEMORIAL SITS IN THE HEART OF MANHATTAN'S WEST VILLAGE AND FEATURES A CANOPY WITH A TRIANGULAR MOTIF.

INTERNATIONAL MEMORIAL OF NOTRE-DAME-DE-LORETTE

Located in Ablain–Saint-Nazaire, northwest of Arras, and completed in 2014, to honor the centenary of World War I, the International Memorial of Notre-Dame-de-Lorette resulted from a competition won by French architect Philippe Prost. Called the Ring of Remembrance, Prost's design comprises an oval-shaped structure that extends over the site's gently sloping terrain and unites the names of the 579,606 combatants who were killed in the northern French region of Nord–Pas-de-Calais during the war. Arranged around the ellipse in alphabetical order, with no distinction of nationality, rank, or religion, the names are engraved on 500 sheets of gilded metal, each 9.8 feet (3 meters) high. (Soldiers with the surname "Smith" occupy three of the panels, a particularly potent reminder of the brutal atrocity of the war.) Among the names, arranged in white sans-serif block capital letters designed by Paris-based typographer Pierre di Sciullo, are 241,214 British, 173,876 Germans, and 106,012 French. In its sheer totality, the circumference of names carries an affecting weight similar to that of Maya Lin's Vietnam Veterans Memorial (page 54) in Washington, D.C.

Tracing a 1,131-foot (345-meter) perimeter with two-thirds of it rooted in the ground, the memorial features an impressive but precarious-looking 184-foot (56-meter) post-tensioned concrete cantilever. A portion of the monument is suspended above a trench, suggesting the fragility inherent in peace. On the outside, dark concrete ("the color of war," in Prost's words) establishes a moody contrast with the light, reflective material inside. Next to a neo-Byzantine chapel and a sprawling war cemetery containing more than 40,000 soldiers' bodies and one of France's largest burial sites, the memorial features openings that provide views on one side toward the Artois countryside, and on the other, toward the rows of graves.

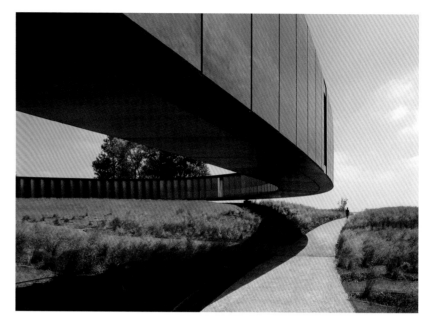

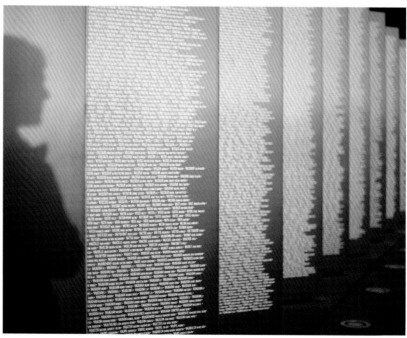

TOP THE MEMORIAL'S ENGINEERING FEAT IS THIS 184-FOOT (56-METER) CANTILEVER THAT EXTENDS OVER A WALKWAY, AS IF HOVERING.

BOTTOM FIVE HUNDRED SHEETS OF GILDED METAL FEATURE THE NAMES OF COMBATANTS WHO WERE KILLED IN THE REGION DURING WORLD WAR I.

OPPOSITE CUTTING A STRIKING FIGURE IN THE COUNTRYSIDE, THE MEMORIAL BRINGS A CONTEMPORARY EDGE TO THE LANDSCAPE.

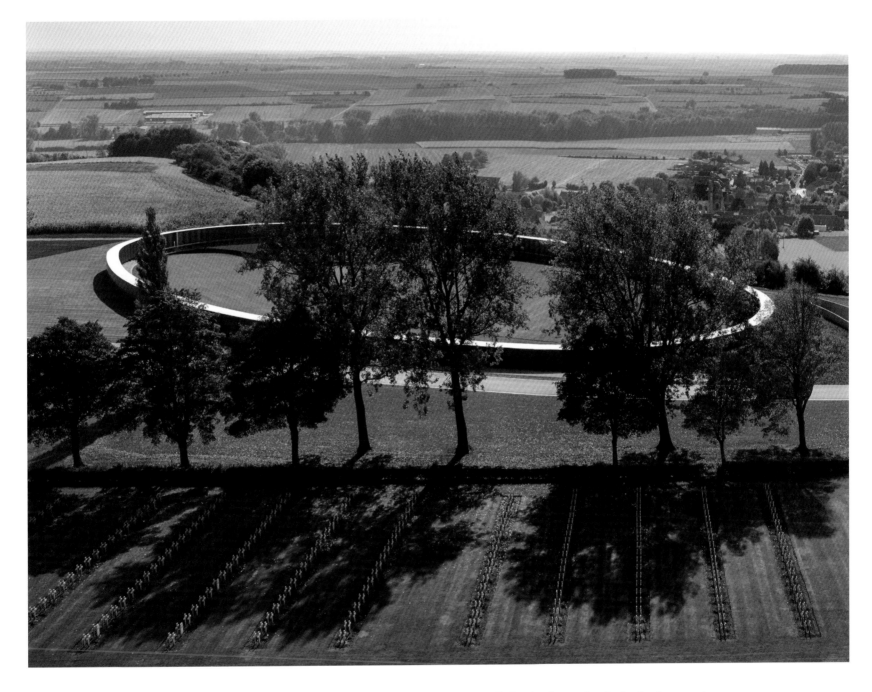

Honoring the centenary of World War I, the oval–shaped Ring of Remembrance cantilevers above a trench, suggesting the fragility inherent in peace.

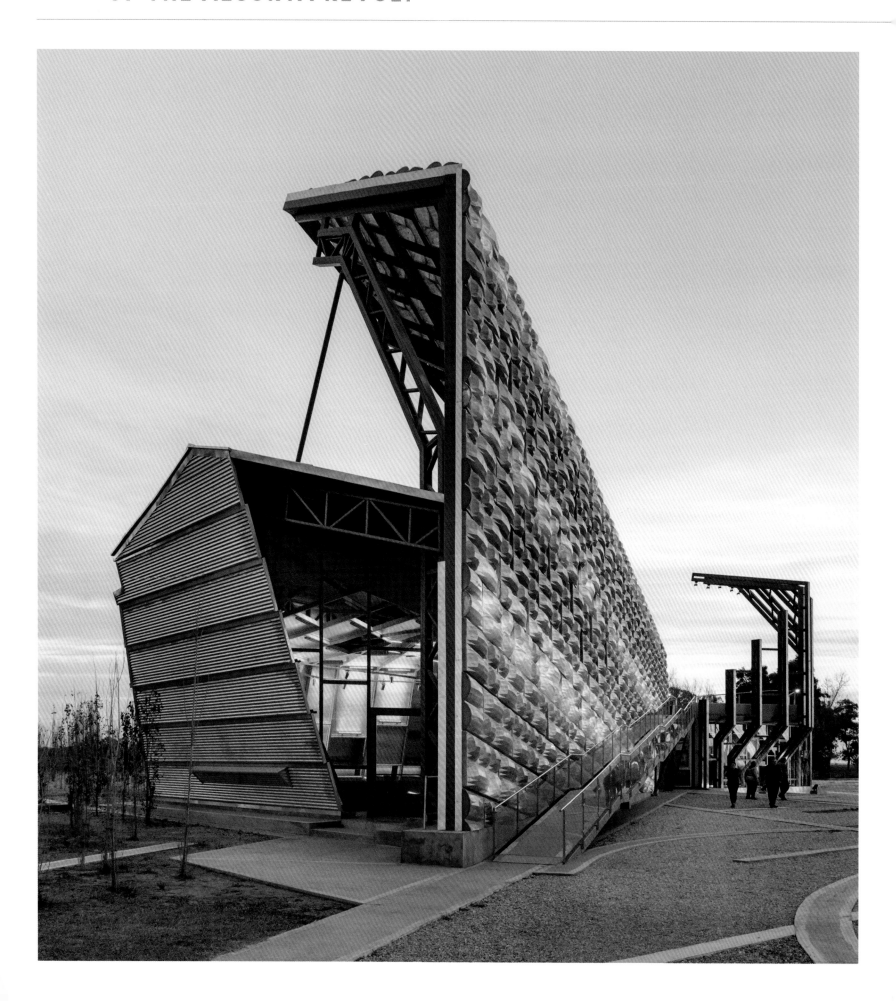

On June 25, 1912, the farmers of the village of Alcorta, Argentina, halted work in the fields. Seeking a series of contractual improvements from their various landowners, they threatened to not sow the corn on time in the fall. From Alcorta, the conflict grew throughout the Santa Fe province, and then into the provinces of Córdoba and Buenos Aires, eventually mushrooming into a full-blown movement for farmers' rights and the creation of the *Federación Agraria Argentina* (FAA) organization. The "Grito de Alcorta," or Shout of Alcorta, as it was called, was the start of further strikes in 1913, 1917, and 1919.

In 2011, the FAA, together with the Alcorta commune, the Santa Fe province, and Argentina's federal government, commissioned the Buenos Aires-based studio Claudio Vekstein, Opera Publica to design a memorial commemorating the hundredth anniversary of this historic revolt. While researching, the project's architect, Claudio Vekstein, came across archival pictures of the harvest season, during which farmers had piled corn-filled burlap sacks into impressively large mounds. Also drawn to the rough textures Antonio Berni's 1934 painting *Manifestación*, alluding to the Shout of Alcorta, Vekstein established a tactile environment that suggests, in an abstract way, an aesthetic homage to the farmers. Recreating a subtle architectural semblance of the piles, Vekstein mixed resin, fiberglass, and burlap, using a series of wood molds to create 275 semitranslucent panels that line the northern facade of the 4,300-square-foot (400-square-meter) structure. The building unfolds into a series of spaces that include a plaza, a 150-seat auditorium, and a gallery and interpretation center featuring artifacts from the events; an adjacent reinforced concrete pavilion is home to FAA offices. Sheet-metal panels make up the remaining walls, forming an interior that during the day brings in soft yellow light and at night lights up like a bright, beaming lantern.

Honoring a momentous 1912 farmers' revolt, the Alcorta memorial recreates a subtle architectural semblance of piles of corn-filled burlap sacks.

LEFT LINING THE NORTHERN FACADE, PANELS OF RESIN, FIBERGLASS, AND BURLAP MAKE REFERENCE TO PILES OF FARMERS' SACKS.

BERLIN WALL MEMORIAL

The primary place of commemoration for the victims of the Berlin Wall—the concrete barrier that divided Berlin both physically and ideologically from 1961 to 1989— the memorial on Bernauer Strasse was a project that expanded in scope and scale over almost two decades. Resulting from a 1994 competition organized by the German government that attracted 259 entries, the first major section of the memorial was completed in 1998. The structure, created by the firm Kohlhoff & Kohlhoff, combined two steel walls enclosing a section of the border grounds with the preserved remains of some of the original fortifications. The next notable addition to the memorial came in 2000, with the completion of the oval-shaped Chapel of Reconciliation. Designed by Rudolf Reitermann and Peter Sassenroth, it was built on the former site of the 1894 Church of Reconciliation, which had been destroyed by East Germany in 1985. By 2006, a master plan for the site was passed by the Berlin Senate, and in 2009 a visitor center opened.

Over time, the focal point and certainly the most visually potent part of the memorial emerged, designed by firms SINAI and ON Architektur: a nearly four-fifths-of-a-mile-long (1.3-kilometer-long) park-like stretch of land, tracing the dramatic, often traumatic events. The project comprises 12-foot-tall (3.6-meter-tall) CorTen-steel poles that run most of the memorial's length, creating a porous division, a poetic illusion that is at once heavy and light, a marker of both the freedoms afforded today and a stark reminder of the blockade that once existed. Punctuating the site are a trail, information stands, famous pictures reproduced on the sides of neighboring buildings, and a Window of Remembrance installation commemorating the 140 people who died at the border. In 2014, the most recent element of the memorial opened: a reconstructed documentation center featuring an open-air platform with an aerial view over the sprawling site.

RIGHT THE MEMORIAL'S POROUS DIVISION COMPRISES CORTEN-STEEL POLES THAT RUN MOST OF ITS LENGTH.

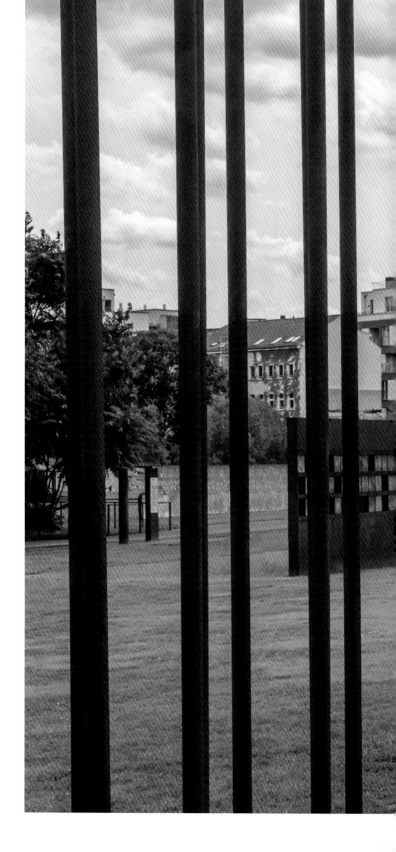

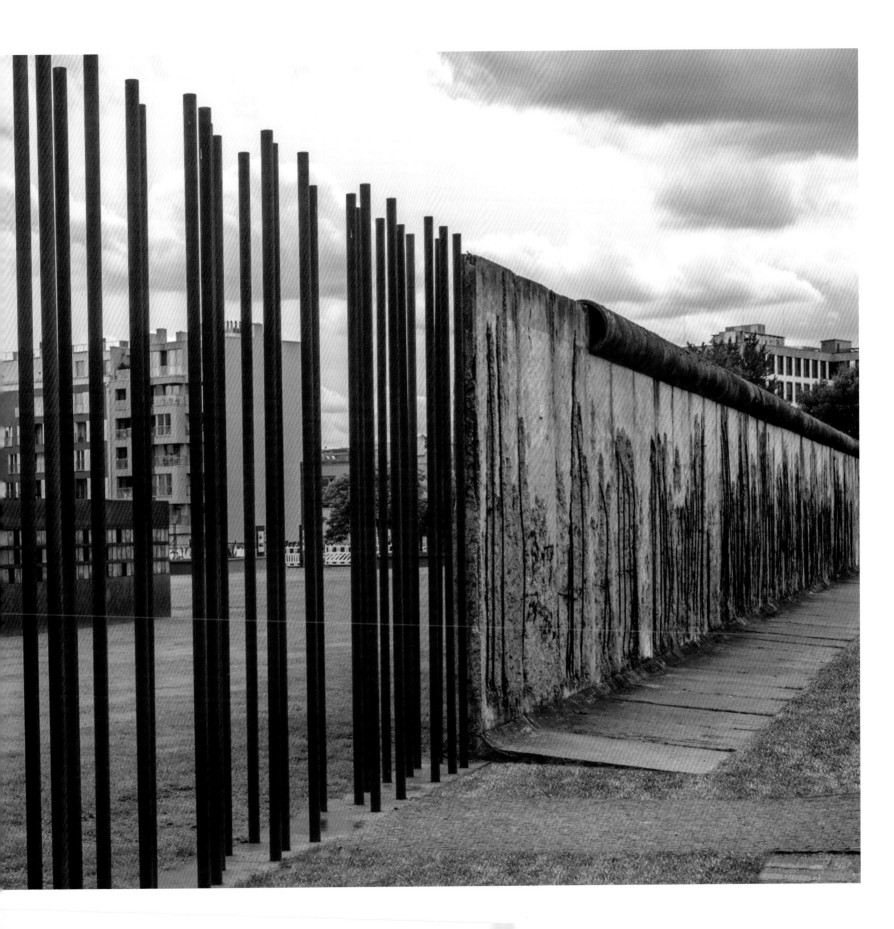

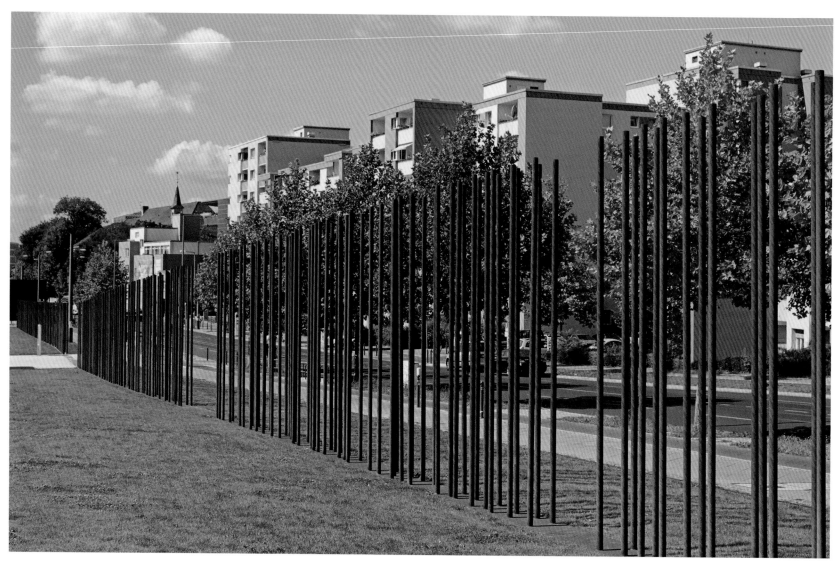

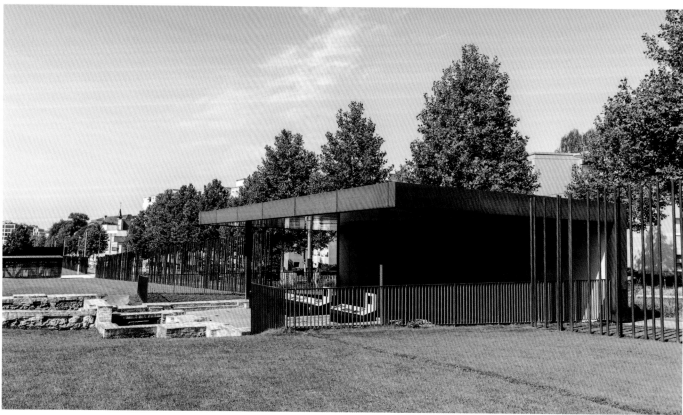

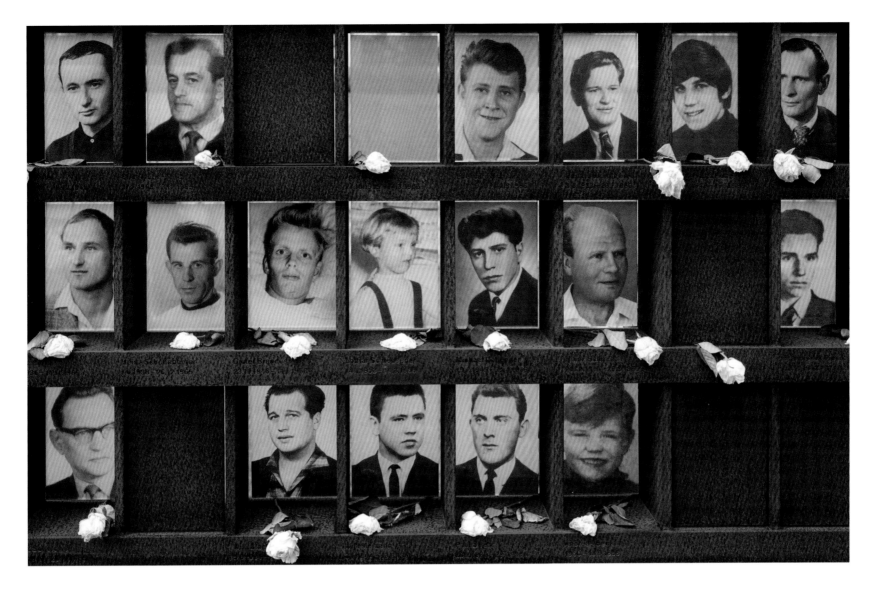

The Berlin Wall Memorial serves as a marker of the freedoms afforded today and a stark reminder of the blockade that once existed.

GUN VIOLENCE MEMORIAL PROJECT

The Gun Violence Memorial Project sprung out of a memorable meeting at the 2018 opening of the National Memorial for Peace and Justice (page 88) in Montgomery, Alabama. Michael Murphy, the founding principal of MASS Design Group, the architects of the Montgomery memorial, was approached by Pamela Bosley and Annette Nance–Holt. As founders of the Chicago gun violence prevention group Purpose Over Pain, Bosley and Nance–Holt asked Murphy if he would be interested in finding a way, through a memorial design, to honor the victims of gun violence—including their two teenage sons. When they gave him their business cards, Murphy noticed that portraits of their deceased children were on them. It shook him. That same day, he told artist Hank Willis Thomas about the introduction. Thomas, whose cousin, Songha Willis, was killed by gun violence in 2000, and whose work explores social–justice issues, said he was interested in exploring the concept of a memorial with Murphy.

The result, the Gun Violence Memorial Project—a collaboration between MASS, Thomas, and Purpose Over Pain, in partnership with Everytown for Gun Safety—debuted in September 2019 as a temporary installation at the Chicago Architecture Biennial. Comprising four white, gabled–roof houses, each made up of 700 hollow transparent glass bricks symbolizing the number of people in America killed every week by guns, the memorial features personal "remembrance objects" inside each brick. Collected from victims' families over several days in Boston, Chicago, and Washington D.C., the objects range from high school graduation tassels, to a bow tie, to a tea set. Inside each house, visitors can listen to audio recordings from interviews conducted by MASS and StoryCorps. One day, the firm hopes to install a permanent iteration of the memorial.

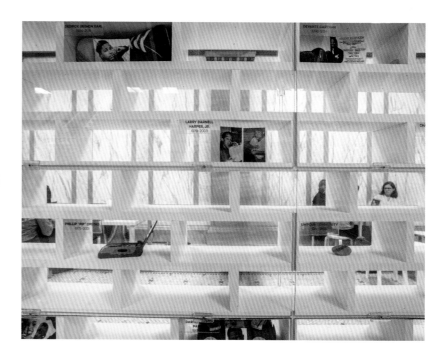

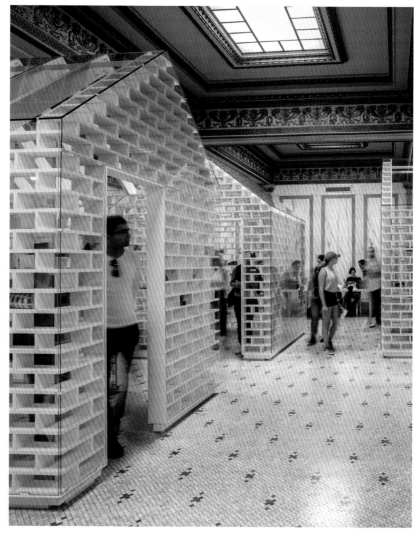

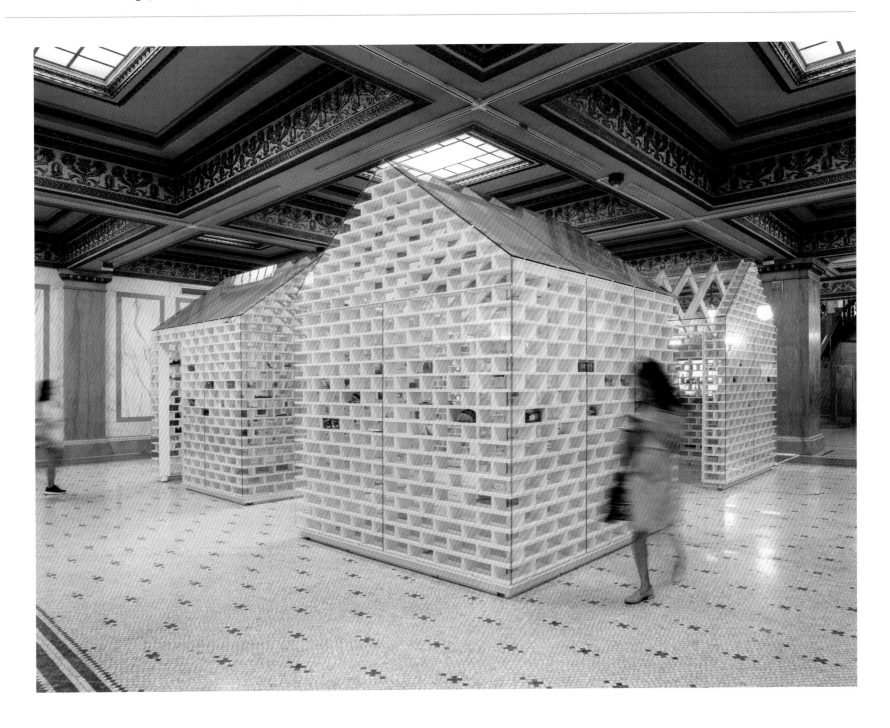

OPPOSITE (TOP) EACH OF THE BRICKS FEATURE REMEMBRANCE OBJECTS, THE NAME OF THE PERSON BEING HONORED, AND THEIR BIRTH AND DEATH YEARS.

OPPOSITE (BOTTOM) THE TRAVELING MEMORIAL OPENED AT THE CHICAGO CULTURAL CENTER AS PART OF THE 2019 CHICAGO ARCHITECTURE BIENNIAL.

ABOVE EACH "HOUSE" FEATURES 700 BRICKS—A REPRESENTATION OF THE AVERAGE NUMBER OF LIVES LOST EACH DAY DUE TO GUN VIOLENCE IN THE U.S.

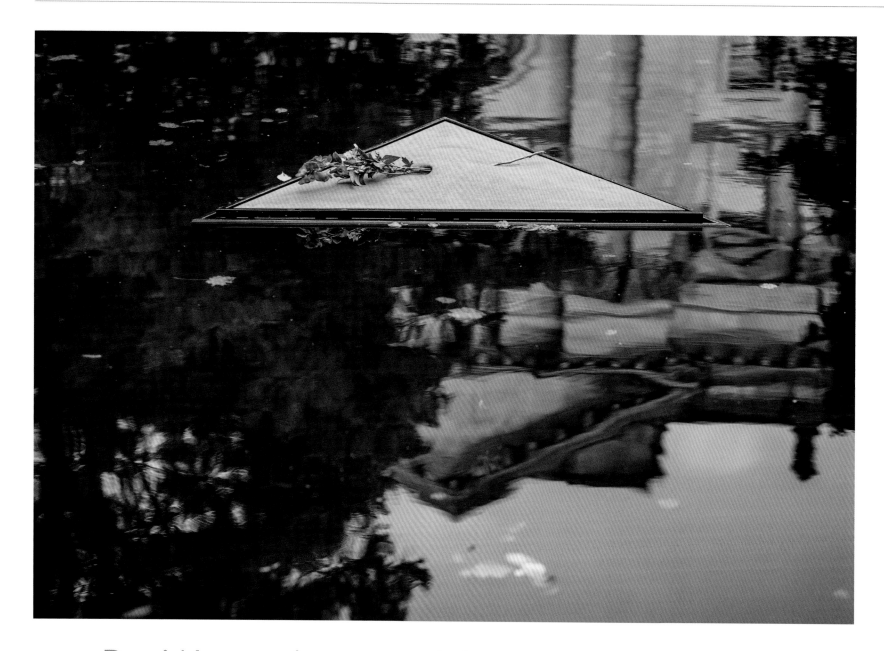

Dani Karavan's memorial suggests to visitors and onlookers: Slow down. Stay aware. Never forget minorities; protect them.

Built to honor the the hundreds of thousands of Sinti and Roma communities (often referred to as gypsies) who were killed in the Holocaust, Israeli sculptor Dani Karavan's quiet, reflective memorial sits next to Berlin's historic Reichstag building in Tiergarten park. A short walk from Peter Eisenman's 2005 Holocaust memorial (page 28) and Elmgreen & Dragset's 2008 memorial for persecuted gay men and lesbians (page 82), Karavan's design is subtly integrated into its surroundings—so much so that it's easy to miss. And maybe that's partly the point. In its humble way, it suggests to visitors and onlookers: Slow down. Stay aware. Never forget minorities; protect them.

Comprising a circular black pool of water with a triangular pillar, surrounded by scattered stones inscribed with the names of Nazi concentration camps, the memorial serves as a metaphor. The strong center fountain mirrors the sky above (and, perhaps intentionally, the Reichstag, too) while the surrounding broken

stones remind visitors of World War II's remaining wreckage. In front of the iron-gated entrance, a small sign on the ground reads, "You are entering a place of remembrance. Please respect the purpose and the people for whom this memorial site was created." Ominously, it concludes, "Those visiting the memorial do so, all year round, at their own risk." Next to the entrance is a glass-walled timeline, as well as a poem inscribed in granite, titled "Auschwitz," by writer and composer Santino Spinelli.

Plans to erect the memorial began in 1992, but it wasn't until 2012 that it would be completed, as disagreements over its design and name delayed construction. (Also no doubt playing a part was the fact that postwar Germany refused to acknowledge the community's suffering until 1982.) In 2015, only three years after its opening, the memorial was defaced with a swastika and the message "Gas them." The paint was hastily removed.

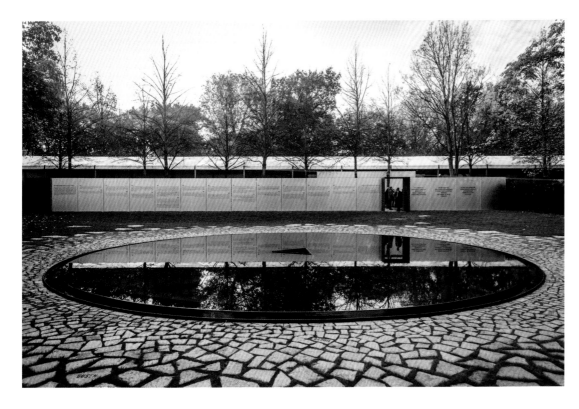

LEFT THE TRIANGULAR PILLAR IN THE MIDDLE OF THE MEMORIAL'S CIRCULAR BLACK POOL OF WATER, WITH THE REICHSTAG MIRRORED ON ITS SURFACE.

OPPOSITE THE MEMORIAL, SURROUNDED BY SCATTERED STONES INSCRIBED WITH THE NAMES OF NAZI CONCENTRATION CAMPS.

CRETTO DI BURRI

The Umbrian artist Alberto Burri began constructing what would become one of the largest works of landscape art in Europe, Cretto di Burri—also known as "Grande Cretto"—in the mid-1980s. A contemporary of boundary-pushing painters like Robert Rauschenberg, Yves Klein, and Lucio Fontana, Burri employed a *cretto*, or crack, technique in some of his later paintings, using thickly layered acrylic. The work, which plays with this technique, covers nearly 22 acres (9 hectares) of the Sicilian town of Gibellina, which in 1968 was flattened and completely destroyed by the Belice earthquake (at least 200 were killed, around 1,150 injured, and more than 98,000 left homeless). Made of 122 angular white concrete blocks, each at a height of 4 to 5 feet (1.2 to 1.5 meters) and measuring 32 to 65 feet (10 to 20 meters) on each side, the memorial depicts the village's original layout, with much of its rubble, furniture, utensils, and various remains left underneath the cement.

Completed in 2015, ten years after Burri's death and on the 100th anniversary of his birth year, the project was more than thirty years in the making. In 1981, in response to the city's mayor, Ludovico Corrao, who had invited a group of artists to present proposals for New Gibellina, which was rebuilt 7 miles (11 kilometers) away, Burri proposed creating something on the ruins of the old town instead. The construction began in 1985, but was halted in 1989 for political and financial reasons. About three-quarters of it was finished. Nearly three decades later, the Fondazione Burri was at last able to complete the monumental work in full. Similar to the broad, gaping 2013 Wenchuan Earthquake Memorial Museum (page 84) in China, Burri's powerful creation evokes the earthquake's devastation and loss in a riveting, quietly affecting way.

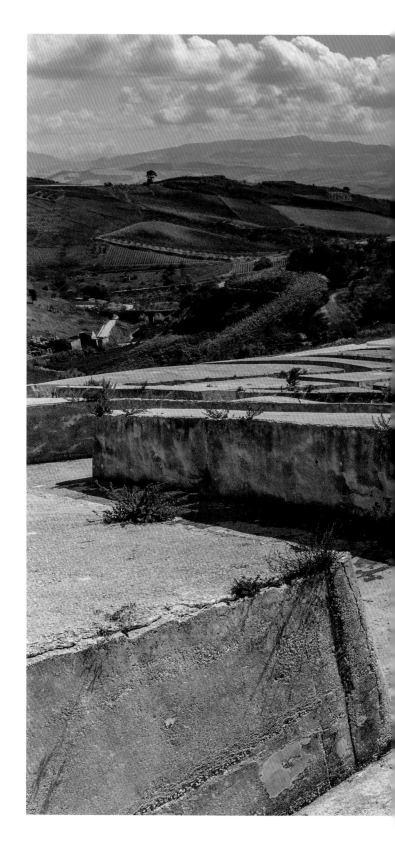

RIGHT THE CONCRETE MEMORIAL COVERS THE LAYOUT OF A SICILIAN TOWN THAT WAS DESTROYED IN A DEVASTATING 1968 EARTHQUAKE.

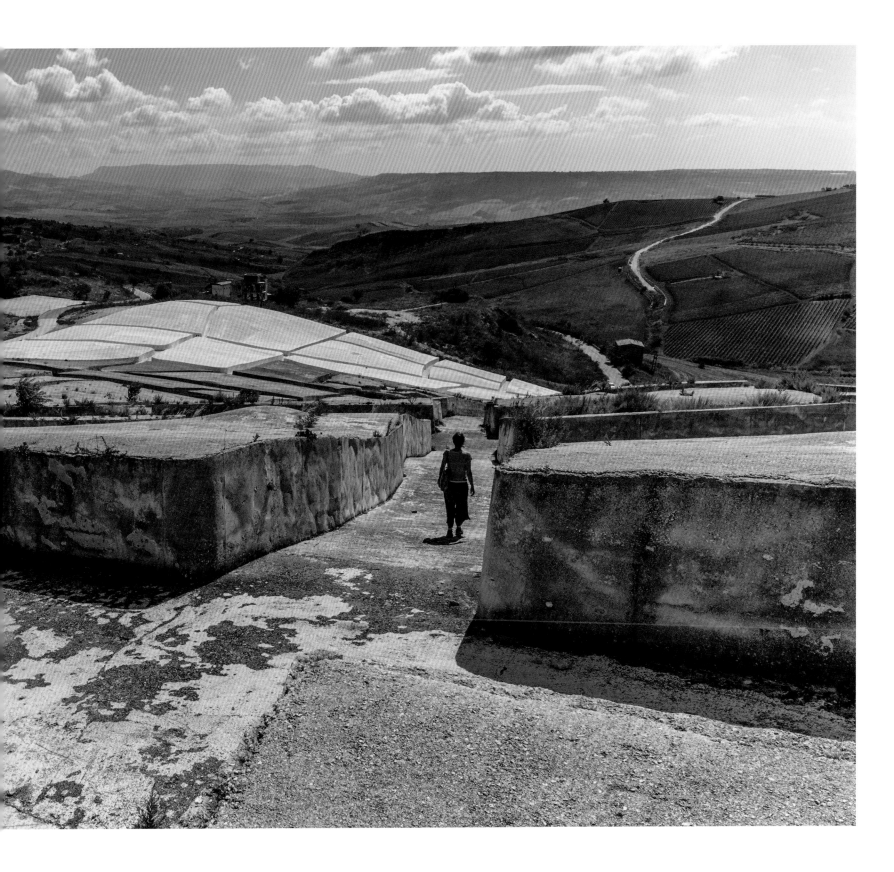

Installed at Judenplatz, a small square in central Vienna, British artist Rachel Whiteread's profoundly affecting memorial to the Holocaust survived a tumultuous, several-years-long political battle waged by various parties—similar to Maya Lin's Vietnam Veterans Memorial (page 54). Completed as Whiteread intended, the interpretive, bunker-like structure—a hulking concrete box—resembles an inside-out library, its book covers facing inwards: a striking architectural abstraction. On the front are double doors with holes where the handles would be; a Star of David appears on the ground at the entrance along with German, Herbrew, and English texts. The latter reads: "In commemoration of more than 65,000 Austrian Jews who were killed by the Nazis in between 1938 and 1945." Also at the foot of the memorial are engravings of the names of the concentration camps at which the victims were killed.

Whiteread, who won the 1994 Turner Prize, was awarded the commission in a 1995 competition chaired by Viennese architect Hans Hollein, following an initiative by "Nazi hunter" Simon Wiesenthal. As with much of her Minimalist work, the artist's intent was largely to "mummify the air in the room," as she has described her practice, to stop or mark time and hold space. Looking at the Holocaust as an outsider (she was born in the U.K. in 1963 and is not Jewish), Whiteread brought a neutral voice to a weighty, complex matter, creating a timeless and style-less commemorative masterwork. At 12 feet (3.7 meters) high, 24 feet (7.3 meters) wide, and 33 feet (10 meters) long, it takes up nearly half the square, designed by Jabornegg & Pálffy Architects, and is impossible to ignore. Upon its completion, *The New York Times* critic Michael Kimmelman hailed the memorial as "an unsentimental rupture."

Located on the site of a synagogue that burned down in 1421 during a pogrom, when several hundred Jews committed suicide to avoid baptism or execution, the memorial also has a deeper layer to it—literally. Through the neighboring Museum Judenplatz, visitors can head underground to view the destroyed synagogue's remains. In 2007, Pope Benedict XVI visited the site, expressing repentance.

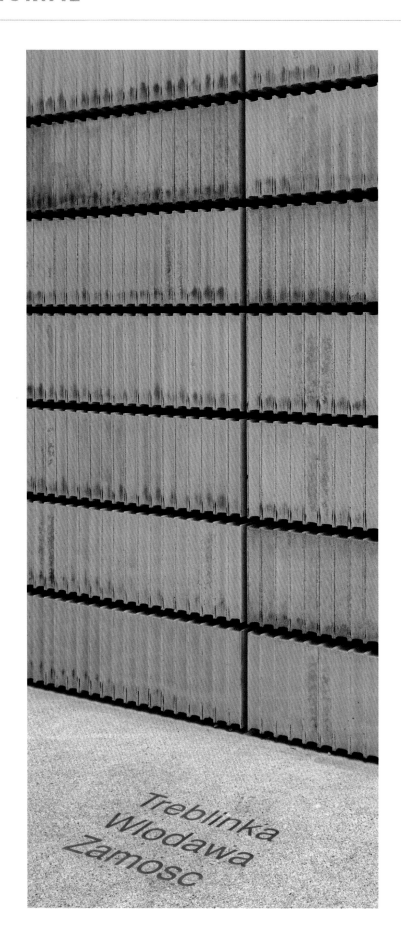

Vienna, Austria. Rachel Whiteread (2000)

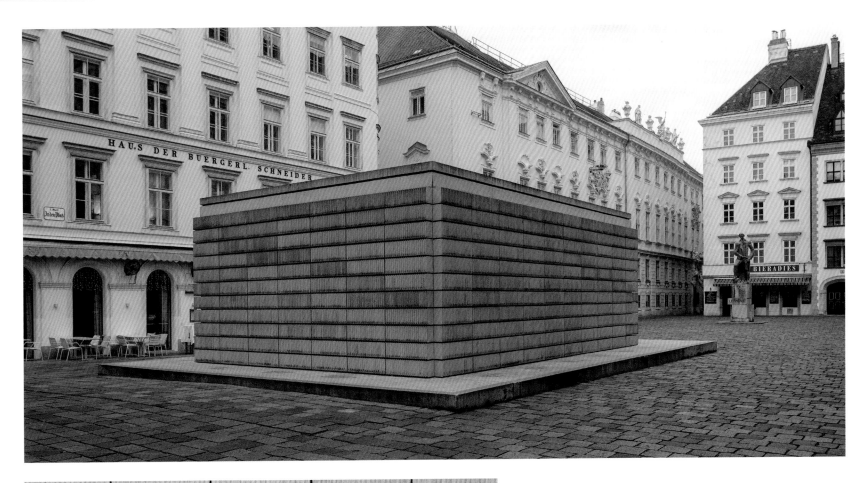

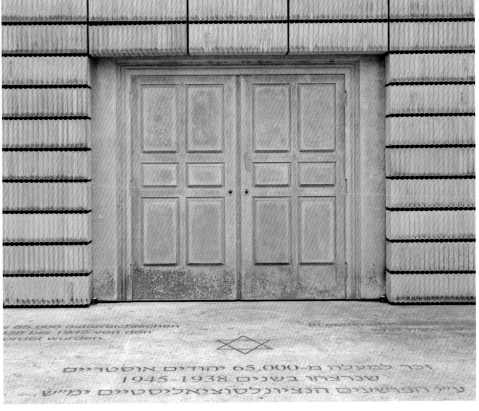

TOP THE TAUPE–COLORED MEMORIAL SITS IN THE MIDDLE OF THE JUDENPLATZ, IN THE HEART OF VIENNA.

BOTTOM AT THE MEMORIAL'S "ENTRANCE" ARE COMMEMORATIVE TEXTS IN HEBREW, GERMAN, AND ENGLISH HONORING THE AUSTRIAN JEWS KILLED BY THE NAZIS.

OPPOSITE AT THE BASE OF THE MEMORIAL, LISTED IN ROWS, ARE ENGRAVINGS OF THE NAMES OF NAZI CONCENTRATION CAMPS.

Shortly after Timothy McVeigh detonated a fertilizer bomb in a rental truck parked outside the Alfred P. Murrah Federal Building on April 19, 1995, killing 168 people, including nineteen children, the mayor of Oklahoma City appointed a local lawyer to oversee a memorial task force. The 350-person committee, comprising various Oklahoma City residents, as well as survivors and families of the dead, determined their wants over several months. Following a competition that attracted 624 entries, a proposal by two young, then-unknown American architects based in Berlin, Hans and Torrey Butzer, along with partner Sven Berg, was selected.

Situated on a 3.3-acre (1.3-hectare) site where the Murrah Federal Building once stood, the Butzers's elegant design features a central reflecting pool and a gently sloping lawn with 168 empty glass-bottomed chairs arranged in nine rows, evoking the nine floors of the Murrah building; nineteen of the chairs, honoring the children who died, are smaller than the rest. At night, the chairs light up from within, creating a candlelight effect. A stone plaque nearby lists the names of the dead. At both ends of the water feature are 42-foot-tall (12.8-meter-tall) bronze-and-concrete entrance gates, one marked "9:01," the other "9:03," to indicate the time of the 9:02 a.m. explosion with subtle potency. Across from the chairs on a terrace is an elm "survivor tree" that escaped the blast; overlooking the memorial, the tree, which dates to the 1920s, carries a guard-like presence.

Next to the memorial is a twelve-gallery museum that is home to 1,000 artifacts, including cast bronze letters from the Murrah building, an elevator control panel, and a victim's briefcase. The Gallery of Honor, a wall of 168 shadow boxes, each representing a victim with a photo, and most of them also featuring mementos and personal effects, completes the affecting presentation.

RIGHT ONE OF THE TWO BRONZE-AND-CONCRETE ENTRANCE GATES, MARKED "9:03," INDICATES THE MINUTE AFTER THE BOMB WENT OFF.

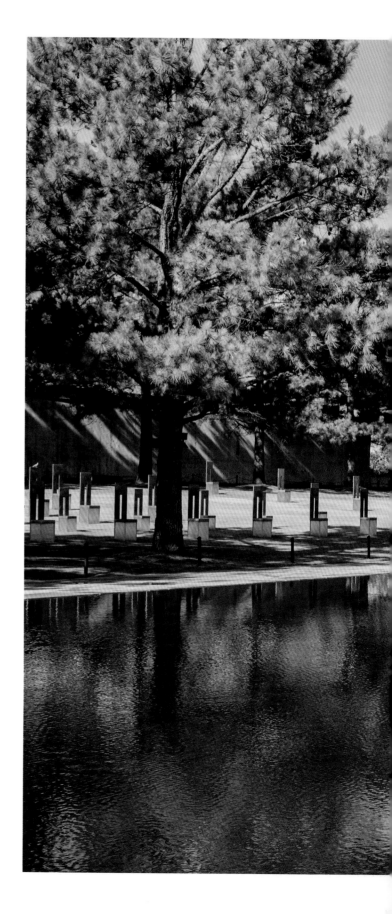

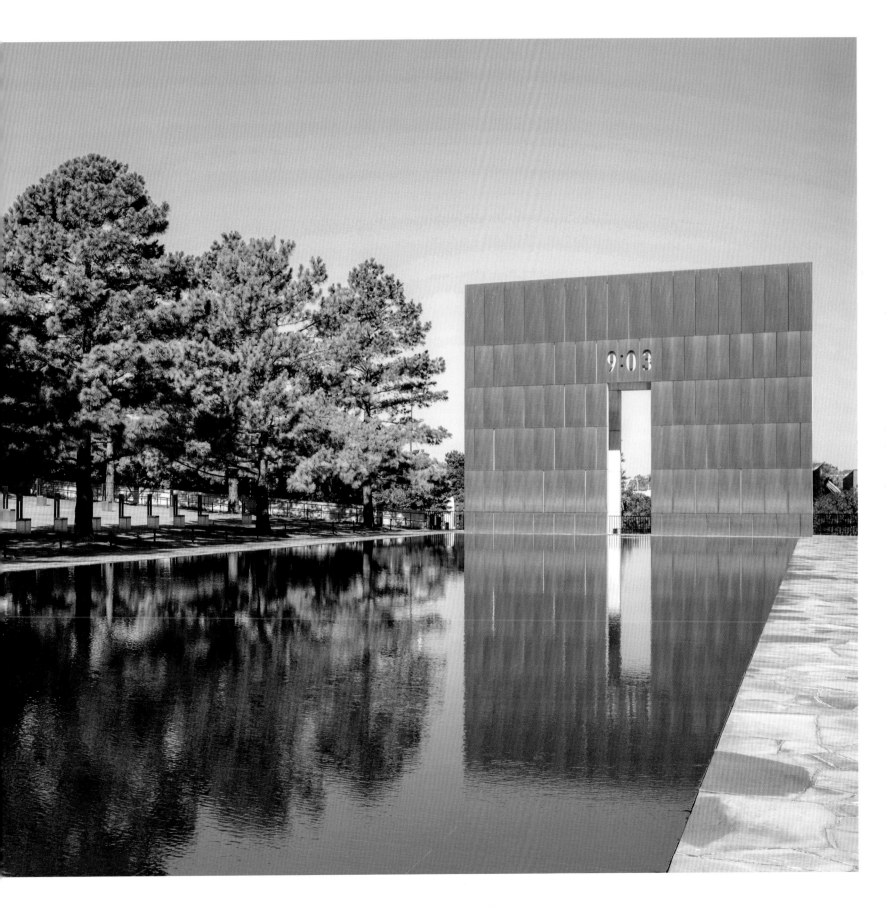

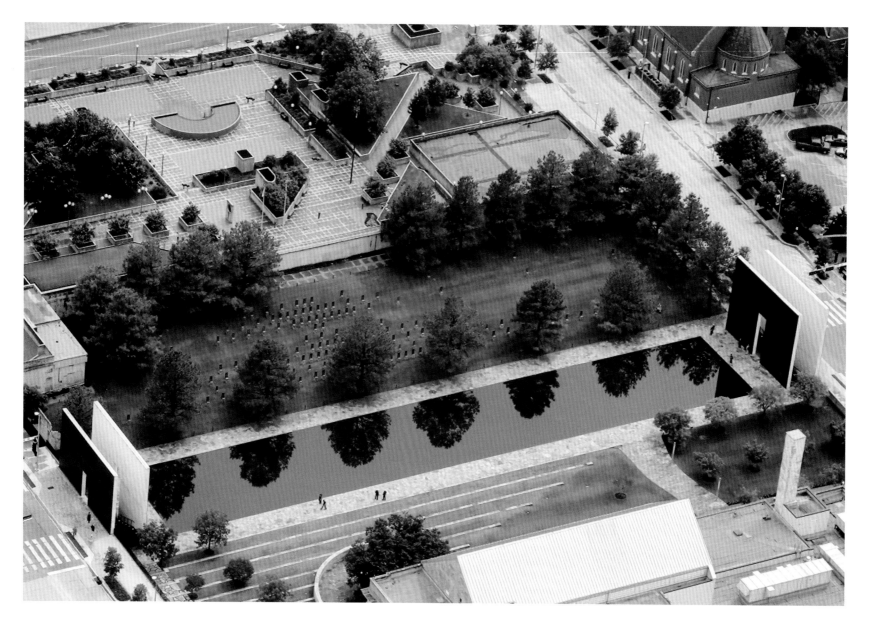

A synthesis of landscape and architecture, the Oklahoma City National Memorial Museum captures a visceral sense of loss and void.

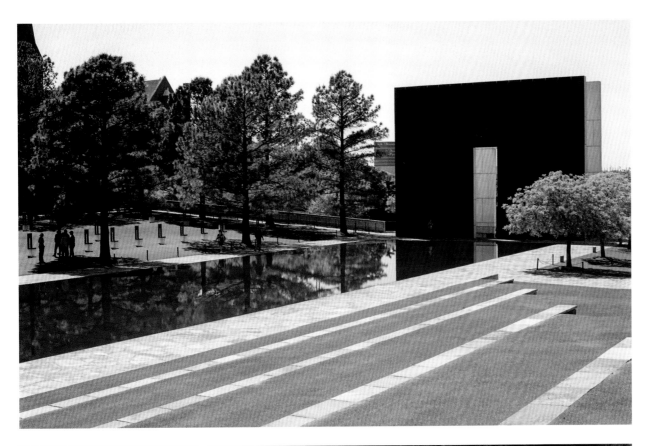

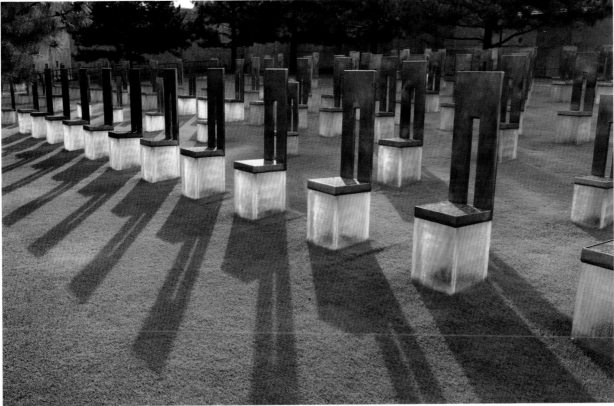

TOP THE VIEW FROM A TERRACE, ABOVE SEVERAL TIERED GRASS STEPS, WHERE A REMAINING ELM "SURVIVOR TREE" THAT ESCAPED THE BLAST STANDS.

BOTTOM A CEMETERY-LIKE LAWN FEATURES 168 EMPTY CHAIRS ARRANGED IN NINE ROWS, EVOKING THE NINE FLOORS OF THE MURRAH BUILDING.

OPPOSITE AN AERIAL VIEW OF THE MEMORIAL MAKES CLEAR THE PERIME-TER OF THE MURRAH BUILDING, WHICH WAS DESTROYED IN THE EXPLOSION.

VIETNAM VETERANS MEMORIAL

Nobody could have predicted the vast impact that the Vietnam Veterans Memorial would one day have on the national and global stage—nor, indeed, its tremendous influence on memorial-making. In a competition that received 1,421 entries that were judged anonymously, a miraculous thing happened: the eight jurors, including architect Pietro Belluschi, landscape architect Hideo Sasaki, and *Landscape Architecture* magazine editor Grady Clay, selected Submission #1026, a Minimalist design by a twenty-one-year-old Yale student named Maya Lin. The concept, described by Lin as "a rift in the earth," inserted a V-shaped polished black granite wall, tapered at the ends and with its vertex below ground, into a landscape at the western edge of the National Mall. Inscribed along its length are the names of the dead. "Against an abundance of precise drawings by more sophisticated competitors," the jury declared, "this entry was a triumph in simplicity." A short walk from the Lincoln Memorial, it is a stark counterpoint to the white Neo-Classical architecture that dominates so much of the capital.

Originally designed as an exercise for a class Lin took at Yale on funerary architecture, taught by Andrus Burr, it was a last-minute entry to the competition. Though the relationship between Lin and Burr would grow contentious, the class proved helpful. During the course, Lin learned about Sir Edwin Lutyens's Thiepval Memorial in the Somme region of France, a project that would come to inform some of her thinking about her Vietnam proposal. Despite the tall order—how to remember the 58,000 American soldiers who had been killed in the conflict, or the more than 300,000 who had been wounded—Lin's focus was clear. As she said in Freida Lee Mock's 1994 documentary *Maya Lin: A Strong Clear Vision*, "The cost of war is these individuals, and we have to remember them first." She understood the power of the listed names, and of visitors seeing themselves reflected in them, tracing their fingers over them.

Upon the announcement of Lin's competition win, an extraordinary fight among various factions began. Angry veterans wrote in to the Vietnam Veterans Memorial Fund with letters of complaint about the unusual design. In *The Washington Post*, Tom Wolfe lambasted Lin's memorial as "The Tribute to Jane Fonda," declaring the jury the "Mullahs of Modernism." Still, many leading architecture critics gushed. Paul Goldberger, writing in *The New York Times*, described Lin's design as "one of the most subtle and sophisticated pieces of public architecture to have been proposed for Washington in many years."

Thus began what the press declared an "art war," with a cohort of veterans demanding a more traditional approach. They wanted, at the very least, a figurative sculpture to be added. (The addition of a flagpole also became a part of the debate.) Frederick Hart, a sculptor who was the competition's third-prize runner-up, stepped in with a proposal for a statue featuring three soldiers—one Hispanic, one African-American, one white. Furious about the situation, Lin would describe Hart's encroachment to *Art in America* magazine as "rape" and "a coup."

Despite this, to Lin's surprise, her memorial—unveiled on November 13, 1982—was completed shockingly close to her original intent. Upon further reflection, in her book *Boundaries*, Lin wrote, "I think it is actually a miracle that the piece ever got built." In 1984, Hart's sculpture was at last installed, as was an adjacent flagpole, both nearby Lin's memorial but removed just far enough to keep a healthy distance.

Lin's Vietnam memorial remains the standard bearer. Nearly thirty years later, in 2011, critic Martin Filler declared in *The New York Review of Books*, "The test of time has proven the validity of her insights into the wellsprings of mourning in the modern age."

OPPOSITE PART OF THE VIETNAM MEMORIAL'S POTENCY IS ITS REFLECTIVE QUALITY—THE FACT THAT VISITORS CAN SEE THEMSELVES IN IT.

Washington, D.C., USA. Maya Lin (1982)

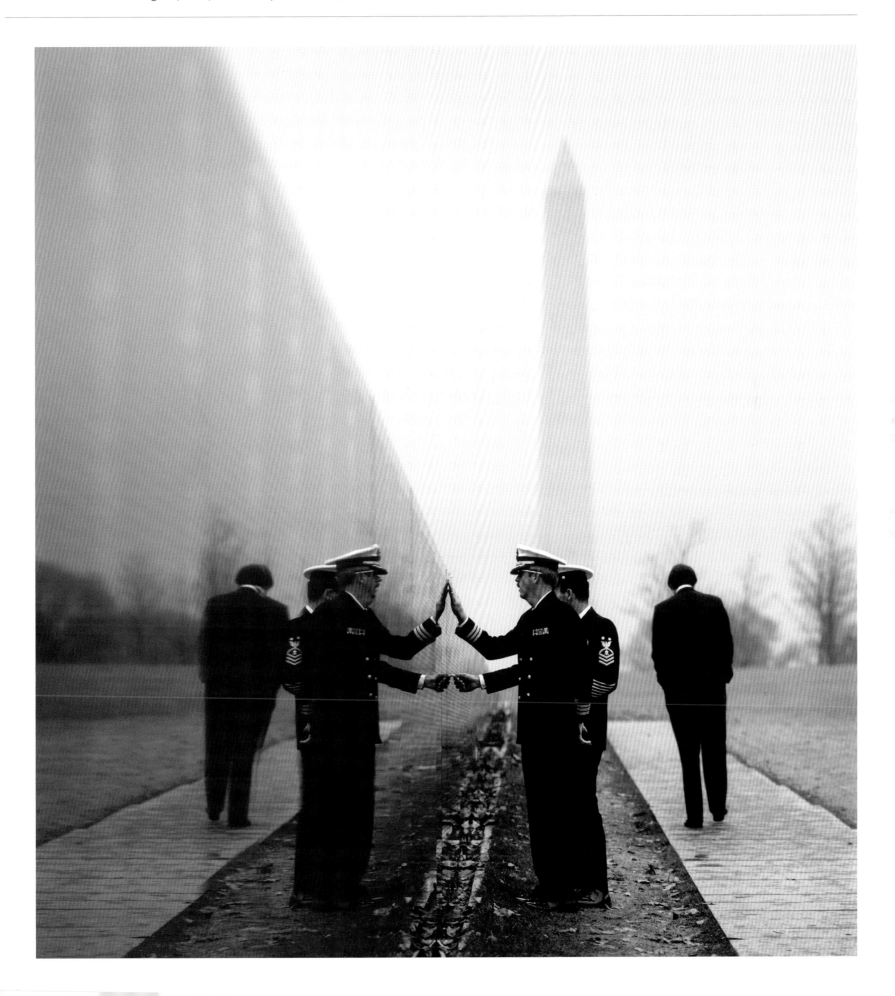

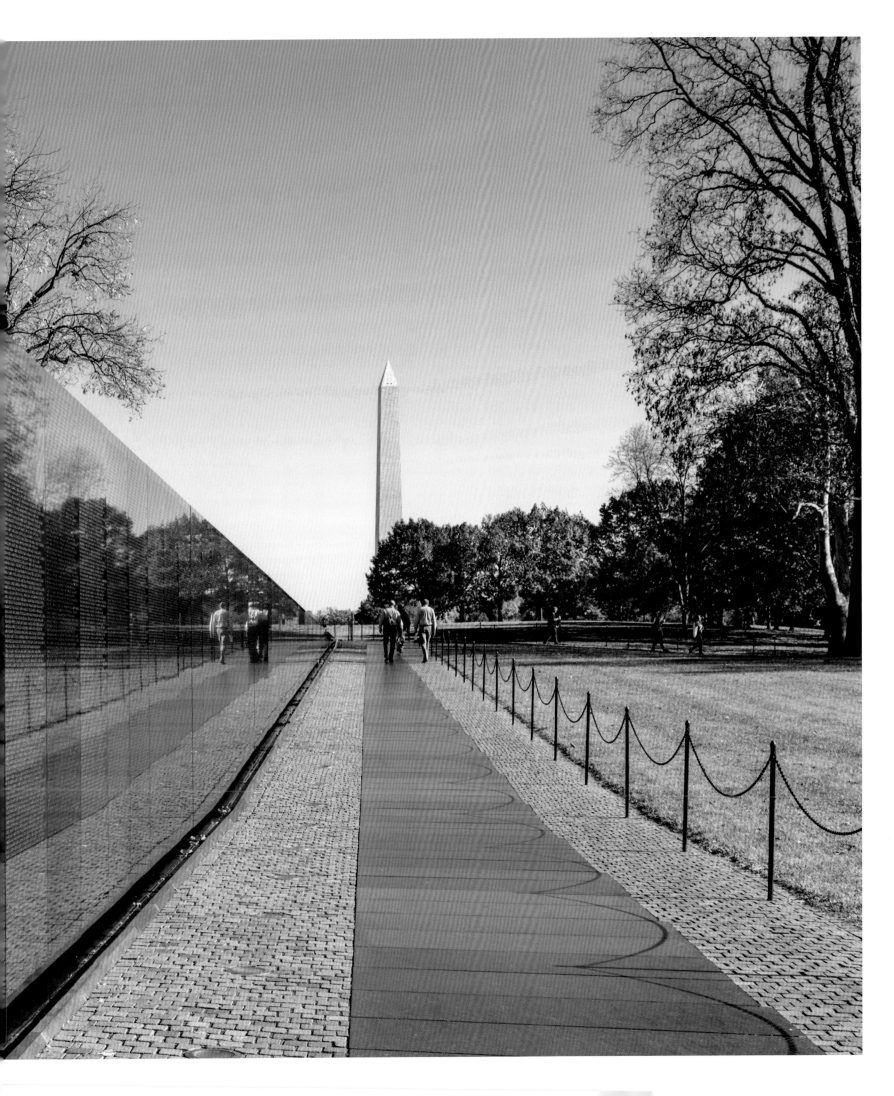

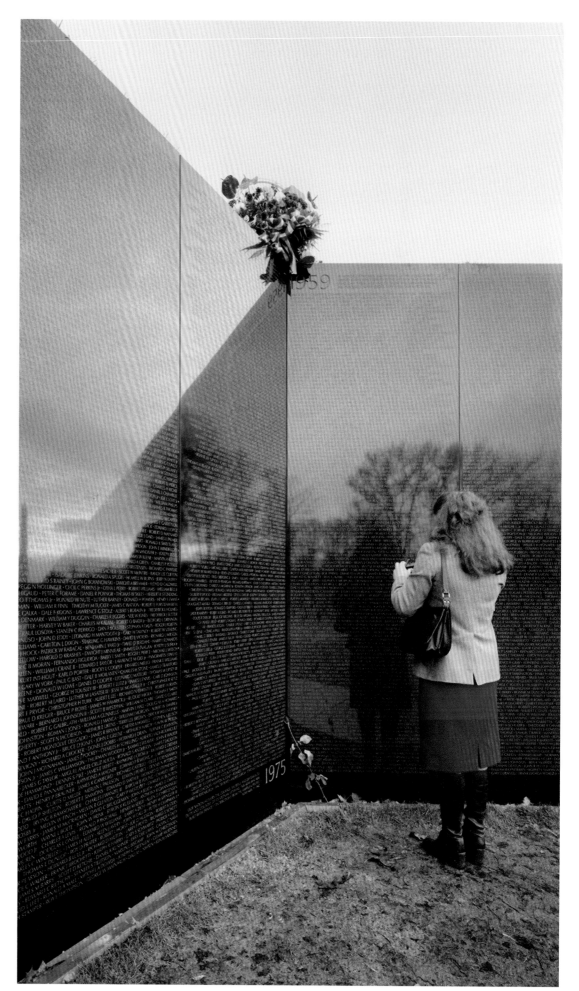

PREVIOUS SPREAD THE MEMORIAL'S POLISHED BLACK GRANITE PANELS STAND IN STARK CONTRAST TO THE WASHINGTON MONUMENT, A TOWERING WHITE OBELISK.

RIGHT THE CHRONOLOGY OF NAMES ALLOWS FOR VETERANS "TO FIND HIS OR HER OWN TIME FRAME ON THE WALL," MAYA LIN WRITES IN *BOUNDARIES*.

OPPOSITE (TOP) THE MEMORIAL'S V-SHAPED WALL TAPERS AT THE ENDS WITH ITS VERTEX BELOW GROUND.

OPPOSITE (BOTTOM) WHEN COMPLETED IN 1982, THE MEMORIAL HAD 57,939 NAMES. MORE HAVE BEEN ADDED: AS OF MAY 2018, THERE WERE 58,320.

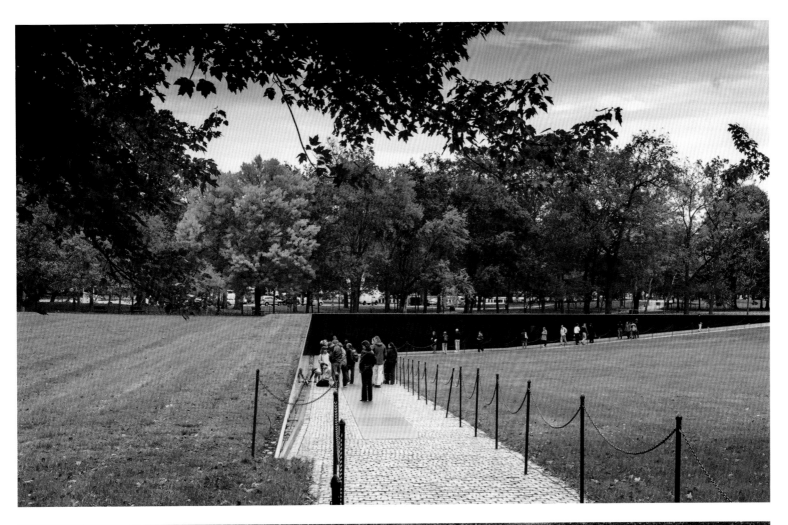

JAMES E CHERRY · WILLIAM T DAMRON · RICHARD A FITTS · ROBERT L FOX Jr · GEN
E C GARRETT · JAMES E GLISSON · JAMES H HALL · SHERLIN A HEIMAN · JEFFREY D H
RONALD E JAMES · JERRY W JEFFERSON · JAMES KENNEDY · ROGER R KERNS · JOSE
RY R LABOHN · DONALD C LEPAK · LONNIE GENE MARTIN · MICHAEL H MEIN · BR
ANNO · LEE V PORDEN Jr · KLAUS D SCHOLZ · RAYMOND C STACKS · GEORGE S ST
TOOMEY III · KING D WASHINGTON · ALLEN E WHITE · CALVIN E YOUNG · RAYMO
AS E ALFORD III · ERVIN P CANOY Jr · CURTIS R CRUM · ROGER A HOLTE · FREDERIC
DAVID P HELLENBRAND · ALFREDO D GRANADO-AVILES · JERRY A KISER · MICHAEL
A MERRILL · NORMAN A MILLER · WILLIAM A PERKINS Jr · NEWTON R PLUMMER · LA
GERS · TULLIE R SMITH Jr · JAMES M STANDEFORD · THOMAS R STUTTS · RICHARD
EN · JIMMIE MARRON ALVAREZ · VINCENT J ANASTASIO · BENNY R GUY · GEORGE H
AS W BLAKESLEE · EARL T BROOKE · JONATHAN BROWN · ROBERT T BURTON · JESUS
MAN · ROBERT K ANDERSON · RAYMOND W TYMESON Jr · WILLIAM G KEELER · JAME
EMER · RICHARD E LATIMER Jr · CLARENCE L LOVE · JOHN E MARASON · DUNCAN
REESE · JOSEPH L RINEHART · JAMES D ROBINSON · THOMAS W ROWLAND · PATRIC
Y LEE SAVOTH · CHARLES E SEATON · GEORGE H STAMPS · LARRY A STEINER · DAVID
NCE · JOSEPH A HADLEY · RONALD E VAN BARRIGER · WILLIAM M WEBB · VICTOR B
M A WHITESELL Jr · ARTHUR WILLIAMS Jr · JOHN R AUSBERN · WALTER T BAHL · MICHE
· EDWARD A BELL · LESLEY BOLING Jr · JAMES J BOLSON · DON W BONNER · DANIE
H T BURSIS Jr · NOLAN D BYRD · CLAUD W CAPRARO · ROBERT A CARNEY · HARVE

VIETNAM VETERANS MEMORIAL

HOPE
STRENGTH
GRIEF
LOSS
FEAR

When I think about the word *hope*, the first thing that springs to mind is Shepard Fairey's "Hope" poster, an image of Barack Obama that came to represent his 2008 presidential campaign. A similar sense of progress, resilience, and change is also represented by the Smithsonian National Museum of African American History and Culture, or NMAAHC (page 192), on the National Mall in Washington, D.C. Completed in the fall of 2016, following a century-long effort to realize it, the NMAAHC arrived as a sort of capstone to Obama's eight years in office.

Designed by architect David Adjaye and comprising a three-tiered, bronze-colored, cast-aluminum facade, the memorial and museum rise out of the ground, just as so many of the powerful figures honored inside once rose up in the face of racism, inequality, and injustice to achieve greatness. Tilted at an angle, the NMAAHC gazes on the National Mall and the largely Neo-Classical surroundings. The building stands confident and proud, clearly conscious of the massive historical and cultural void it's filling. It is a much-needed wellspring, a home for better understanding the complexity and richness of what it means to be African American. It is built hope.

The interior of the NMAAHC is an experience of hopefulness, too, of rising through the darkness and into the light. Once inside the museum's subterranean galleries, I felt a sense of compression and restriction. With each step, the heaviness was difficult to shake off. The brutal history of slavery in America is clearly yet respectfully presented, with the architecture serving as a procession through it. At various points, I saw visitors around me in tears. I cried, too. It was only when

I made it up several ramps—and past artifacts including a branding iron, a reconstructed slave cabin, Nat Turner's bible, Emmett Till's casket, an Angola prison guard tower, and a segregated railway carriage—and to the top of the lower-level galleries that the weight started to lift. There, a reconstructed *Oprah* set, a Public Enemy banner, and Obama election ephemera stand in stark contrast to the horrific histories presented below them. The exhibition, as with the history it presents, rises up.

On NMAAHC's top floor, hope crescendos in a music-themed gallery featuring Chuck Berry's Red Cadillac Eldorado and, beyond it, George Clinton's P-Funk Mothership—two symbols of the liberating, transportative power of music. There I saw three young girls, dancing in the middle of the gallery, sing along to Aretha Franklin's "Respect," which was playing on speakers nearby. The scene stopped me in my tracks. It was hard to believe that, within just three hours, I could go from the museum's dark depths to *this*.

Many memorials, in one way or another, evoke a palpable sense of hope—consider the reflective, skyward-facing 1991 Space Mirror Memorial in Cape Canaveral, Florida, or the sloping, soaring 2016 Estonian National Museum (page 172) in Tartu, Estonia—but none with the dynamism of the NMAAHC.

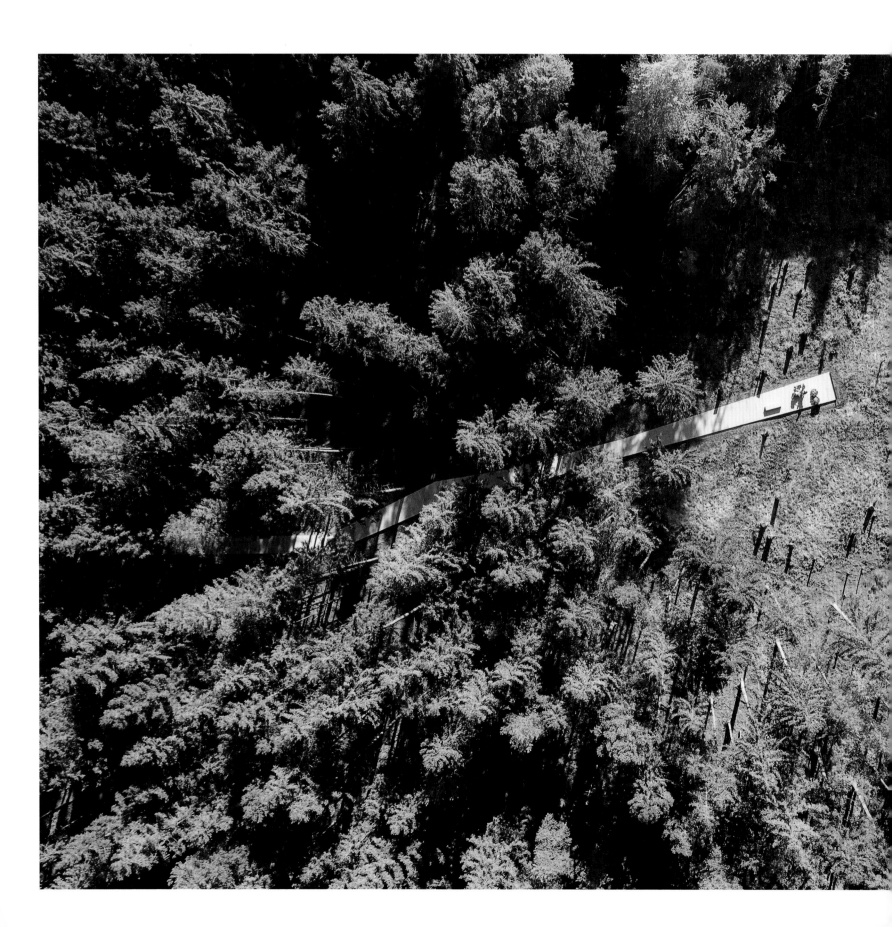

How to make the invisible comprehensible—and to do so in an affecting, abstract way—was the task Latz + Partner set out to achieve with Memorial Place. Its location in the Bavarian town of Mühldorf was on the site of what was the second-largest satellite camp of Dachau. For nearly three decades, beginning in the early 1980s, local volunteers, many of them through the *Verein für das Erinnern* (Remembrance Society), petitioned to keep alive the dark memory of the Nazi atrocities that took place there. In an invited design competition in 2012, the landscape firm Latz + Partner was chosen out of the seven finalists to create a memorial on the site. (The runner-up was SINAI, one of the studios behind the Berlin Wall Memorial; see page 38.)

Organized into three areas—"Forest Camp," "Mass Grave," and "Armament Bunker" (the latter is yet to be completed)—Latz + Partner's design respectfully intervenes in the landscape, adding a quiet new layer composed of custom-made concrete parts on raised steel girders bolted into the ground. Visitors begin in an information area, situated at the former main entrance to the camp, where a roofless concrete structure, screened off from the surroundings and consisting of two U-shaped elements, introduces the site with historical texts and pictures. From there, a "narrative path" directs visitors to a fork that leads them, on one side, to the "roll-call ground," and on the other side to the former camp area, the axes of which was made visible by removing vegetation. At the site of a former mass grave, where the remains of more than 2,200 people were, Latz + Partner created a visually arresting clearing of trees, each cut to 5.5 feet (1.7 meters) in height. Throughout the site, steel "remembrance bars" featuring quotations from contemporary witnesses, both former prisoners and local residents, testify to the area's traumatic past.

LEFT AT THE SITE OF A FORMER MASS GRAVE, A CLEARING WITH TREE STUMPS PROVIDES AN EERIE FEELING OF LOSS AND ABSENCE.

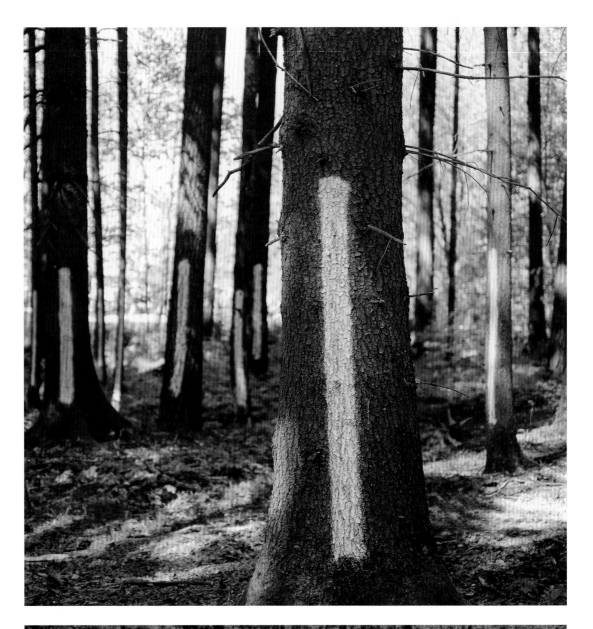

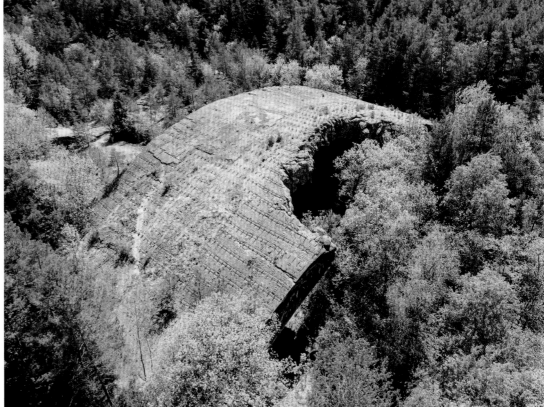

TOP A SITE WHERE PRISON ROLL CALLS WERE HELD; THE WHITE STRIPES ON THE TREES MAKE THE LOCATION VISIBLE AND ADD TO THE SITE'S EMOTIONAL WEIGHT.

BOTTOM THE REMAINS OF AN ARMAMENT BUNKER—THE MOST SIGNIFICANT HISTORICAL STRUCTURE STILL ON THE SITE.

OPPOSITE RESPECTFUL OF THE EXISTING LANDSCAPE, THE PATH IS MADE OF CONCRETE PARTS ON RAISED STEEL GIRDERS BOLTED INTO THE GROUND.

Memorial Place respectfully intervenes in the landscape, a subtle but potent testimony to the site's traumatic past as a Holocaust satellite camp.

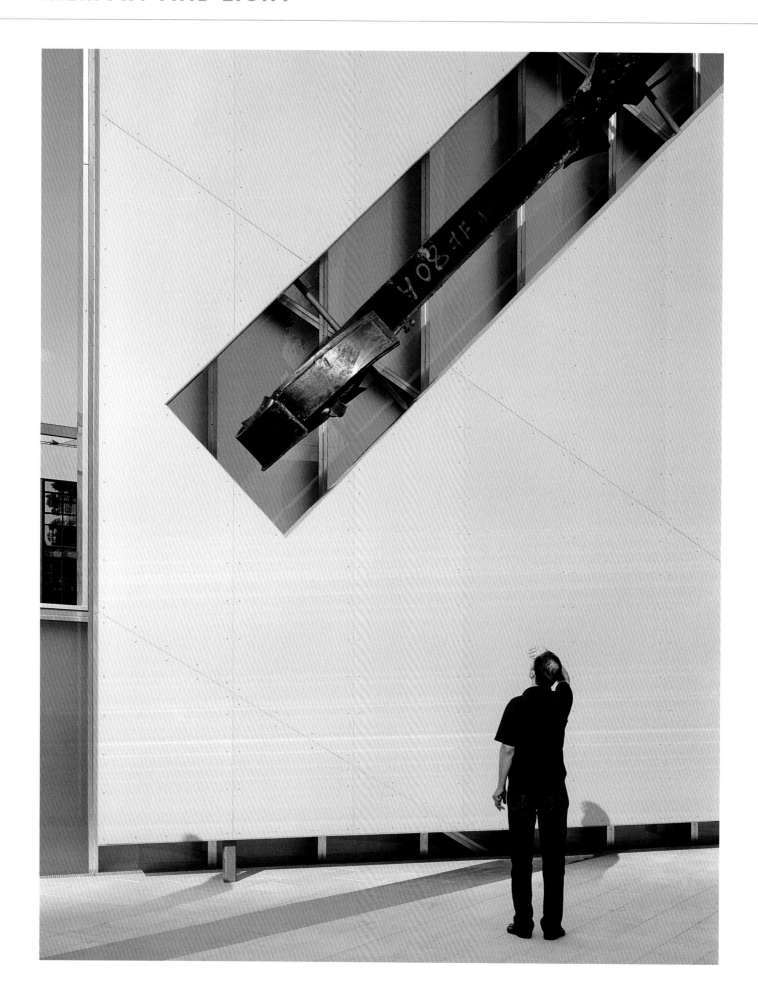

In the aftermath of the September 11, 2001, World Trade Center attacks, the Port Authority of New York and New Jersey donated salvaged steel remains to cities, museums, firehouses, and military bases for use in memorials around the world—to London, in the form of artist Miya Ando's *Since 9/11* sculpture; to Denver, Colorado, where the pieces are on display in Babi Yar Park and at the Counterterrorism Education Learning Lab; to the George W. Bush Presidential Library and Museum in Dallas, Texas. One steel beam, given by the U.S. to the region of Veneto, Italy, went to the city of Padua, where it was incorporated as a core part of Daniel Libeskind's evocative *Memoria e Luce* (or Memory and Light) memorial, a 56-foot-tall (17-meter-tall) book-shaped structure.

Joined later by Michael Arad's Reflecting Absence (page 118) and Snøhetta's 9/11 Memorial Museum (page 120) at the World Trade Center site, Paul Murdoch's Flight 93 National Memorial in Shanksville, Pennsylvania (page 156), and Julie Beckman and Keith Kaseman's

National 9/11 Pentagon Memorial (page 112), Memory and Light is one of more than a thousand 9/11-related memorials to proliferate around the world following the attacks—and is certainly, as with the Staten Island 9/11 Memorial (page 114), among the more noteworthy small ones. (Others worth mentioning, but not featured in this book, include the Boston Logan International Airport 9/11 Memorial, the September 11 Memorial Garden in London's Grosvenor Square, the 9/11 Living Memorial Plaza in Jerusalem, and Moving Memories in Phoenix, Arizona.)

Situated next to the Scrovegni Chapel, dating to the early fourteenth century and home to masterful Giotto frescoes that recount the story of salvation, Libeskind's memorial is, in the architect's mind, a sort of extension of this history—essentially, an "open book." The steel beam, as it is installed, floats between land and sky, hovering between past and future, haloed, almost like a biblical figure.

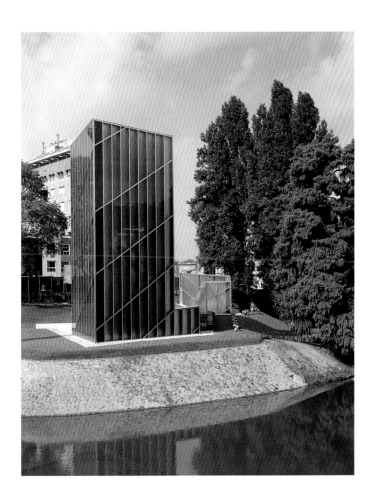

LEFT THIS "FLOATING" STEEL BEAM WAS SALVAGED IN THE AFTERMATH OF THE 9/11 WORLD TRADE CENTER ATTACKS AND SENT TO PADUA, ITALY.

OPPOSITE THE MEMORIAL'S BOOK-SHAPED FORM IS INTENDED, IN PART, TO REFERENCE THE IDEA OF SALVATION IN CONTEMPORARY LIFE.

ROSIE THE RIVETER MEMORIAL

Located on the edge of San Francisco Bay, the Rosie the Riveter Memorial sits on a site that was once a tidal wetland prone to flooding. World War II changed that, transforming the area into an industrial shipyard. After the war, the property became neglected and, eventually, derelict. Ripe for redevelopment, by the mid–1980s the city began turning it into what is now the well–manicured Marina Bay Park, which includes an overlook, a promenade, a playground, walking trails, and—dedicated in the fall of 2000—this memorial. Spurred in the 1990s by council member Donna Powers, the memorial became the first national tribute to the home–front labor of American women during World War II.

Designed by landscape architect Cheryl Barton in collaboration with artist Susan Schwartzenberg—who were chosen out of more than 100 competition entries—the memorial honors the "Rosies," as the women who worked in the shipyards were called. The memorial is the same length as the 441–foot–long (134–meter–long) Liberty cargo ships that were once built there, and features a downward–sloping "keel walk" and a central sculpture made of prefabricated marine–grade stainless steel. It displays a timeline of World War II that runs the length of the walkway and includes sandblasted quotes in white granite from women who worked there. Integrated into the sculptural structure are thirty–nine photographs, post-cards, and other ephemera, and twenty–five tiles containing quotes and timelines. Gardens of rockrose and dune grass make up the metaphorical ship's fore and aft hatches.

Upon completion, the memorial soon became a place of pilgrimage—it was designated the World War II Home Front National Historical Park in 2003—with an annual "Rosie Rally." Visitors often leave notes or candles in the sculpture's "hull." Partly designed to showcase the magnitude of World War II, it also pro-vides long–overdue recognition of the often–overlooked contributions of American women to the war effort.

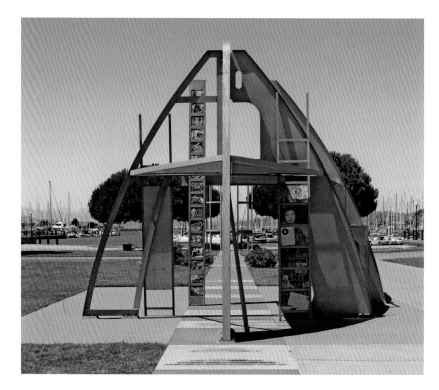

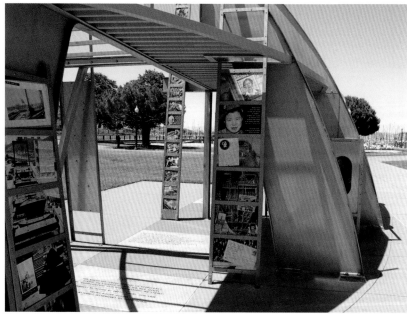

TOP THE MEMORIAL'S CENTRAL SCULPTURE IS MADE OF PREFABRICATED MARINE-GRADE STAINLESS STEEL.

BOTTOM INSTALLED ON THE MEMORIAL'S PAVILION STRUCTURE ARE PHOTOGRAPHS, POSTCARDS, AND OTHER EPHEMERA, AS WELL AS QUOTES AND TIMELINES.

OPPOSITE AN OVERHEAD VIEW OF THE SITE SHOWS ITS 441-FOOT (134-METER) LENGTH—THE SAME SIZE AS THE CARGO SHIPS THAT WERE ONCE BUILT THERE.

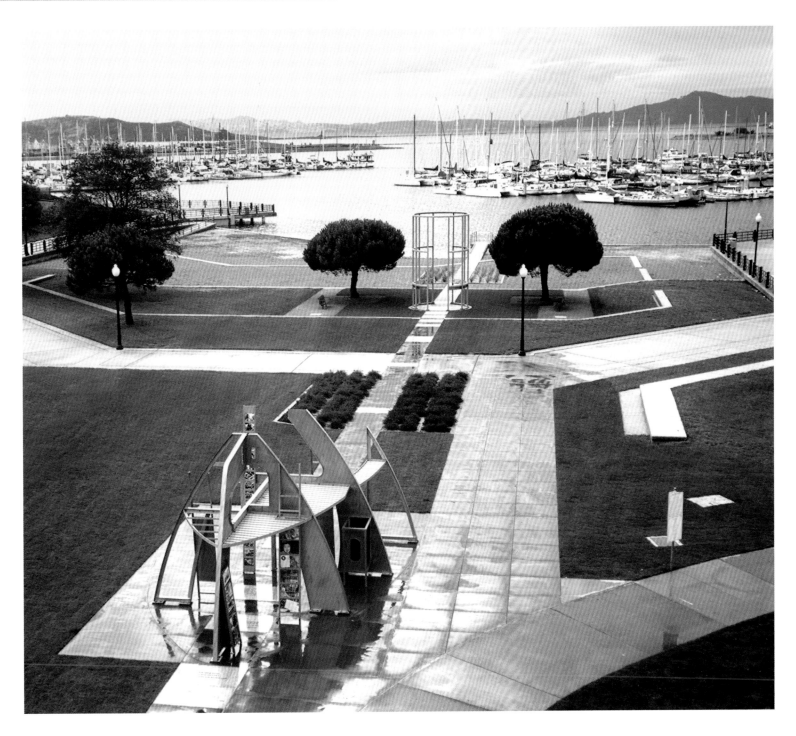

This memorial provides overdue recognition of the often–overlooked contributions of American women to World War II.

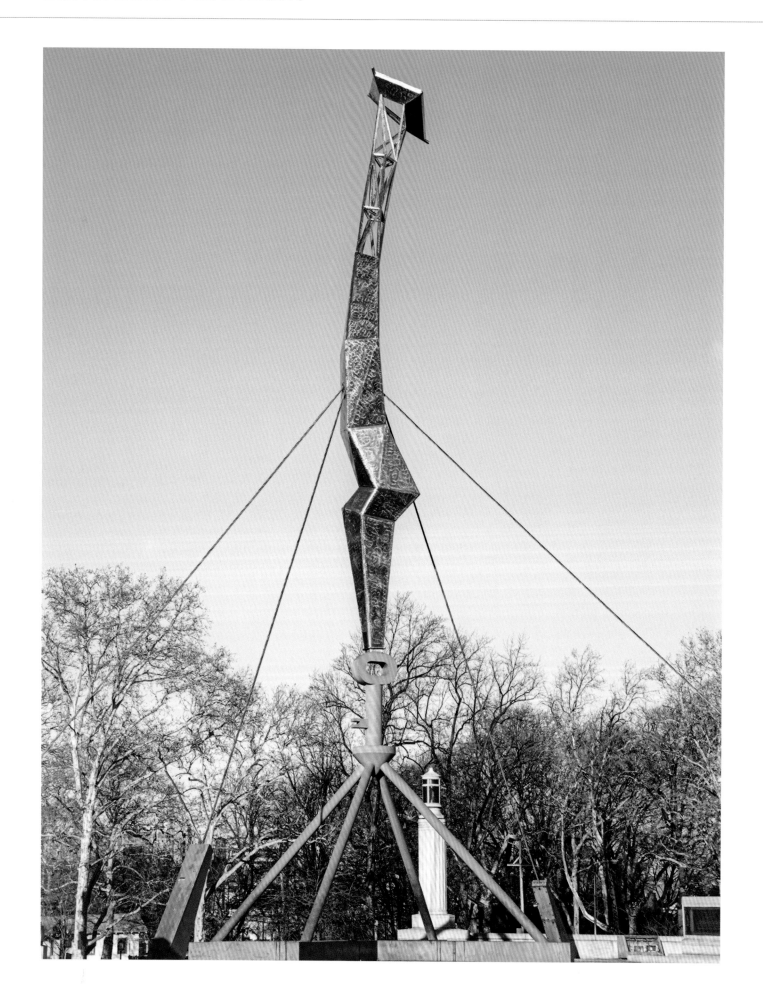

Isamu Noguchi's memorial to Benjamin Franklin is a testament to patience and perseverance. Originally designed in 1933 for a competition—which Noguchi didn't win—the sculpture, technologically advanced for its time, would finally get constructed more than fifty years later. (Noguchi was age twenty-eight when he designed it; when it was completed, he was seventy-nine.) The idea to build it was revived in 1979, following an exhibition of Noguchi's work at the Philadelphia Museum of Art that had included a model of the design.

More representational than most of Noguchi's works (though certainly in line with his thinking as an artist in the 1930s, and still decidedly nonfigurative), the 102-foot (31-meter) tubular steel sculpture, situated at the axis of Philadelphia's Independence Mall and the Benjamin Franklin Bridge, has a four-legged, pyramid-shaped base from which its zigzagging form rises. (It's anchored to the ground by four support cables attached at its midsection.) Depicting a key at the base, a bolt of lighting above that, and at the top a kite, the memorial references Franklin's ingenuity and invention, something Noguchi felt he shared with the statesman-polymath. The gargantuan memorial, weighing 60 tons (54,500 kilograms) and a feat made possible with help from engineer and frequent Noguchi collaborator Paul Weidlinger, took a year and a half to fabricate.

While many initial reactions to the sculpture, as reported in *The New York Times*, were flattering, others were decidedly less so. In 1984, *The Philadelphia Inquirer* called it "a crumpled, bent-can of a sculpture." Writing in *Philadelphia* magazine in 2010, Larry Mendte bitingly described Noguchi's creation as "a mistake," adding, "It looks like a construction site abandoned long ago." Weidlinger himself once described Noguchi's sculpture as "mad" and said, "I would not have done it for anybody I didn't like a lot."

Built more than fifty years after it was first designed, Isamu Noguchi's quirky memorial to Benjamin Franklin pays homage to the statesman's ingenuity.

OPPOSITE A REFERENCE TO BENJAMIN FRANKLIN'S INVENTIVE SPIRIT, ISAMU NOGUCHI'S TRIBUTE FEATURES A KEY, A BOLT OF LIGHTNING, AND A KITE.

MEMORIAL TO THE VICTIMS OF VIOLENCE IN MEXICO

Located next to Mexico City's Chapultepec Park, on land that previously belonged to Mexico's Ministry of Defense—and funded with money seized from cartels—the Memorial to the Victims of Violence pays tribute to the tens of thousands of lives lost in the country's drug war. Designed by local firm Gaeta-Springall Arquitectos, which won a national competition, the 3.5–acre (1.4–hectare) site is composed of four primary elements: CorTen steel, water, light, and trees. The memorial comprises seventy steel walls, each nearly 40 feet (12 meters) tall and arranged vertically and horizontally among a forest. Its main space features a 13,000–square–foot (1,200–square–meter) reflecting pool, part of which, covered in bar grating, visitors can walk across. Stenciled into many of the slabs are quotes, selected by the architects, on violence, memory, love, and other related subjects, from figures such as Gandhi, Martin Luther King Jr., novelist Carlos Fuentes, and poet Octavio Paz. At night, recessed lighting creates a dramatic effect, emphasizing the voids between the panels.

A "living experience," in the architects' words, the memorial invites visitors to interact with it by allowing them to leave messages on the steel walls in chalk. *Pinta lo que sientes . . . expresa lo que piensas,* reads a white–painted graffiti message at the entrance. "Paint what you feel . . . express what you think."

Controversial from the start, the memorial stirred debate about who exactly in the country's drug war it was honoring. One prominent opponent of the drug war, whose son was kidnapped and killed in 2011, objected to its location next to a military base and the fact that it features no names of the dead. But that it features no names is exactly its strength: its haunting simplicity and intimate physicality evoke the weight of the unknown loss and acknowledge the pain through markings made by the living.

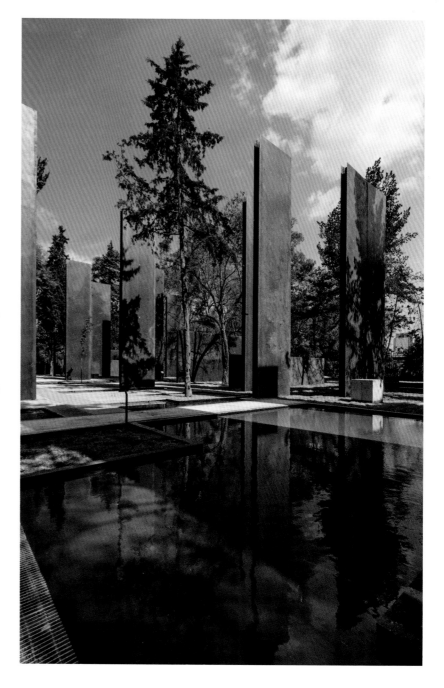

TOP THE MAIN SPACE FEATURES A 13,000–SQUARE–FOOT (1,200–SQUARE–METER) REFLECTING POOL.

OPPOSITE THE MEMORIAL COMPRISES SEVENTY STEEL WALLS, EACH NEARLY 40 FEET (12 METERS) TALL AND ARRANGED AMONG A FOREST.

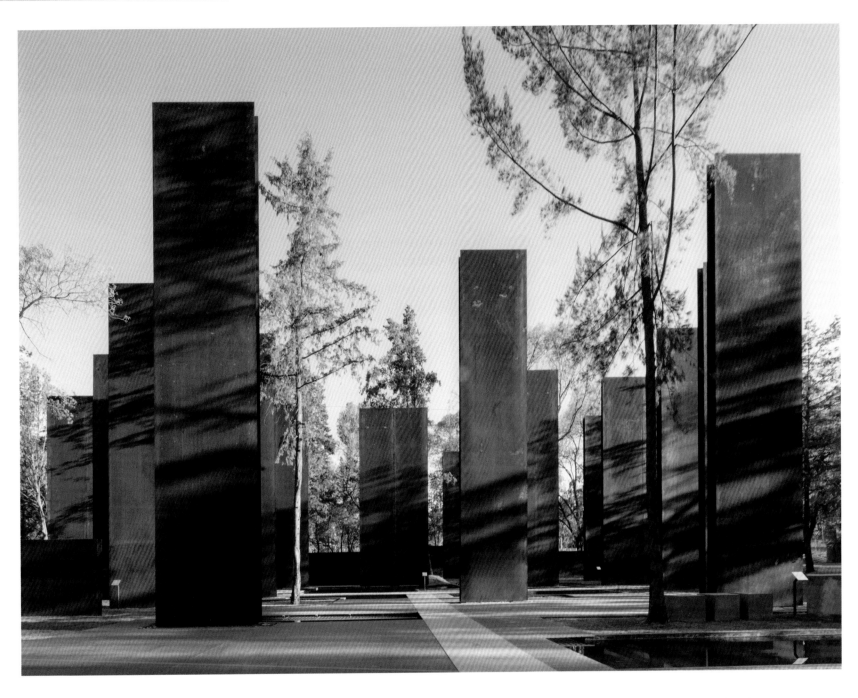

The poetic, rhythmically arranged memorial pays tribute to the many thousands of lives lost in Mexico's drug war.

DR. KALLAM ANJI REDDY MEMORIAL

Kallam Anji Reddy, the founder and chairman of the multinational pharmaceutical company Dr. Reddy's Laboratories, grew up the son of a turmeric farmer in Andhra Pradesh, India, and went on to become one of the country's most successful pharmaceutical entrepreneurs. Following his death in 2013, at age seventy-four—his personal wealth was estimated at $1.5 billion—Reddy's family brought in Sanjay Mohe of Bengaluru-based Mindspace Architects, who had known him, to construct a commemorative space.

A 1.2-acre (0.4-hectare) park-like setting next to the company's laboratories, where Reddy used to walk from his farmhouse to his lab, the memorial emphasizes the trees that were already there: silver oaks, gulmohars, ashokas, casuarinas, and palms. Arranging the site into six pavilions, five of them "paths," all around a reflective black granite water feature with a void at the center, Mindspace sought to emphasize Reddy's personality and life, as well as evoke, in Mohe's words, "the presence of absence."

As the inscription at the entrance puts it, the memorial takes visitors on a journey through, "milestones of his life's journey." "Spend a few contemplative moments here, soaking in the serenity," the text reads. "And allow its peace to flood your mind." One path symbolically features textured stones that begin rough, then become semi-polished and then polished, and then finally turn into a grassy lawn with a Bodhi tree—a symbol of enlightenment. Another, a gently sloping path celebrating Reddy's entrepreneurialism, comprises wood-and-concrete benches inscribed with inspirational quotes from scientists; at the lower end is a display of his first motorbike, suggesting humble beginnings, and on higher ground, enclosed in a glass-walled box, his Mercedes-Benz. The memorial's semi-transparent stone walls, which light up at night, are meant to subtly reflect Reddy's openness while wind chimes placed on the property are intended to serve as a reminder of his infectious laugh.

RIGHT ONE OF THE MEMORIAL'S SEMI-TRANSPARENT STONE WALLS CREATES AN ABSTRACTED VIEW OF A DISPLAY CASE FEATURING ARTIFACTS.

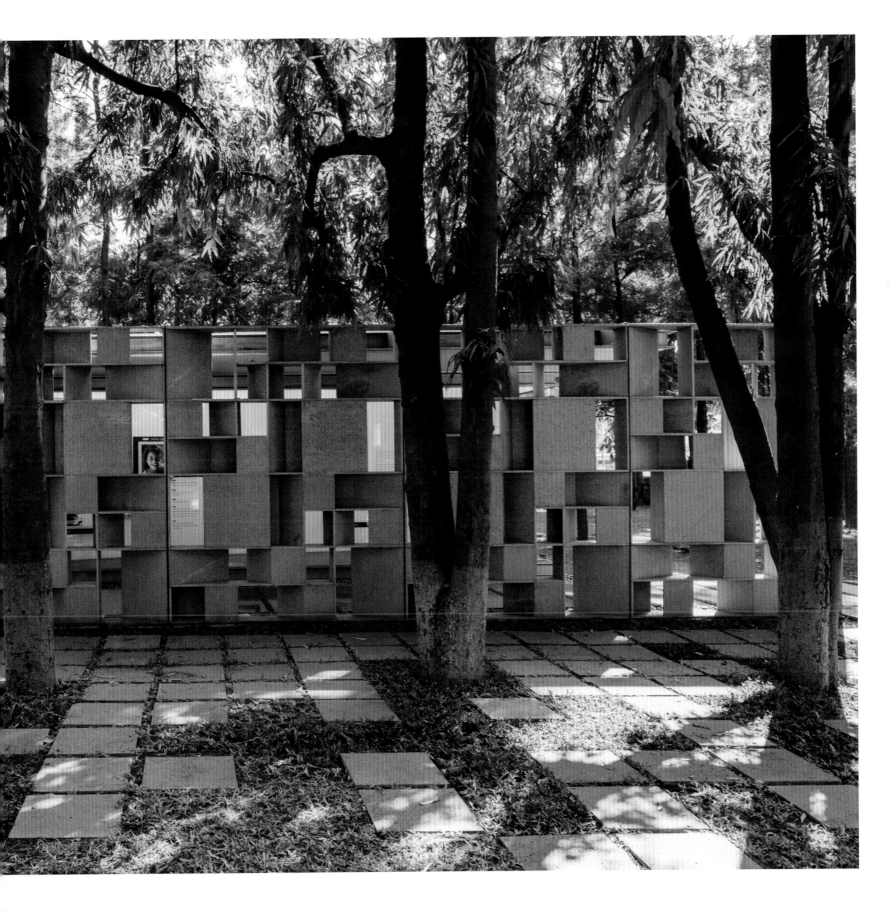

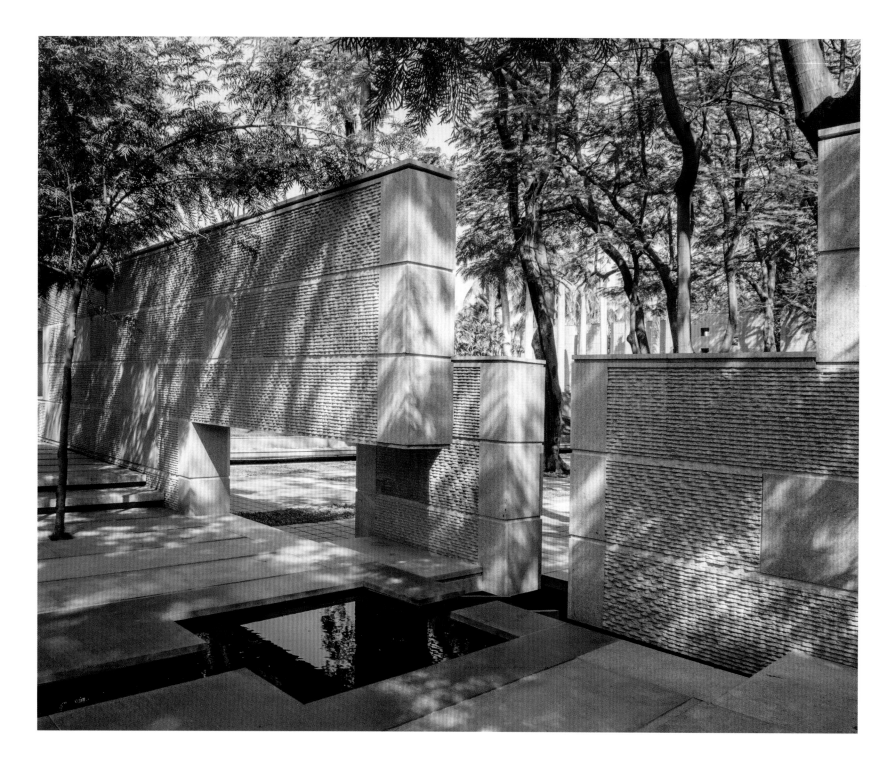

ABOVE A WATER FEATURE, MADE OF
BLACK GRANITE AND CREATED TO
ESTABLISH A REFLECTIVE VOID, RUNS
THROUGH THE SITE.

OPPOSITE (LEFT) A PARK-LIKE
LANDSCAPE WITH BENCHES ALLOWS
VISITORS TO RELAX AND TAKE IN
THE SERENE SETTING.

OPPOSITE (RIGHT) THE STONE PARTITION
WALLS ARE ARRANGED TO CREATE
VARIED LAYERS OF TRANSPARENCY
AROUND THE POETIC PROPERTY.

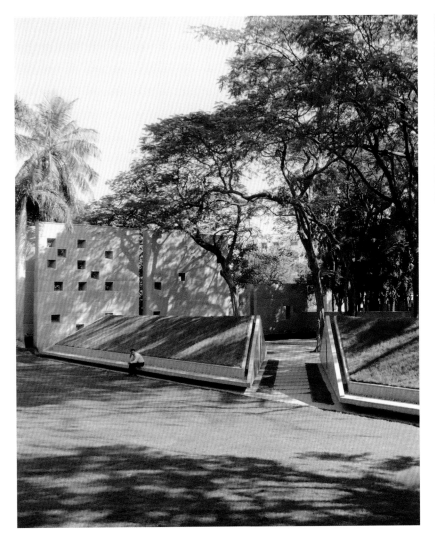
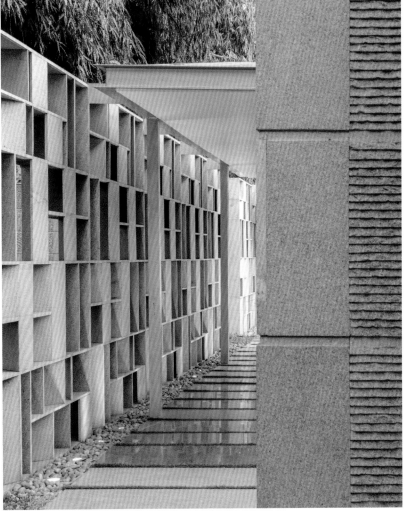

The Dr. Kallam Anji Reddy Memorial emphasizes the doctor's personality and life, and evokes, in the architect's words, "the presence of absence."

NATIONAL MEMORIAL HALL FOR ISRAEL'S FALLEN

Excavated into a hillside at Mount Herzl, the site of Israel's national cemetery, the National Memorial Hall for Israel's Fallen commemorates those who have died in service for the country. The memorial features a spiraling, 825-foot (250-meter) Wall of Names built of 23,600 white bricks. Each brick is inscribed with a name of the dead person and the date they died, and arranged in chronological order, from the most recent fatalities back to the 1870s. Every Israeli fallen service-person is remembered, whether from the army, the police, the Shin Bet security agency, or the Mossad spy agency. The memorial broadly defines the fallen, ranking no one above or below each other and no single battle, war, or circumstance more important than the next.

Designed from the inside out and emphasizing its large void, the Minimalist memorial is flooded with natural light from an oculus that opens at the top of an irregularly shaped funnel. In collaboration with the university ETH Zurich, the architects developed con-crete bricks with load-bearing aluminum cores screwed together at precut joints in order to support the struc-ture. Small candle-like lights, positioned next to each name, are lit on the date of each person's death, per Jewish tradition. Toward the exit, twelve pillars mounted with digital screens provide additional information.

Though the building itself took ten years of plan-ning and construction, the memorial is actually the result of, as journalist Isabel Kershner put it in *The New York Times*, "decades of political wrangling, emotional strife, and procrastination." The idea for the building began in 1949, and was a part of the national conversation in the 1970s and then again in the '90s. It took until 2006 for Israel's Ministry of Defense to commission it, following a long dialogue with many of the fallen's families, who sought for the dead to be remembered individually, not just collectively.

RIGHT AT THE ENTRANCE OF THE MEMORIAL IS A VIDEO INSTALLATION BY ARTIST MICHAL ROVNER, FEATURING SOLDIERS FROM ISRAEL'S VARIOUS WARS.

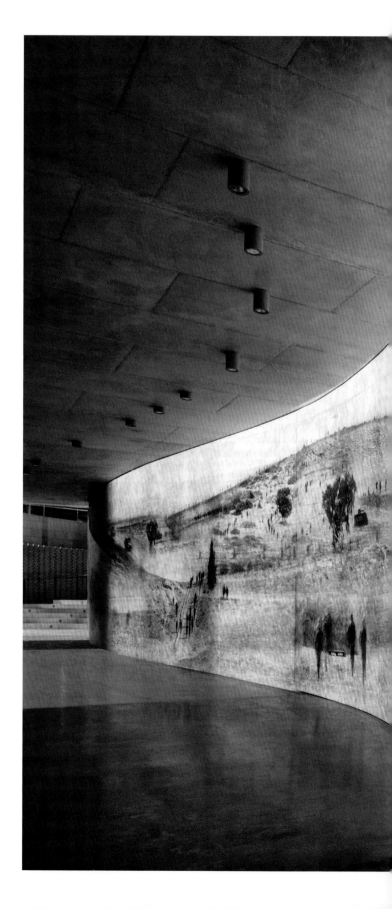

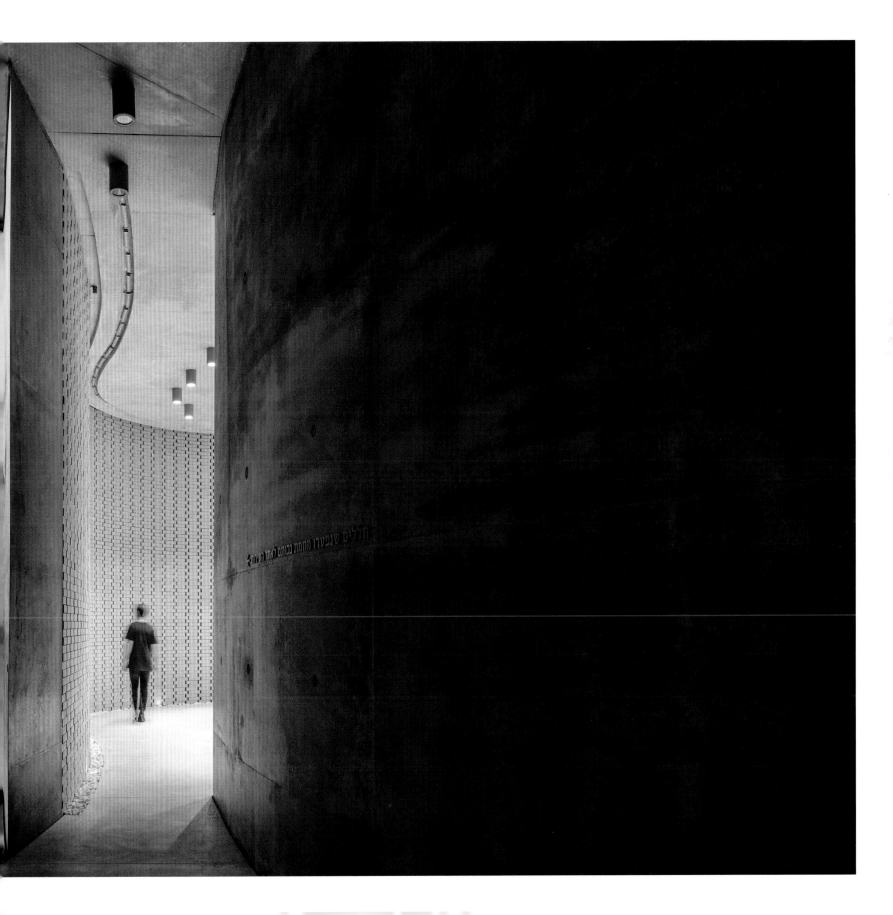

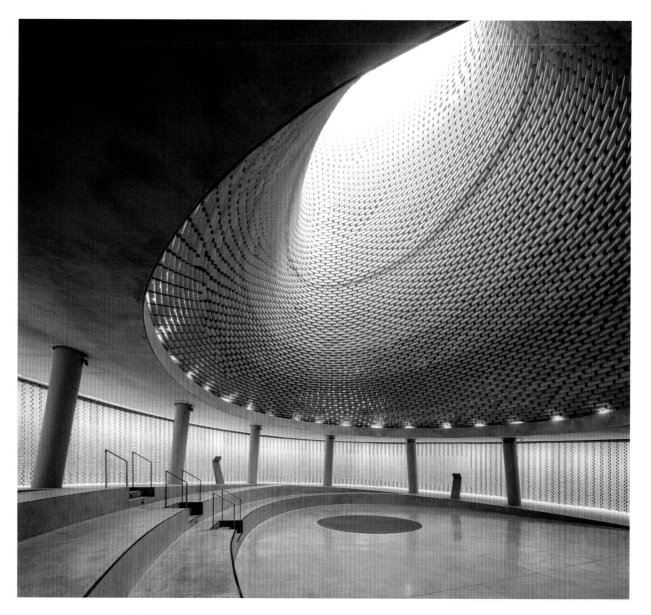

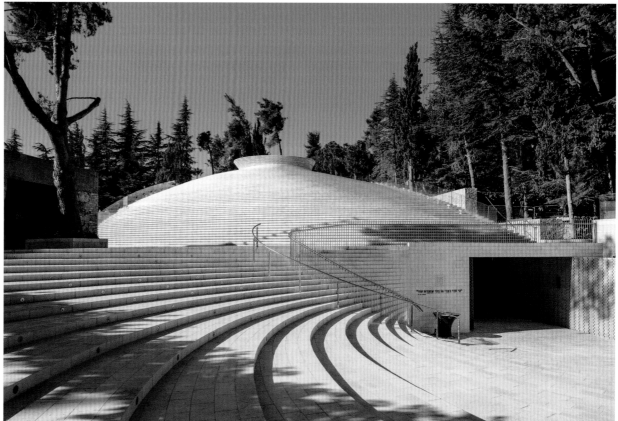

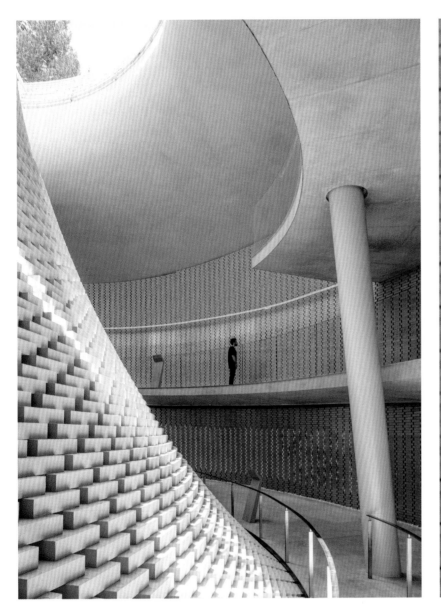
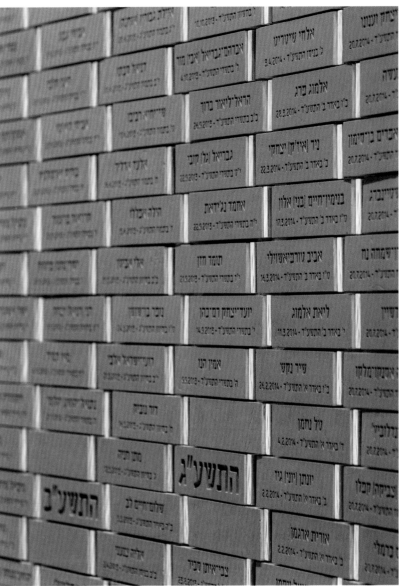

The National Memorial Hall for Israel's Fallen emphasizes its large, impressively engineered void—a reflection of both the nation's palpable might and profound loss.

TOP (LEFT) A WALL OF NAMES, BUILT OF MORE THAN 23,000 BRICKS, CIRCLES AROUND THE CENTRAL SCULPTURAL BRICK STRUCTURE.

TOP (RIGHT) EACH BRICK FEATURES THE NAME OF A FALLEN SOLDIER, THE DATE THE SOLDIER WAS KILLED, AND SPACE FOR A CANDLE TO BE LIT.

OPPOSITE (TOP) THE MEMORIAL'S FUNNEL-SHAPED FORMATION OF BRICKS OPENS TO THE SKY AND FLOODS THE SPACE WITH NATURAL LIGHT.

OPPOSITE (BOTTOM) EXCAVATED IN MOUNT HERZL, THE MEMORIAL HALL WAS BUILT TO ECHO THE TEXTURE OF THE ADJACENT CEMETERY.

NATIONAL MEMORIAL HALL FOR ISRAEL'S FALLEN

MEMORIAL TO THE HOMOSEXUALS PERSECUTED UNDER THE NATIONAL SOCIALIST REGIME

Located in Berlin's Tiergarten park, across the street from the city's arresting Holocaust memorial—Peter Eisenman's 2005 sea of concrete stelae (page 28)—sits another concrete block memorial, this one honoring the gay victims of the Nazi regime. The hulking monolith is the work of the local artist duo Elmgreen & Dragset (Michael Elmgreen, a Dane, and Ingar Dragset, a Norwegian). It is a somber, Minimalist sculpture that doesn't call attention to itself from the outside, though it does echo, on some level, Eisenman's adjacent design, almost like an enlarged version of one of its pillars. In a similar fashion to Rachel Whiteread's Judenplatz Holocaust memorial in Vienna (page 48), the Elmgreen & Dragset monument quietly creates a curiosity, pulling viewers in—what is this big, sloping chunk of concrete doing in the park?—and encouraging onlookers to get a bit closer to it. And, in fact, to take a peek inside.

On the western-facing side of the memorial, a small aperture lets visitors gaze into the sculpture.

Inside it, there is a black-and-white film of two men kissing, with horrific images of the Nazi atrocities scrolling behind them. It is an impossible-to-forget video work, at once recognizing the horrors of the past while celebrating how, in the end, love prevails. (Criticized that the original plan only included two men kissing, and that lesbians were left out, Elmgreen & Dragset changed the project so that every two years the film would feature other same-sex representations.)

Remembering the roughly 50,000 homosexuals who were labeled criminals—10,000 to 15,000 gay men were deported to concentration camps during World War II—the memorial provided a vital addition to Berlin's memorial landscape in the first decade of the twenty-first century, preceding the 2012 Sinti and Roma memorial (page 44) and 2014 "Euthanasia" memorial (page 214), both of which are within walking distance.

Elmgreen & Dragset's mysterious memorial encourages onlookers to get a bit closer to it. And, in fact, to take a peek inside.

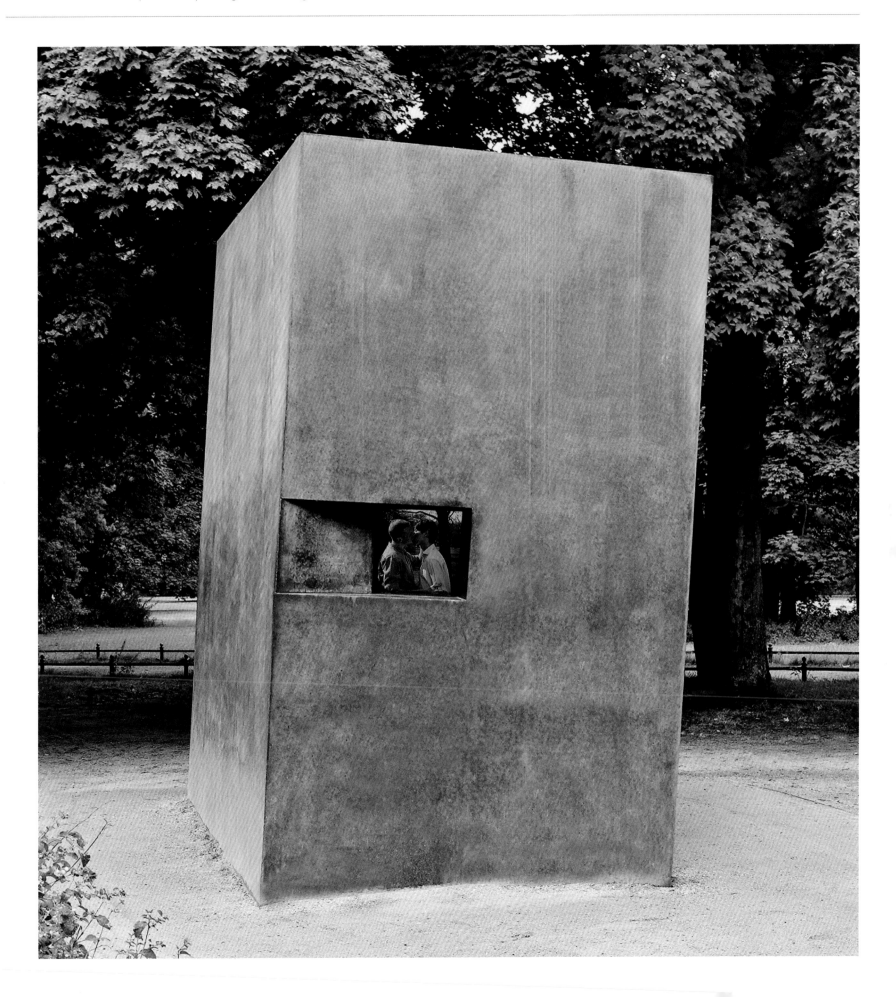

Following the devastating 7.9-magnitude earthquake in China's Sichuan Province on May 12, 2008—which caused roughly 70,000 deaths and destroyed around 1.5 million houses—the Sichuan government decided to build a memorial and museum. It commissioned Tongji University in Shanghai, and chose the town of Qushan, in Beichuan County, where more than 15,000 people died, as the site. The university then set up an internal competition within its Architectural Design and Research Institute. Thirty-six submissions came in, and five were chosen to present to the Sichuan government.

The winning proposal, a bold, jarring design by architecture faculty member Cai Yongji, manages to be at once literal and abstract. A fractured network of slate-paved walkways, echoing the cracked landscape found in the earthquake's aftermath, separate the CorTen-steel-walled, grass-roofed museum's main and secondary buildings—indicative of the violent damage of the disaster, one of the deadliest ever to hit China.

The dramatically shaped memorial, sitting on a 34.5-acre (14-hectare) site, integrates some of the grounds of the former Beichuan Middle School, which collapsed in the earthquake, killing more than 1,000 students, teachers, and administrators. Cai felt it was important to leave some remains of the school that had been there. He was able to salvage a sports field, turning it into a park-like courtyard for private ceremonies, and incorporated the ground-floor footprint of an adjacent school building. Inside the exhibition space are photographs, artifacts, wax sculptures, and an earthquake simulator that collectively narrate the disaster and its aftermath. Dawn redwood trees surround the gently sloping subterranean buildings and dot the complex. Whereas Maya Lin's Vietnam Veterans Memorial (page 54) created a "rift" in the earth, Cai's museum provides a rupture: an evocative, visually affecting tribute to the thousands of lives lost.

The bold, jarring design of the Wenchuan Earthquake Memorial forms an evocative, visually affecting tribute to the thousands of lives lost.

OPPOSITE THE MUSEUM'S BUILDINGS COMPRISE WALLS OF CORTEN STEEL AND GRASS ROOFS ARRANGED IN AGGRESSIVE, JAGGED ANGLES.

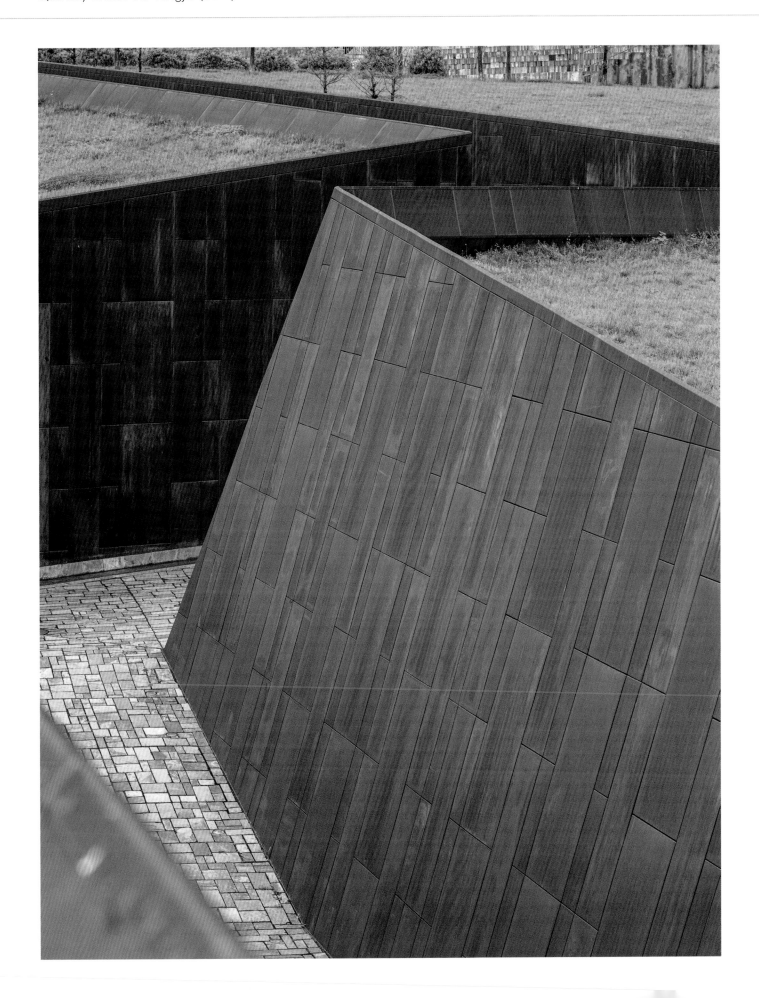

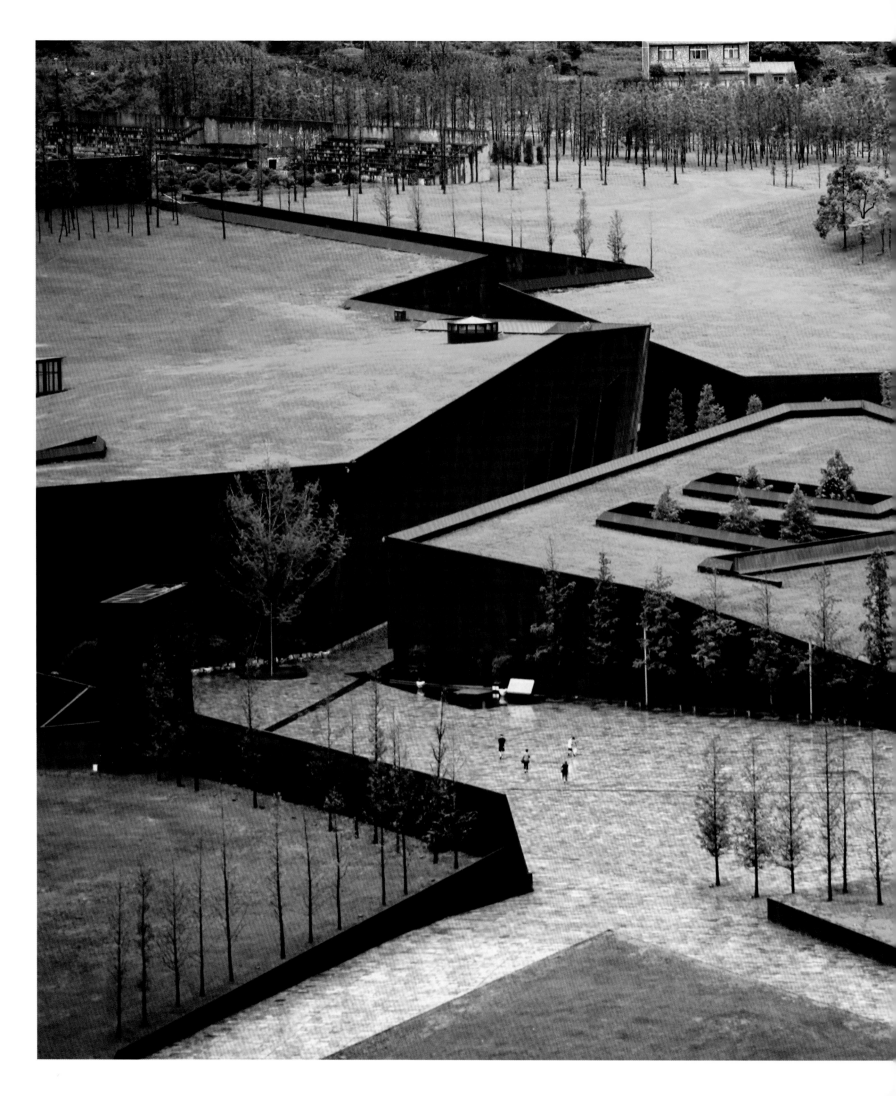

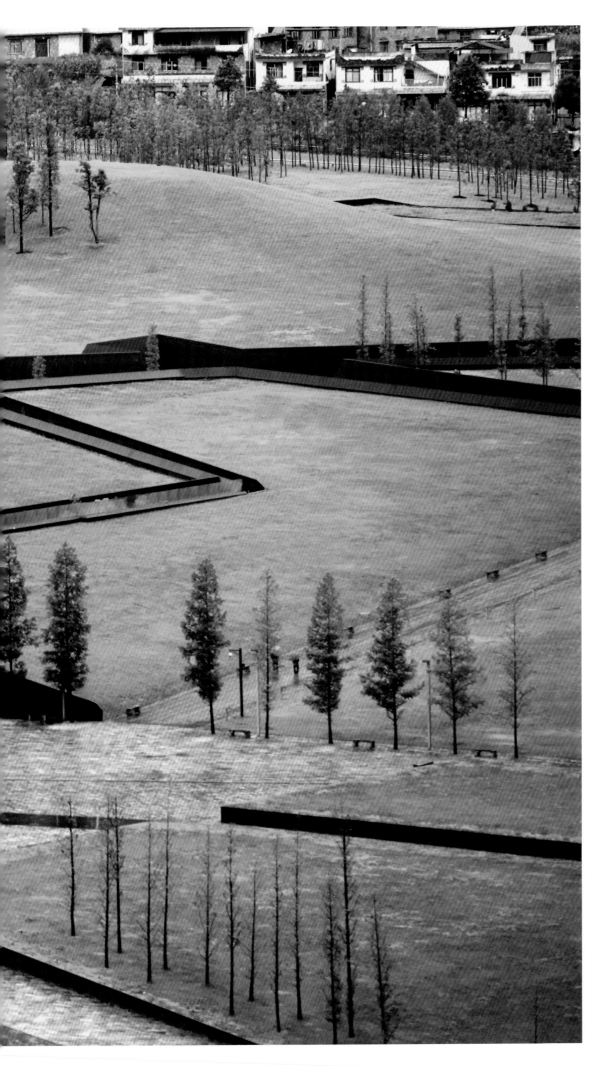

NATIONAL MEMORIAL FOR PEACE AND JUSTICE

The National Memorial for Peace and Justice is a potent, deeply affecting tribute to the 4,400 black Americans who were murdered in lynchings in the U.S. between 1877 and 1950. The memorial in Montgomery, Alabama, was established by Bryan Stevenson, a human rights lawyer and the executive director of the legal advocacy nonprofit Equal Justice Initiative (EJI), and designed by MASS Design Group. It features 816 CorTen–steel slabs hanging from the ceiling, each 6–foot–tall (1.8–meter–tall) column representing a U.S. county where a lynching took place and featuring the names of people who were lynched there (many are simply listed as "unknown"). The great weight of, and tremendous void resulting from, this dark and destructive history is made profoundly, intensely clear through the memorial's vast pavilion. Its visually arresting design, comprising what MASS's Michael Murphy calls "spatial vignettes," could be considered built poetry.

Located on a six–acre (24,000–square–meter) site overlooking the Alabama State Capitol, the memorial was inspired in part by the Apartheid Museum in Johannesburg and the Robben Island Museum, also in South Africa, and could be viewed as an aesthetic relative of Peter Eisenman's Holocaust memorial in Berlin (page 28). Critic Holland Cotter, writing in *The New York Times*, pointed out that the roots of the memorial go back to 1970s earthworks and site–specific installations that "combined Minimalist abstraction and scale with a Conceptualist capacity for political metaphor."

Opening up new, much–needed historical narratives, and taking visitors on a journey into some of the most harrowing and horrific depths of America's past, the memorial begins with a claustrophobic feeling. At the pavilion's entrance, there's a low–ceilinged display of tightly arranged standing slabs, after which a directed journey continues via a gently sloping descent, the columns hovering higher and higher above with each step. At a certain point, visitors are left gaping upwards, necks craned to see the columns, not entirely unlike how the spectators of public lynchings once looked up at those about to be hanged.

As visitors walk further into the memorial, dozens of wall texts reveal the brutal history, detailing various lynchings: "Stephen Sasser was lynched in 1884 in Early County, Georgia, for living with a white woman."

"George Briscoe was lynched in Annapolis, Maryland, in 1884 for alleged robbery." "Caleb Gladly was lynched in Bowling Green, Kentucky, in 1894 for walking behind the wife of his white employer." At the base of the memorial, embedded in a waterfall feature, block–lettered wall text reads: "Thousands of African Americans are unknown victims of racial terror lynchings whose deaths cannot be documented, many whose names will never be known. They are honored here."

In the center of the pavilion, a grassy hill provides a contemplative pause, one with a view of the state capitol building beyond, visible through but also obscured by the columns. The park–like setting, surrounded on all sides by the slabs, effectively puts the viewer on view as well. Outside of the structure, lined up in cemetery–like rows, are duplicates of the slabs, which EJI is inviting the corresponding counties to claim (following a process of acknowledgment and reconciliation, they'll be placed in their respective communities). The memorial is thus an active, living site, designed to change with time.

Several figurative sculptures are interspersed throughout, including, toward the conclusion of the visitor journey, the striking *Raise Up* (2016) by Hank Willis Thomas that evokes police suspects lined up at gunpoint. At the very end of the path, inscribed on a vertical slab of reflective black granite, is Elizabeth Alexander's poem "Invocation." Its final line: "The wind brings everything. Nothing is lost."

EJI's accompanying Legacy Museum, located in a warehouse that was once a slave market, is a mile away in the city's downtown district.

OPPOSITE OUTSIDE THE PAVILION, DUPLICATES OF THE HANGING SLABS ARE LINED UP IN ROWS, AS IF TOMBSTONES.

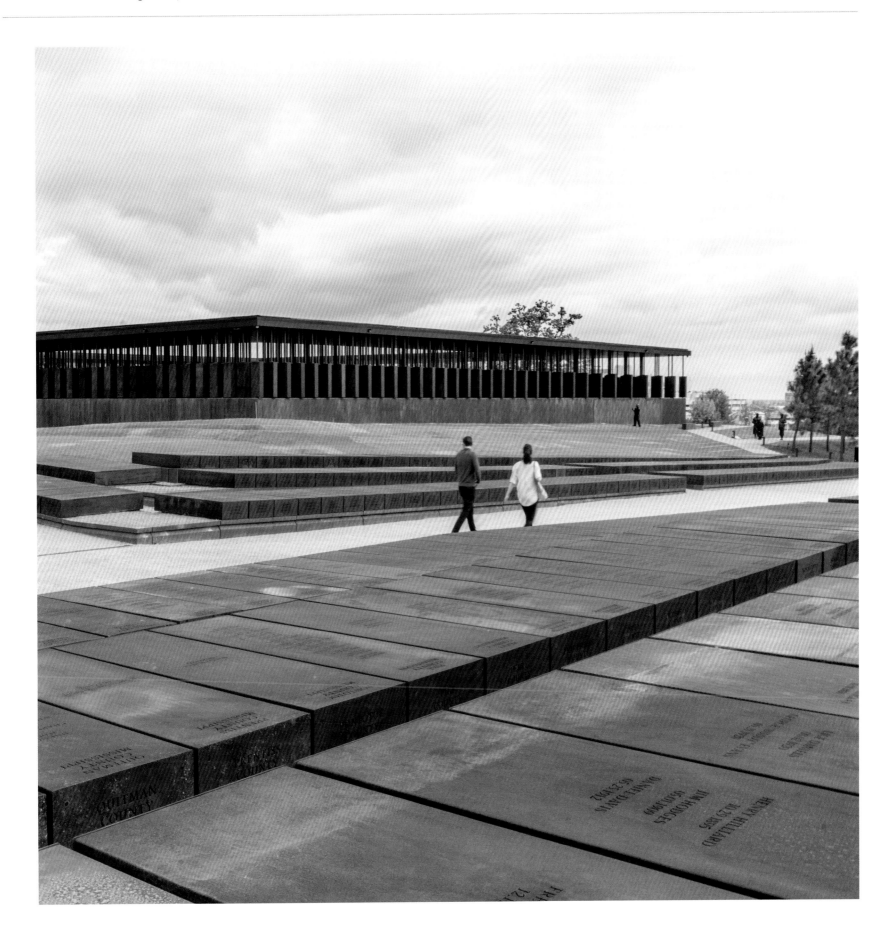

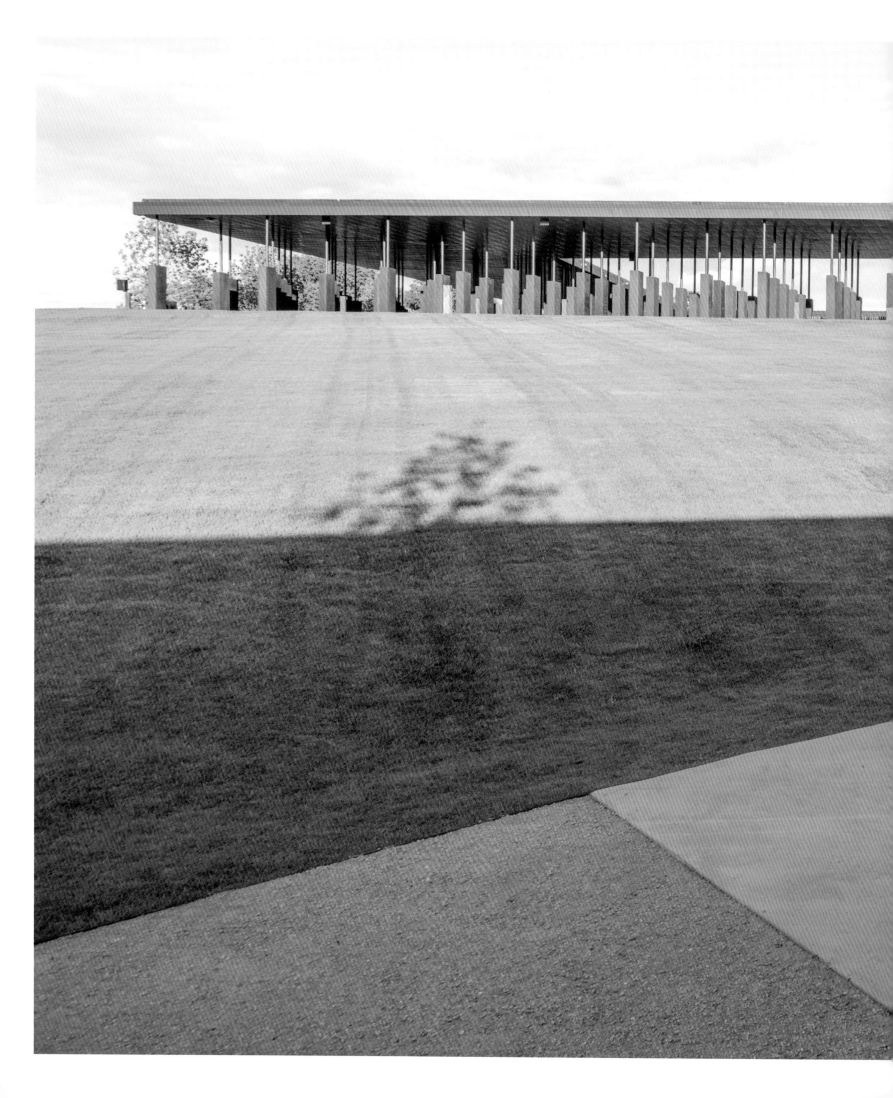

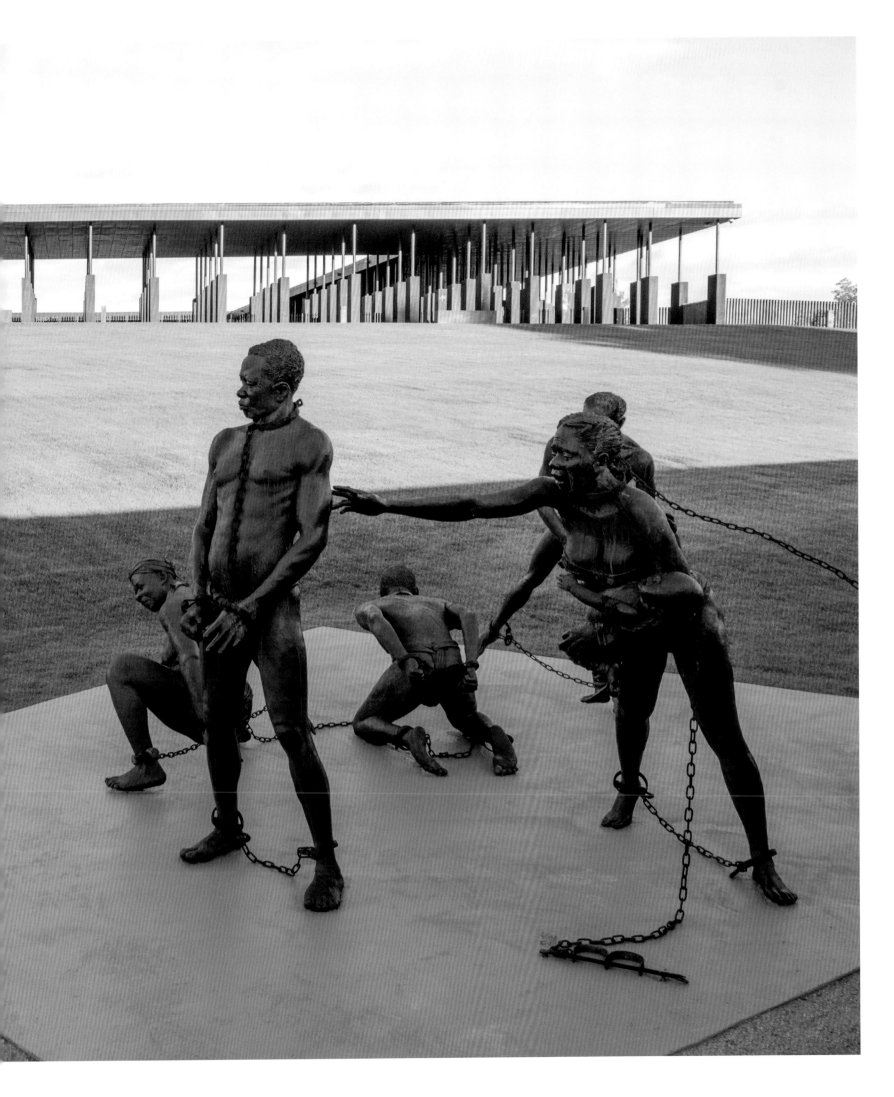

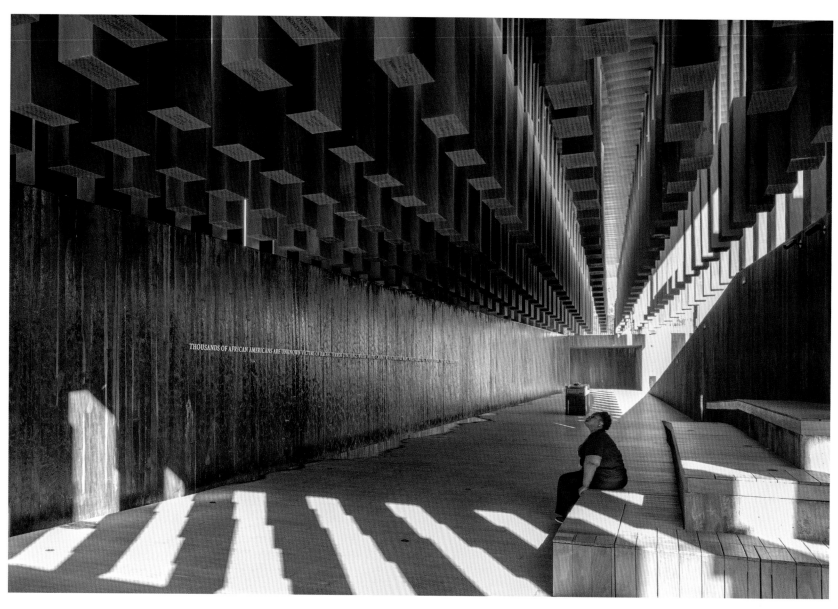

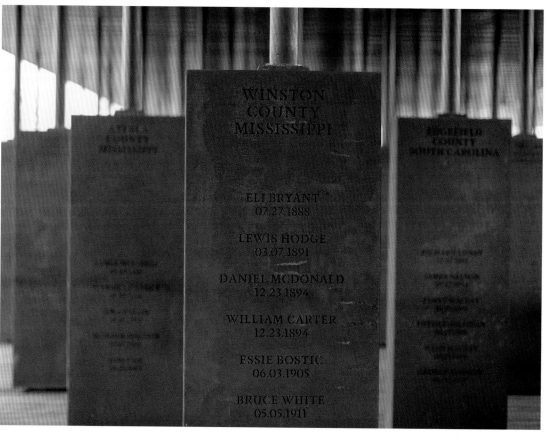

PREVIOUS SPREAD NEAR THE ENTRANCE IS KWAME AKOTO-BAMFO'S *NKYINKYIM* INSTALLATION (2018), PICTURED, WITH THE PAVILION BEYOND IT.

TOP EIGHT HUNDRED SIXTEEN CORTEN-STEEL SLABS HANG FROM THE CEILING, LEADING VISITORS TO CRANE THEIR NECKS UPWARD.

BOTTOM EACH COLUMN REPRESENTS A U.S. COUNTY WHERE A LYNCHING TOOK PLACE, AND FEATURES THE NAMES OF PEOPLE WHO WERE LYNCHED THERE.

OPPOSITE THE MEMORIAL FEATURES A DIRECTED JOURNEY THAT CONTINUES VIA A GENTLY SLOPING DESCENT.

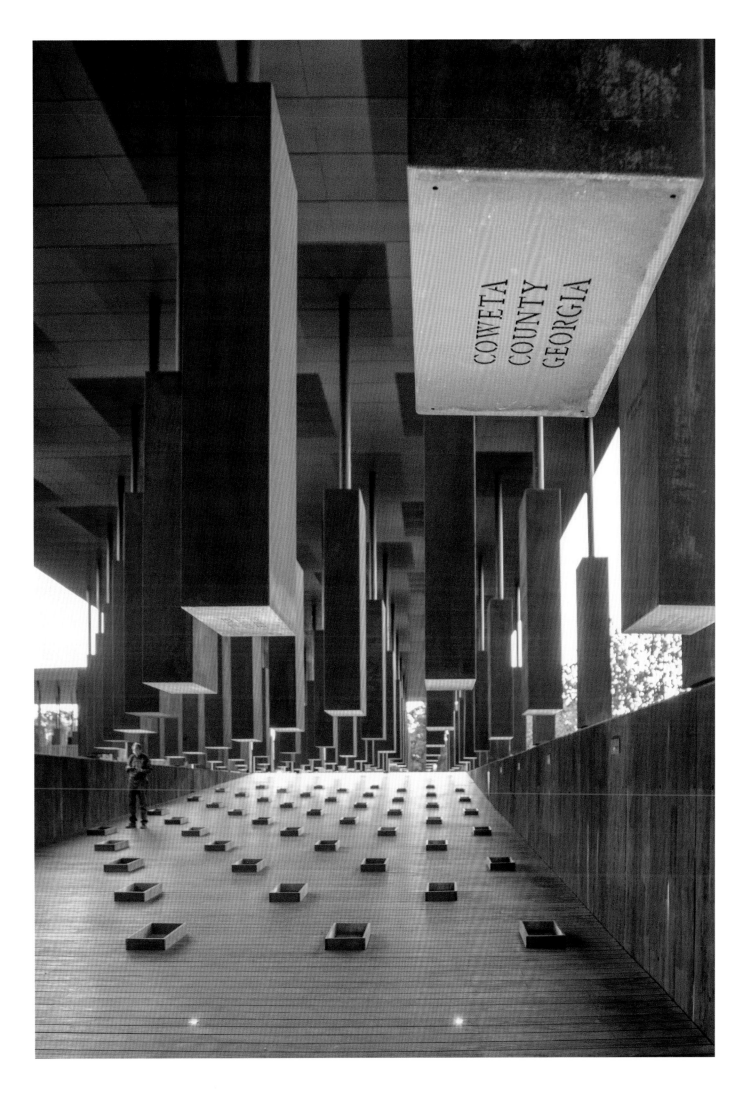

HOPE

STRENGTH

GRIEF

LOSS

FEAR

While memorials tend to be viewed predominantly as carrying negative or dark feelings, one positive, forward-looking emotion underlies most of them, and can occasionally serve as a focal point: strength. Sometimes, the materiality itself suggests toughness, tenacity, or determination; other times, it's the form. In certain cases, it's simply the context or subject matter.

At Louis Kahn's Franklin D. Roosevelt Four Freedoms State Park (see following pages) on Roosevelt Island in New York City, completed posthumously in 2012, all of these elements coalesce into a masterwork by one of the twentieth century's greatest architects. By incorporating thick granite walls and long, sloping walkways, Kahn gave the memorial a weighty sense of permanence. Its triangular, tree-lined, grassy pitch opens up and directs visitors down toward the centerpiece: a bronze bust of Roosevelt which, rather than overpowering the site or distracting from the abstract landscape's emotional impact, adds a welcome layer to it. Unusual for a figurative sculpture, perhaps because of its elegant form and relatively small size within the context of the large park, it doesn't dictate; in fact, it helps the adjacent list of Roosevelt's Four Freedoms—"Freedom of Speech, Freedom of Worship, Freedom from Want, and Freedom from Fear"—become all the stronger. In essence, this elegant edge of the city serves as a poignant place of resolve, a fitting tribute to Roosevelt's unwavering belief in freedom and the future. It may well be the most ethereal public space I've ever been to.

In Boston, Stanley Saitowitz's 1995 New England Holocaust Memorial (page 208) approaches strength in a far different, less-expected way—through fragility. Comprising six pillars, each sheathed in twenty-two glass panels, the memorial was intentionally designed by the architect as a covenant not to touch it. The very fragility of the material shows its inherent strength and meaning. In 2017, in two different instances, vandals shattered the glass. Both times, the memorial was quickly fixed, a display of its resilience and, as was Saitowitz's intent, an apt metaphor for the strength of the post-Holocaust Jewish spirit.

Another exemplary memorial embodying strength was a temporary viewing platform at Ground Zero (page 116) built just three months after 9/11. Created as a simple solution for on-site mourning, it also evoked the raw fortitude of New Yorkers following the attacks. Utilitarian in material (plywood, metal scaffolding), the structure—designed by the architects David Rockwell, Elizabeth Diller and Ric Scofidio, and Kevin Kennon—provided an opportunity for all walks of New York City life to come together around the abominable, unfathomable event, and to engage in it head on through 180-degree views of the rubble.

At Isamu Noguchi's 1988 Challenger Memorial (page 206) in Miami's Bayfront Park, commemorating the 1986 space shuttle explosion, the artist and designer conjured strength through form: in this case, a tetrahelix. The DNA strand—like structure vaguely resembles a rocketship ready for liftoff, exemplifying American ingenuity and power. Standing directly underneath it and looking up toward the blue sky, I felt as if I could be transported into another world.

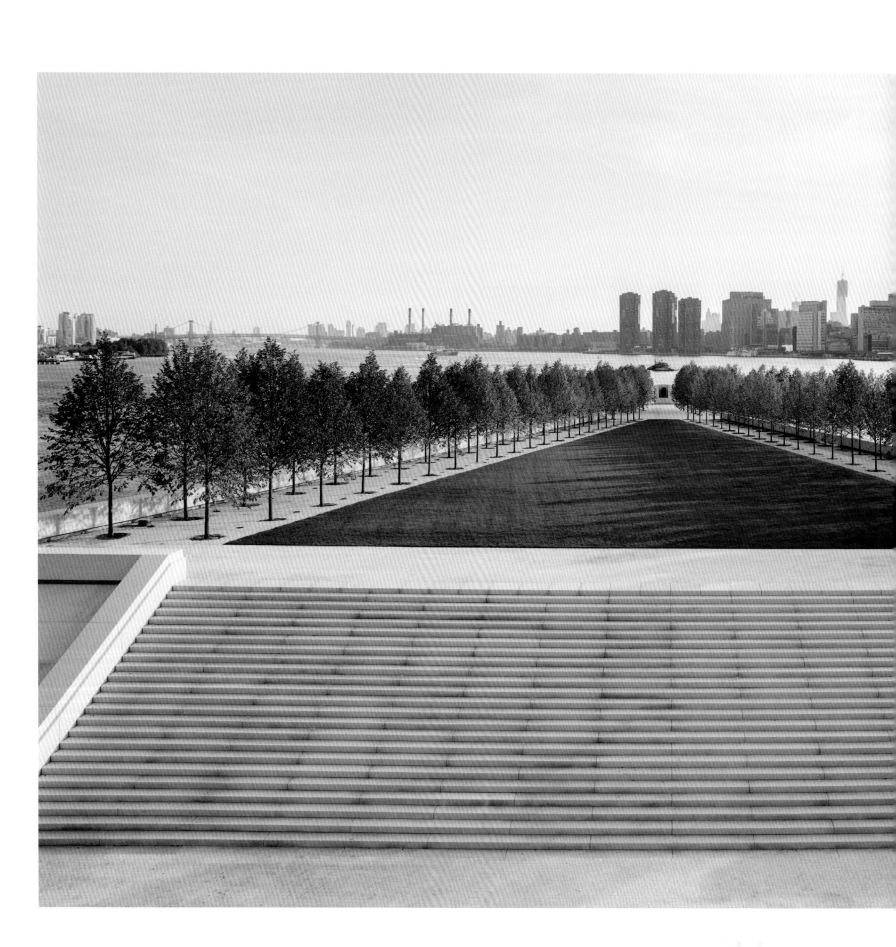

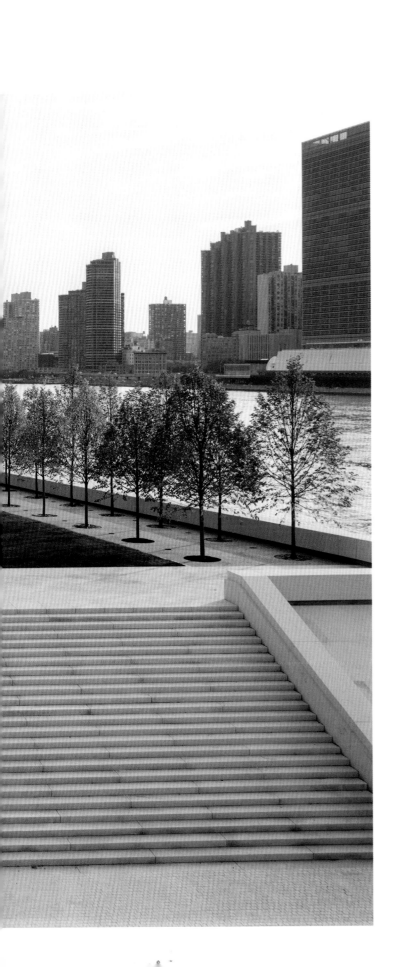

When Louis Kahn died on March 17, 1974, at age seventy-three, in the men's bathroom at New York's Pennsylvania Station, he had recently finished drawings for a memorial to Franklin Delano Roosevelt, to be located on the southern tip of Roosevelt Island, in New York's East River. The project—the prolific architect's final design—was almost left unrealized. But nearly four decades later, on the same triangular, four-acre (1.6-hectare) sweep of land for which it was designed, it became a reality. In the 2000s, former U.S. Ambassador William vanden Heuvel reignited the project, establishing a limited company, Franklin D. Roosevelt Four Freedoms Park, in 2008, and promising to build it to Kahn's design. Bringing in the Mitchell Giurgola architecture firm to oversee the project, vanden Heuvel raised the funds it took to build it. In October 2012, the park was at last inaugurated.

Certain practical matters of the design, of course, needed amending. For example, to accommodate sea-level rise due to climate change, the base of the memorial was lifted about 15 inches (38 cm) higher than where Kahn had placed it. But on the whole, the project was built just as the late architect intended. Powerful in its simplicity and abstraction, like so much of Kahn's elegant, poetic work, Four Freedoms State Park is a masterpiece of public space, a profound synthesis of city, sky, sea, and earth. Its slightly sloping pitch comprising two walkways lined with linden trees leads down to a wide plaza featuring a clear view of the United Nations building. The centerpiece, located at the plaza's entrance, is based upon a bronze 1933 bust by Jo Davidson, walled in by granite slabs (one side is engraved with Roosevelt's Four Freedoms, from his famed 1941 State of the Union speech). Surrounding it are twenty-eight massive blocks of granite, each weighing 36 tons (32,650 kilograms).

LEFT THE PARK'S SLIGHTLY SLOPING PITCH COMPRISES TWO TREE-LINED WALKWAYS THAT LEAD DOWN TO A WIDE PLAZA.

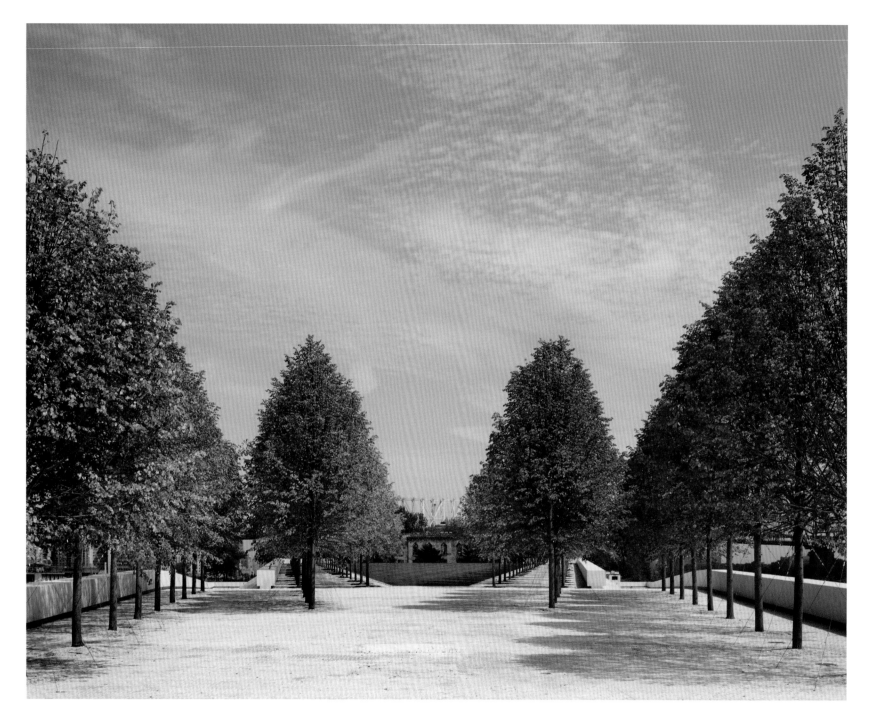

Like so much of Louis Kahn's elegant, poetic work, Four Freedoms State Park is a masterpiece of public space, a profound synthesis of city, sky, sea, and earth.

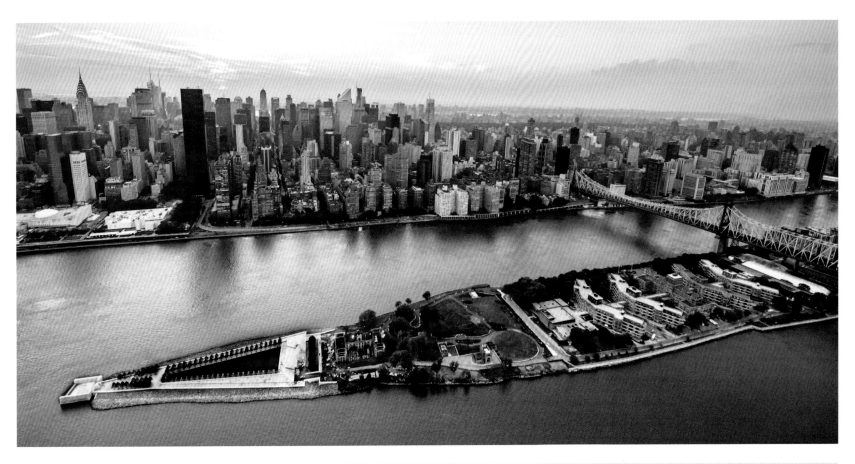

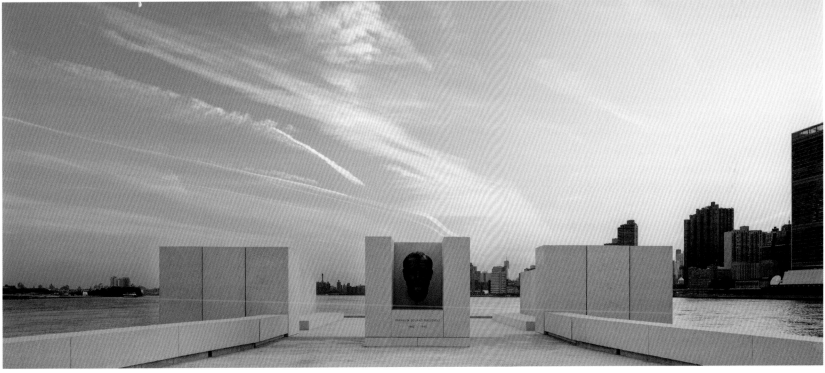

TOP THE PARK WAS COMPLETED POSTHUMOUSLY IN 2012, TO LOUIS KAHN'S 1970S DESIGN, AT THE SOUTHERN END OF ROOSEVELT ISLAND.

BOTTOM A BRONZE BUST OF ROOSEVELT, BASED ON JO DAVIDSON'S ORIGINAL 1933 WORK, FORMS THE CENTREPIECE OF THE MEMORIAL.

OPPOSITE EVENLY ARRANGED ROWS OF TREES CREATE SHADE AND AN IDYLLIC SENSE OF SPACE.

FRANKLIN D. ROOSEVELT FOUR FREEDOMS STATE PARK

MUSEUM OF MEMORY AND HUMAN RIGHTS

Dramatically hovering over an 86,100-square-foot (8,000-square-meter) sunken, open-air plaza on the edge of downtown Santiago, the Museum of Memory and Human Rights remembers and educates visitors on the atrocities of Augusto Pinochet's bloody 1973 coup and the seventeen-year dictatorship that followed. Built as part of an effort to revitalize the neighborhood, the politically motivated, government-sponsored memorial and museum was pushed forward shortly after Michelle Bachelet was elected president in 2006. (Almost twenty years in the making, it was rooted in a recommendation from a 1991 truth and reconciliation report.) Bachelet, who had been tortured and whose father was killed during the Pinochet years, quickly put together a Commission for Human Rights Policy and in the fall of 2007 tapped journalist Marcia Scantlebury to lead the project, in consultation with human rights expert María Luisa Sepúlveda. Scantlebury and her team traveled to sites including the United States Holocaust Memorial Museum in Washington, D.C. and the Apartheid Museum in Johannesburg. The Brazilian firm Estúdio América was chosen to design the building in an architecture competition.

The result is a hulking construction, made of glass, steel, copper, and concrete, that calls to mind Lina Bo Bardi's 1968 São Paulo Museum of Art, which also floats above a public square. Walking down a gentle slope toward the museum's discreet entrance, visitors pass along the thirty articles of the UN's Universal Declaration of Human Rights engraved into a concrete wall. Also adorning the walls are a poem by folksinger and theater director Victor Jara, one of the more famous victims, and a quote that reads, "The museum is a school; the artist learns to communicate; the public learns to make connections." Inside, a chronological exhibition details the coup and subsequent violence through artifacts (such as trinkets made by political prisoners), recordings, letters, videos, photographs, and other materials.

RIGHT THE MUSEUM OF MEMORY AND HUMAN RIGHTS DRAMATICALLY BALANCES OVER A PUBLIC PLAZA IN DOWNTOWN SANTIAGO.

Santiago, Chile. Estúdio América (2010)

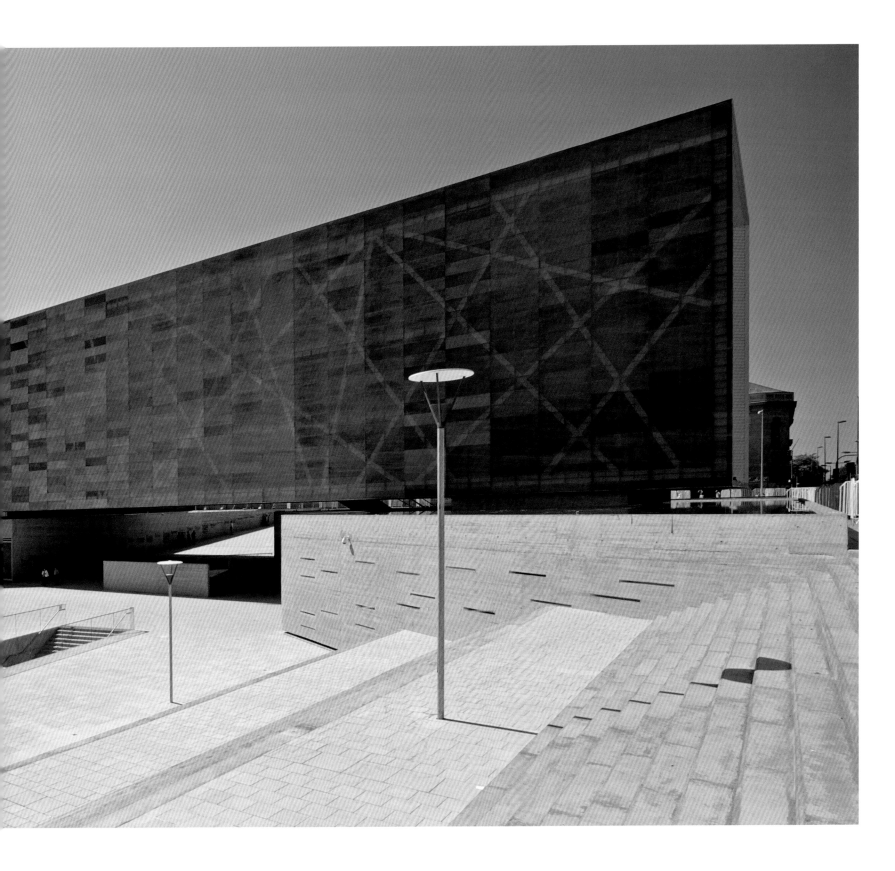

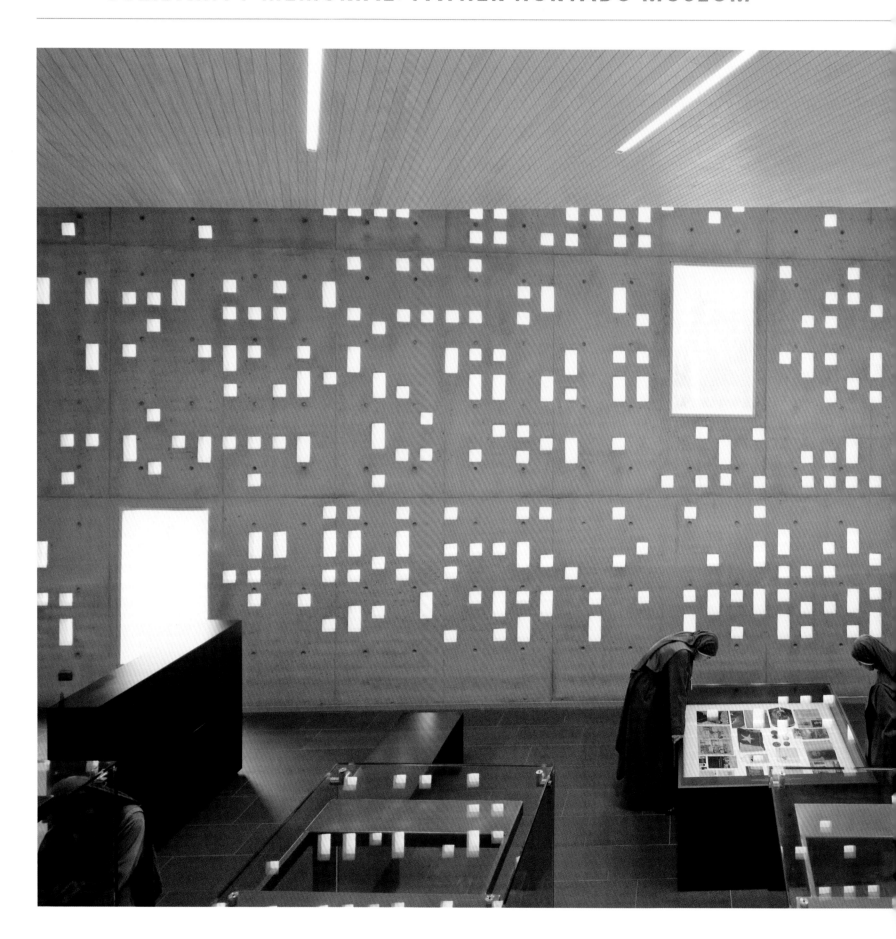

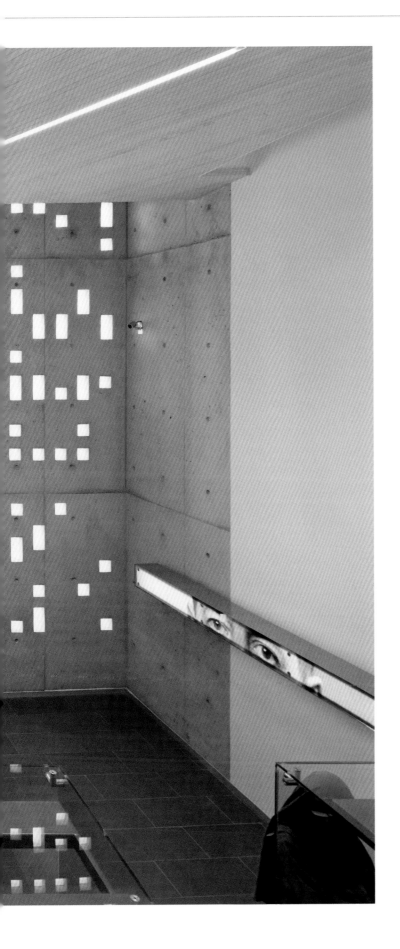

Nestled in a small park in one of Santiago's poorest enclaves near the city's historic center, San Alberto Hurtado's memorial commemorates the life of the priest Father Alberto Hurtado, who died of pancreatic cancer in 1952, at age fifty-one. Known throughout Santiago in the twentieth century for his charitable work and solidarity with those in distress, Hurtado established an organization there called *Hogar de Christo* (Christ's House) that helped and comforted some of the city's neediest residents, including abandoned children. (The charity still exists today.) He was recognized through-out Santiago for driving around in his green 1946 Ford pickup and retrieving homeless people to bring back to the shelter. Eventually, he expanded the shelter to include an education center with job-training pro-grams. Though his life was brief, Hurtado's impact was noted globally when the Catholic Church beatified him in 1994, and then again in 2005, when he was canon-ized by Pope Benedict XVI and made a saint—only the second in Chile.

The 7,620-square-foot (708-square-meter), three-story memorial and museum, designed by Cristián Undurraga of Undurraga Devés Arquitectos, was completed in 2010 as an addition to an earlier 1995 competition the firm won to build a 16-foot-deep (5-meter-deep) concrete-walled passageway that runs lengthwise through the park, to where Hurtado's remains are buried. (Though there were attempts to clear the area, including building a superhighway through it, public outcry allowed the memorial and park to prevail.) Made of raw concrete, glass blocks, and bleached-pine ceilings, Undurraga's discreetly arranged museum incorporates natural light, which punctuates the serene space through randomly patterned windows, drawn and constructed by hand, that the architect has likened to braille. Ramps lead visitors up and down through the double-height galleries featuring various artifacts and sacred objects, a spiritual setting as humble and welcoming as the remarkable man it honors.

LEFT RANDOMLY PATTERNED APERTURES IN THE MAIN EXHIBITION SPACE ADMIT NATURAL LIGHT, ESTABLISHING A SERENE ENVIRONMENT.

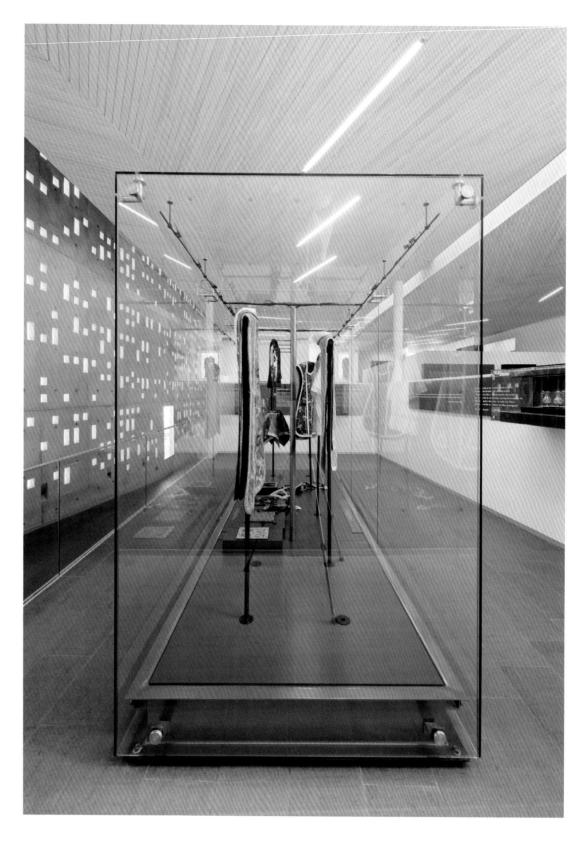

The Father Hurtado Museum establishes an ethereal spiritual setting as humble and welcoming as the remarkable man it honors.

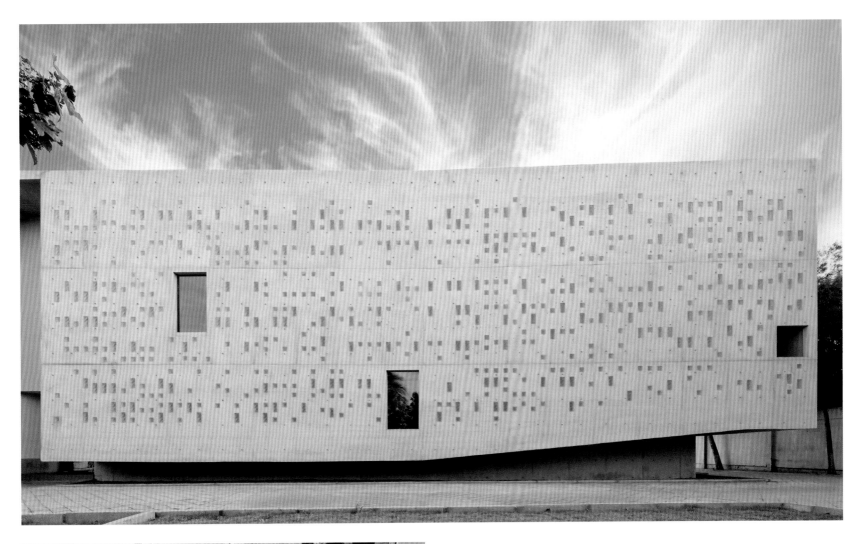

TOP THE 7,620-SQUARE-FOOT (708-SQUARE-METER) MEMORIAL AND MUSEUM FACADE IS MADE OF RAW CONCRETE AND GLASS BLOCKS.

BOTTOM AN AERIAL VIEW SHOWING THE FULL SCALE OF THE SITE, A PARK SQUEEZED IN A DENSE URBAN SETTING.

OPPOSITE A GLASS DISPLAY CASE IN THE DOUBLE-HEIGHT GALLERY PRESENTS ARTIFACTS AND SACRED OBJECTS.

SOLIDARITY MEMORIAL, FATHER HURTADO MUSEUM

NAGASAKI NATIONAL PEACE MEMORIAL HALL FOR THE ATOMIC BOMB VICTIMS

Located near the Atomic Bomb Museum (1996) and the Nagasaki Peace Park (established in 1955 and featuring a Peace Statue monument created by sculptor Seibo Kitamura), the Nagasaki National Peace Memorial Hall for the Atomic Bomb Victims serves as a quiet, solemn addition to the city's memorial landscape. Commemorating and mourning the August 9, 1945, atomic bombing, it is the counterpart to a similar 2002 building by Kenzo Tange in Hiroshima (page 212). The Nagasaki project, designed by Akira Kuryu and completed in 2003, itself dates back to 1990, when the Japanese government began discussing how to mourn those killed by the atomic bomb. By 1994, talk of memorialization began, and by 2000 construction started on Kuryu's building.

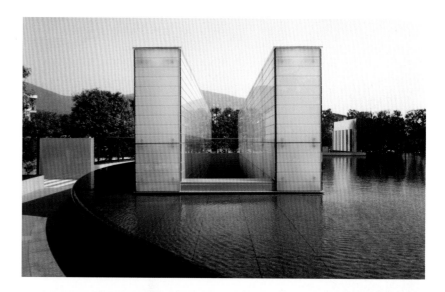

A below-ground memorial with two lower levels, it is topped with a sculpted water basin, which at night features 70,000 fiber-optic lights: a tribute referencing the rough number of those who were listed as dead as of December 1945 (municipal records noted 73,884 victims). At the entrance, visitors first see signage in Japanese, English, Korean, and Chinese—notable, perhaps, not only to account for the range of visitors, but also because Koreans, Chinese, and other foreigners died in the bombing. Next, visitors circle counterclockwise around the basin, and then descend into an exhibition center featuring more than 36,000 *hibakusha,* or accounts written by survivors. Beyond that, a "loft" offers a contemplative view. On the lowest level, a library with reference terminals and a waiting chamber allow for a pause before the memorial's focal point, Remembrance Hall, which comprises twelve towering, lit-up green-glass columns and books listing the names of the registered victims. As of 2020, there were 115,000 names in 186 books.

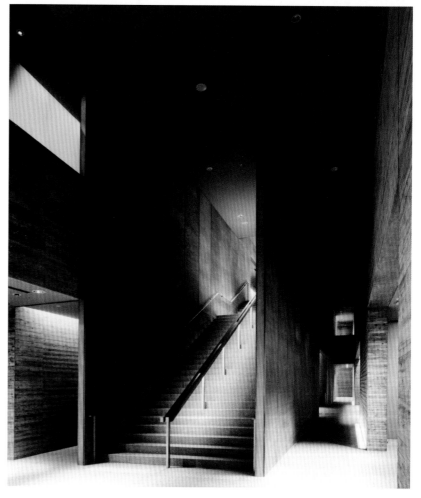

Nagasaki, Japan. Akira Kuryu (2003)

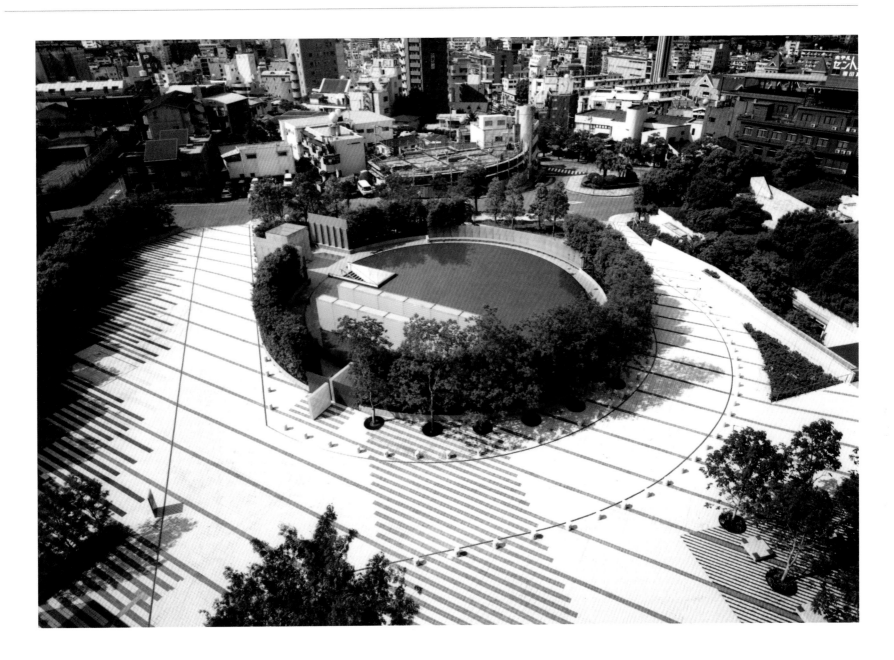

ABOVE AN OVERHEAD VIEW SHOWS
THE FULL MEMORIAL, WHICH IS
SITUATED NEAR NAGASAKI PEACE PARK
(ESTABLISHED IN 1955).

OPPOSITE (TOP) A STRIKING WATER
BASIN GREETS VISITORS AS THEY CIRCLE
COUNTERCLOCKWISE TO ENTER THE
SUBTERRANEAN SPACE.

OPPOSITE (BOTTOM) A DRAMATIC
STAIRCASE LEADS VISITORS TO
THE EXHIBITION CENTER, LIBRARY,
AND REMEMBRANCE HALL.

MEMORY, PEACE, AND RECONCILIATION CENTER

Built in 2012 on the grounds of the Central Cemetery of Bogotá in the city's historic center, the Memory, Peace, and Reconciliation Center recognizes the violence that has besieged Colombia for more than seventy years, beginning in 1948 with the civil war. Unlike most memorials or places of memory, the space—which comprises a library, an auditorium, a reading room, and exhibition areas—was completed while the country's internal conflict was still going on. It was only in 2015, following years of negotiations, that the country's president, Juan Manuel Santos, and *Fuerzas Armadas Revolucionarias de Colombia* (FARC) leader, Timoleón Jiménez, signed a peace treaty, ending more than half a century of internal clashes.

Joined in 2013 by the Memory House Museum in Medellín, the center is part of a national effort by communities across Colombia to remember, mourn, and make sense of their collective trauma. Resulting from conversations with human-rights NGOs and peace organizations, the Bogotá mayor's office decided in 2009 to fund the project. Following a public competition that received forty-one entries, a design by local architect Juan Pablo Ortiz was chosen.

Due to the building's sensitive location—which, to lay the foundations, required more than 3,600 buried bodies to be exhumed—Ortiz designed a building that isn't only respectful of the site; he also allowed the public to participate in its construction. Partly inspired by Joseph Beuys's *7,000 Oaks*, in which volunteers helped plant 7,000 oak trees in Kassel, Germany, Ortiz invited victims' associations from across the country to participate in fifteen symbolic ceremonies, bringing soil from their respective regions and depositing it into the form-work via glass tubes. (The soil alludes to the fact that land ownership, in large part, was the origin of the conflict.) Subtly integrated into the cemetery's topography, the squat monolithic structure features four entrances, each from a cardinal point, offering a bridge between a horrific past and a hopeful future.

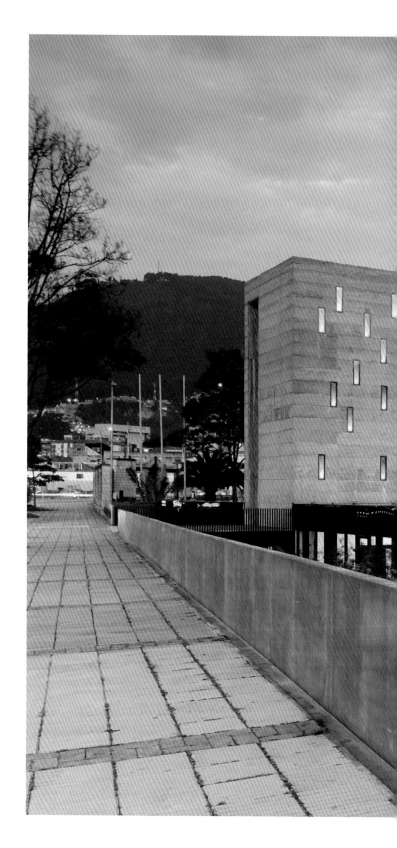

RIGHT PART OF BOGOTÁ'S CENTRAL CEMETERY COMPLEX, THE MEMORIAL SENSITIVELY INTEGRATES ITSELF INTO THE EXISTING TOPOGRAPHY.

Bogotá, Colombia. Juan Pablo Ortiz Arquitectos (2012)

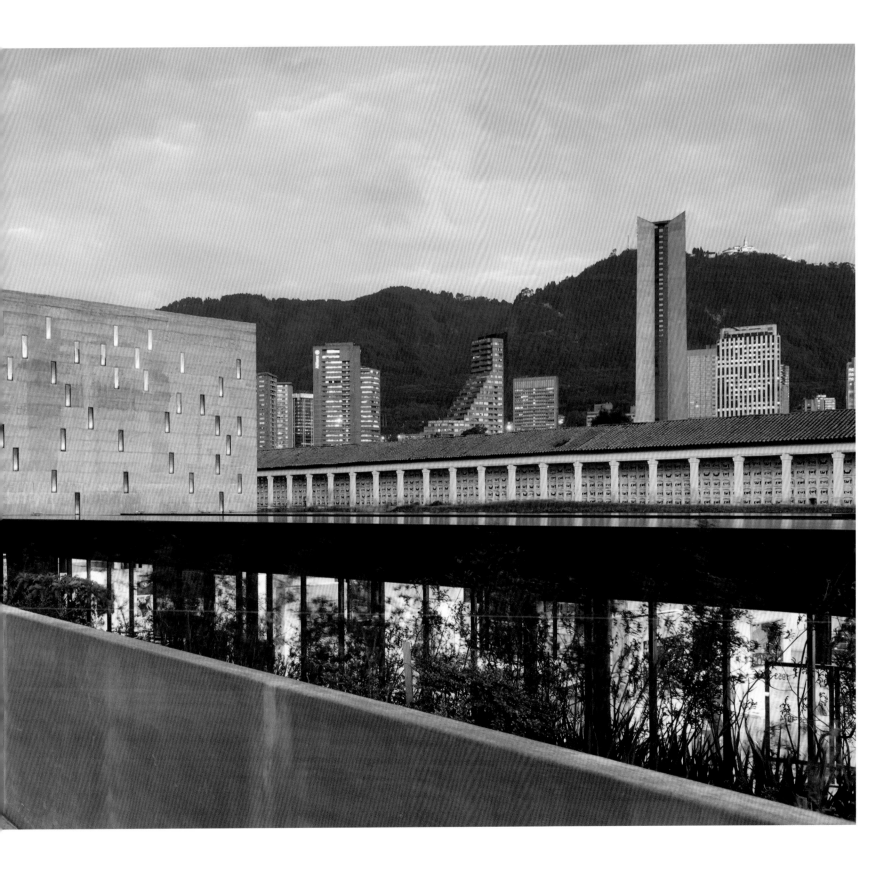

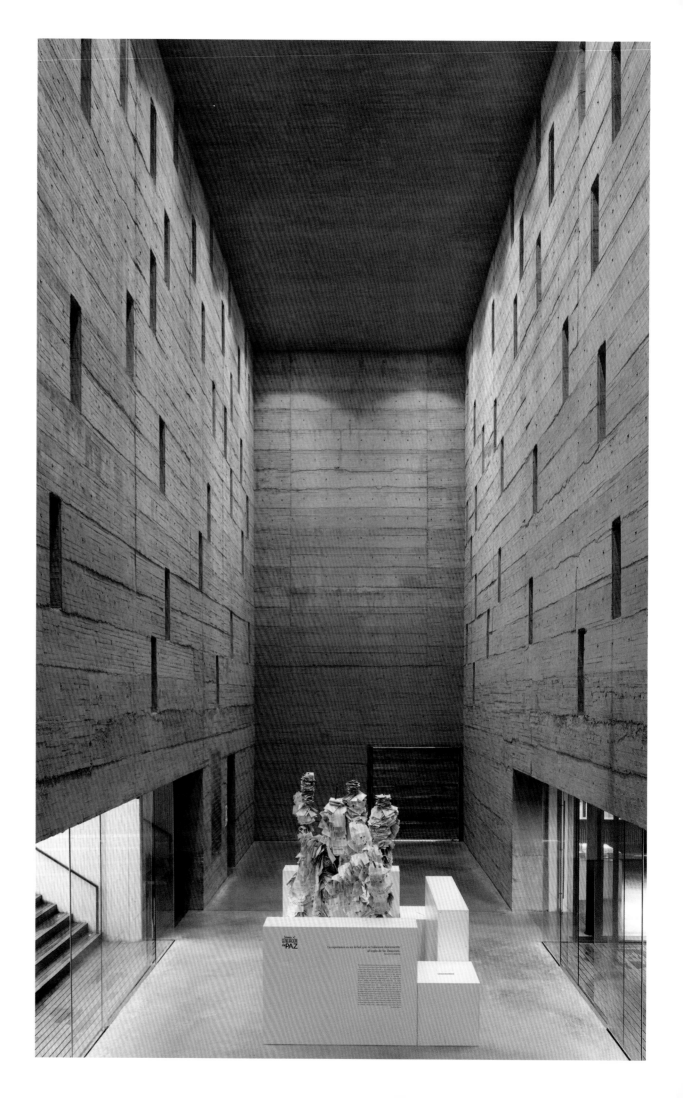

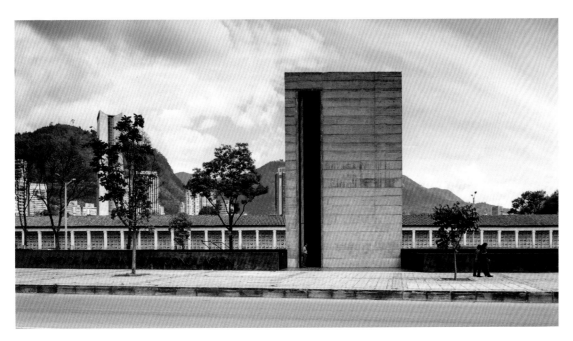

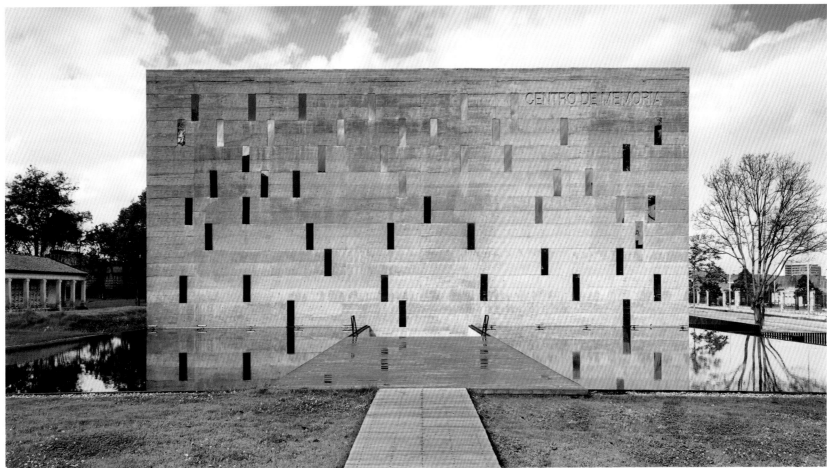

TOP ONE OF THE MEMORIAL'S FOUR ENTRANCES, EACH OF WHICH IS ARRANGED AT A CARDINAL POINT.

BOTTOM ANOTHER ENTRANCE LEADS VISITORS PAST A WATER FEATURE AND DOWN STAIRS.

OPPOSITE THE BUILDING INCLUDES A LIBRARY AND READING ROOM, AN AUDITORIUM, AND EXHIBITION SPACES.

NATIONAL 9/11 PENTAGON MEMORIAL

Similar to the Hans and Torrey Butzer's Oklahoma City National Memorial Museum (page 50), the park-like National 9/11 Pentagon Memorial in Washington, D.C., employs seats—in this case, rows of 14-foot-long (4.2-meter-long) benches—as a central element. Occupying a 1.9-acre (7,680-square-meter) site and situated on government land near where American Airlines Flight 77 hit the Pentagon, the memorial comprises 184 cantilevered benches—made of polished stainless steel and inlaid with Spanish granite—each representing a victim of the terrorist attack on the building on September 11, 2001. Each bench, under-lit and positioned above a pool of trickling water, is engraved on the end with the name of a victim, starting at the site's southeast corner with the youngest, three-year-old Dana Falkenberg, and finishing in the northwest corner with the oldest, 71-year-old John Yamnicky. The names on fifty-nine of the benches, honoring those who were on the plane, are oriented in the direction where the aircraft came from; the other 125 benches, dedicated to victims inside the Pentagon, face the south facade of the building, where the plane hit. Maple trees accent the grounds. (An original plan to have 184 trees, each representing a victim, was scrapped when it was determined that the death of a tree could cause further anguish.)

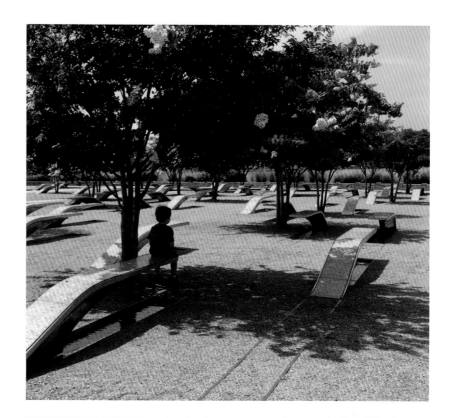

As with the Oklahoma memorial, as well as Maya Lin's Vietnam Veterans Memorial (page 54), the architects of the Pentagon Memorial, Julie Beckman and Keith Kaseman, were young and unknown when they were selected in a competition. The jury—which included landscape architect Walter Hood, Gregg Pasquarelli of SHoP Architects, two former defense secretaries, and two relatives of the victims—received 1,126 memorial proposals and from them selected six finalists. (Upon revealing the finalists, Pasquarelli resigned from the jury, as Kaseman was then working at his firm.)

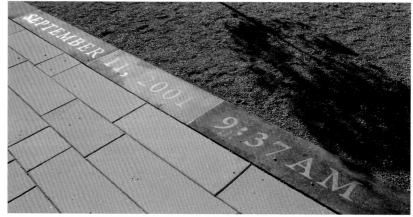

At the memorial's entrance, there's an etched stone, recovered from the Pentagon's ruins, that reads "September 11, 2001—9:37 a.m.," marking the moment of impact.

Washington, D.C., USA. Julie Beckman and Keith Kaseman (KBAS Studio) (2008)

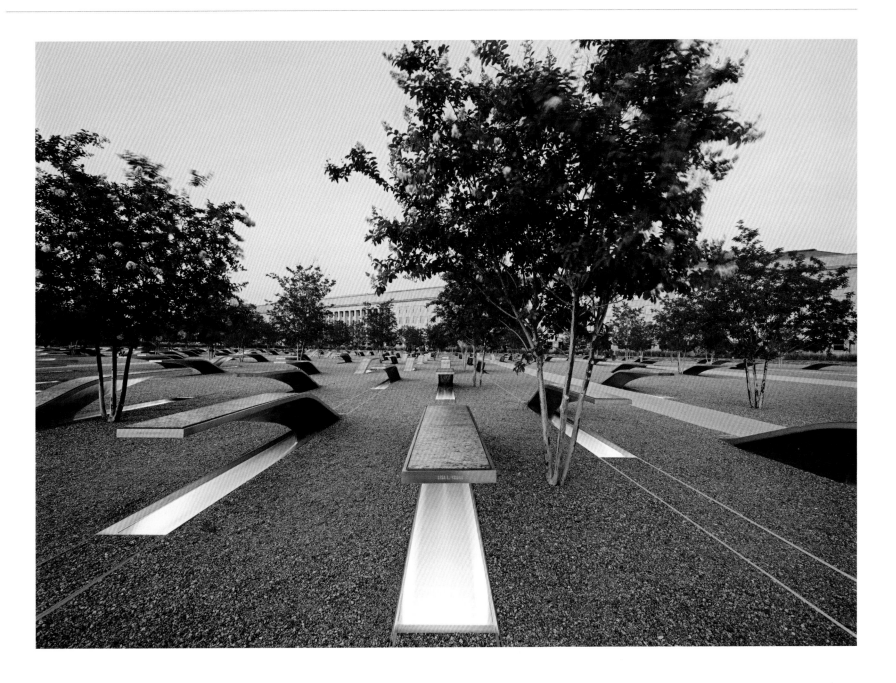

ABOVE THE MEMORIAL COMPRISES 184 ELEGANTLY CANTILEVERED BENCHES, EACH MEASURING 14 FEET (4.2 METERS) IN LENGTH.

OPPOSITE (TOP) EACH BENCH, UNDERLIT AND WITH A POOL OF WATER BENEATH IT, REPRESENTS A VICTIM OF THE 9/11 ATTACKS ON THE PENTAGON.

OPPOSITE (BOTTOM) THE DATE AND TIME OF THE ATTACK ARE INSCRIBED AT THE SITE.

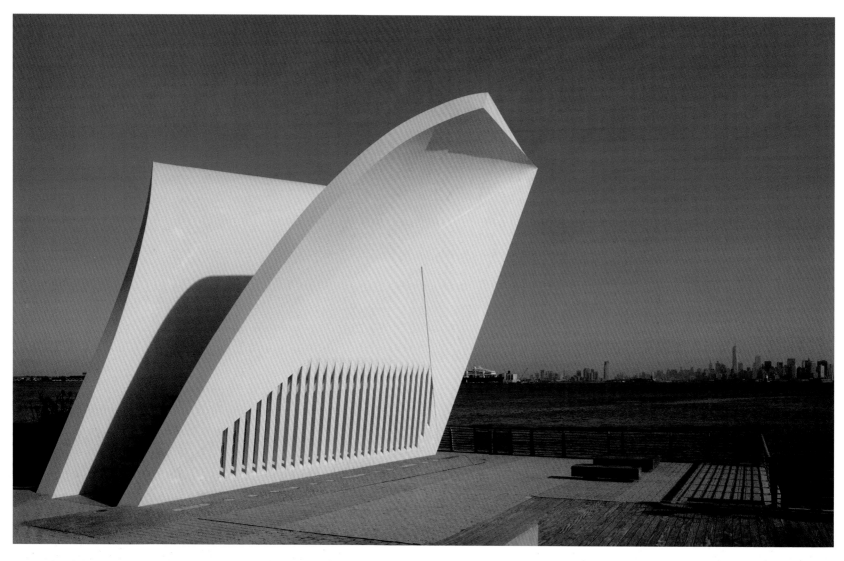

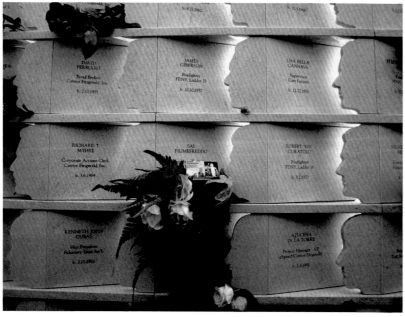

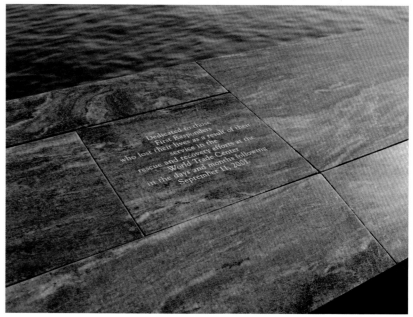

Opened on September 11, 2004, just three years after the 9/11 World Trade Center attacks, the Staten Island September 11 Memorial was among the earliest 9/11 memorials to be completed—and the first major one in the New York region. Designed by architect Masayuki Sono, the project was selected in a competition and was completed in just fifteen months. The proposal, titled "Postcards," was intended to relate to the idea of a postcard—something personal and intimate, to be sent to loved ones. Its two walls, folded over, create a metaphorical pair of postcards that are oriented toward the former twin towers, spreading outward to the sea and sky. Originally intended to be built with concrete, the finished structure was eventually made with carbon fiber fabricated by New England Boatworks in Portsmouth, Rhode Island. The result, as architect and professor Jeffrey Karl Ochsner has declared, creates "the fortuitous effect of enhancing the feeling of lightness, and even flight."

Included inside the memorial, on granite plaques, are the names of 263 Staten Islanders who died in the attacks, each denoted by a victim's name, birth date, and place of work at the time of the attack, as well as a profile silhouette—the latter an entirely original element to the project. Behind each silhouette is a perforated wall that allows light in, both natural and, at nighttime, artificial. In 2017, Sono expanded the site with the September 11 First Responders Memorial, made of polished blue-green quartzite stone with white engraved texts listing the responders' names, titles, units, and dates of death. An elegant tribute, the two memorials frame both the World Trade Center site and the memory of those who died, with dignity and grace.

Oriented toward the former twin towers, the Staten Island September 11 Memorial elegantly spreads its wings—a signal of inner strength and hope.

OPPOSITE (TOP) THE MEMORIAL'S TWO WALLS ARE MEANT TO REPRESENT A PAIR OF POSTCARDS, ACTING AS A METAPHORICAL MESSAGE TO THE FORMER TWIN TOWERS.

OPPOSITE (BOTTOM LEFT) BACKLIT GRANITE PLAQUES MARK EACH VICTIM'S NAME, BIRTH DATE, AND PLACE OF WORK, AS WELL AS THEIR SILHOUETTE.

OPPOSITE (BOTTOM RIGHT) A PLAQUE AT THE ADJACENT 9/11 FIRST RESPONDERS MEMORIAL, MADE OF BLUE-GREEN QUARTZITE.

WORLD TRADE CENTER VIEWING PLATFORM

In the immediate aftermath of 9/11, four New York City architects came together to create a temporary, pro-bono viewing platform overlooking the remains of the destroyed World Trade Center site—or, as the workers there called it, "the pile." Raising money from private donors, including TV producer Norman Lear and developer Larry Silverstein, the civic-minded design team—comprising David Rockwell, Elizabeth Diller and Ric Scofidio, and Kevin Kennon—built a simple 13-foot-high (3.9-meter-high) platform with two long, gently sloping ramps and a stage offering 180-degree views. Completed on December 27, 2001, and made of raw plywood with metal scaffolding as supports, it was the first piece of post–9/11 public architecture at the site. Only later would the competition for the World Trade Center memorial (page 120) get underway.

The project started when Rockwell was asked by city officials to redesign a private viewing platform for the victims' families—a job, in time, he decided to turn down. Instead, Rockwell brought in Kennon, as well as Diller and Scofidio, and the group conceived a different, more democratic concept. The team approached the Office of Emergency Management (OEM), which was in charge of the cleanup effort, for approval. OEM quickly welcomed the idea, and then contacted the mayor's office and victims' families, both of which also came around to giving it the go-ahead (the families required some prodding and convincing).

"The first experience people will have here, when they see this, is not as a construction site," Rockwell told a newscast, "but as an incredibly moving burial ground." The temporary piece, a humble example of utilitarian architecture, served as a facilitator of dialogue—its bare walls could be written on and tagged—and as a physical place for reflection, for pondering the future of Ground Zero, and for thinking far beyond that, too.

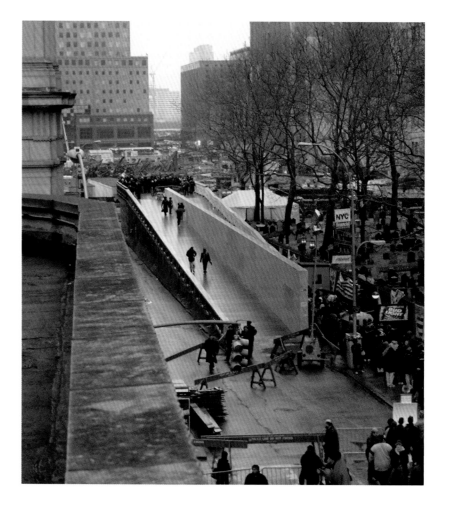

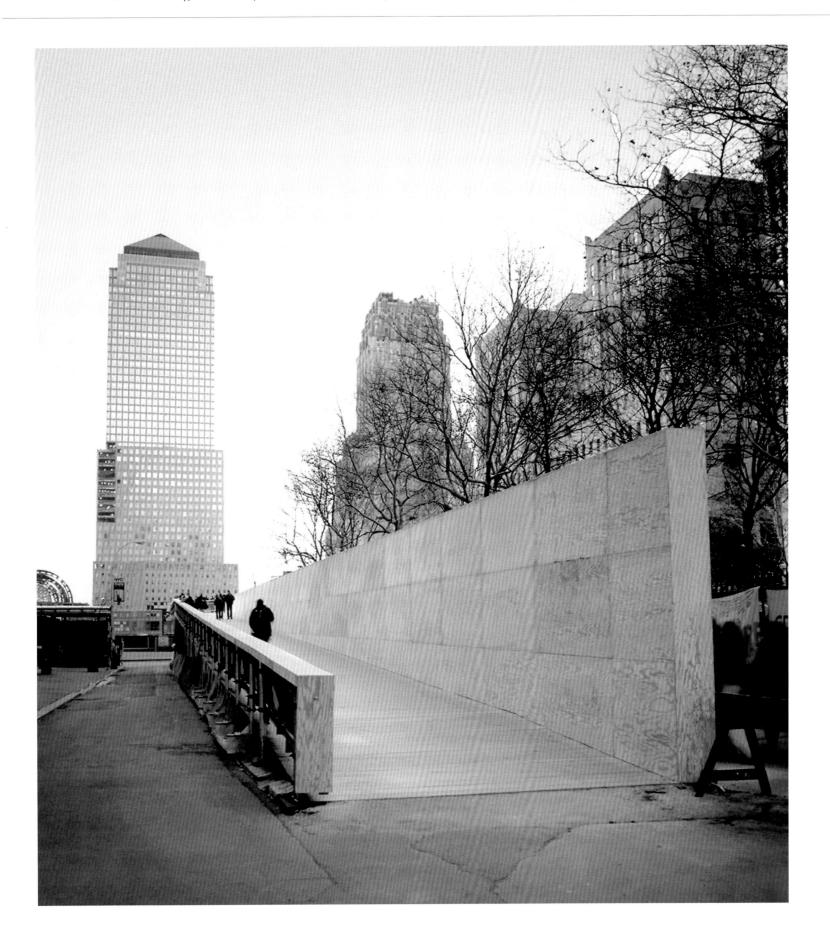

REFLECTING ABSENCE

Perhaps the most highly visible, deeply controversial, and argued–about memorial ever built, Michael Arad's Reflecting Absence marks the footprints of Manhattan's Twin Towers destroyed on September 11, 2001, with deep voids. Located on the 16–acre (6.5–hectare) World Trade Center (WTC) site, the memorial comprises two pools, measuring 176 feet (53.6 meters) on each side. Thundering waterfalls cascade 30 feet (9.1 meters) down into square basins, then drop another 20 feet (6.1 meters) into smaller abysses. The names of 2,983 people killed in both the 2001 and 1993 attacks are inscribed on canted bronze parapets that ring the edges of the pools. An area honoring those who are sick or died after 9/11 as a result of exposure to toxins, called Memorial Glade, opened in May 2019 and features a granite pathway arranged with six large stone mono–liths, each inlaid with WTC steel.

Within days of 9/11, an onslaught of power struggles began between architects, politicians, victims' families, and others, each wanting to determine the site's fate. The Lower Manhattan Development Corporation (LMDC) launched a design competition in April 2003, forming a thirteen–person jury that included Maya Lin, designer of the Vietnam Veterans Memorial (page 54) in Washington, D.C., and Paula Grant Berry, whose husband, David, had died on 9/11. The jury winnowed the 5,201 entries down to eight, ultimately picking Arad's design. Arad, then a young architect at the New York City Housing Authority, asked Peter Walker, a veteran designer based in Berkeley, California, to be his landscape partner. Hailing the resulting plan, the jury wrote that it "expresses both the incalculable loss of life and its consoling regeneration." Many people praised the design for its beauty and boldness; others thought it was bland and cold.

At once overwhelming, awe–inspiring, gutwrenching, sobering, and uplifting—and, like the process to build it, flawed and compromised—Arad's Reflecting Absence manages to capture a palpable sense of loss to profoundly poetic effect.

RIGHT THE MEMORIAL'S SOUTHERN POOL, FEATURING 30-FOOT (9.1 METER) WATERFALLS THAT DRAMATICALLY CASCADE INTO THE BASIN BELOW.

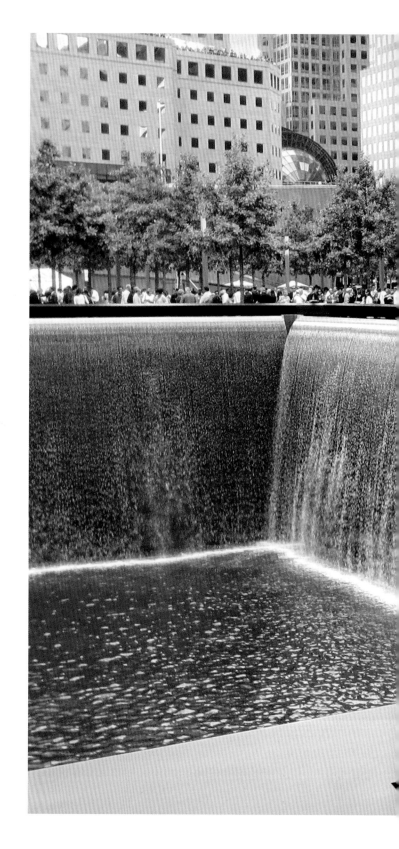

New York City, New York, USA. Michael Arad and Peter Walker (2014)

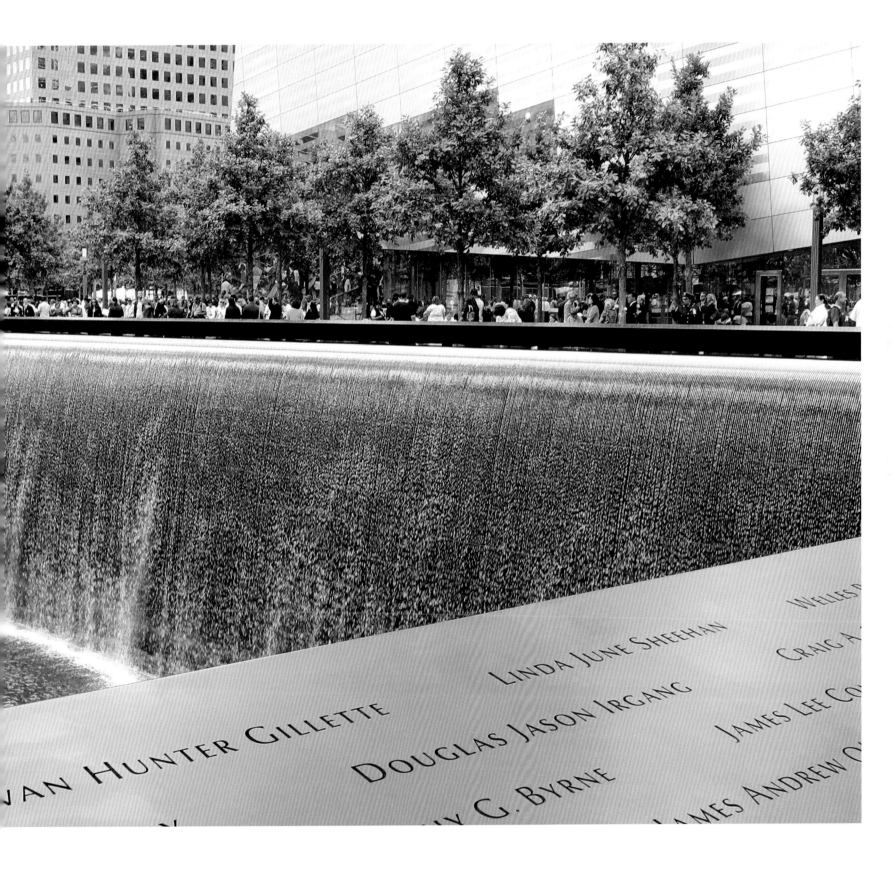

9/11 MEMORIAL AND MUSEUM

On the morning of September 11, 2001, architect Craig Dykers was aboard a plane that was about to land at Kennedy International Airport when, out of his window, he witnessed United Airlines Flight 175 crash into the South Tower of the World Trade Center. He describes that day as "abstract" and "surreal." Just three years later, Dykers's Oslo- and New York–based firm, Snøhetta, of which he is a founding partner, won the commissioned to design a cultural museum complex: the only above-grade building on the World Trade Center's memorial plaza.

At first, even Dykers's profound personal connection to the event itself didn't drive or sway him to take the job. But the memorial's initial program, which was to include two cultural organizations, the Drawing Center and a new institution—the International Freedom Center (IFC), intrigued him—and ultimately persuaded him to pursue the opportunity. Soon after Snøhetta signed on, though, the project got bungled, with various warring factions opposing the two institutions involved. Within a year, the Drawing Center pulled out and the IFC was scrapped.

By 2008, the building was resuscitated, this time with an entirely new proposal: a museum and memorial devoted to documenting the attacks, honoring those impacted, and presenting and preserving the related artifacts. A remnant of an early version of Daniel Libeskind's master plan, the angular, iceberg-like glass-and-steel building finally opened in 2014 following years of political sparring, arguments about financing, and various delays and inaction. Wedged on a tight sliver in between Michael Arad's Reflecting Absence memorial pools (see preceding page), also completed in 2014, and nearby Santiago Calatrava's Oculus transit hub, it includes the museum's visitor entrance, a 180-seat auditorium, a café, and private rooms reserved for victims' relatives. (It also houses air shafts from the neighboring PATH train station.) Acting as a bridge between inside and outside and above ground and below, the Snøhetta structure leads visitors downward into a 110,000-square-feet (10,200-square-meter) subterranean series of galleries designed by the firm Davis Brody Bond (DBB) with exhibition designs by Local Projects and Thinc.

At the entrance (which is also the exit), visitors pass two fork-shaped, 80-foot (24-meter) tridents, salvaged from the North Tower facade. Next they descend on a long, gently sloping ramp—dubbed "The Ribbon" by DBB—that guides them to the bedrock level. At about 40 feet (12 meters) below, they reach a balcony that overlooks a vast space housing the museum's centerpiece: the Last Column, the final slab of steel removed from the Ground Zero cleanup. Accenting the environment is the adjacent rough-hewn slurry wall, built with the original towers to retain the Hudson River.

Farther in, there's a quote by Virgil ("No day shall erase you from the memory of time") rendered in cast steel recovered from the original towers. At the end of the ramp are the remains of the Vesey Street stairs, which provided hundreds of workers a path of escape. At the base level, visitors face a repository where approximately 14,000 unidentified human remains have controversially been entombed, to the objection of many relatives (controlled by New York City's medical examiner, it's closed to the public; only family members have access).

In the emotionally charged galleries, more than 4,000 artifacts—including fire trucks, a torn seatbelt from one of the airplanes that hit the towers, photographs, a wedding band, drumsticks, ballet slippers, and even a Viking helmet—are displayed. A historical exhibition chronicles the attacks and the aftermath. A separate memorial exhibition honors the 2,977 killed on 9/11, as well as the six killed in the 1993 World Trade Center terrorist bombing. Throughout, there are specially made stands for dispensing tissues.

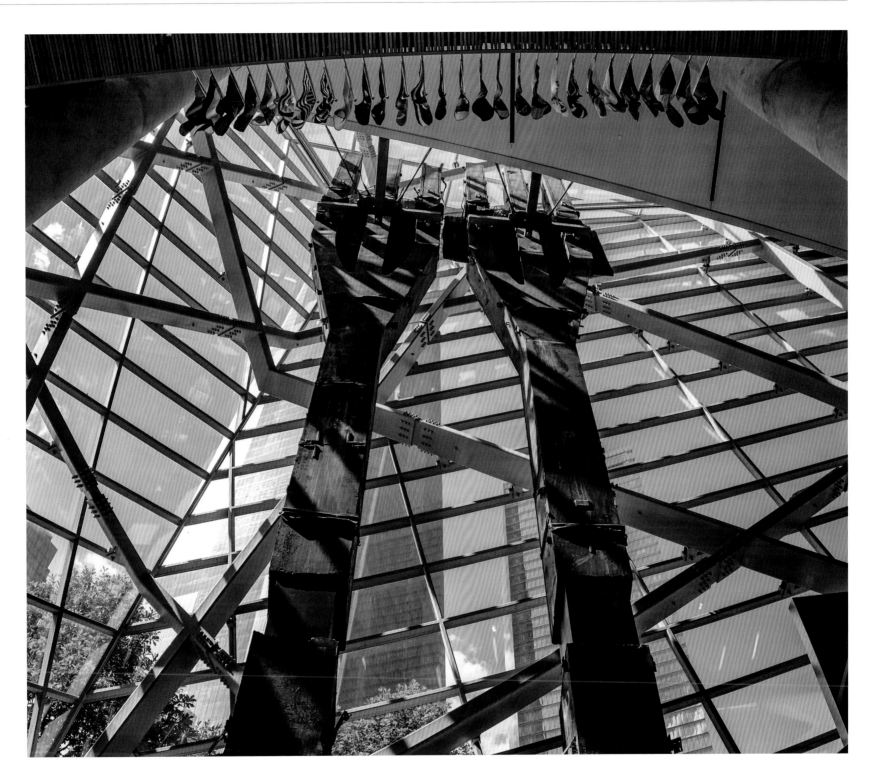

A quiet presence on a loaded site, the 9/11 Memorial and Museum sensitively bridges inside and out, above ground and below.

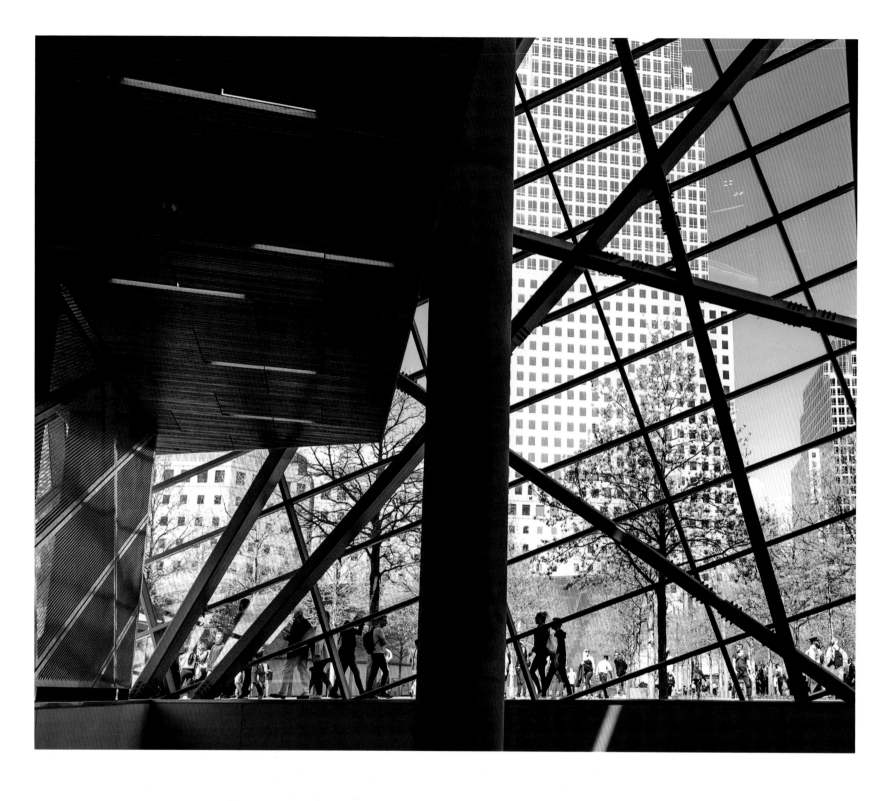

ABOVE SNØHETTA'S AIRY PAVILION
ENTRY LEADS VISITORS INTO GALLERIES
DESIGNED BY DAVIS BRODY BOND.

OPPOSITE ANOTHER VIEW OF
THE SALVAGED TRIDENTS IN THE
ENTRANCE—ONE OF THEM MARKED
"SAVE" IN WHITE SPRAY PAINT.

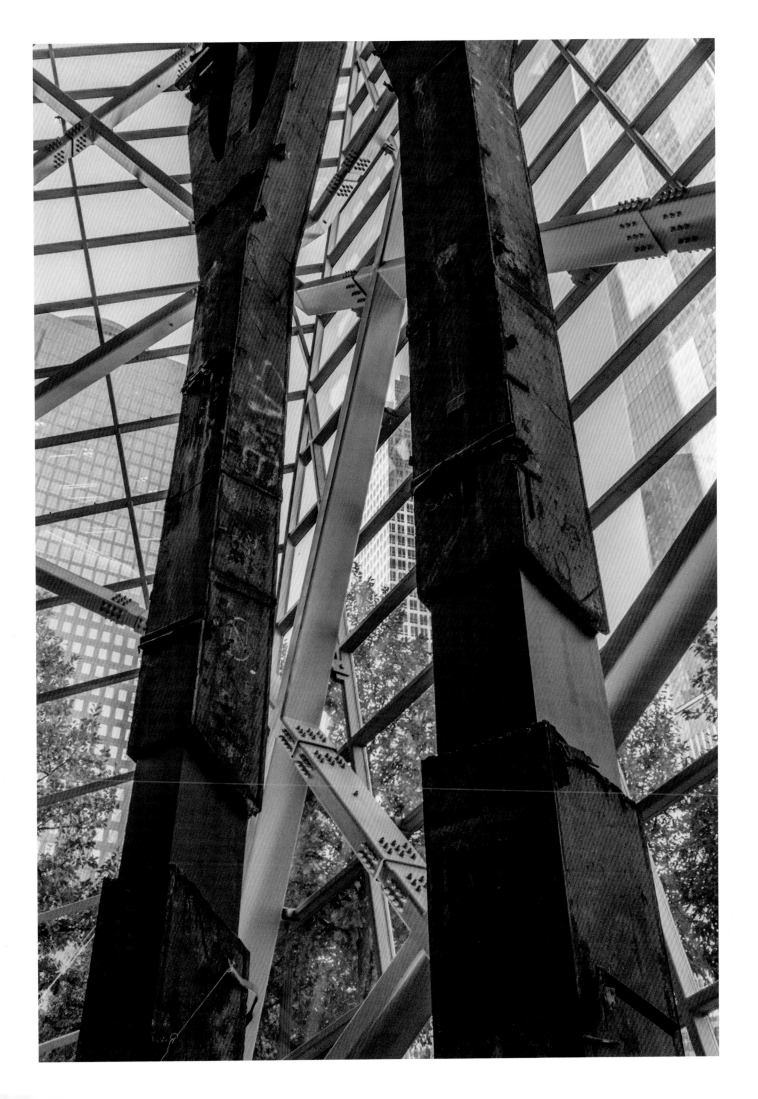

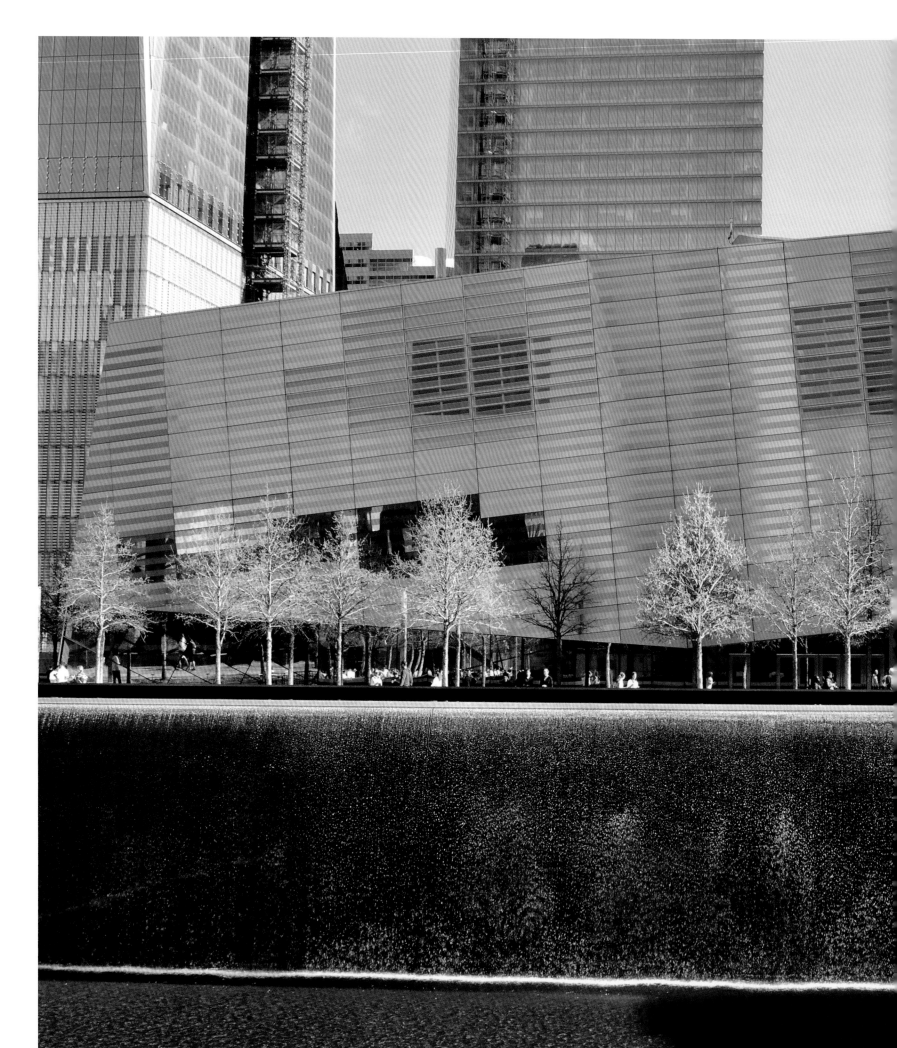

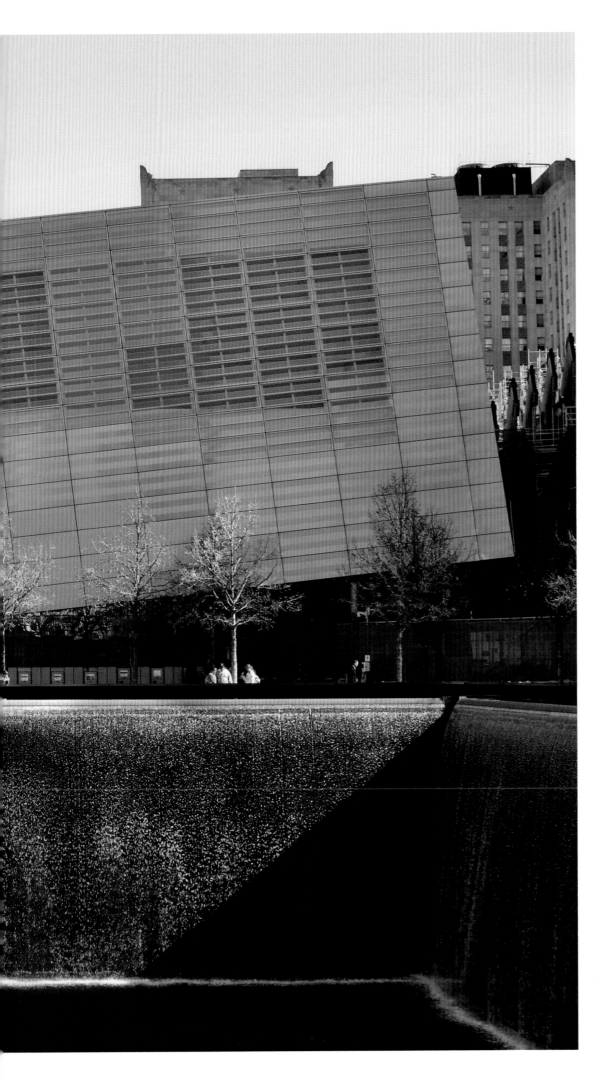

LEFT THE PAVILION'S JEWEL-LIKE FACADE CARRIES A QUIET, ALMOST UTILITARIAN PRESENCE ON THE SITE.

HOPE

STRENGTH

GRIEF

LOSS

FEAR

When created for mourning and commemoration, architecture can have incredible weight and power. Few buildings and structures are able to carry as much emotion and meaning as memorials. Through a combination of abstraction, materiality (often concrete or steel), light, and shadow, many memorials give form to deep sorrow. This built alchemy can provoke profound, unshakable grief, something I felt enormously throughout the writing of this book. The inescapable melancholy of certain memorials lingered in my body and mind for days or weeks.

Consider MASS Design Group's 2018 National Memorial for Peace and Justice (page 88) in Montgomery, Alabama, which honors the victims of lynching in the United States. After walking through it, I felt so grief-stricken by what I had seen that I had to sit down on a bench for thirty minutes to recover. It is not an exaggeration to say I was speechless. I can still conjure the heavyhearted feeling that washed over me as I walked along the memorial's 816 hanging CorTen-steel slabs, as well as their lined-up duplicates outside the pavilion. Without question, it was the most staggering visit to a memorial I've ever made.

On another affecting day, in Washington, D.C., over the course of eight hours, I walked through David Adjaye's 2016 Smithsonian National Museum of African American History and Culture (page 192) and then the United States Holocaust Memorial Museum, designed by James Freed of Pei Cobb Freed & Partners in 1992. On the Amtrak train back to New York that night, my sense of mourning was so intense that I questioned whether it had been a wise idea for my health to visit both in one day.

Sometimes, the sight of an everyday object—such as high school graduation tassels or a bow tie—is enough to instill a palpable sense of grief. For the Gun Violence Memorial Project (page 42), which was on view during the 2019 Chicago Architecture Biennial, MASS Design Group and the artist Hank Willis Thomas filled four glass-brick houses with items once belonging to gun-violence victims. Similarly, in the Gallery of Honor at Hans and Torrey Butzer's 2000 Oklahoma City National Memorial Museum (page 50), 168 shadow boxes are filled with personal effects of the dead. These simple displays speak volumes.

I've found that Holocaust memorials construct a particularly acute sense of grief—no doubt a result of the collective memory and mass death and trauma they reflect on. During a three-day trip to Berlin, I visited eight memorials, seven of them connected to the Holocaust, another emotionally draining experience. The Garden of Exile at Daniel Libeskind's 2001 Jewish Museum Berlin (page 224), composed of forty-nine concrete pillars, and Peter Eisenman's 2005 Memorial to the Murdered Jews of Europe (page 28), made of 2,711 concrete stelae, left me feeling disoriented, in awe of architecture's ability to evoke anguish.

Dedicated to the thirty-one British nationals who were killed in two terrorist attacks in Tunisia in 2015, the Sousse and Bardo Memorial in Birmingham's Cannon Hill Park serves as a symbol of continuity. *Infinite Wave*, designed by the architect George King, is composed of thirty-one twisting, turning steel-tube "streams," each representing a British national who died in the attacks—one on March 18 at the Bardo National Museum, the other on June 26 at the Imperial Marhaba Hotel at Port El Kantaoui, north of Sousse. The memorial, as if frozen in time, is inspired by the geometries of flowing water (it's worth noting that King, before establishing his firm in 2015, worked for Zaha Hadid Architects, famous for its fluid parametric designs). Rather than functioning as individual elements, each of the threads—no two tubes are identical—"flow" into each other, creating a wave-like arch, allowing visitors to walk in, around, and through it. Made in three sections by a metalwork fabricator in Lancashire, the complex construction features 250 pipes and 496 distinctive bends. At certain angles, the abstract design appears to resemble a pair of wings, the architect's way of suggesting a feeling of peace and hope.

Continuing the theme of water around the sculpture, the landscaping comprises 200 granite blocks that form concentric circles, with seventy different sizes of paving, establishing a ripple effect—a metaphor for the reverberations felt by the attacks and the impact they had on the survivors, the victims' families, local communities, the British nation, and the world. From above, the installation almost looks like an eye, with the sculpture as its pupil, the pavers its iris.

Nineteen design proposals were submitted to an independent jury, which chose seven finalists. Following consultation with family members connected to the attacks, *Infinite Wave* was chosen.

The Sousse and Bardo Memorial serves as a striking symbol of continuity—a metaphor for the reverberations felt by the 2015 Tunisia attacks.

OPPOSITE THE SHAPE OF *INFINITE WAVE*, COMPRISED OF 31 "STREAMS," IS INSPIRED BY THE GEOMETRIES OF FLOWING WATER.

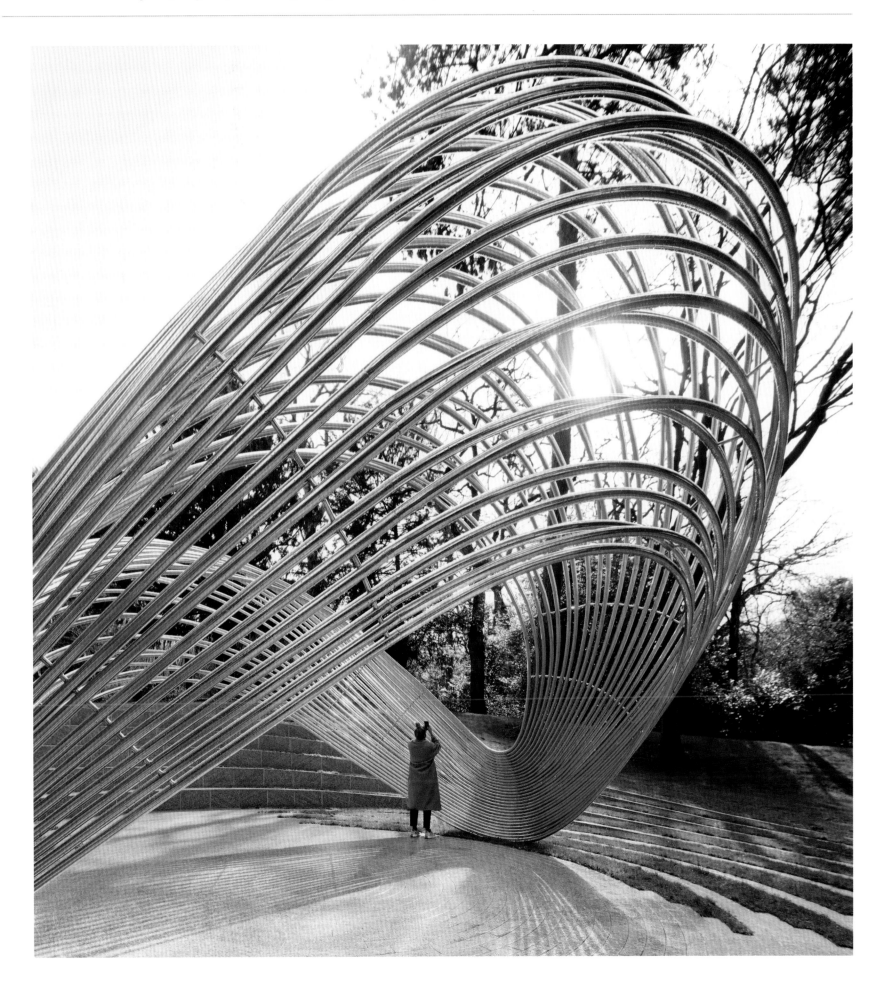

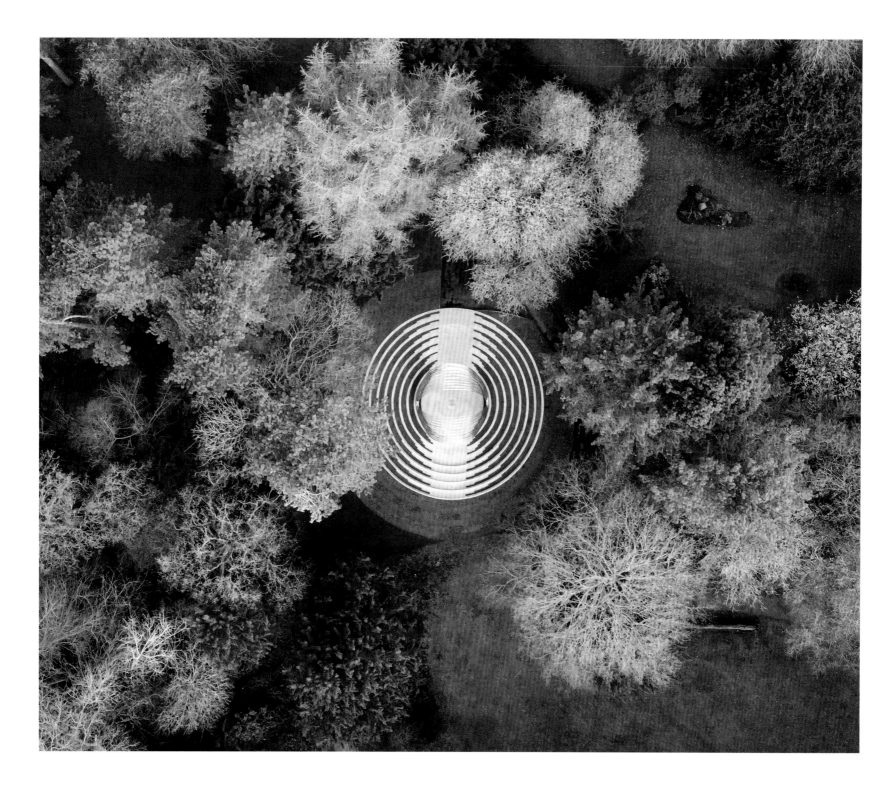

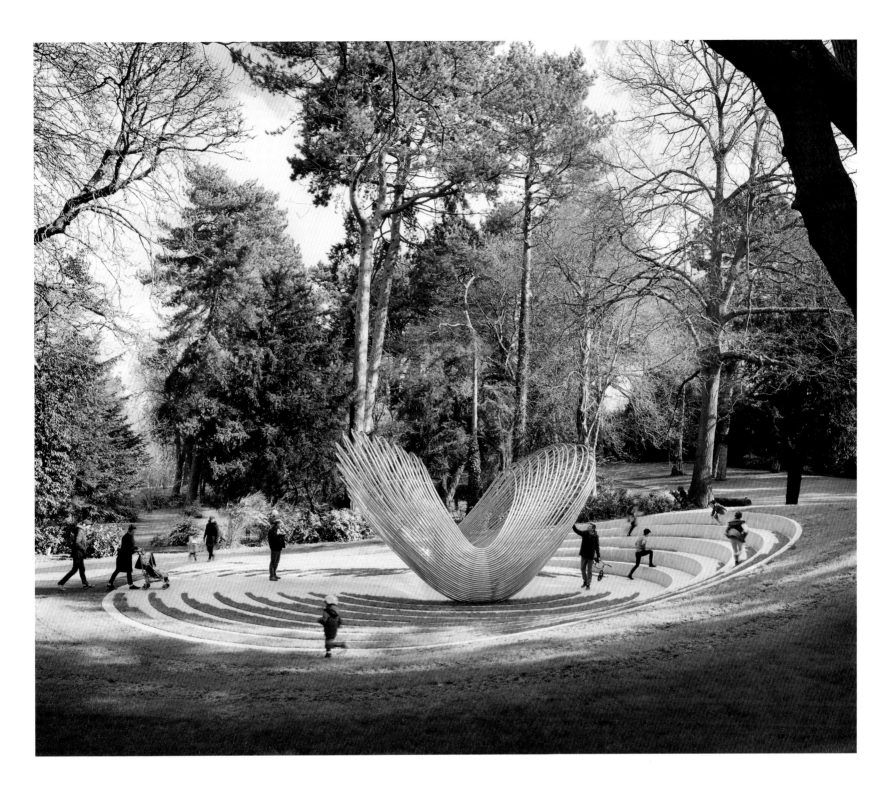

ABOVE FROM CERTAIN ANGLES, THE
MEMORIAL RESEMBLES A PAIR OF WINGS.

OPPOSITE AN AERIAL VIEW REVEALS
THAT THE PLAN IS A PURE CIRCULAR
FORM—A SYMBOL OF CONTINUITY.

SOUSSE AND BARDO MEMORIAL

NATIONAL VETERANS MEMORIAL AND MUSEUM

Part of a city–revitalization effort, the National Veterans Memorial and Museum (NVMM) was realized by the Columbus Downtown Development Corp. and initiated by Ohio's richest man, Leslie H. Wexner, the founder, chairman, and CEO of L Brands. In the early stages, Wexner engaged U.S. senator John Glenn, a Marine pilot and astronaut who, until his death in 2016, helped shape and steer the project's vision. Following an invited competition funded by Wexner, Brad Cloepfil of Allied Works Architecture was selected to design the memorial, which evolved from a local effort to a statewide one—and, ultimately, to gaining a national designation. It is the first memorial of its kind dedicated to U.S. veterans from all conflicts and all branches of the military.

Occupying a 7–acre (2.8–hectare) site that includes a 2.5–acre (1–hectare) memorial grove designed by the landscape firm Olin, the building forms an abstract, earthwork–like structure that's both lifted from and bound to the ground, and acts as a visual beacon along the banks of the Scioto River. Cloepfil himself describes the technologically advanced building—composed of intersecting, concentric bands of concrete, and constructed with eleven layers of reinforced steel—as a "textile," suggesting that, like the soldiers it honors, the architecture holds its ground through its inner strength. Comprising a "processional" ramp, galleries, and a rooftop "sanctuary" amphitheater, the 53,000–square-foot (4,900–square–meter) building follows a circling, light–filled path through exhibitions designed by Ralph Appelbaum Associates. The galleries feature fourteen interactive displays arranged thematically, including "A Nation Called," "Why We Serve," "In Combat," and "Service and Citizenship." Largely showcasing stories—many of them first–person—rather than artifacts, the memorial, in its directness, spareness, and simplicity, offers the necessary room for reflection, a sacred space to honor those who served and sacrificed for their country.

RIGHT SITUATED ON THE BANKS OF THE SCIOTO RIVER, THE MEMORIAL CUTS A BOLD FIGURE NEAR DOWNTOWN COLUMBUS.

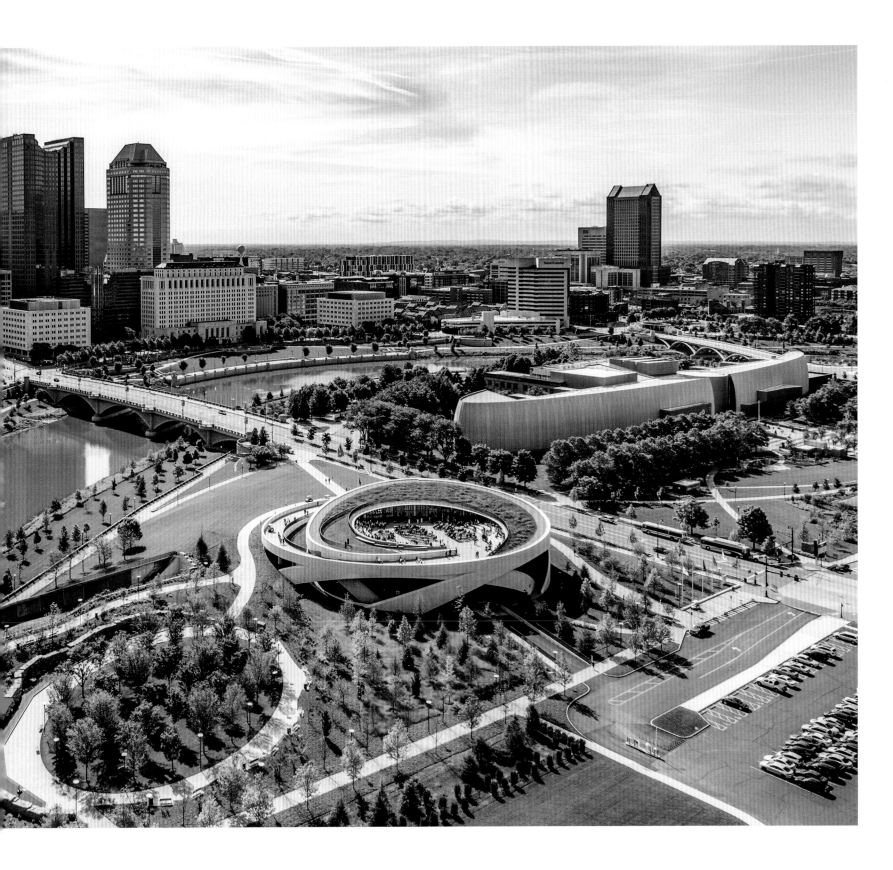

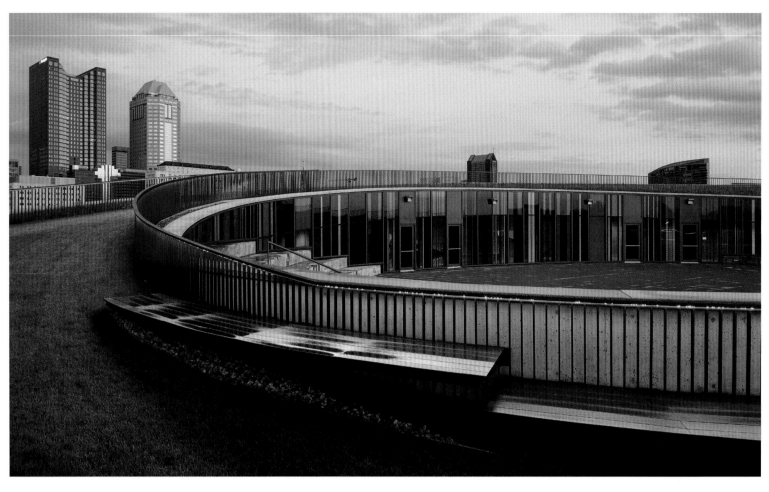

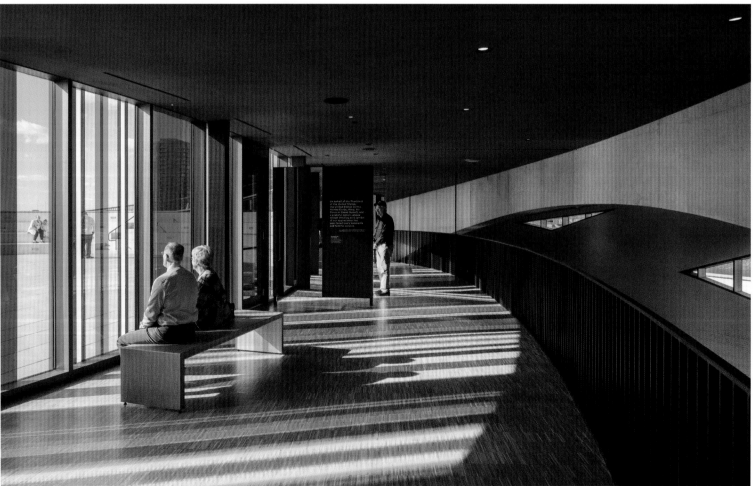

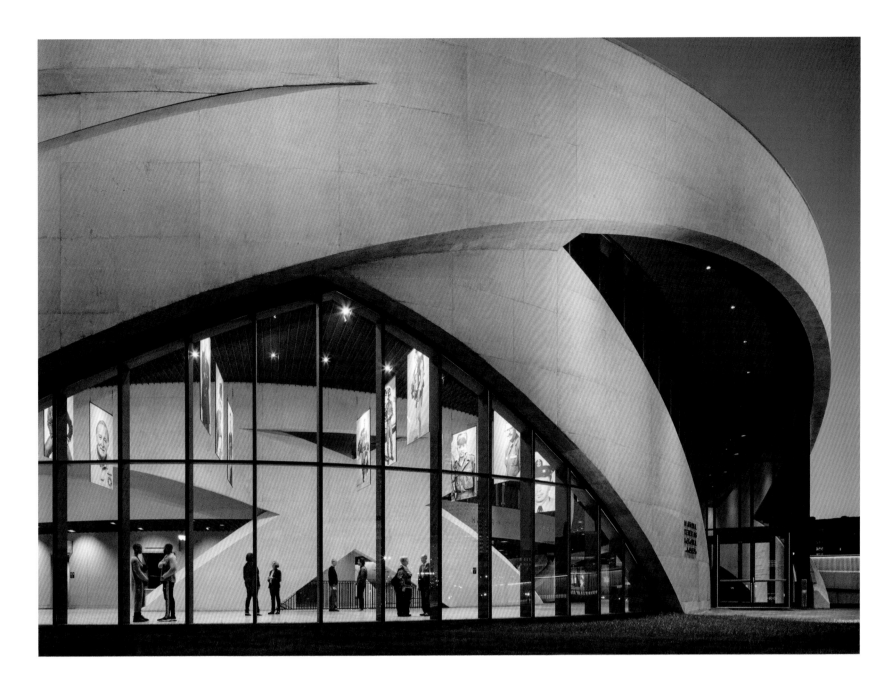

OPPOSITE (TOP) THE BUILDING INTE-
GRATES A CEREMONIAL LANDSCAPE
THAT CULMINATES IN A GRASS-ROOFED,
OPEN-AIR AMPHITHEATER.

OPPOSITE (BOTTOM) THE
"REMEMBRANCE GALLERY" INCLUDES
A FLOOR-TO-CEILING STAINED
GLASS INSTALLATION INSPIRED BY
MILITARY CAMPAIGN RIBBONS.

ABOVE THE STRUCTURE'S STRIKING
FORM IS COMPOSED OF INTERSECTING,
CONCENTRIC BANDS OF CONCRETE
AND LAYERS OF REINFORCED STEEL.

M9 MEMORIAL

The M9 Memorial (or Memorial for 9 Girls) commemorates a tragic 2005 bus crash that took place in Putre, Chile, a mountain village perched in a rugged northern region near the Peruvian and Bolivian borders. Thirty-six students from an all-girls Catholic school were onboard; nine of them died in the accident. The memorial is sited in Bicentennial Park in Santiago's affluent Vitacura neighborhood, with the nearby Manquehue Hill just beyond it, near where the girls and their families lived.

The number nine, a reference to the girls who died, is symbolized throughout. Completed in 2011, the Minimalist memorial comprises a 29.5-foot-(nine-meter) diameter cone with nine lights and nine identically sized "modules" distinguished around a ring. Planted in the center is a magnolia tree, the flowers of which often have nine petals. Made of concrete infused with titanium dioxide, the subterranean structure provides a "sacred place" of refuge, in the words of the

project's architect, Gonzalo Mardones, whose firm's office is located nearby (and who later designed the similarly elegant and geometric Cruzados Caballeros Memorial, completed in 2019 and honoring athletes of the Universidad Católica's sports club). Visitors enter the memorial, which is built into a grassy mound, down a gently sloping path paved with stones and sided with a tempered glass guardrail system that's embedded into the concrete. This leads them into the sunken central oratory, open to the elements through a roof aperture. A bench that lines the room's perimeter faces a statue of Virgin Mary, presented on a cantilevering plinth above a small field of plants. Inserted into the folds of the concrete are nine candles, again representing the dead, and twenty-seven smaller candles, distinguishing those who survived. Cut into a concrete wall, to the left of Mary's statue, is a cross of nine abstracted lines.

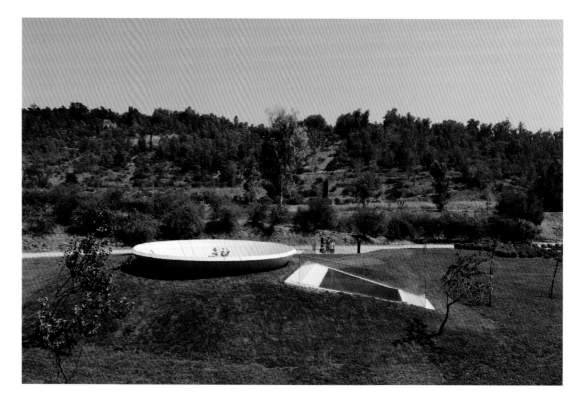

RIGHT LOCATED IN BICENTENNIAL PARK IN SANTIAGO, THE SUNKEN MEMORIAL IS BURIED INTO A GRASSY MOUND.

OPPOSITE THE MEMORIAL'S CENTRAL ORATORY, ITS ROOF OPEN TO THE ELEMENTS, FEATURES A STATUE OF VIRGIN MARY ON A PLINTH.

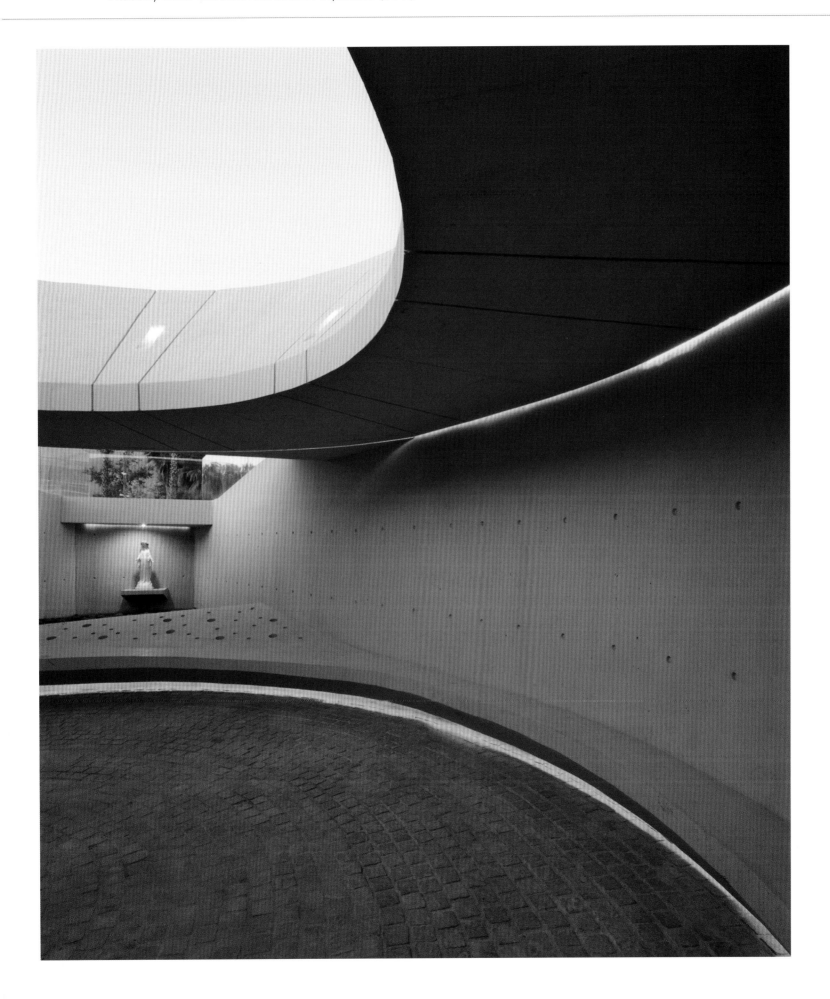

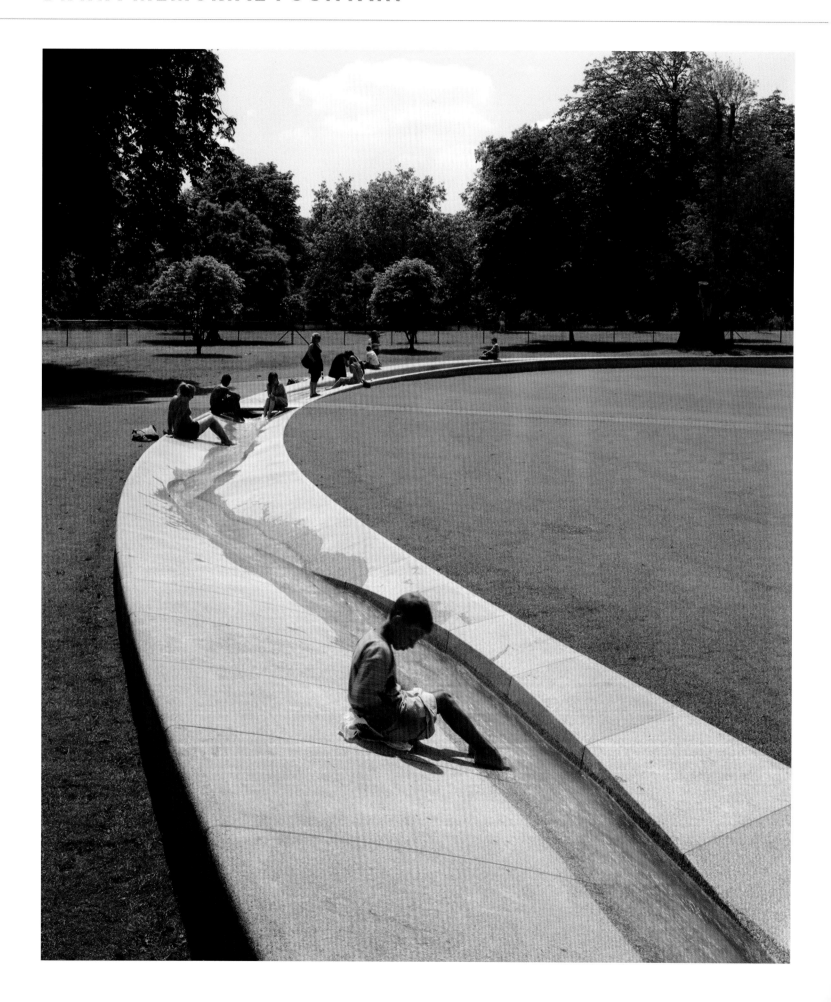

Installed just south of the Serpentine Galleries in London's Hyde Park, the Diana Memorial Fountain—honoring the Princess of Wales, who died in a car accident in Paris in 1997—has proven itself to be a gentle, calming tribute. This wasn't always necessarily the case for Kathryn Gustafson and Neil Porter's project. After opening in July 2004, the memorial hit its fair share of snags: due to drain-cloggage problems and public-safety issues (three people slipped and were hospitalized), it had to be closed twice in its first ten months. The critics came sniping, with one noting that the fountain was "an unsatisfactory mix of fey decoration and a layout that did not work." Elton John, a friend of the princess, likened the site to "a sewer." Time has shown the memorial to be something else: a strong and simple solution, if a slightly flawed one, for accommodating a complex life and legacy.

The winner of a much-contested, hotly debated competition, the oval-shaped fountain triumphed against a bold proposal by the artist Anish Kapoor and the architects Future Systems. Made of 545 finely crafted blocks of white Cornish granite, from the De Lank quarry, the project features a circulating water system with rippling effects that Gustafson's firm has termed as a "Chadar Cascade," a "Swoosh," a "Stepped Cascade," and a "Rock and Roll." The water at the basin slows to a stop, still and serene. Intended by Gustafson and Porter as a metaphor for the princess's inclusivity and accessibility—her "reaching out, letting in" affinity and ability—the 690-foot-long (210-meter-long) memorial has also been interpreted as a showcase of her joy and grief. Or, as *The Guardian*'s Jonathan Glancey put it, "the cycle of a princess's life, you see, with all its ups and its downs, and their ultimate draining away."

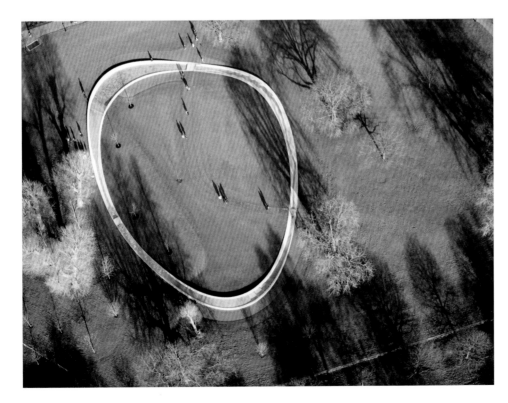

LEFT AN OVERHEAD VIEW OF THE OVAL-SHAPED MEMORIAL, WHICH OFFERS A CALMING SPACE OF CONTEMPLATION WITHIN HYDE PARK.

OPPOSITE VISITORS DIP THEIR FEET IN THE MEMORIAL'S CIRCULATING WATER SYSTEM WITH RIPPLING EFFECTS.

IRISH HUNGER MEMORIAL

Chosen out of thirteen finalists and 150 submitted portfolios, artist Brian Tolle selected 1100 Architect and landscape architect Gail Wittwer-Laird to collaborate with him on the design of the Irish Hunger Memorial. The team approached the project with a straightforward objective: to commemorate the Great Hunger of Ireland, which blighted the country from 1845—52.

Gracefully achieving that through a meditative landform, the resulting memorial—located in Lower Manhattan, just off the Hudson River and two blocks from the World Trade Center site—is built on a base of Kilkenny limestone and illuminated glass. Recreating a semblance of a windswept, rain-soaked quarter-acre (1,000-square-meter) hillside from nineteenth-century Ireland, it comprises walls made of stones from each of the country's thirty-two counties, abandoned potato fields, and indigenous grasses and wild-flowers. A reconstructed roofless famine-era County Mayo farmhouse adds to the decidedly bleak yet still beautiful scene—one that's loaded with meaning: the Gregory Clause passed by the British parliament in 1847 stated that plots exceeding a quarter-acre would not qualify for aid; without a roof, it became easier for farmers to declare destitution.

Dramatically cantilevering on a concrete slab and rising 25 feet (7 meters) high, the memorial was originally designed to offer views of Ellis Island, the Statue of Liberty, and New York Harbor. A ferry terminal that was later built nearby now inhibits that outlook slightly. Regardless, the topographical structure establishes a potent setting for reflection. Inscribed into the illuminated walls of the base are texts that recount the history of the Hunger, both acknowledging that highly politicized period while also positioning the event within the context of global hunger at large today. In *The New York Times*, critic Roberta Smith heralded the site, writing that it "could be New York City's equivalent of the Vietnam War Memorial."

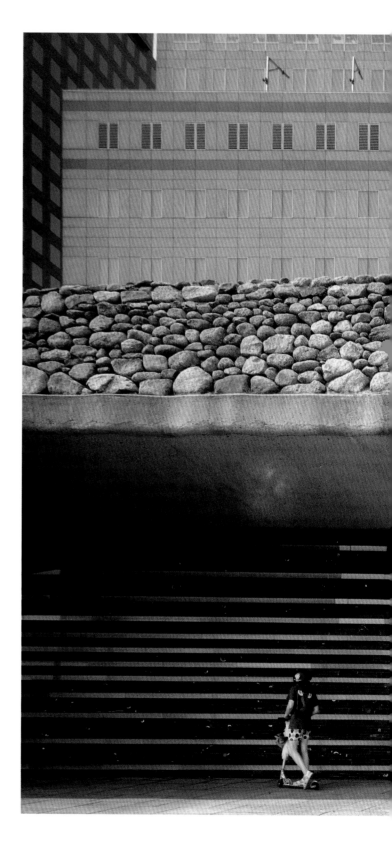

RIGHT THE MEMORIAL'S JUTTING CONCRETE CANTILEVER, WHICH LOOKS OUT OVER NEW YORK'S HUDSON RIVER.

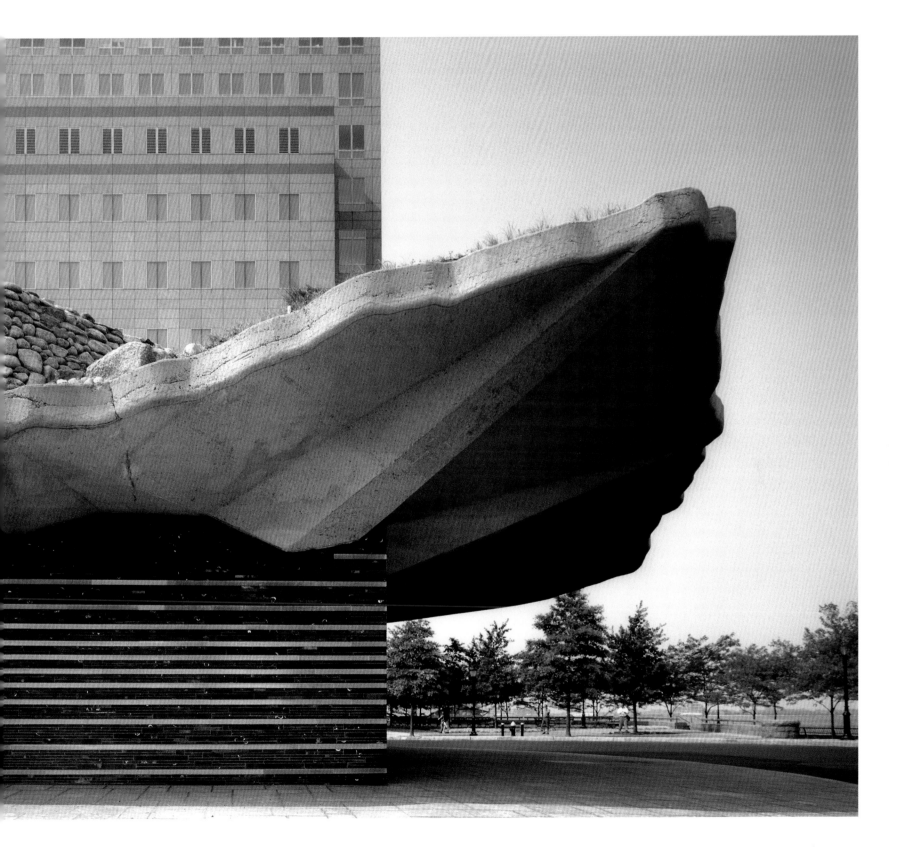

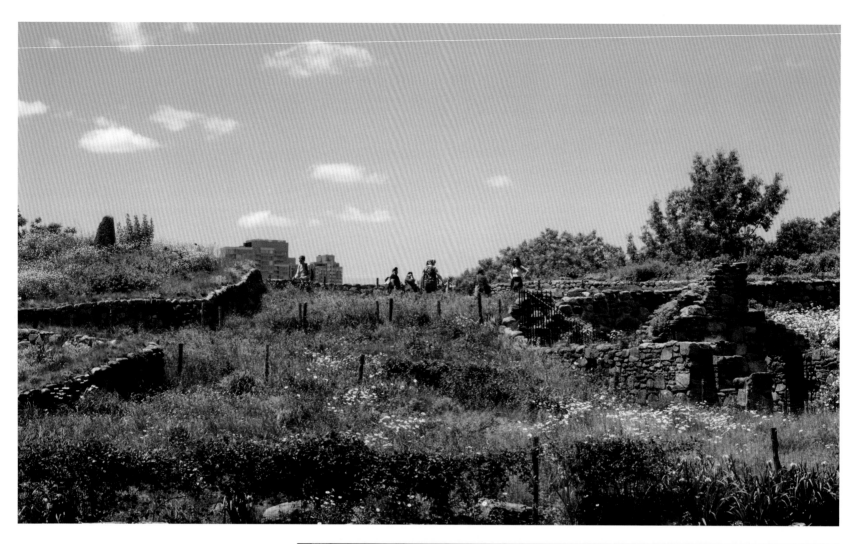

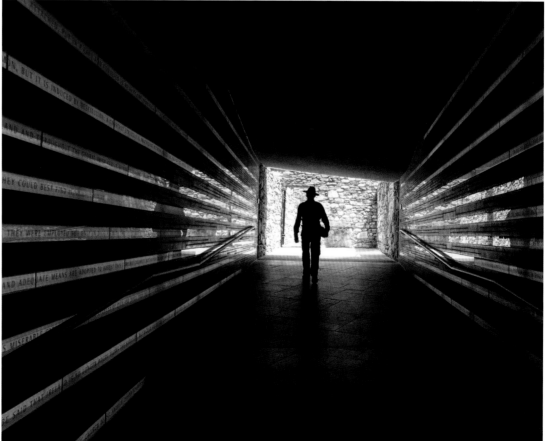

TOP A VIEW OF THE MEMORIAL, WHICH IS DESIGNED TO RESEMBLE A WINDSWEPT, IRISH HILLSIDE FROM THE NINETEENTH CENTURY.

BOTTOM THE ENTRANCE, MADE OF KILKENNY LIMESTONE AND ILLUMINATED GLASS, FEATURES TEXTS THAT RECOUNT THE HISTORY OF THE HUNGER.

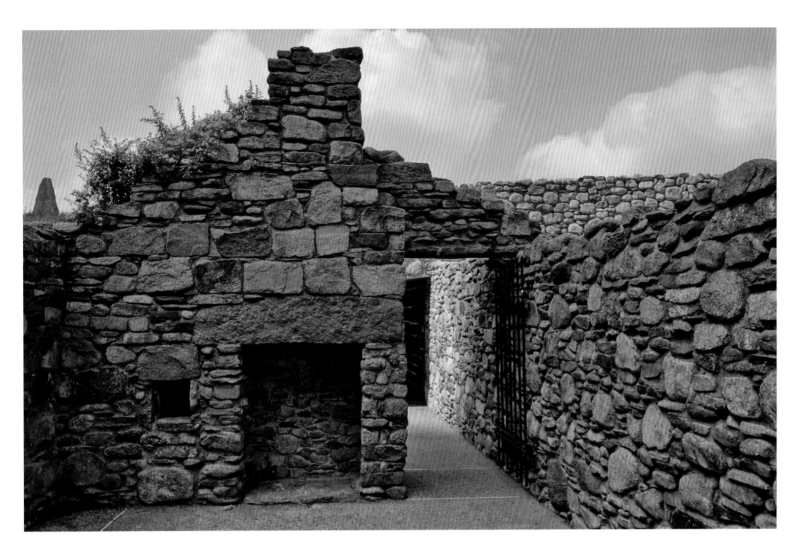

The topographical structure of the Irish Hunger Memorial establishes a transportative, artfully constructed setting for reflection.

ABOVE A VIEW TOWARD THE ENTRANCE, WITH WALLS MADE OF STONES FROM EACH OF IRELAND'S THIRTY-TWO COUNTIES.

NATIONAL HOLOCAUST MONUMENT

Emblematically located across from the Canadian War Museum and near Parliament Hill, Ottawa's National Holocaust Monument establishes a somber and haunting space of meditation. Comprising six concrete triangles, its design is meant to reference both the yellow Star of David that Jews were forced to wear during the Holocaust, as well as the triangular identification badges required to be displayed by gays and lesbians, Sinti and Roma, Jehovah's Witnesses, and other victims persecuted and murdered by the Nazis. As with the Garden of Exile at Libeskind's 2001 Jewish Museum Berlin (page 224), the site combines cast-in-place, exposed concrete with the surrounding landscape to powerful effect.

Libeskind's Ottawa memorial stands out in particular for is its unusual integration of large-scale photography: contemporary landscapes of former Holocaust sites, including concentration camps and killing fields, captured by Canadian artist Edward Burtynsky, who traveled thousands of miles through Europe in 2015 searching for sights to reproduce. When combined with Libeskind's angular architecture, Burtynsky's expressive pictures—painted onto the canted walls in arresting detail—create a potent and unexpected level of depth, evoking a dark, heavy feeling of terror. Surrounding the structure is a landscape of trees and pebbles.

When the memorial opened in the fall of 2017, there was an immediate uproar over a glaring omission—no mention of the Jews. A plaque on the site, placed by the Canadian government, noted that the memorial was a tribute to "millions of men, women, and children murdered during the Holocaust." Politicians, the Israeli news media, and others seized on it, and the plaque was swiftly taken down. A new text was affixed several months later, matter-of-factly stating that the memorial "commemorates the six million Jewish men, women, and children murdered during the Holocaust and the millions of other victims of Nazi Germany and its collaborators."

RIGHT LOCATED NEAR OTTAWA'S PARLIAMENT HILL, THE MEMORIAL STANDS OUT AS A SOMBER SITE OF MEDITATION.

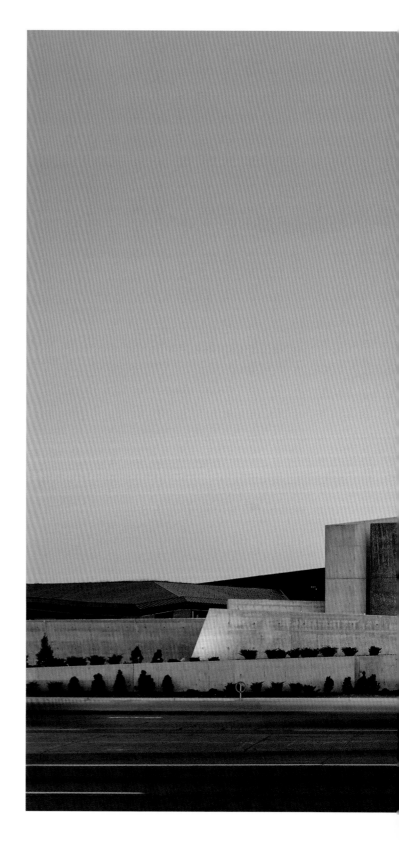

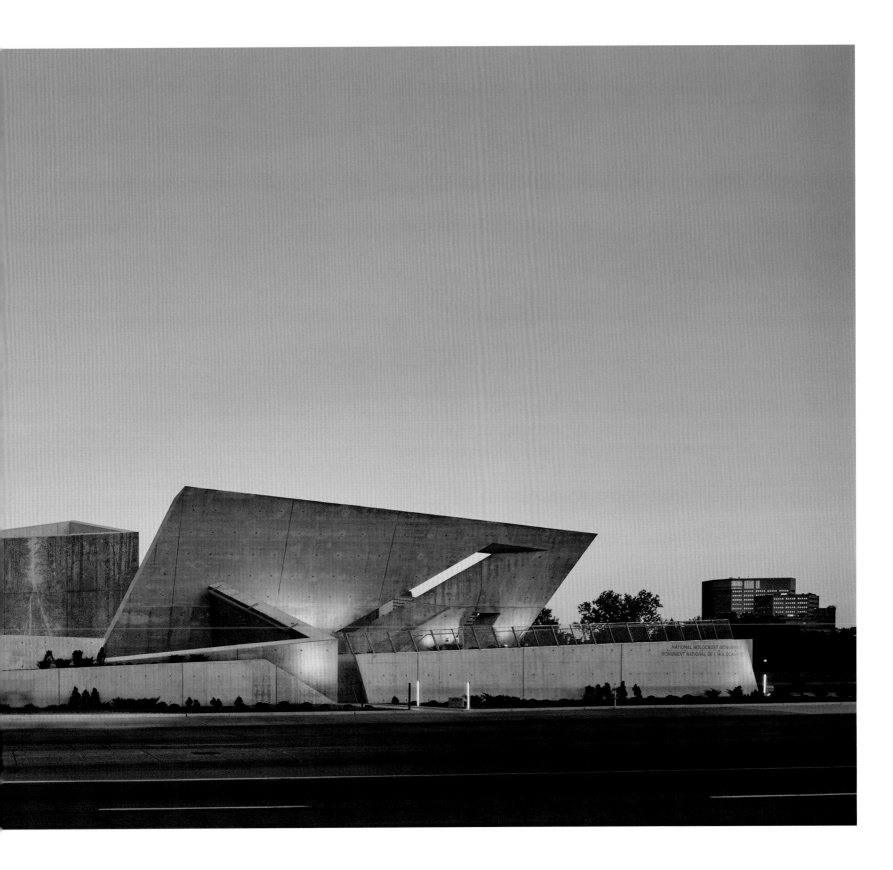

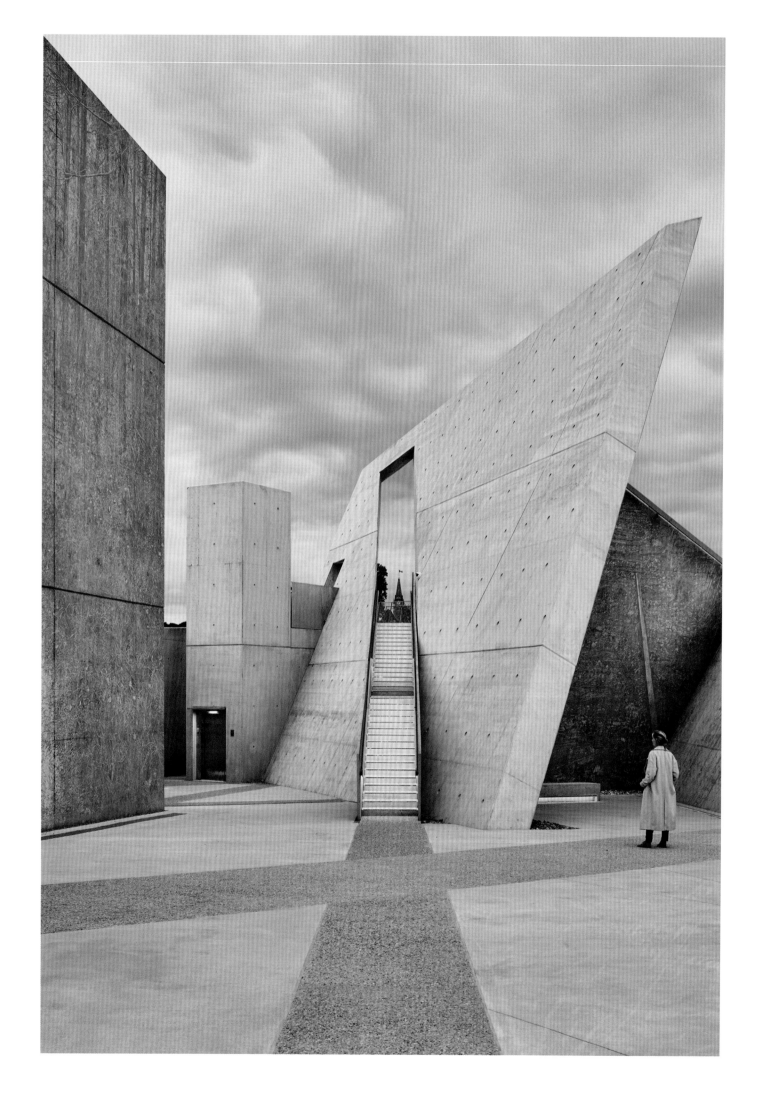

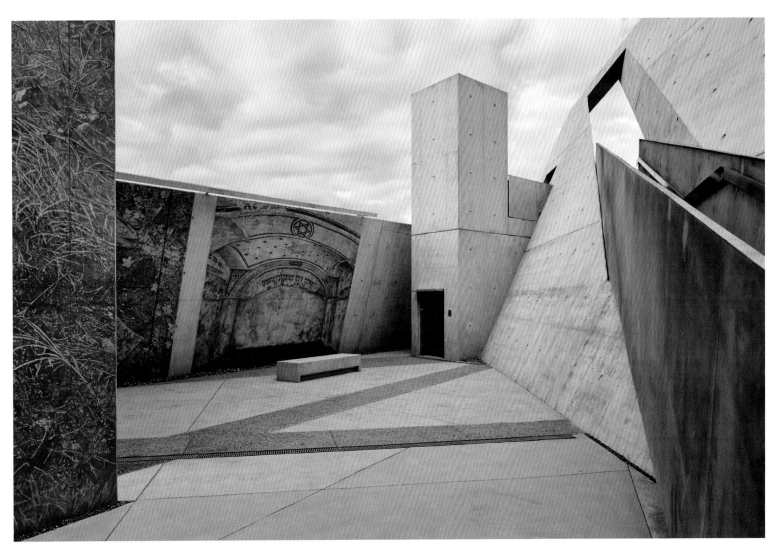

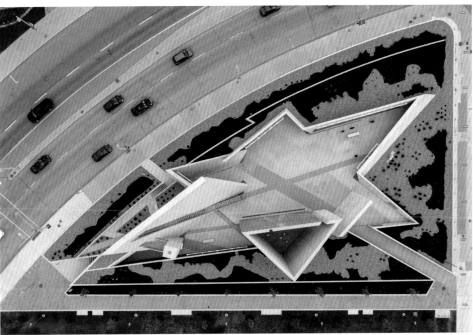

TOP MANY OF THE MEMORIAL'S INTERIOR WALLS FEATURE HAUNTING PICTURES OF FORMER HOLOCAUST SITES BY EDWARD BURTYNSKY.

BOTTOM THE MEMORIAL, SEEN HERE FROM ABOVE, COMPRISES SIX CONCRETE TRIANGLES—A REFERENCE TO THE STAR OF DAVID.

OPPOSITE COMPOSED OF CAST-IN-PLACE, EXPOSED CONCRETE, THE MEMORIAL ESTABLISHES A PROFOUND SENSE OF HEAVINESS AND LOSS.

STEILNESET MEMORIAL

Built on the barren, rugged landscape of Vardø, Norway, Swiss architect Peter Zumthor's Steilneset Memorial, a collaboration with artist Louise Bourgeois, broods along the coast of the Barents Sea. Remembering the ninety-one people in the town who, from 1600 to 1692, were convicted of witchcraft and burned at the stake, the main structure features ninety-one porthole windows, each representing a victim and including a single bulb. Accompanying each window are pieces of silk with texts by historian Liv Helene Willumsen, author of the book *The Witchcraft Trials in Finnmark Northern Norway*, listing the date of birth, the date of burning, and the charges, confession, and verdict; most of the victims were women, some of them indigenous Sámi people. Wrapped in a sailcloth-like fiberglass canvas coated with Teflon, and supported by a pine framework, the somber, oak-floored 400-foot (125-meter) memorial is, as Zumthor has put it, "a floating passageway of fabric;" tethered to the stark landscape, it moves with the wind, its light bulbs eerily swaying, almost as if aboard a ship.

A second building, a Zumthor-designed cube of seventeen mirrored freestanding black glass panels, memorializes the burning itself. Inside it is *The Damned, The Possessed, and The Beloved*, a work by Bourgeois comprising five jets of fire burning atop a chair— her last major installation before her death, at age ninety-eight, in 2010. The interior also includes seven large mirrors that reflect and distort the flames, adding emotional gravitas.

The project began when Bourgeois and Zumthor were commissioned in 2007 by Svein Ronning of Norway's National Tourist Routes program, a series of eighteen highways featuring interventions by architects like Snøhetta, Reiulf Ramstad, and Todd Saunders. Through a slow process of collaboration across continents (with Bourgeois faxing a sketch of her specifications to Zumthor), the two eventually came to this abstract, profoundly moving result.

RIGHT SITUATED ALONG THE COAST OF THE BARENTS SEA, THE MEMORIAL'S MAIN STRUCTURE FEATURES NINETY-ONE PORTHOLE WINDOWS REPRESENTING THE VICTIMS.

Vardø, Norway. Peter Zumthor and Louise Bourgeois (2011)

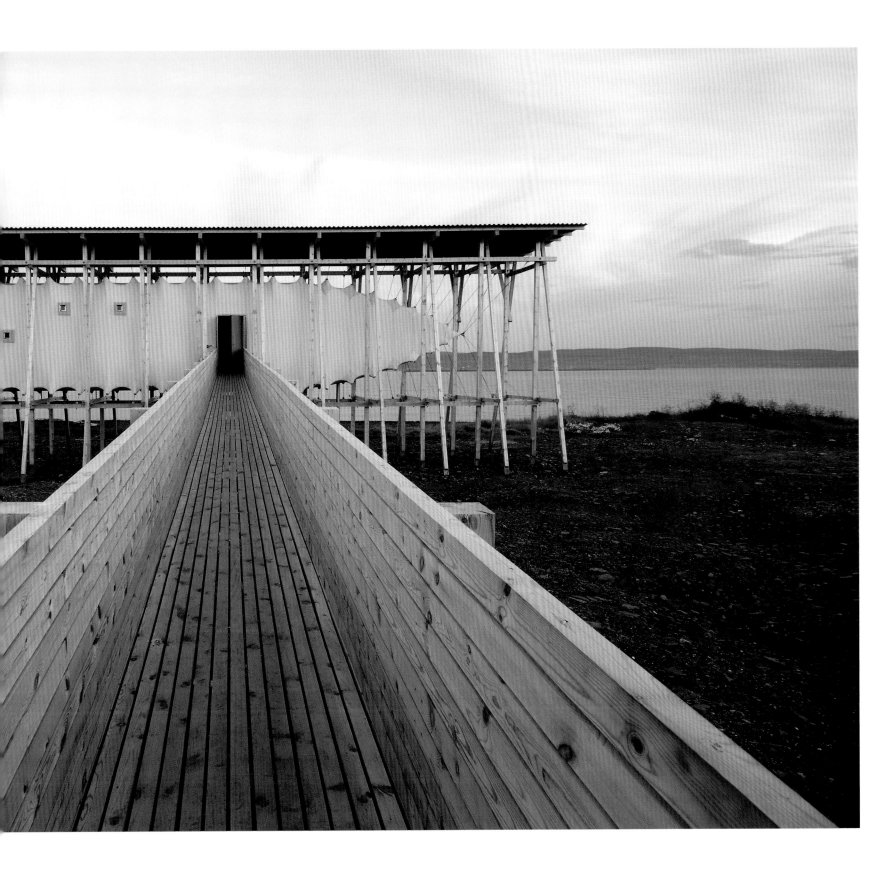

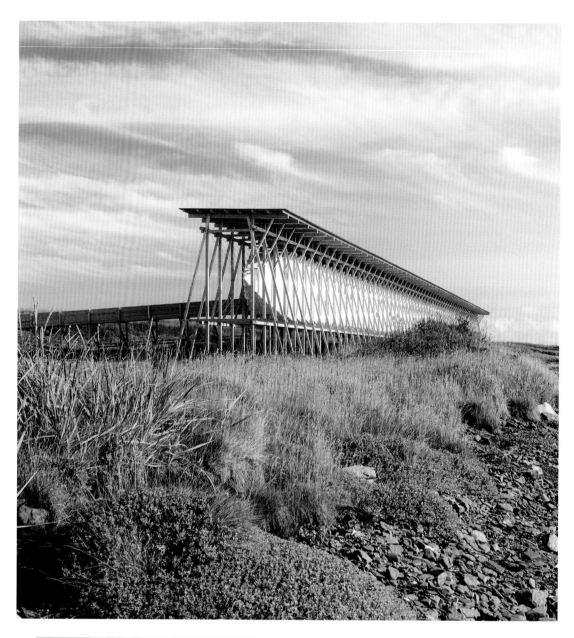

TOP THE MEMORIAL IS WRAPPED IN A
SAILCLOTH-LIKE FIBERGLASS CANVAS
COATED WITH TEFLON AND SUPPORTED
BY A PINE FRAMEWORK.

BOTTOM *THE DAMNED, THE POSSESSED,
AND THE BELOVED* (2010), A WORK BY
LOUISE BOURGEOIS COMPRISING FIVE
JETS OF FIRE BURNING ATOP A CHAIR.

OPPOSITE BESIDE THE MAIN STRUCTURE
IS A CUBE OF SEVENTEEN MIRRORED
FREE-STANDING BLACK GLASS PANELS;
THE BOURGEOIS INSTALLATION IS INSIDE.

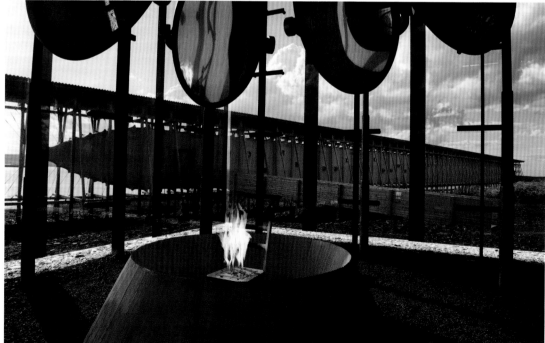

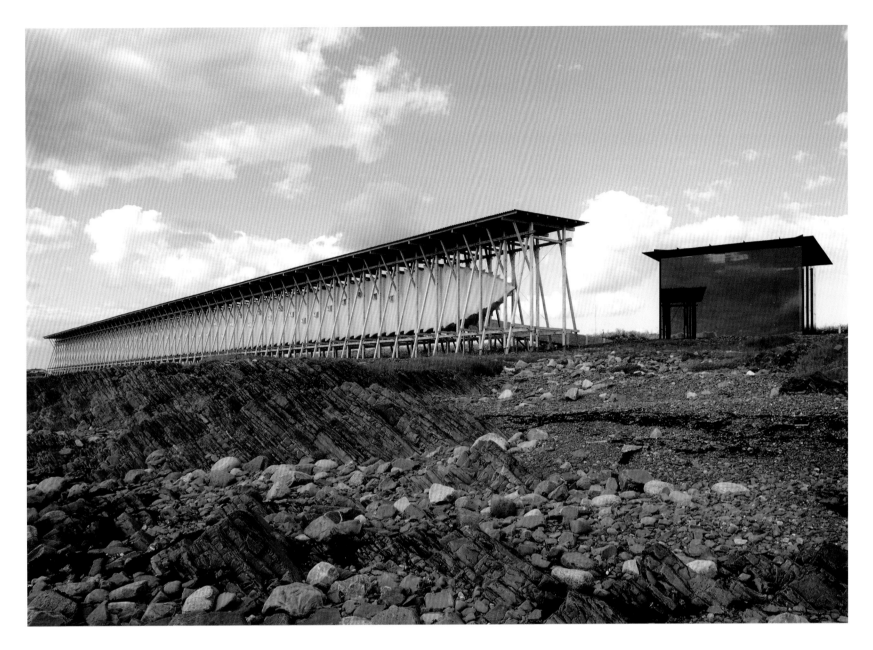

Tethered to the stark landscape of Vardø, Norway, Peter Zumthor's Steilneset Memorial eerily broods along the coast of the Barents Sea.

TOPOGRAPHY OF TERROR

Located on the site that was once home to the Nazis' Gestapo and SS headquarters in the Kreuzberg district of Berlin, the Topography of Terror museum recounts the history of the center-of-evil axis on which it sits. Rife with tension from the start, the project became a frustratingly long, bungled, drawn-out process before it was finally built. Dating back to 1992 and originally designed by Swiss architect Peter Zumthor (who had won the bid in an open competition), the plan was to build the city's third memorial dedicated to remembering the Nazis' atrocities, following Daniel Libeskind's 2001 Jewish Museum Berlin (page 224) and, scheduled to finish a few years later, Peter Eisenman's 2005 Holocaust memorial (page 28).

Zumthor's Topography of Terror building started construction in 1997, but just two years later it had ground to a halt. By 2004, due to various delays and rising costs, the project was scrapped altogether and its foundation razed. In 2005, a new competition, also government-funded, was announced. Out of 309 entries and from a shortlist of thirteen finalists, Ursula Wilms (of Heinle, Wischer, and Partners) and landscape architect Heinz W. Hallmann were chosen. (The same team would go on to design the 2014 Memorial for the Victims of National Socialist "Euthanasia" Killings, also in Berlin; see page 214.)

Wilms's and Hallmann's project, an indoor-outdoor scheme completed in 2010, is a spare, Minimalist affair that pairs a square squat building clad in two layers of metal mesh—in stark contrast to the neighboring Neo-Classical Walter Gropius building—with a notably sanitized landscape. Indoors are exhibition halls, a library, offices, and seminar rooms; outdoors, a "trench" exhibition space featuring exposed wall remnants runs along Niederkirchnerstrasse. Overall, the spare aesthetic has a chilling effect, not unlike visiting a concentration camp. Which is exactly the point: the architecture gets out of the way and allows the permanent exhibitions to serve their harrowing function without distraction.

RIGHT THE CENTER'S SPARE, MINIMALIST AESTHETIC STANDS OUT NEXT TO THE NEIGHBORING NEO-CLASSICAL ARCHITECTURE.

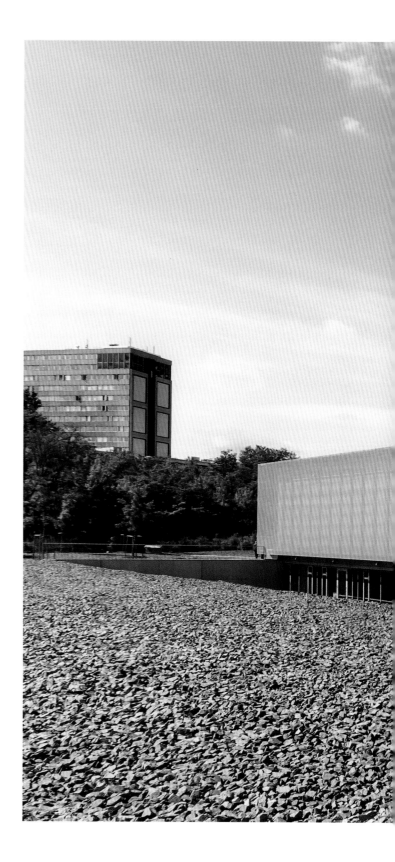

Berlin, Germany. Ursula Wilms and Heinz W. Hallmann (2010)

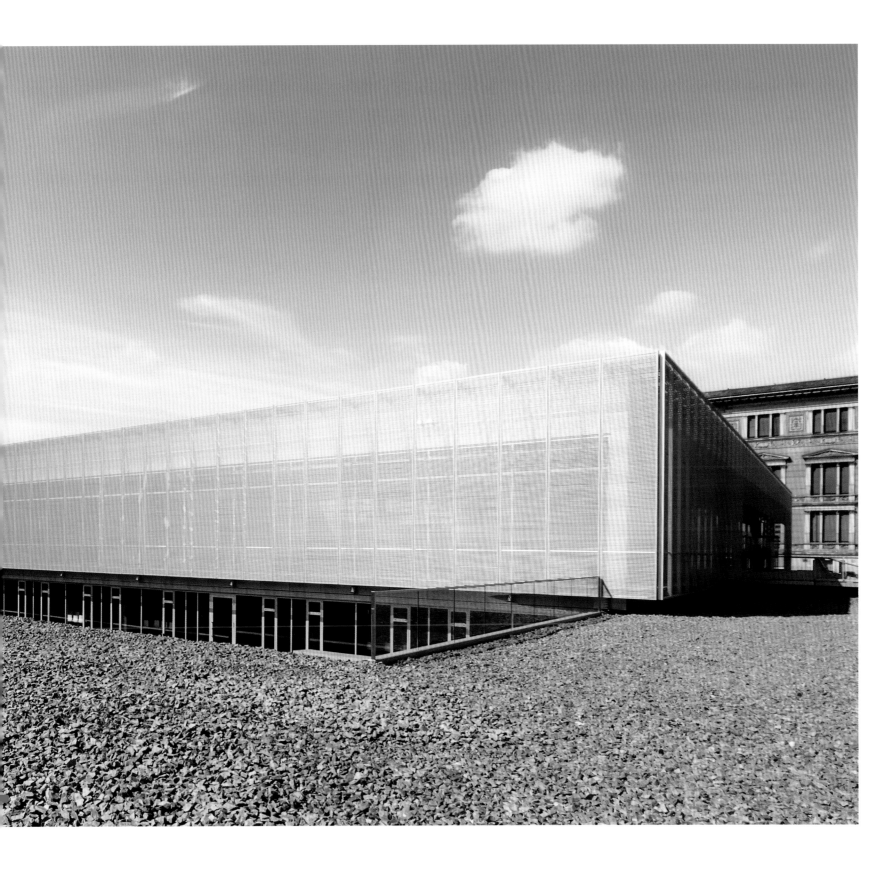

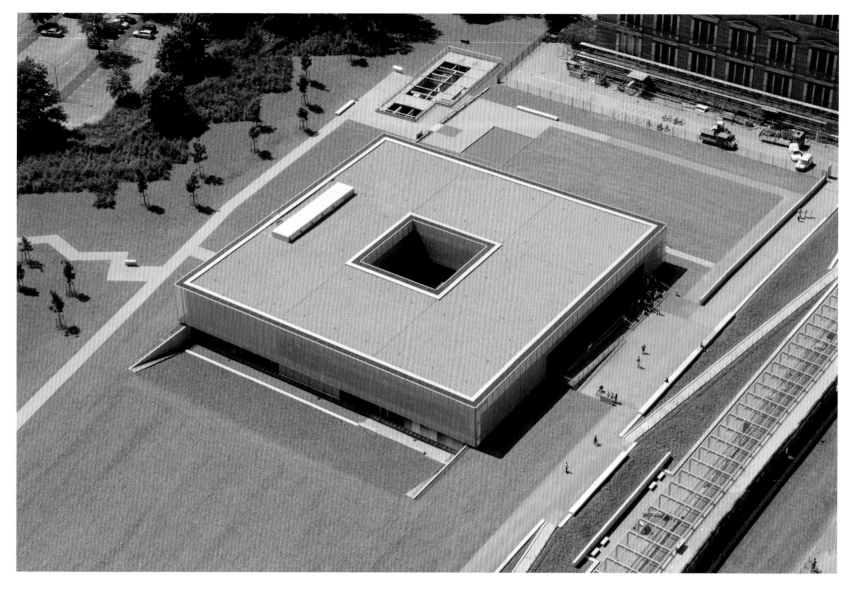

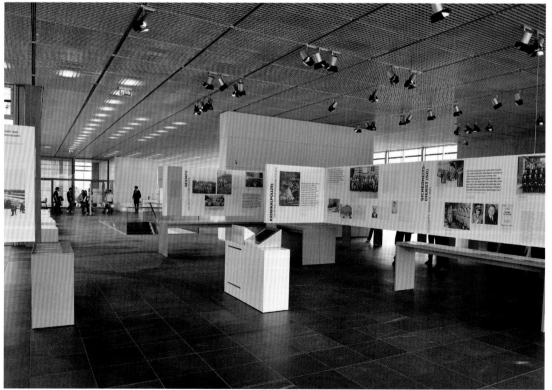

TOP THE SPARE SETTING LACKS VEGETATION—A CLEANSING OF LIFE FROM A SITE THAT WAS ONCE HOME TO THE NAZIS' SECRET POLICE HEADQUARTERS.

BOTTOM THE PERMANENT EXHIBITION SPACE DETAILS HOW THE NAZIS PLANNED THEIR ATROCITIES.

OPPOSITE THE "TRENCH" EXHIBITION SPACE FEATURES EXPOSED WALL REMNANTS THAT RUN ALONG NIEDERKIRCHNERSTRASSE.

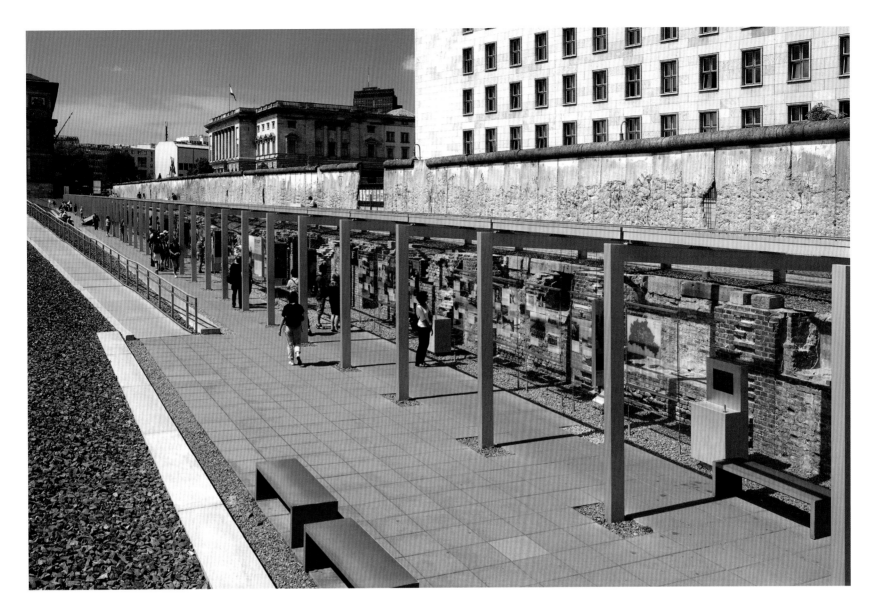

The notably sanitized landscape of Topography of Terror has a chilling effect, not unlike visiting a concentration camp.

FLIGHT 93 NATIONAL MEMORIAL

When New York's World Trade Center site announced its memorial competition in 2003, Los Angeles—based architect Paul Murdoch scrambled a submission together. Though his firm didn't win, the proposal would prepare him for submitting—in January 2005, along with around 1,100 other firms—an entry to the competition for the Flight 93 National Memorial in Shanksville, Pennsylvania. The memorial would be located at the site where the United Airlines plane crashed on September 11, 2001, taking the lives of its forty passengers and crew. This time, Murdoch's studio's scheme would rise to the top.

A collaboration with landscape architecture studio Nelson Byrd Woltz, the design establishes a sensitive synthesis of landscape and architecture, transforming the place into an interpretive setting for healing. Built in three stages, the memorial opened on the tenth anniversary of 9/11, with a plaza that's located along the edge of the elegantly reshaped crash site (or Sacred Ground). A bowl-shaped landform (or Field of Honor) features a wall of the victims' names. A second phase, completed in 2015, introduced a visitor center, as well as a meandering walkway that connects to the crash site. The final phase, dedicated in 2018 and completed in 2020, is the 93-foot-tall (28-meter-tall) Tower of Voices, a musical instrument that holds forty polished-aluminum wind chimes, each meant to represent a different tone or "voice."

Hemlocks—acknowledging the long-existing hemlock grove at the site—serve as a subtle motif. Using recycled timbers from 150-year-old Pennsylvania barns, form liners were made to create the textured, hand-hewn concrete walls, a reference both to the neighboring trees and the region's barn vernacular. Elsewhere—in, for example, the blackened concrete overlook—aeronautical references, both in material and form, can be found. The resulting memorial at once looks inwards and outwards, backwards and forwards: a beacon for both remembering and moving on.

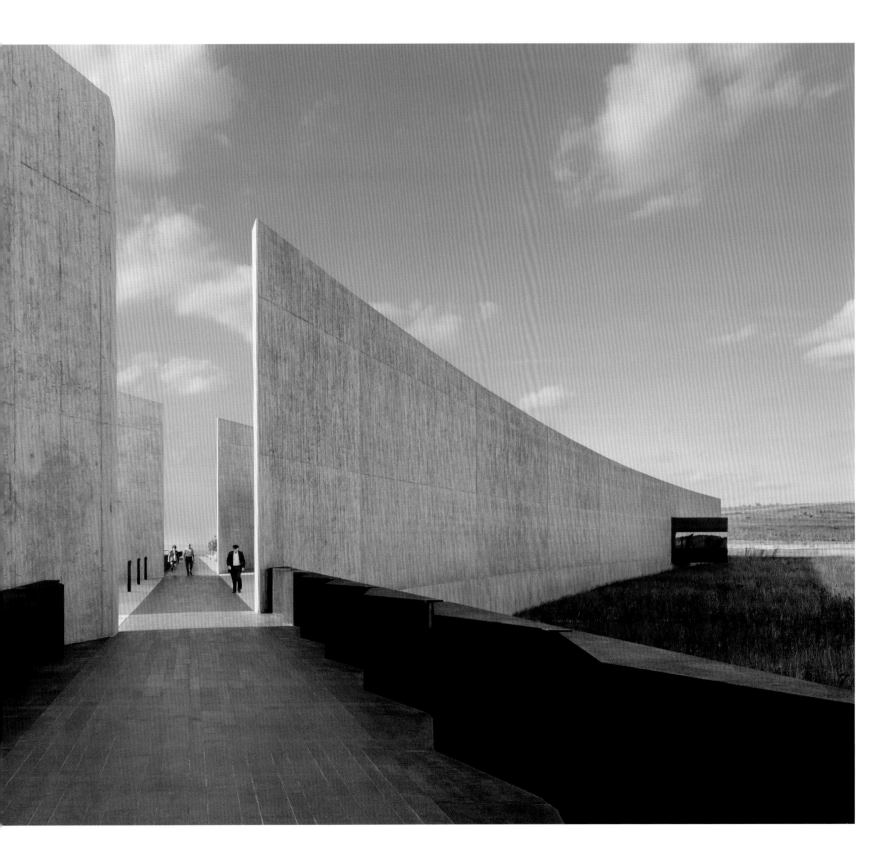

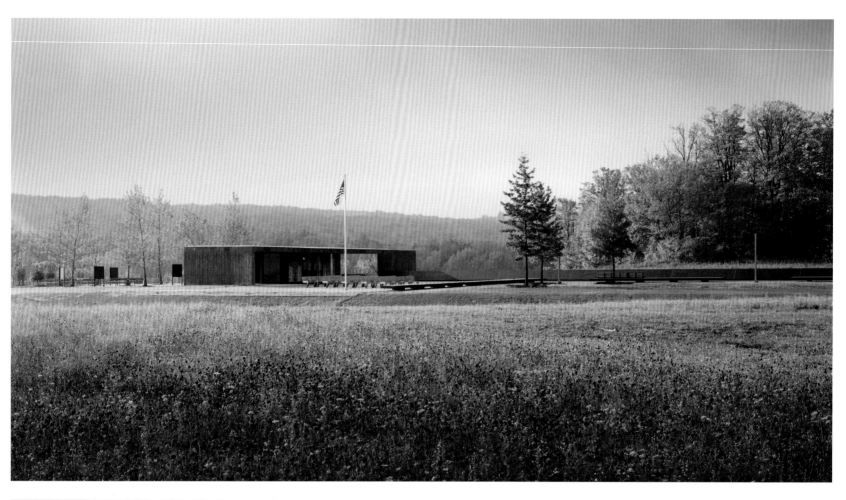

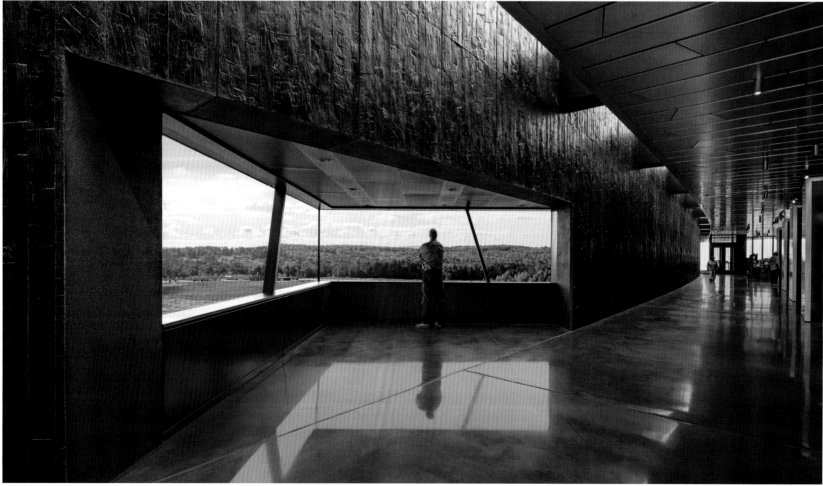

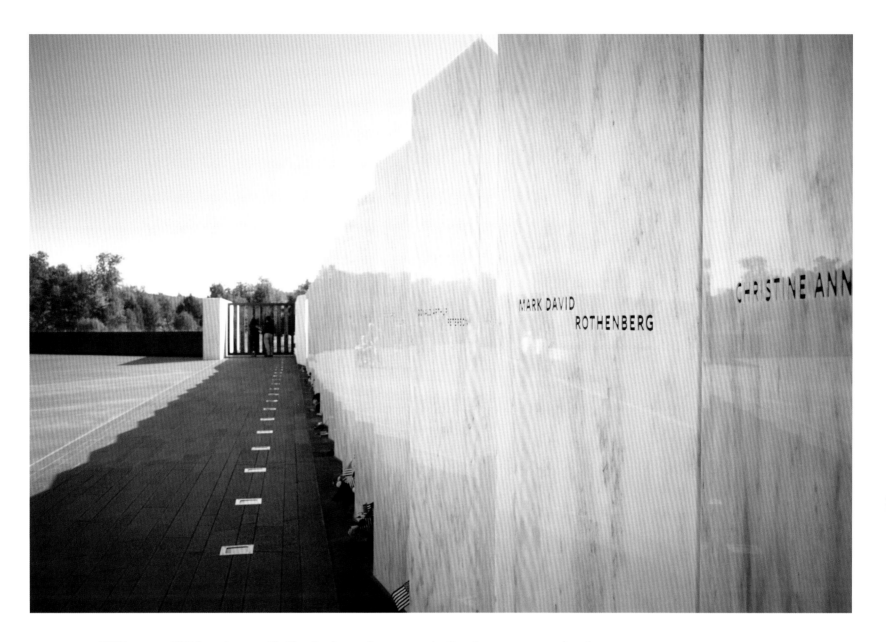

The Flight 93 National Memorial at once looks inwards and outwards, backwards and forwards: a beacon for both remembering and moving on.

OPPOSITE (TOP) A COLLABORATION WITH THE LANDSCAPE PRACTICE NELSON BYRD WOLTZ, THE MEMORIAL SITS SENSITIVELY ON THE SITE.

OPPOSITE (BOTTOM) INSIDE THE VISITOR'S CENTER, WITH VIEWS OF THE SITE AND NEIGHBORING HEMLOCK GROVE.

ABOVE A WALL OF FORTY REFLECTIVE WHITE-MARBLE SLABS IS INSCRIBED WITH THE NAMES OF THE PASSENGERS AND CREW MEMBERS.

NEXT SPREAD THE MEMORIAL'S OVERLOOK CARRIES SUBTLE AERONAUTICAL REFERENCES, BOTH IN MATERIAL AND FORM.

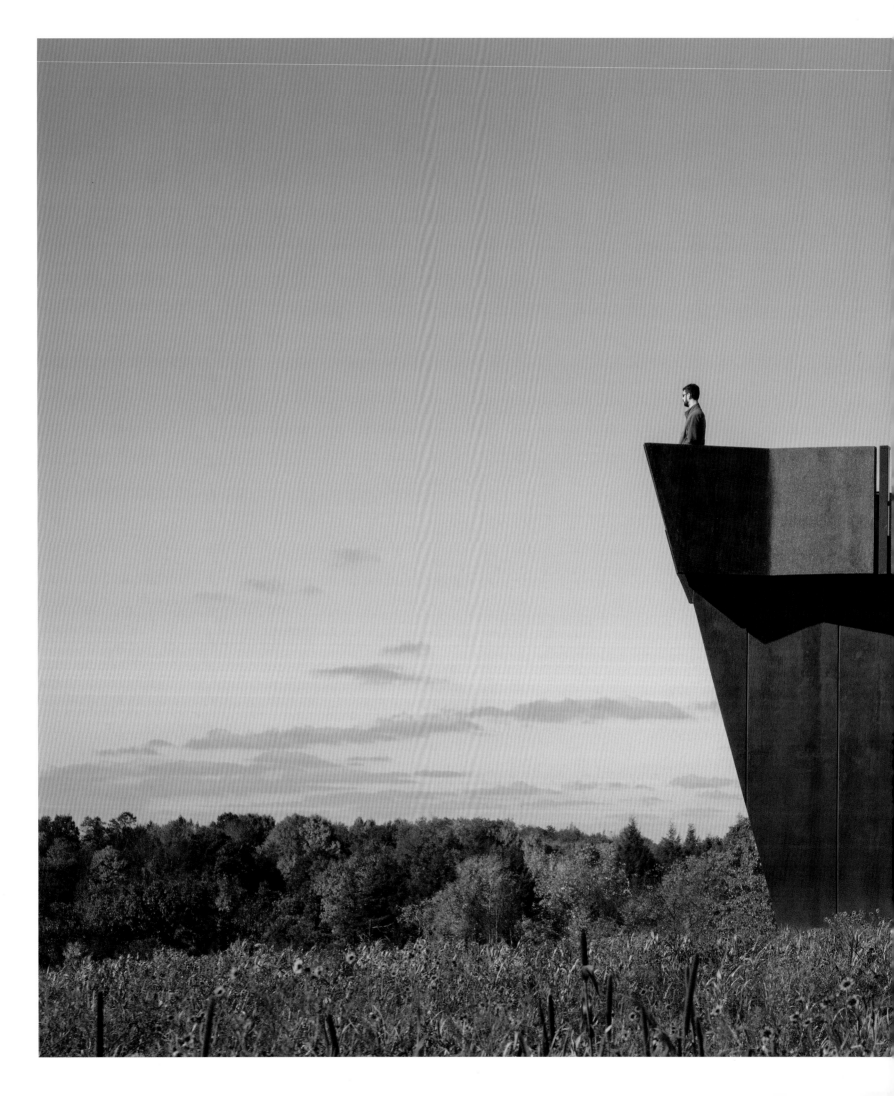

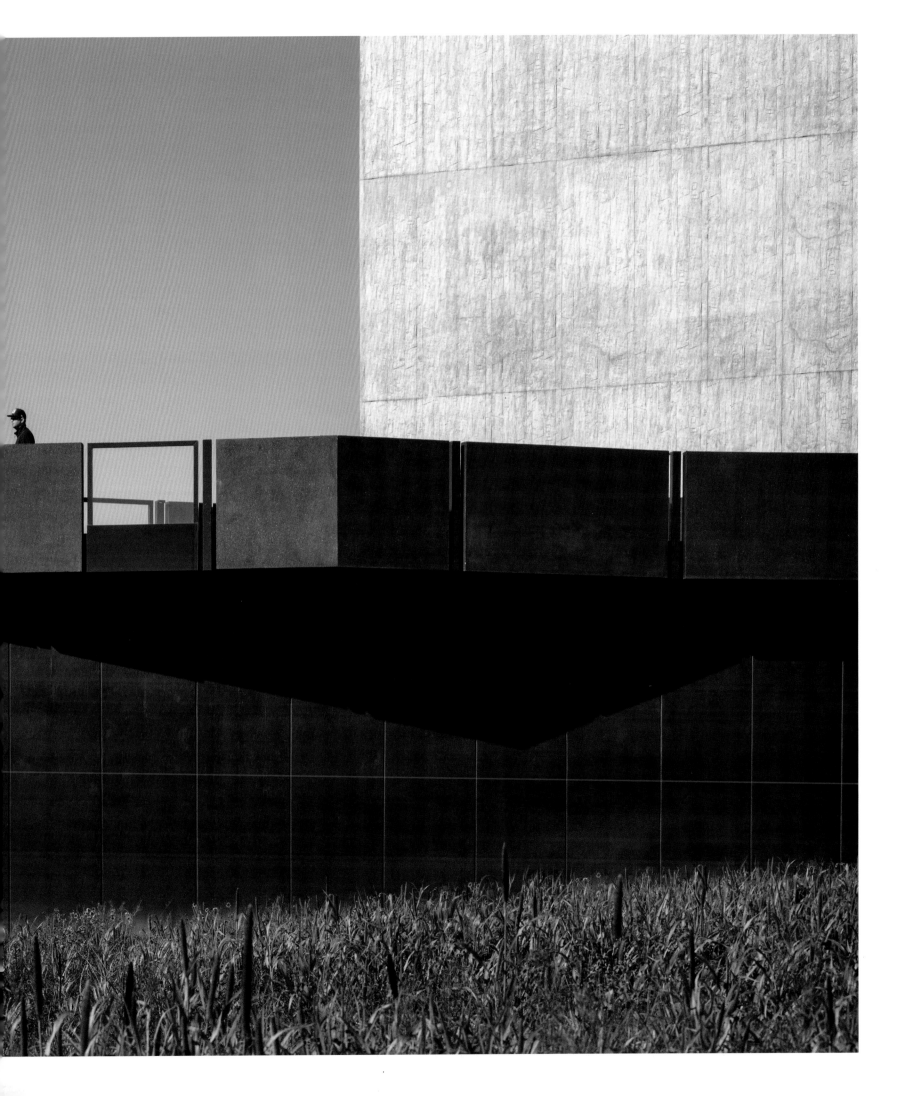

HOPE

STRENGTH

GRIEF

LOSS

FEAR

In contemporary memorial–making, the feeling of loss seems to be achieved most powerfully through the listing of names or the creation of a massive physical void, or a combination of the two.

Maya Lin's 1982 Vietnam Veterans Memorial (page 54), which does both, can claim to have reshaped the memorial landscape over the decades to come. Indeed, if this book were to have a family tree, most of its branches would stem from Lin's memorial. Built on the National Mall in Washington D.C., the solemn, V–shaped design cuts into the earth, as if a gaping wound in the nation's heart, and its polished black granite surface reflects the 58,320 names of the dead. The memorial's simplicity, in message and form, allows for seemingly endless readings—all of them, though, with a great sense of loss. Touching the smooth stone is especially affecting. As I walked down, into, and out of the sunken, gently sloping landscape, slowly tracing my fingers along the names on the wall, I felt the kind of visceral, spine–tingling sensation that can come with a profound realization. The Vietnam memorial was built to be a tactile, sensory experience. One *feels* the loss there, and also sees oneself reflected on the shiny surface. The sheer scale of the names jolts the body. I can readily conjure up the awe I felt the first time I stood in front of it.

To similarly strong effect, Maryann Thompson and Charles Rose's 1997 Bartholomew County Memorial for Veterans (page 188) in Columbus, Indiana, combines stone (in this case, regional limestone, rough on the outside and smooth on the inside); a twenty–five–pillar structure; and inscriptions of letters home from active service members. Other memorials that use naming in weighty, poignant ways include Michael Arad's 2014 Reflecting Absence (page 118) at the World Trade Center; Philippe Prost's 2014 International Memorial of Notre–Dame–de–Lorette (page 34) in Ablain–Saint–Nazaire, France; Kimmel Eshkolot Architects's 2017 National Memorial Hall for Israel's Fallen (page 78) in Jerusalem; and MASS Design Group's 2018 National Memorial for Peace and Justice (page 88) in Montgomery, Alabama.

At Hans and Torrey Butzer's 2000 Oklahoma City National Memorial Museum (page 50), abstraction primarily appears in the form of 168 empty glass–bottomed chairs arranged like tombstones, each representing someone killed in the 1995 Oklahoma City bombing. Haunting in its beauty and purity of form, the installation serves as a heartbreaking reminder of the lives taken. Walking from chair to chair, I felt the collective and individual loss in a way that an artifact could rarely, if ever, accomplish.

For me, when it comes to loss, the most stirring memorial was artist Taryn Simon's *An Occupation of Loss* (page 190) installation at New York's Park Avenue Armory, in the fall of 2016. Comprising eleven tow–ering concrete pipes designed by Shohei Shigematsu of OMA, inside of which thirty professional mourners from around the world performed for half an hour each night, it was effectively a built memorial to mourning itself—an overpowering, all–encompassing meditation on loss. I left feeling both distraught and, somehow, astonishingly relieved.

RIVESALTES CAMP MEMORIAL

The Rivesaltes Camp Memorial is about six miles (ten kilometres) outside of Perpignan, in southern France, and appears excavated from the area's orange–hued earth, almost as if it were a colossal, gently inclined coffin. An 800–foot–long (240–meter–long) monolithic slab of cast–in–place ochre concrete, with no windows (the only views are upwards, via three skylights), the structure carries a weighty, solemn presence.

The memorial uncovers the site's dark past. Built as a military ground in 1939, within a year it was repurposed into an internment camp which, from 1941 to 1942, housed 17,500 people, including 6,500 Jews, 2,300 of whom were eventually sent to Auschwitz; 1,300 Gypsies; and Spaniards who in 1939 had fled that country's civil war. At one point temporarily turned into a German military barracks, France took it over again after the war and held German soldiers and French Nazi collaborators there. From 1962 to 1964, 20,000 *Harkis*, (indigenous Muslim Algerians) who, seen by their countrymen as traitors, had fled after France abandoned the war of independence, were housed there. In 1986, part of the site was transformed into an immigrant holding center, which stayed open until 2007.

Designed by Rudy Ricciotti—who, with the studio Passelac & Roques, won a 2005 competition—and capturing and remembering this complex history, the memorial comprises permanent and temporary exhibition spaces, a 145–seat auditorium, a research center, and learning labs. The project, in many ways, dates back to 1993, when a memoir written by a nurse, who had been working for a relief organization at Rivesaltes, was published. Then, in 1997, after original archives of the camp were found in a garbage dump, the public became more aware of it. Ricciotti's design joins a 1994 stela on the site, dedicated to the deported Jews; a 1995 one honoring the Harkis; and another, from 1999, in commemoration of the Spanish Republicans.

The Rivesaltes Camp Memorial uncovers the site's dark past, intimately capturing and remembering its complex history.

OPPOSITE SEEN FROM ABOVE, THE MEMORIAL APPEARS TO BE A GIANT COFFIN EMBEDDED IN THE AREA'S ORANGE–HUED EARTH.

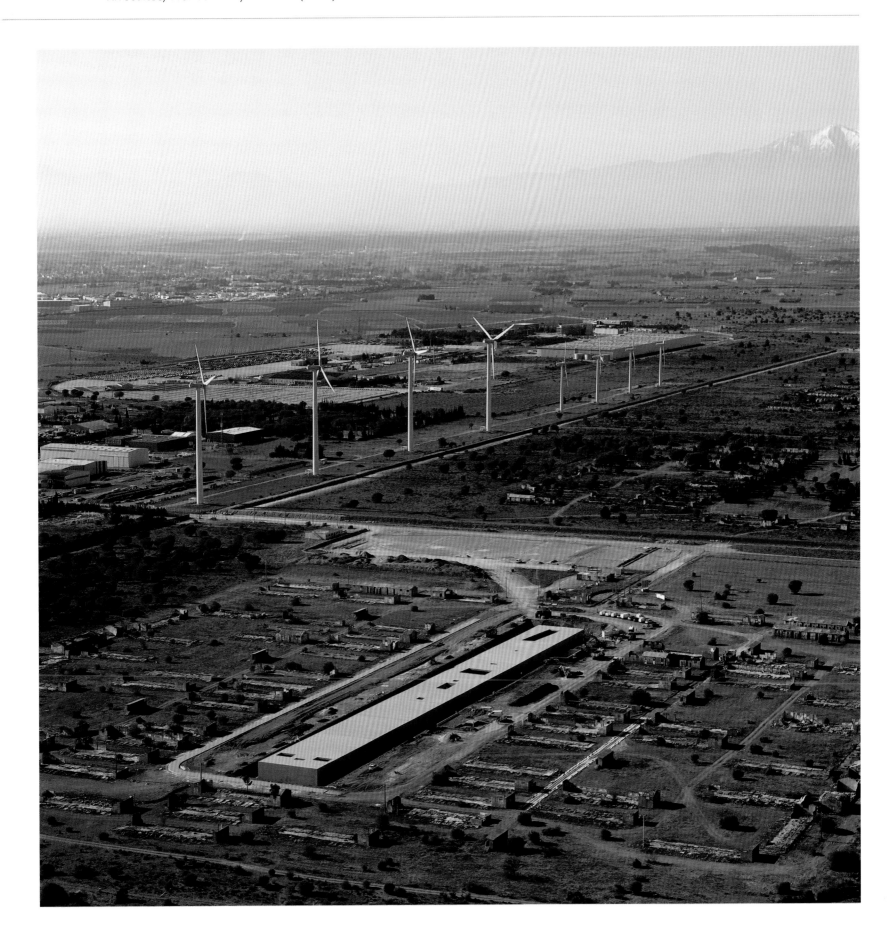

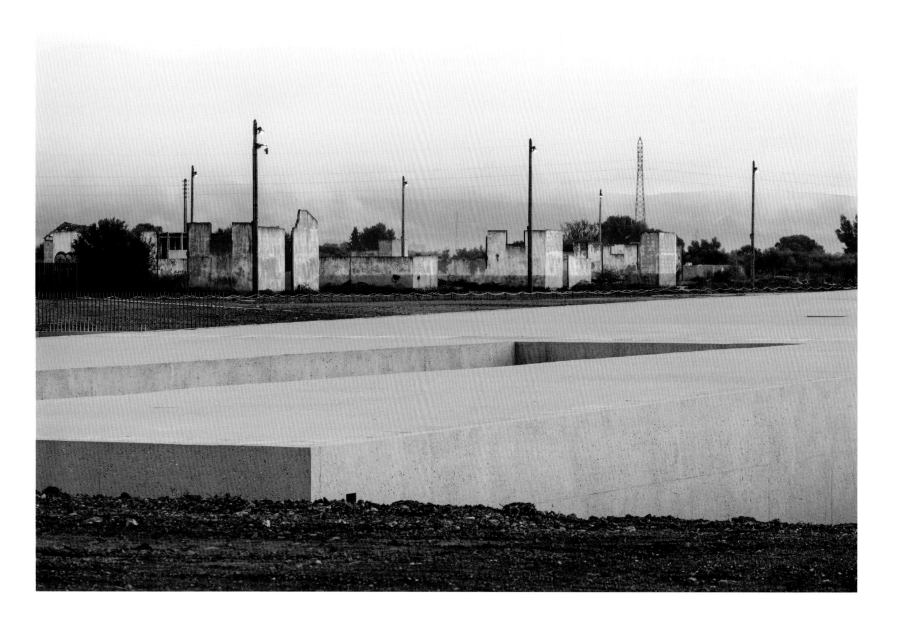

ABOVE THE CAST-IN-PLACE OCHRE CONCRETE FACADE CARRIES A WEIGHTY, SOLEMN PRESENCE.

OPPOSITE (TOP) A REDBRICK-PAVED INTERIOR COURTYARD OPENS UP TO THE SKY ABOVE VIA ONE OF THE MEMORIAL'S THREE SKYLIGHTS.

OPPOSITE (BOTTOM) THE MEMORIAL INCLUDES EXHIBITION SPACES (PICTURED), AN AUDITORIUM, A RESEARCH CENTER, AND LEARNING LABS.

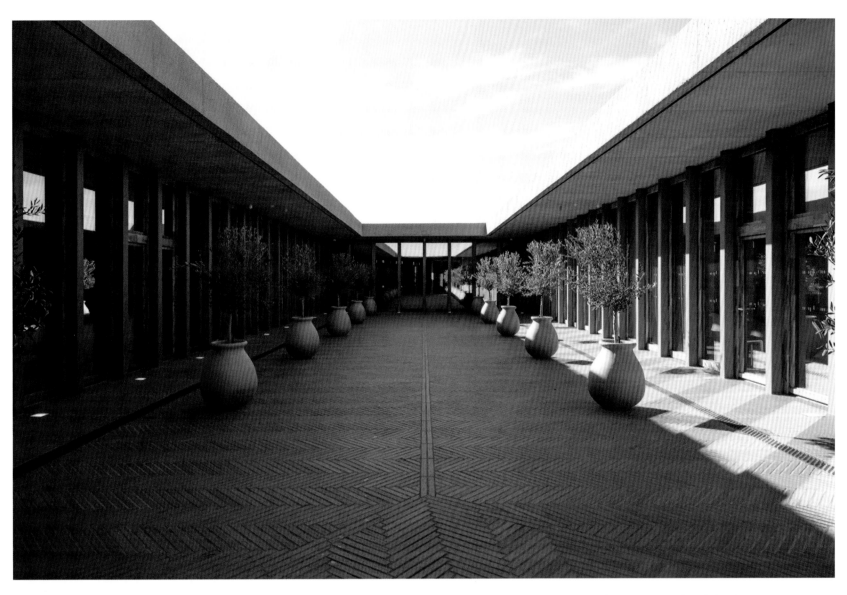

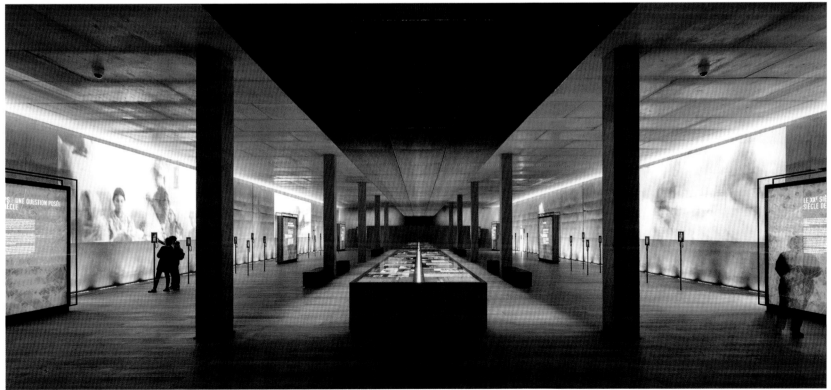

RIVESALTES CAMP MEMORIAL

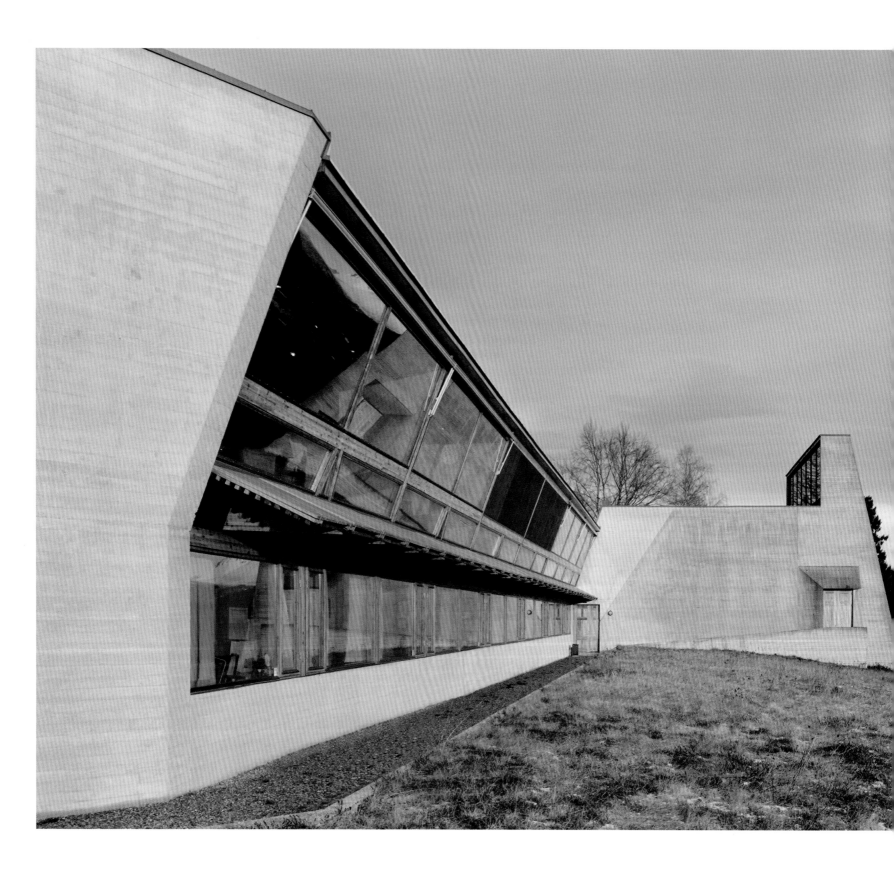

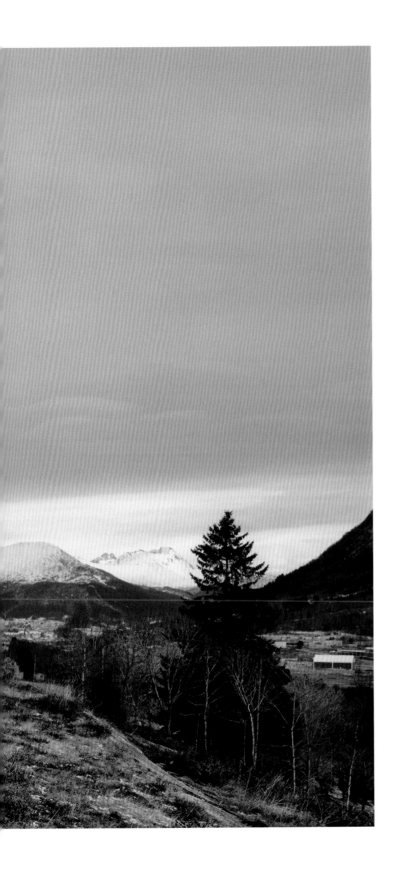

Few buildings dedicated to the life and work of an individual function beyond being a museum (or, for that matter, a mausoleum), or simply an archive or library. The Ivar Aasen Centre—dedicated to and honoring the Norwegian philologist, lexicographer, playwright, and poet who is best known for collecting and constructing the *Nynorsk* ("New Norwegian") language—is one such building. In addition to being a museum, library, and cultural center, it could also be considered a memorial to the nineteenth–century scholar. Located in Hovdebygda, along the western coastline of Norway, and elegantly nestled into a south–facing hillside just across the E39 highway from Ørsta–Volda Airport, the concrete structure, accented in wood and glass, architecturally references the work of Aasen, who was born on the site.

The centre's architect, Pritzker Prize–winner Sverre Fehn (1924—2009), once described the building's form as "entering between the pages of a book," and called the structure "my own manuscript." It is indeed memory in built form, a tangible, physical ode to the seemingly intangible: the life and work of a man and the language he created. Arranged as a timeline of Aasen's path to creating Nynorsk, the building itself and its exhibition follow a linear, wide–open line from front to back (visitors can see all the way through as they walk in). To the east of the entrance is Aasen's childhood home and farmstead; to the left upon entering, there's a chapel–like auditorium, a kind of bookend to the building.

Widely lauded for a body of work that harmonized with light and landscape, with most projects in Scandinavia, including the Glacier Museum (1991) in Fjærland, Norway, Fehn was known for his rare ability to combine Modernist thinking with Nordic forms and materials, a sensitivity that's on full display in this quiet commemorative space, a built poem.

LEFT SEEN FROM OUTSIDE, THE BUILDING'S AUDITORIUM APPEARS TO BOOKEND THE STRUCTURE, AN ODE TO A REVERED PHILOLOGIST AND POET.

MEMORIAL TO THE ABOLITION OF SLAVERY

The interior of the Memorial to the Abolition of Slavery evokes the disorienting, extremely cramped hulls of the slave ships that once transported an estimated half a million slaves to the New World through the port of Nantes. (France shipped roughly 1.4 million captives in total; Nantes was the country's busiest port, making up about 40 percent of the French slave trade.) For decades, Nantes, as with many other European cities, paid little mind to its slave-trade past. It was only in the 1980s and '90s, thanks to historians and local groups, many of them representing people of color, that a new mindset emerged about understanding it—and coming to terms with it. The exhibition *Les Anneaux de la Mémoire* (*The Shackles of Memory*), open from 1992 to 1994 at the Château des Ducs de Bretagne, especially ignited the conversation. Then, in 1998, during the 150th anniversary of the abolition of slavery, the local government announced a memorial. In 2002, a design by Polish artist Krzysztof Wodiczko and American architect Julian Bonder, of the Wodiczko + Bonder partnership, was selected.

Built on the Loire River, along the Quai de la Fosse, and cut into the wharf's promenade, the memorial transforms what was a nineteenth-century embankment wall into a space of healing and deep meaning. Above ground, inserted into a 74,000-square-foot (6,880-square-meter) esplanade, are 2,000 glass panels, 1,710 of them featuring the names of the slave ships. Open-air staircases on either end bring visitors down into a subterranean passageway, where a boardwalk leads them along a 295-foot-long (90-meter-long) wall of sloped opaque glass. Visitors are welcomed by the Universal Declaration of Human Rights and, behind it, the word "freedom," displayed in forty-seven languages from countries impacted by the slave trade. On display are poems and other texts spanning Europe, Africa, the Americas, and the Indian Ocean, all testifying to the harrowing history.

RIGHT THE MEMORIAL IS BUILT ON THE LOIRE RIVER, ALONG THE QUAI DE LA FOSSE, AND CUT INTO THE WHARF'S PROMENADE.

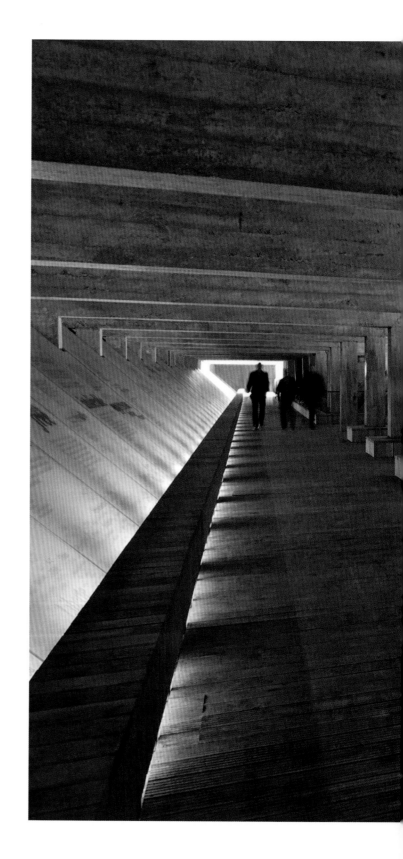

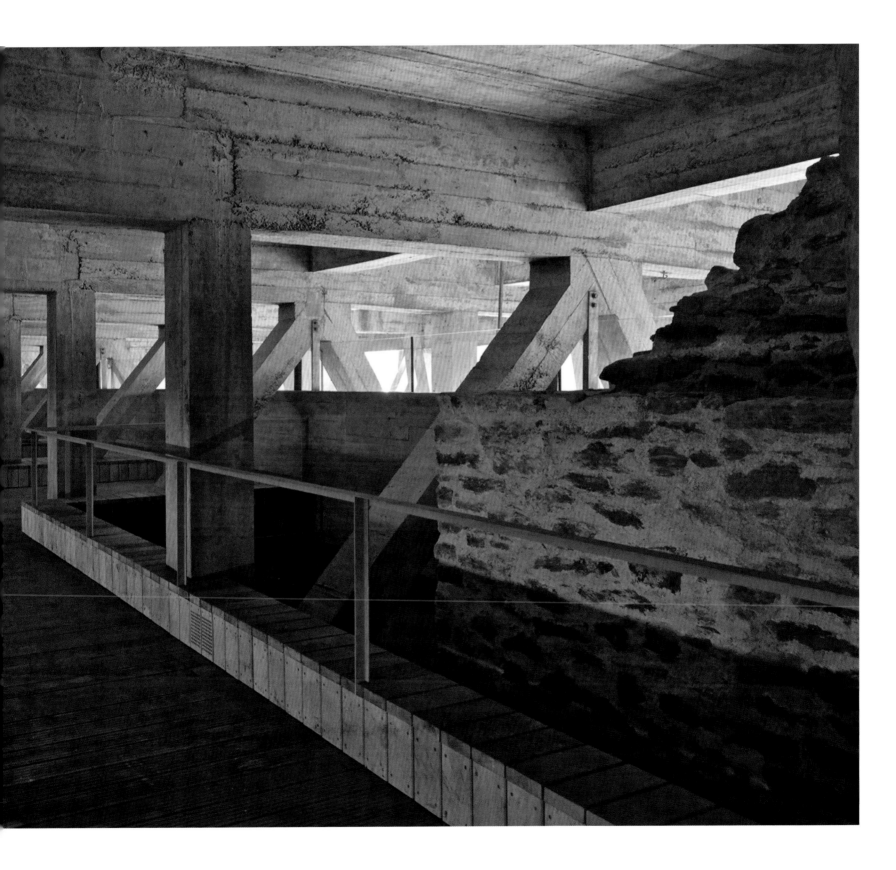

ESTONIAN NATIONAL MUSEUM

When they won an international competition in 2005 to design the Estonian National Museum in Tartu, the architects Dan Dorell, Lina Ghotmeh, and Tsuyoshi Tane hadn't even formed their own firm yet. The design they submitted was completed during late nights and off-hours while working for the architects Jean Nouvel (Dorell, Ghotmeh) and David Adjaye (Tane). But soon after the announcement, the three moved to Paris and formed DGT Architects, to work on the Estonian museum project full-time. (Upon the building's completion, in 2016, DGT disbanded, with each partner forming their own firm.) While not explicitly a memorial, the museum was designed with memorialization in mind. Built on the former site of a Soviet airfield located 1.2 miles (2 kilometers) outside the city, the 1,165-foot-long (355-meter-long) structure is designed to symbolize the country emerging from its dark past. (Estonia gained its independence from Soviet rule in the 1920s, but after its parliament disbanded from 1934—38 it was annexed by the Soviet Union in 1940 and subsequently by the Third Reich. Reoccupied by the Soviet Union in 1944, Estonia didn't gain independence again until 1991. In 2004, after a period of rapid socioeconomic reform, it joined the European Union.)

Literally and figuratively coming out of this painful and precarious history, the sloping form of the 366,000-square-foot (34,000-square-meter) museum, which houses a collection of 140,000 objects, gradually increases from a height of 9.8 feet (3 meters) at the far end to 45 feet (14 meters) at its entrance. Creating an infinite horizon, the site also establishes, as the architects have described it, a "memory field." Included inside are gallery spaces, a conference hall, a library, a café, offices, and an archive. Covering the triple-chamber glass panel facade is a printed abstract cornflower motif; referencing Estonia's national flower, it gives the glazing a frosted appearance while also reflecting the country's heritage.

RIGHT THE BUILDING'S HEIGHT GRADUALLY INCREASES FROM 9.8 FEET (3 METERS) AT ONE END TO 45 FEET (14 METERS) AT ITS ENTRANCE.

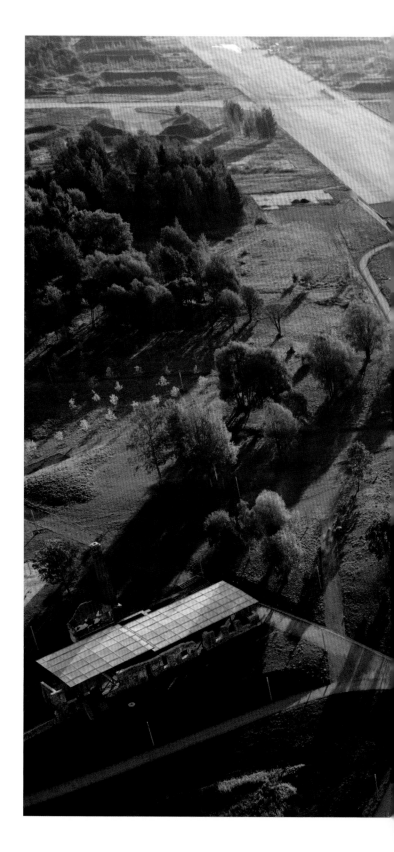

Tartu, Estonia. Dan Dorell, Lina Ghotmeh, and Tsuyoshi Tane (2016)

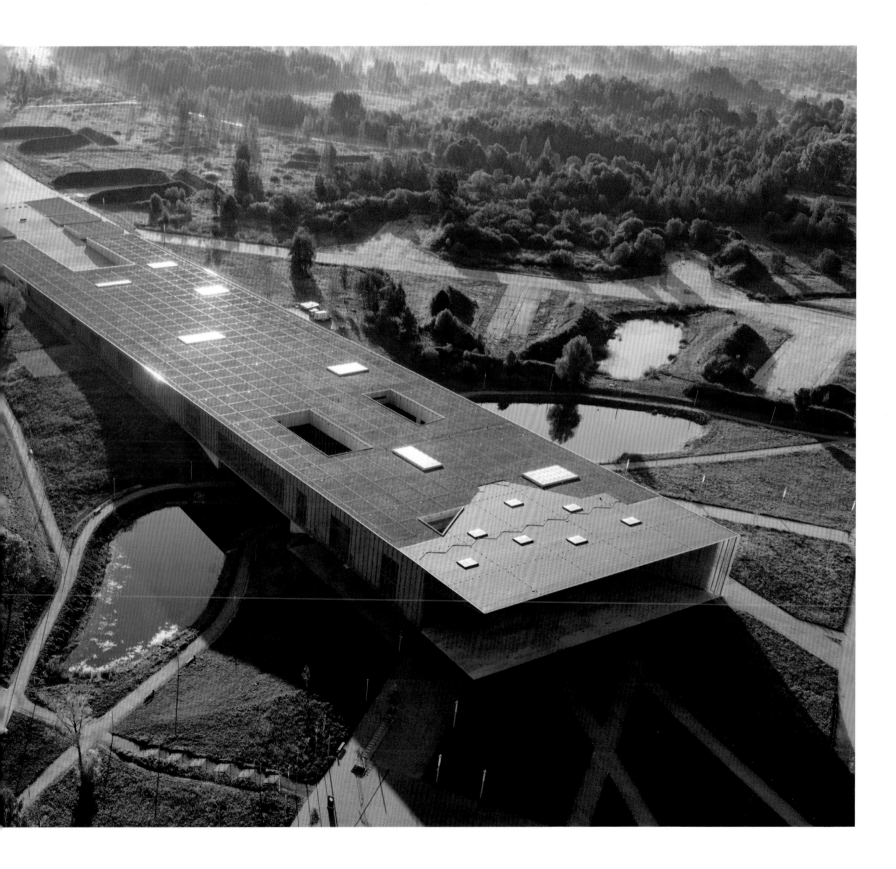

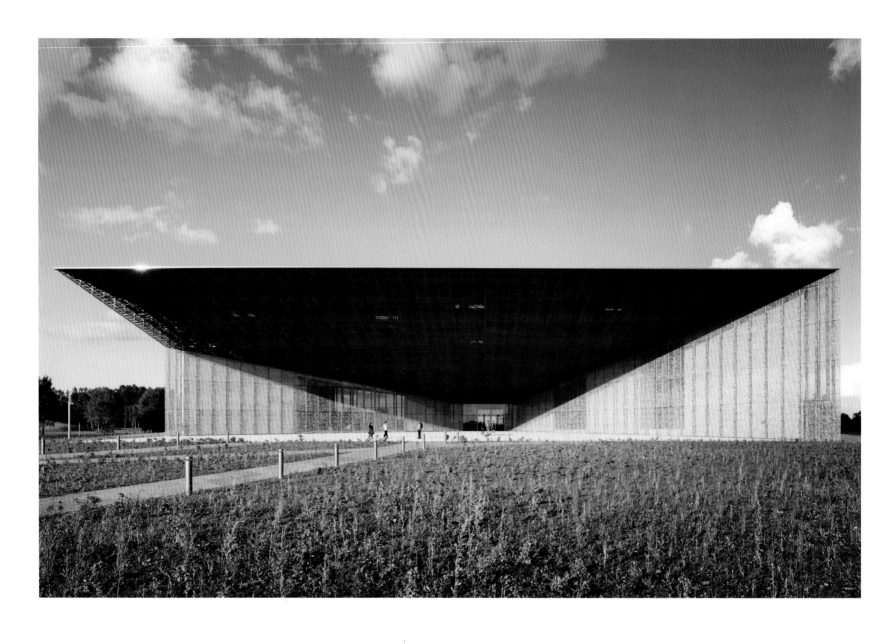

TOP THE STRUCTURE'S EVOCATIVE TALL
ENTRANCE FEATURES A DRAMATIC,
WELCOMING CANTILEVER.

OPPOSITE THE LIGHT AND AIRY
INTERIOR INCLUDES GALLERY SPACES,
A CONFERENCE HALL, A LIBRARY,
A CAFÉ, OFFICES, AND AN ARCHIVE.

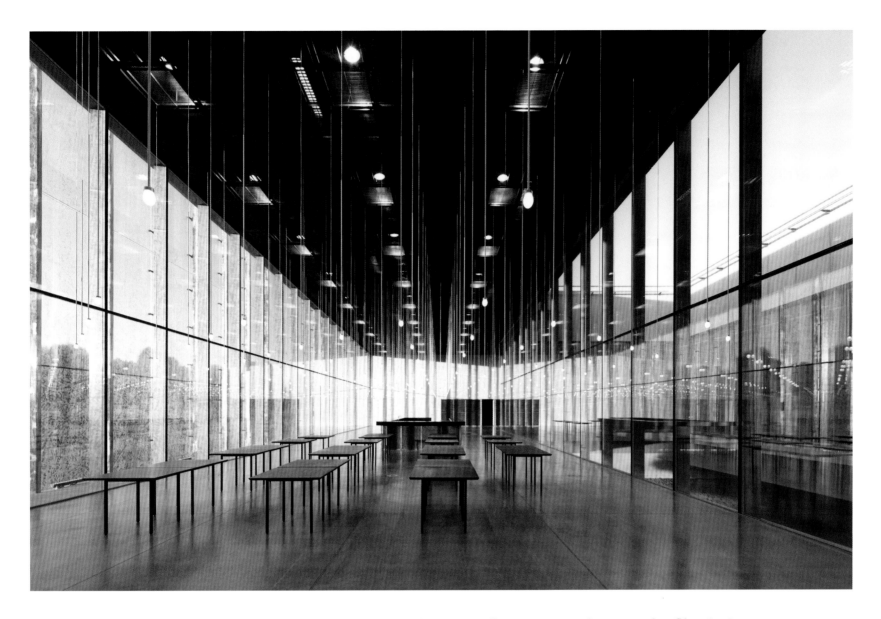

Built on the former site of a Soviet airfield, the Estonian National Museum literally and figuratively rises up out of the nation's painful and precarious past.

HEGNHUSET MEMORIAL AND LEARNING CENTER ON UTØYA

Architect Erlend Blakstad Haffner was brought in to help Norway recover from one of its darkest, and most infamous, days: a series of terrorist attacks. Haffner collaborated with Labour Party leaders, survivors and victims' families to redevelop a youth camp on Utøya, the site of one of the politically motivated massacres in July 2011. Far-right extremist Anders Behring Breivik detonated a bomb in central Oslo, killing eight, and later that day, fatally shot sixty-nine people on the island— most of them teenagers attending a Norwegian Labour Party youth camp. Haffner split from the firm Fantastic Norway in 2013 to focus entirely on the Utøya project, with the aim of making Utøya an international symbol for democracy and free speech. He established a new main square with a library, a conference room, and meeting spaces.

Set apart but arranged on the same axis as these buildings is *Hegnhuset,* or "safe house," a memorial and learning center with a double-layer facade that pre- serves the tragic event and also offers a sensitive way to look forward. Located on the site of the café where thirteen people were killed, Haffner's design, made of glue-laminated pine, preserves both areas where there were casualties—the windows left open from people trying to escape, the walls and furniture pocked with bullets—as well as the restrooms where nineteen survived. A glazed exterior envelops the space, which features sixty-nine wood support beams, each repre- senting someone who lost a life that day. A fence com- prising 495 outer poles—a reference to all of the Utøya survivors—surrounds the building; it has random open- ings and five entrances, an emphasis on the chance of survival. In a dugout area underneath the old café is the learning center.

Another Utøya memorial, a suspended silver ring by architects 3RW, was installed in 2015. Swedish artist Jonas Dahlberg's proposed Memory Wound memorial was cancelled in 2017 after protests.

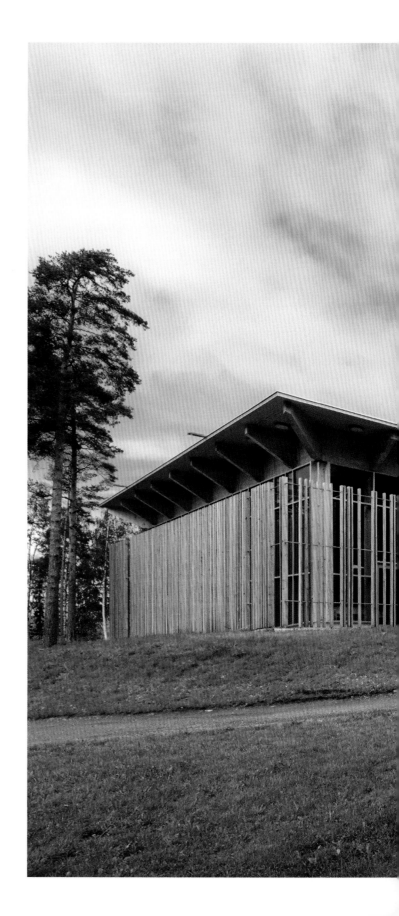

Utøya, Norway. Blakstad Haffner Architects (2017)

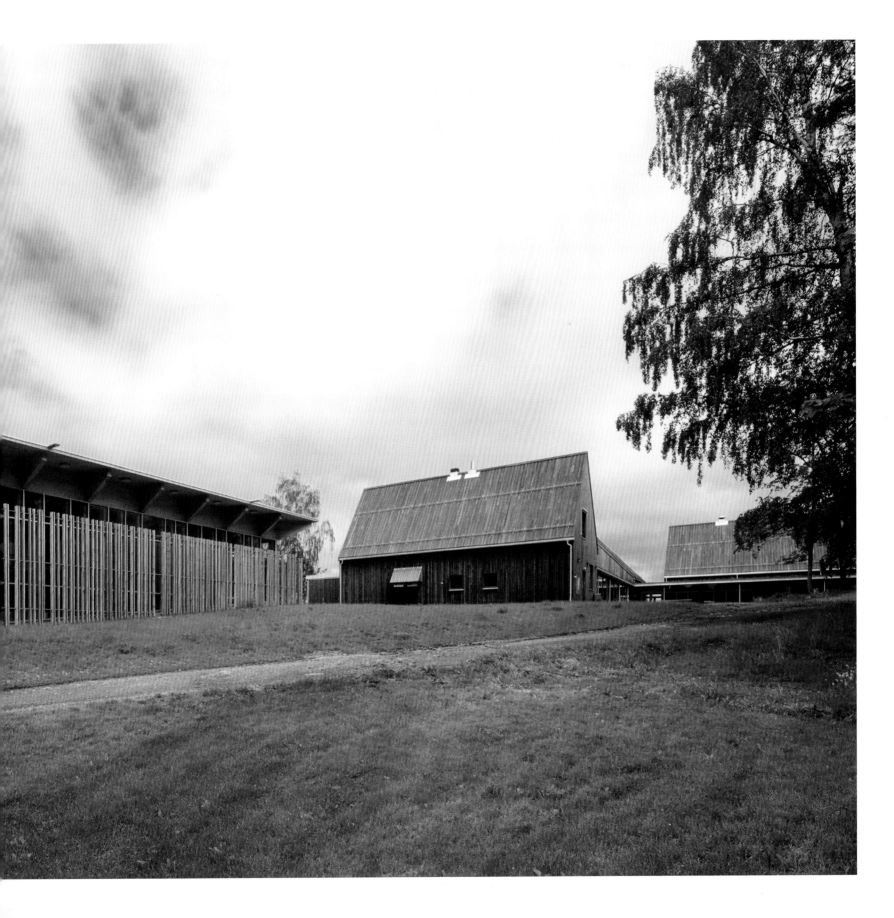

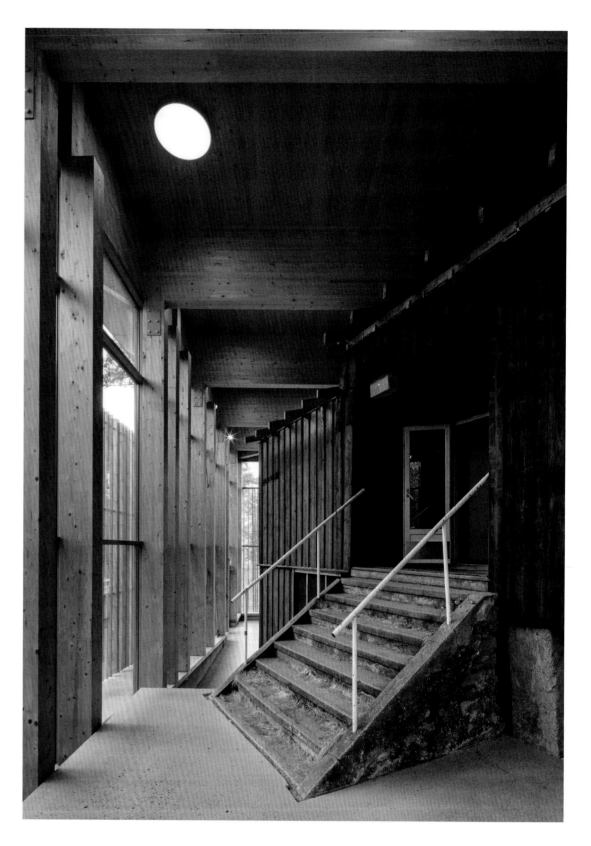

The Hegnhuset Memorial and Learning Center preserves the tragic July 2011 Utøya attack and also offers a sensitive way to look forward.

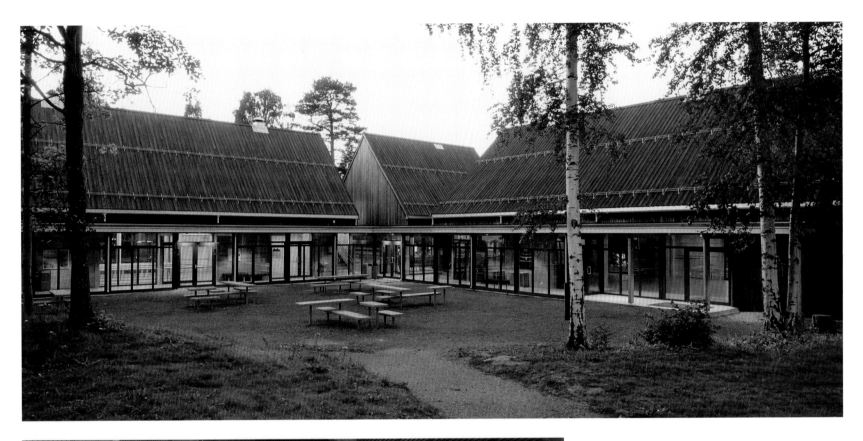

TOP THE CABIN–LIKE BUILDING
FEATURES STEEPLY PITCHED ROOFS
AND GLASS WALLS WITH VIEWS
TO THE SURROUNDING FOREST.

BOTTOM THE MEMORIAL'S INTERIOR
INCLUDES A LIBRARY (PICTURED),
A CONFERENCE ROOM, AND
MEETING SPACES.

OPPOSITE THE BUILDING HAS A GLAZED,
SLIGHTLY MIRRORED EXTERIOR TO
CONCEAL THE CAFÉ STRUCTURE FROM
THOSE WHO WISH NOT TO SEE IT.

HEGNHUSET MEMORIAL AND LEARNING CENTER ON UTØYA

100-STEP-GARDEN AT AWAJI-YUMEBUTAI

In January 1995, after Tadao Ando began designing the Awaji-Yumebutai, a conference center and hotel on the northeastern shore of Awaji Island, the Great Hanshin earthquake hit hard, at a magnitude of 6.9. More than 6,000 people died. It was one of the worst earthquakes to strike Japan in the twentieth century.

In the aftermath, Ando revised his construction plans with a memorial concept, dubbed "100-Step-Garden," in remembrance of those whose lives were lost. Ando's hope was to create, as he once put it, "both a physical and spiritual rebuilding," as well as "a symbol to calm the souls of those who lost their lives in the disaster." A massive undertaking, at fifty-three acres (213,000 square meters), the mixed-use site was also built as a sort of natural regeneration: the existing landscape had already been torn up for other uses, including for the artificial landfill on which the Kansai International Airport is built. Perhaps the central-most element to the site, and positioned at the highest point of the complex, the rigorous, rhythmically designed memorial comprises a cascading arrangement of one hundred flower beds nestled into the hillside and evenly positioned amid a geometric maze of M.C. Escher-esque stairs, featuring either seven or fourteen steps between each landing. A 33-foot-wide (10-meter-wide) waterfall feature runs down a portion of it. (The development also features a tea ceremony building, a church, restaurants, and an amphitheater.)

As with most of Ando's Minimalist architecture—including the serene Honpuku-Ji water temple (1991) in nearby Hyogo, Japan—the primary material he chose to work with was concrete, and integrating nature at the site was a chief consideration. Home to a Westin hotel, the project may have a commercial intent, but Ando designed the memorial in such a way that it stands apart, a sensitive tribute.

RIGHT REMEMBERING LIVES LOST IN THE GREAT HANSHIN EARTHQUAKE, THE MEMORIAL COMPRISES ONE HUNDRED EVENLY ARRANGED FLOWER BEDS.

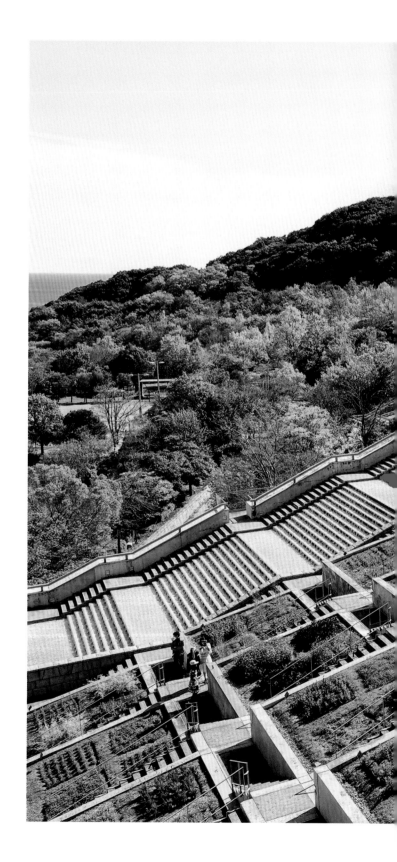

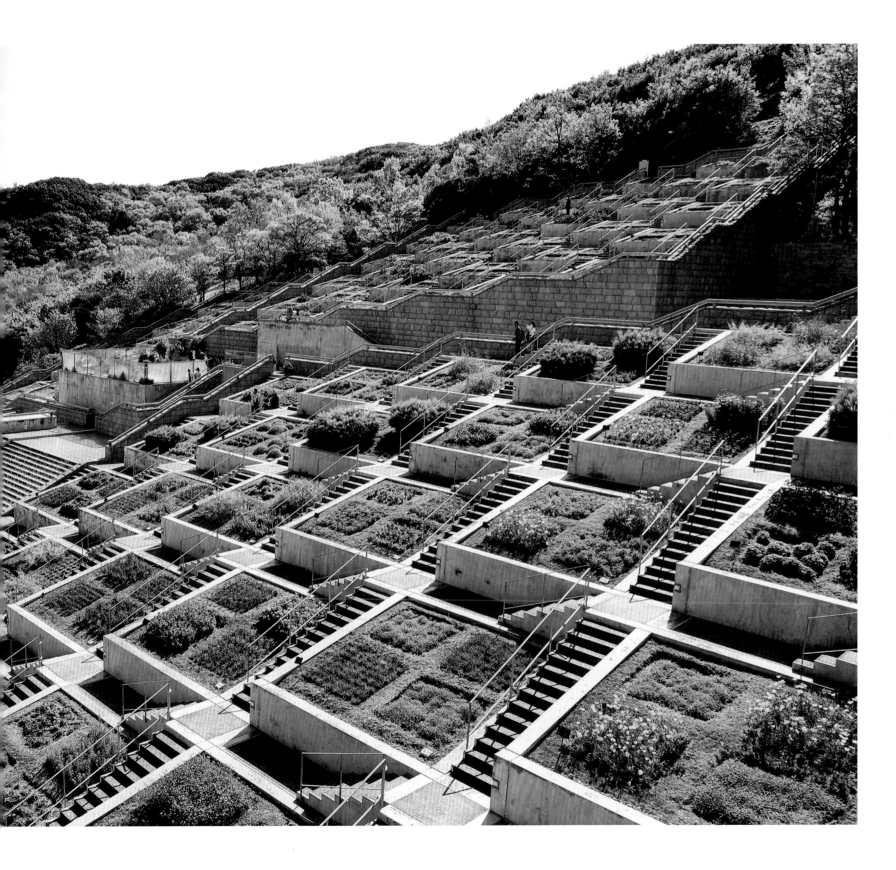

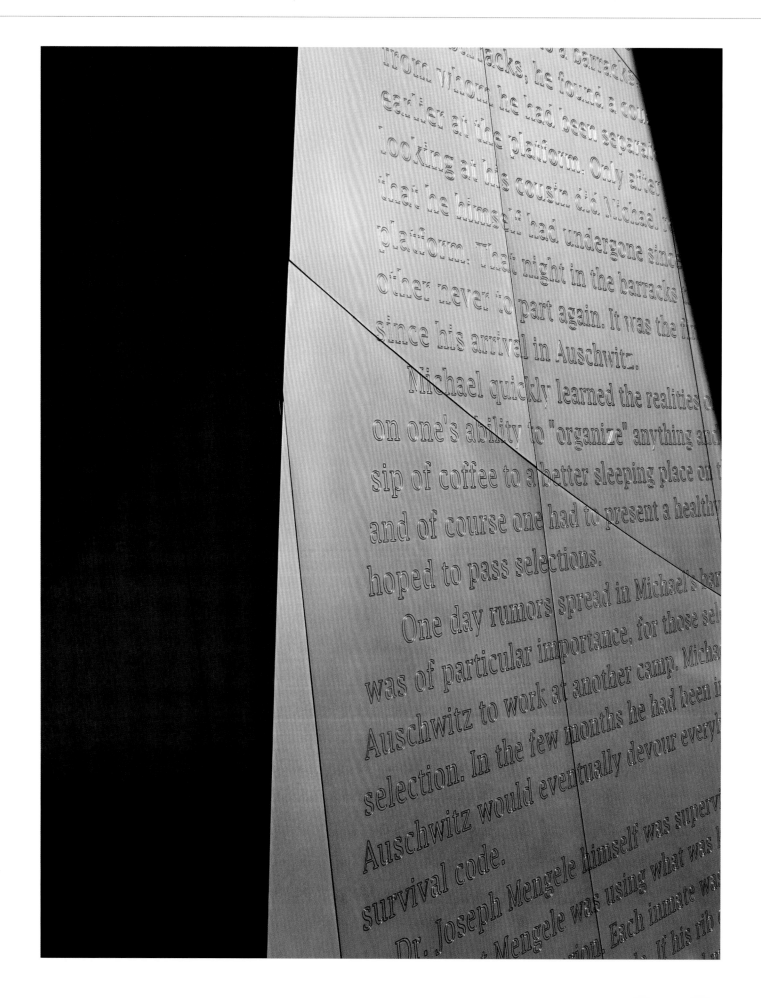

The Ohio Holocaust and Liberators Memorial commemorates the six million Jews murdered in the Holocaust and other Nazi victims, as well as honoring the United States soldiers from Ohio who helped free concentration camps during World War II. Daniel Libeskind's creation, which is located on the south lawn of the Ohio Statehouse, marks the first Holocaust memorial built on state-owned land in the United States. As with the United States Holocaust Memorial Museum, completed in 1992 and located just off the National Mall in Washington, D.C., creating the Ohio memorial was rife with conflict and turned into a literal turf battle—in this case, mostly between two politicians. Proposed in 2012 by Ohio's governor, John Kasich, the privately funded memorial received loud opposition from Richard H. Finan, who was director of the agency overseeing the statehouse and grounds. Following the spat, Finan

resigned, saying that the memorial had "played a role" in his decision.

As with Libeskind's Memory and Light 9/11 memorial (page 66) in Padua, Italy, the Ohio Holocaust memorial resembles a book. Split down the middle—a sort of metaphorical schism for the trauma—the 18-foot-tall (5.4-meter-tall) bronze centerpiece reveals, in its void, an abstracted six-point star. Along a path of fractured granite that leads to the piece are two limestone walls and a pair of benches. Inscribed on one of the walls is the Talmud inscription "If you saved one life, it is as if you saved the world." Inscribed on the bronze sculpture is the powerful story of Holocaust survivor Michael Schwartz, a narrative pulled from a 1979 interview in the book Hasidic Tales of the Holocaust.

The memorial's hollow (and, in turn, hallowed) center—outlined in stainless steel—effectively bonds the site, bringing together those it represents.

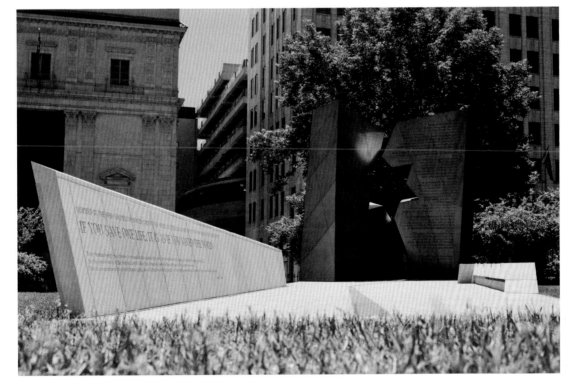

LEFT LOCATED OUTSIDE THE OHIO STATEHOUSE, THE SCULPTURE IS THE ONLY HOLOCAUST MEMORIAL IN THE U.S. BUILT ON STATE-OWNED LAND.

OPPOSITE THE POWERFUL STORY OF HOLOCAUST SURVIVOR MICHAEL SCHWARTZ IS INSCRIBED ON THE MEMORIAL'S BRONZE PANELS.

WHEEL

Based on the Bighorn Medicine Wheel in Wyoming and Plains Indian Earth Renewal lodges, the *Wheel* memorial is artist Edgar Heap of Birds's first large-scale public sculpture. It comprises ten porcelain red forked tree forms, each 12 feet (3.6 meters) tall, and is located in Denver's Golden Triangle neighborhood. The installation reflects on the history of Native Americans in the West and memorializes the victims of the Sand Creek Massacre, which took place in southeast Colorado in 1864. On each tree are words and drawings that illustrate historical events, many of them depicting heartbreaking violence and tragedy. The final four trees celebrate Native American strength and perseverance.

From 2005 to 2018, *Wheel* stood next to the entrance of the Denver Art Museum's 1971 North Building, designed by Gio Ponti. But in 2016, when the museum announced it would be renovating the Ponti building, it determined it would need to move the memorial as part of the plan. Heap of Birds considered

the site "holy ground"—it had been ceremonially blessed by spiritual leaders and was a site for Native comunity members' prayers and tears—and wrote to the museum in protest. The two parties ultimately reached an agreement to collect the top 12 inches (30 cm) of soil from the memorial's grounds and move the earth to a new site several dozen yards away.

A nearly decade-long project, *Wheel* began in 1996 when the museum solicited nine Native American artists to submit proposals for a public sculpture. Heap of Birds's original design featured twelve panels, a reference to the Earth Renewal lodge, but he ultimately switched the concept to ten in order to create a sense of abstraction, making the memorial secular and universal. A planned wall listing the names of the ninety-seven families who were at Sand Creek was eventually scrapped; instead, a more optimistic and hopeful message, the Cheyenne phrase "We are always returning back home again," was added.

Wheel depicts heartbreaking violence and tragedy but also celebrates Native American strength and perseverance.

RIGHT THE INSTALLATION REFLECTS ON NATIVE AMERICAN HISTORY IN THE WEST AND MEMORIALIZES THE VICTIMS OF THE 1864 SAND CREEK MASSACRE.

OPPOSITE LOCATED ADJACENT TO THE DENVER ART MUSEUM, *WHEEL* COMPRISES TEN PORCELAIN RED FORKED TREE FORMS.

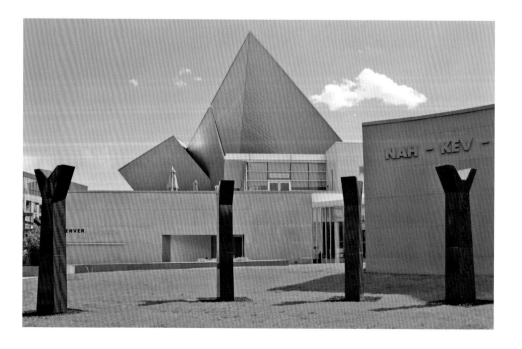

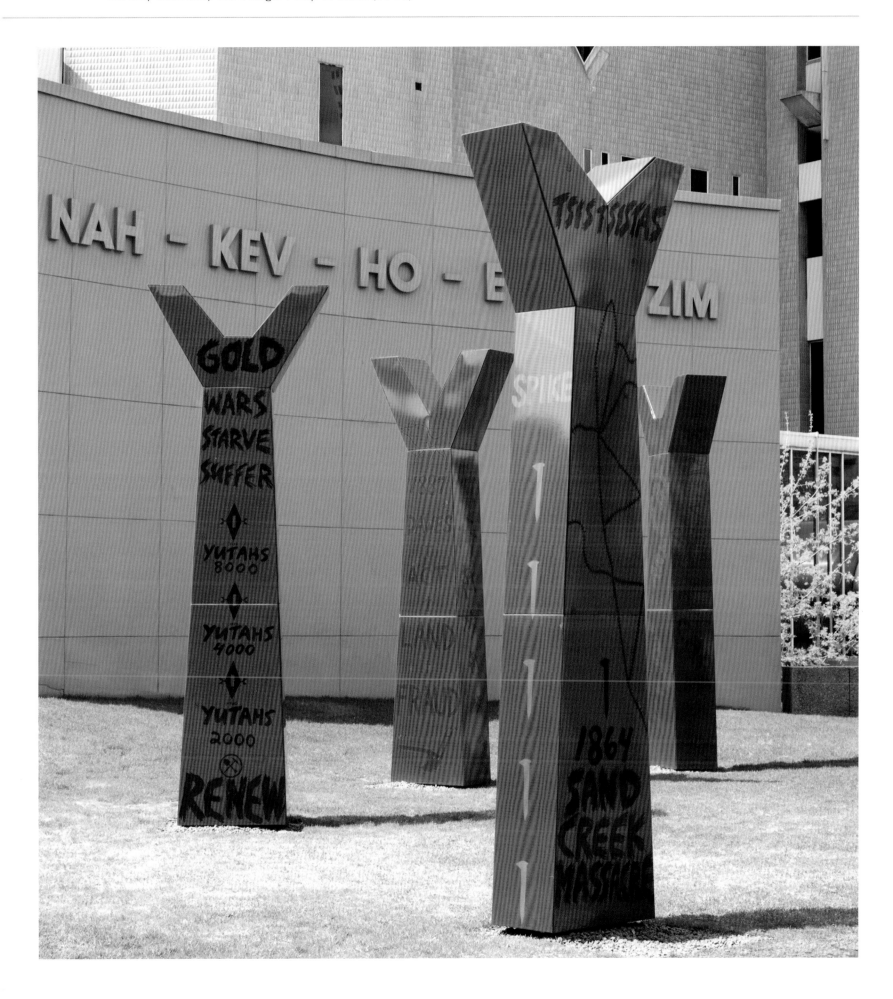

GWANGJU PAVILION

Three years before the opening of his Smithsonian National Museum of African American History and Culture (page 192) in Washington D.C., the Ghanaian–British architect David Adjaye created this intimate reading–room pavilion as part of the 2013 Gwangju Biennale in South Korea. In collaboration with the London–born writer Taiye Selasi, who is of Nigerian and Ghanaian descent, Adjaye conceived a space to be built in memory of protesting Chonnam National University students massacred there during uprisings in May 1980. It was one of eight "follies" created as part of the Gwangju Folly project, which was started in 2011. The matte–gray timber and concrete building, situated on the banks of the Gwangju River, establishes a somber setting for reading, reflection, and contemplation. Similar to the "Horizon" pavilion Adjaye presented in London in 2007 and Rome in 2008, the Specere shelter he built in Scotland in 2009, and the "Genesis" pavilion he created for the 2011 edition of the Design Miami fair, the Gwangju structure filters natural light in a fluid, tranquil way through cutaway timber. (Both the Smithsonian and Gwangju projects were part of a 2019 Adjaye Associates exhibition on memorials at London's Design Museum titled *Making Memory*.)

The project takes inspiration from traditional Korean pavilions and is designed to accommodate 200 books, selected by Selasi and dealing with human-rights issues (Chimamanda Ngozi Adichie's *Half of a Yellow Sun* and Emile Zola's *Germinal* were among them). The four–sided, two–level design features steps that form a series of seats and a viewing platform. Acting as a literal stepping stone from the street level above to the grassy seasonal park below, it features a concrete base that allows for flooding. When the concrete is submerged at high tide, the memorial appears to float above the water, an ethereal presence.

Built in memory of protesting students massacred in 1980, David Adjaye's Gwangju Pavilion establishes a somber setting for reading, reflection, and contemplation.

OPPOSITE (TOP) THE MATTE-GRAY TIMBER AND CONCRETE PAVILION IS SITUATED ON THE BANKS OF THE GWANGJU RIVER.

OPPOSITE (BOTTOM LEFT) THE STRUCTURE FILTERS NATURAL LIGHT IN A FLUID, TRANQUIL WAY THROUGH CUTAWAY TIMBER.

OPPOSITE (BOTTOM RIGHT) THE PROJECT'S DESIGN ACCOMMODATES 200 BOOKS AND INCLUDES STEPS THAT FORM A SERIES OF SEATS.

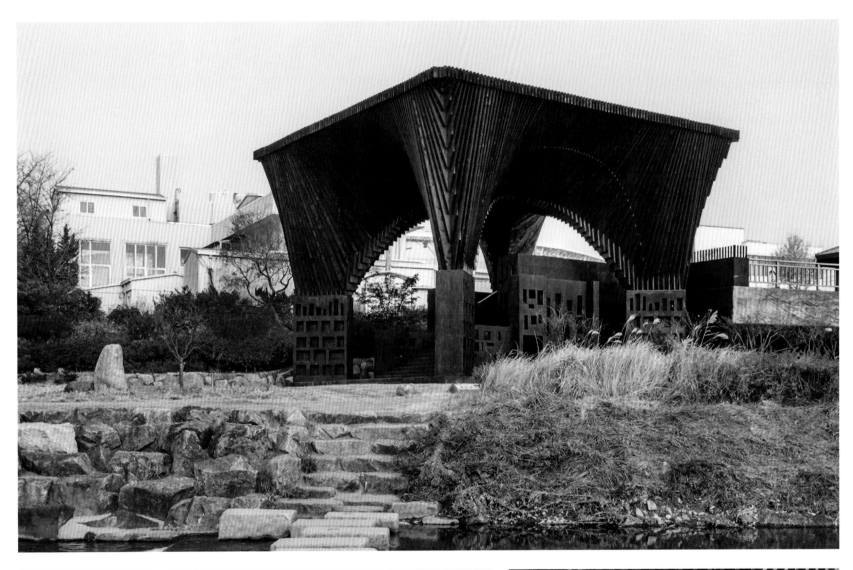

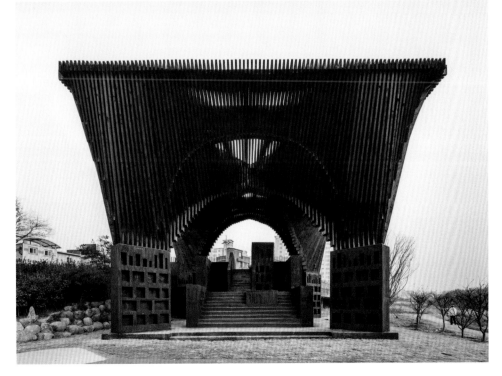

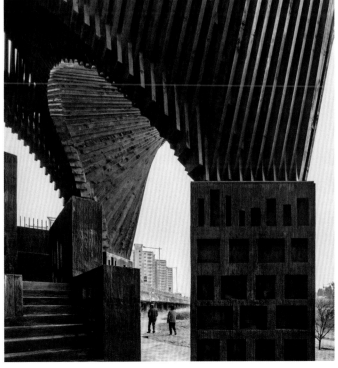

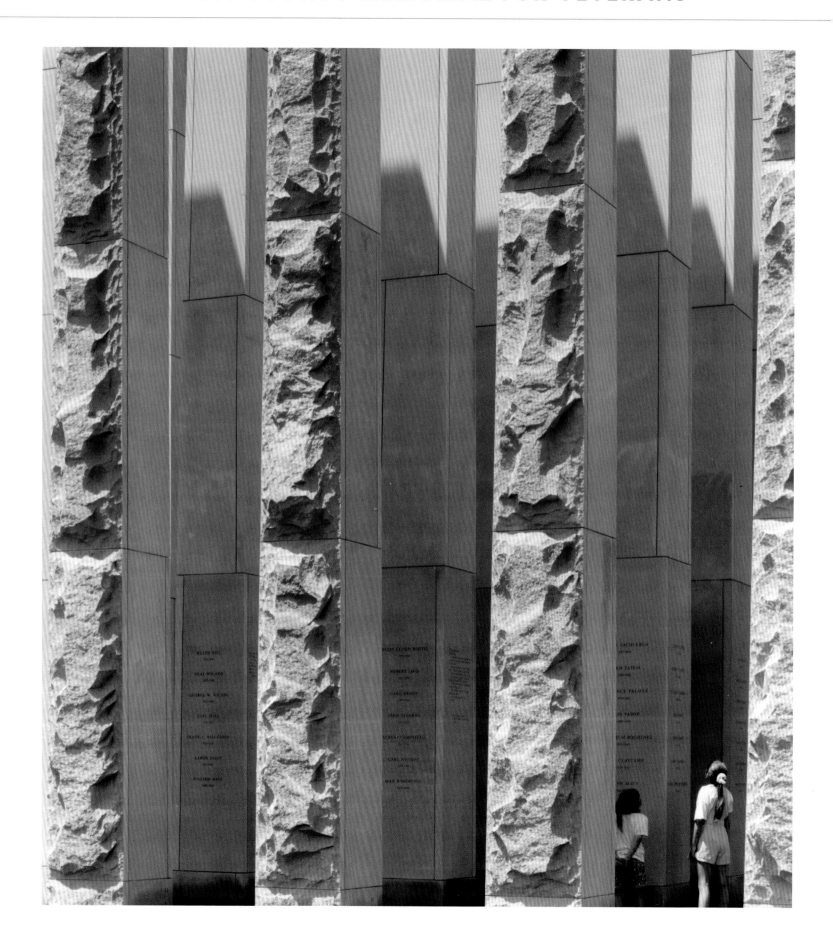

Designed by Charles Rose of Charles Rose Architects, and Maryann Thompson, with surrounding grounds by the landscape architect Michael Van Valkenburgh, the Bartholomew County Memorial for Veterans in Columbus, Indiana, comprises twenty-five pillars made of regional limestone, each 40 feet (12 meters) tall and arranged in a five-by-five grid. Though the memorial is crafted of rough-hewn stone on the outside, the interior walls are smooth-cut and feature inscriptions of letters home from active service members, collected from local families by the city's *Republic* newspaper. One, dated from April 1944, reads: "Displaying outstanding courage and showing complete disregard for his own safety, Private Bumbalough crossed the river. While advancing to his objective, in the face of overwhelming enemy fire, he was killed. His magnificent courage and devotion to duty in the face of vastly superior odds served as an outstanding example and an inspiration to all who witnessed his actions."

The concept, which rose above proposals from Maya Lin and Vito Acconci in a competition, establishes a profound sense of compression. Intentionally designed to appear as if the stones were growing up out of the ground, the memorial's pillars taper toward the sky, creating a feeling at once heavy and hopeful. The inscriptions provide an added emotional element. Maya Lin's Vietnam Veterans Memorial in Washington, D.C. (page 54) served as a key reference point for articulating the notion of a mass grave. A sort of sacred space, the memorial feels weighty upon entering, but looking up, perforations of skylight shine in, lightening the mood.

Since its completion, the memorial has hosted annual Memorial Day and Veterans Day gatherings. In the 2017 Kogonada-directed film *Columbus*, it serves as a sort of architectural protagonist, a place where the movie's star, Jin (played by John Cho), goes to reflect on and mourn his ailing architecture-scholar father.

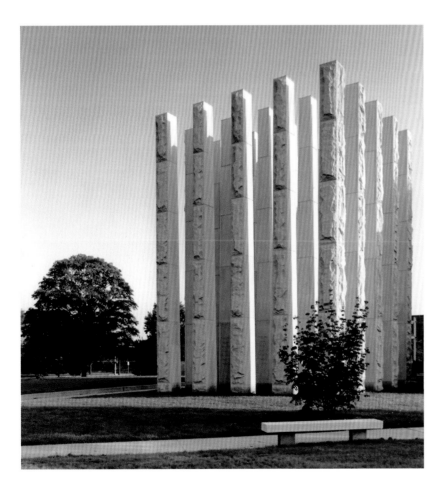

LEFT THE MEMORIAL COMPRISES TWENTY-FIVE PILLARS MADE OF REGIONAL LIMESTONE, ARRANGED IN A FIVE-BY-FIVE GRID.

OPPOSITE COLUMNS FEATURE INSCRIPTIONS OF LETTERS BY ACTIVE SERVICE MEMBERS, COLLECTED FROM FAMILIES AND A LOCAL NEWSPAPER.

AN OCCUPATION OF LOSS

For her first directed performance, the artist Taryn Simon collaborated with architect Shohei Shigematsu and OMA New York to create a large-scale sculpture for mourning. Comprising eleven concrete wells, each 45 feet (13.7 meters) tall and composed of eight stacked rings, the temporary installation effectively formed a massive, organ-like architectural instrument for the thirty professional mourners from around the world who performed each night. On view for twelve days in September 2016 in the Park Avenue Armory's Drill Hall, the hulking, somber silos—made of 675,000 pounds (306,000 kilograms) of cast concrete and arranged in a semicircle—were built not as a physical embodiment of loss or grief, but rather as a means to establish an abstract, sonically, and aesthetically powerful environment for the performers. Described by OMA as a "ready-made ruin," the pipes were inspired by *dakhmas*, or towers of silence: circular, raised structures built by Zoroastrians for excarnation. Inside each well was a seating ledge for the mourners.

During the unscripted performances, fifty visitors were allowed in thirty minutes at a time, ducking in and out of the towers through half-height entryways, while the mourners sang, lamented, wept, wailed, and cried. Working with linguists, musicologists, anthropologists, and field workers, Simon was able to identify the mourners (many of whose rituals go back to pre-Christian and pre-Islamic eras) and, with the help of translators and fixers, hire them, filing petitions with U.S. Citizenship and Immigration Services for P-3 visas and documenting the application process in detail. Among the performers creating the potent, harmonic cacophony of sound throughout the vast space were Buddhist monks from Bhutan, a blind Ecuadorian accordion player, and a trio of Greek polyphonic singers. At the end of each performance, left in complete silence, visitors exited with a palpable sense of emptiness and void.

RIGHT THE ORGAN-LIKE INSTALLATION'S ELEVEN CONCRETE WELLS, EACH 45 FEET (13.7 METERS) TALL, WERE COMPOSED OF EIGHT STACKED RINGS.

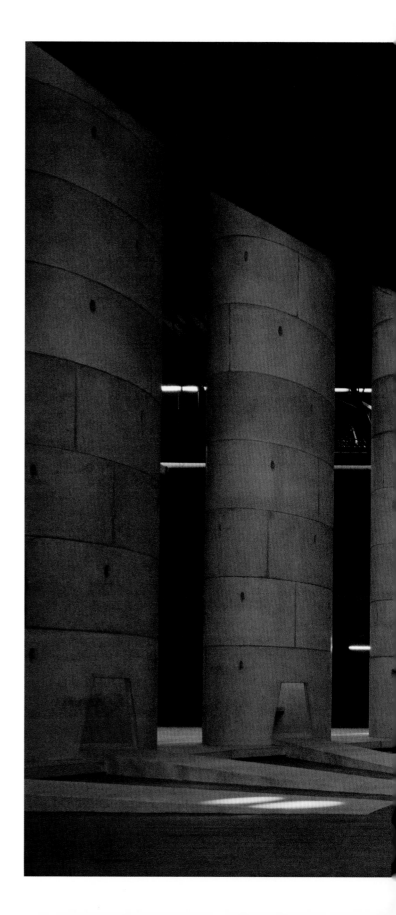

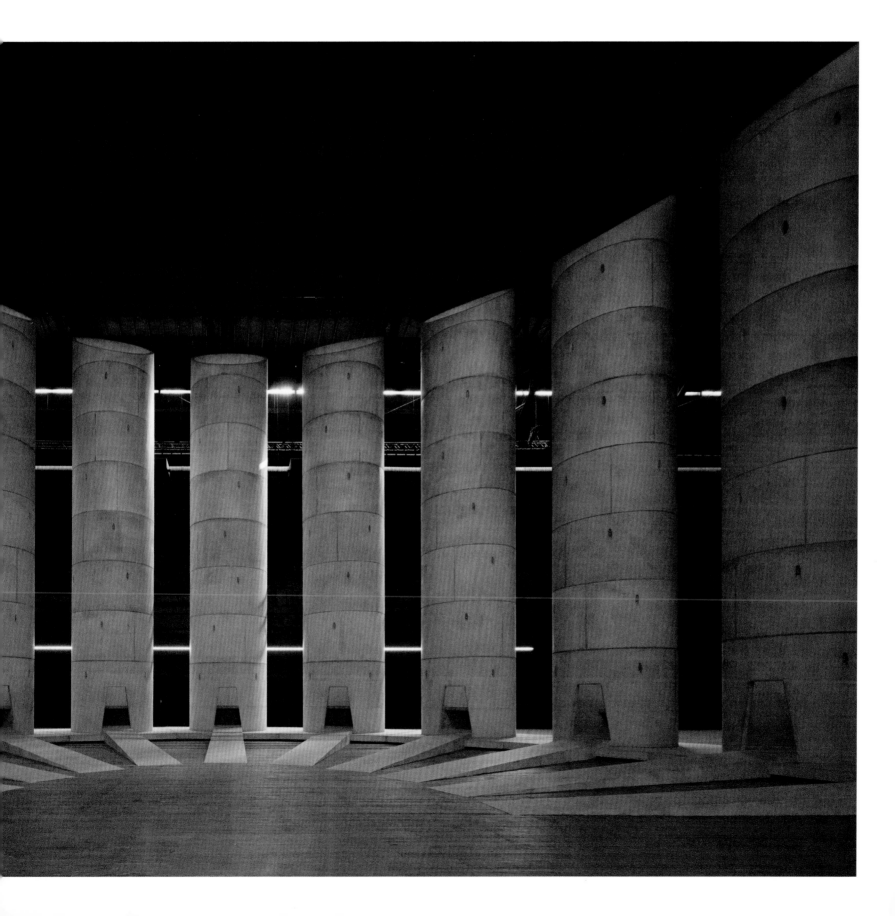

SMITHSONIAN NATIONAL MUSEUM OF AFRICAN AMERICAN HISTORY AND CULTURE

Overcoming nearly a century of bureaucratic hurdles, the Smithsonian National Museum of African American History and Culture testifies to resilience, progress, and hope. The impetus for the institution dates back to 1915, when black Union Army veterans formed a "colored citizens' committee." This continued in the 1920s with a design for a "National Negro Monument," an idea that in 1929 gained governmental support but ultimately languished. In 1966, the effort restarted, with Congress establishing a commission to study the feasibility of a "National Negro History Museum," and by the mid–1980s a campaign for a national museum on the National Mall began in earnest. The proposed bills to accomplish this, however, failed to pass. In 2001, a commission was again created to study the feasibility of a national museum. This time, President George W. Bush signed the bill, and by November 2003 the National Museum of African American History and Culture Act was enacted. In 2005, Lonnie G. Bunch III was hired to be the museum's founding director. Creating the institution—called the Smithsonian National Museum of African American History and Culture (NMAAHC)—from scratch, Bunch spent the next decade shaping it into a potent place of reconciliation and healing, helping to raise hundreds of millions of dollars and forming a 35,000–object collection. The museum was opened by President Barack Obama in September 2016.

Located on a 5–acre (2–hectare) site on the Mall, just 800 feet (240 meters) from the Washington Monument and in the shadow of the White House, the 420,000–square–foot (39,000–square–meter) NMAAHC floats on the landscape as a dark, ethereal presence—in sharp contrast to the the area's squat buildings rooted in Neo–Classical tradition, many of which are made of white stone or concrete. Featuring a three–tiered facade evoking a crown motif from ancient Yoruba sculpture and bronze–colored cast–aluminum panels that reference ironwork by Southern slaves, the architecture on the outside alludes to the complex narratives displayed inside. (Some say the Modernist exterior also symbolizes hands lifted in prayer.) At the entrance, next to a water feature, is a covered outdoor "porch," a subtle nod to the Southern architectural convention. In its abstraction, the building becomes a memorial; indeed, its form carries deep weight and meaning not unlike Maya Lin's nearby Vietnam Veterans Memorial (page 54).

Designed by the Ghanaian–British architect David Adjaye as lead designer for the Freelon Adjaye Bond SmithGroup—the NMAAHC was the result of an inter-national architecture competition with firms such as Foster + Partners, Diller Scofidio + Renfro, and Moshe Safdie as finalists. Adjaye, who had already spent ten years exploring the cultural and architectural heritage of Africa, and who closely studied work of the Mall's planner, Pierre Charles L'Enfant, conceived a multilay-ered, contextually sensitive symbol.

Inside, the building houses galleries displaying more than 3,000 artifacts, a 300–seat theater, a shop, storage rooms, and administrative offices. After walking through the vast glass–walled lobby, visitors begin by taking an elevator 65 feet (20 meters) underground to the museum's "crypt," as Ajdaye has described it, home to 60 percent of the interior. From there, they work their way back up five subterranean levels, through a chronological presentation that includes everything from a reconstructed slave cabin, to Emmett Till's casket, to a segregated railway carriage, to a reconstructed *Oprah* set. Above ground, pivotal exterior views emerge as visitors migrate upstairs, ascending through exhibition floors that feature objects related to sports and the military and, on the top level, art and music.

Through both its architecture and contents, the NMAAHC stands proudly, if quietly, defiant. A literally and figuratively uplifting setting, it fills a long–empty void in the nation's consciousness, bringing visitors up out of the ground and into the light.

OPPOSITE THE NMAAHC'S "CONTEMPLATIVE COURT" FEATURES A MEDITATIVE CYLINDRICAL FOUNTAIN THAT RAINS INTO A POOL IN THE CENTER OF THE ROOM.

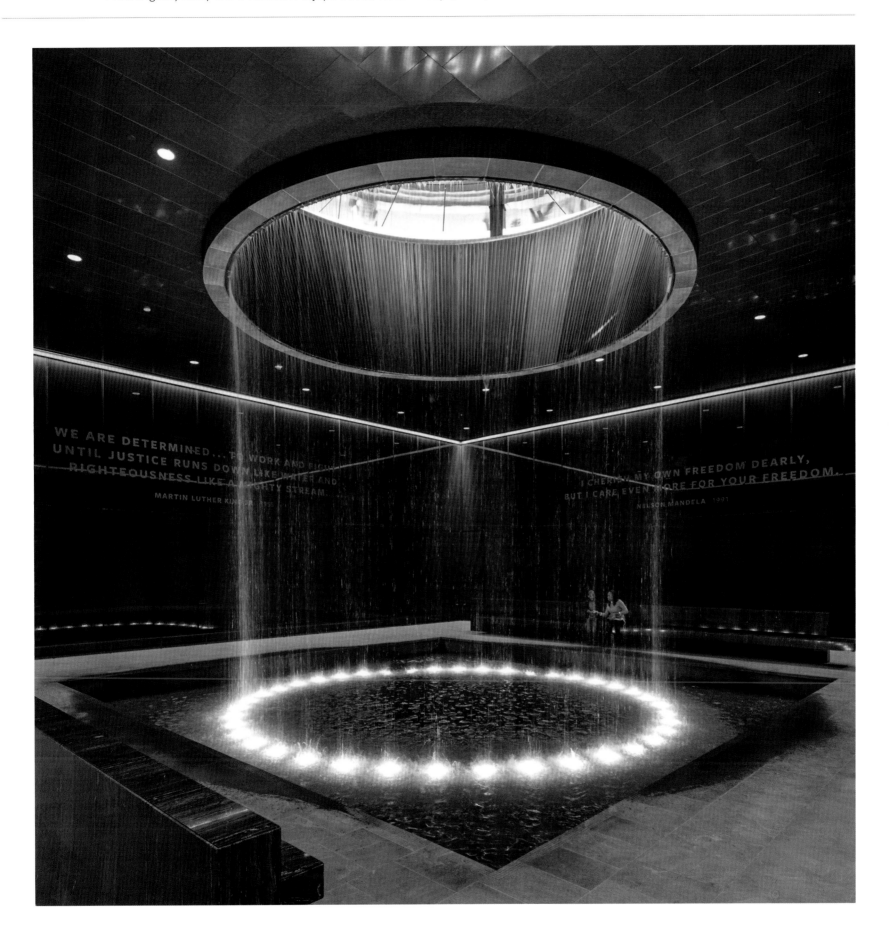

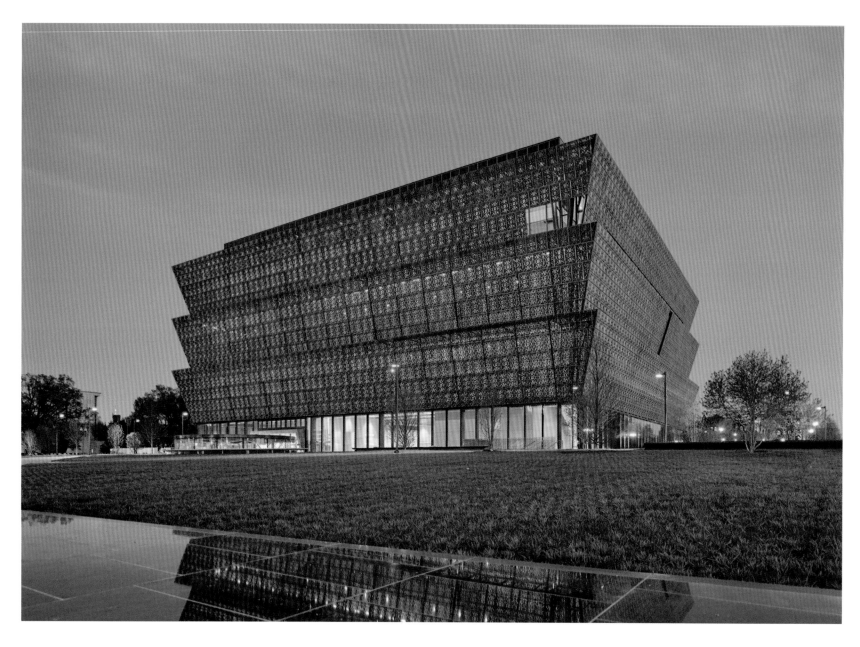

Nearly a century in the making, the Smithsonian National Museum of African American History and Culture testifies to resilience, progress, and hope.

TOP THE THREE-TIERED FACADE WAS PARTLY INSPIRED BY A SCULPTURE BY THE EARLY-TWENTIETH-CENTURY YORUBAN ARTIST OLOWE OF ISE

OPPOSITE THE BUILDING'S MAIN ENTRANCE INCLUDES A WATER FEATURE AND, PICTURED HERE, A SHADED "PORCH."

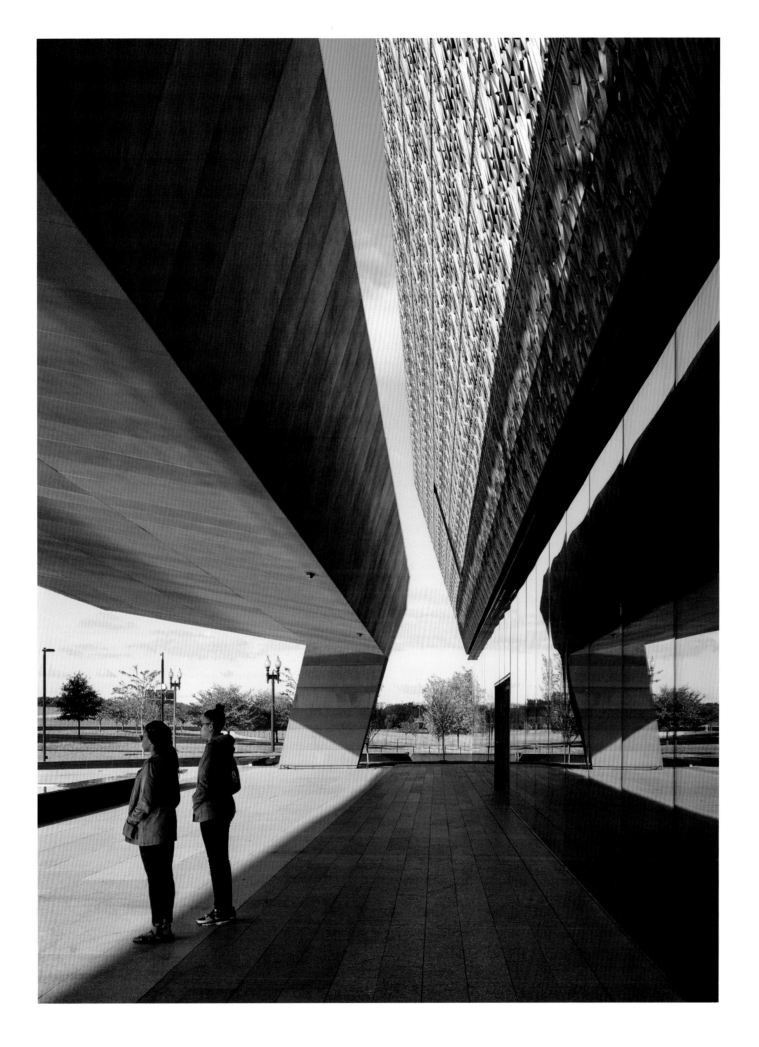

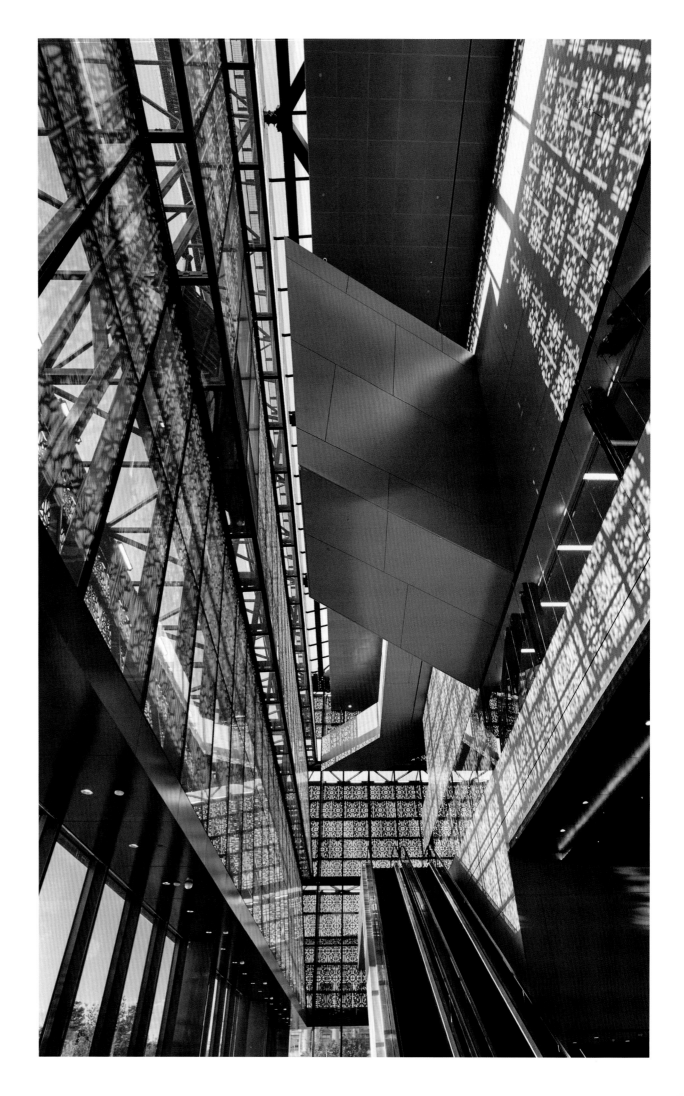

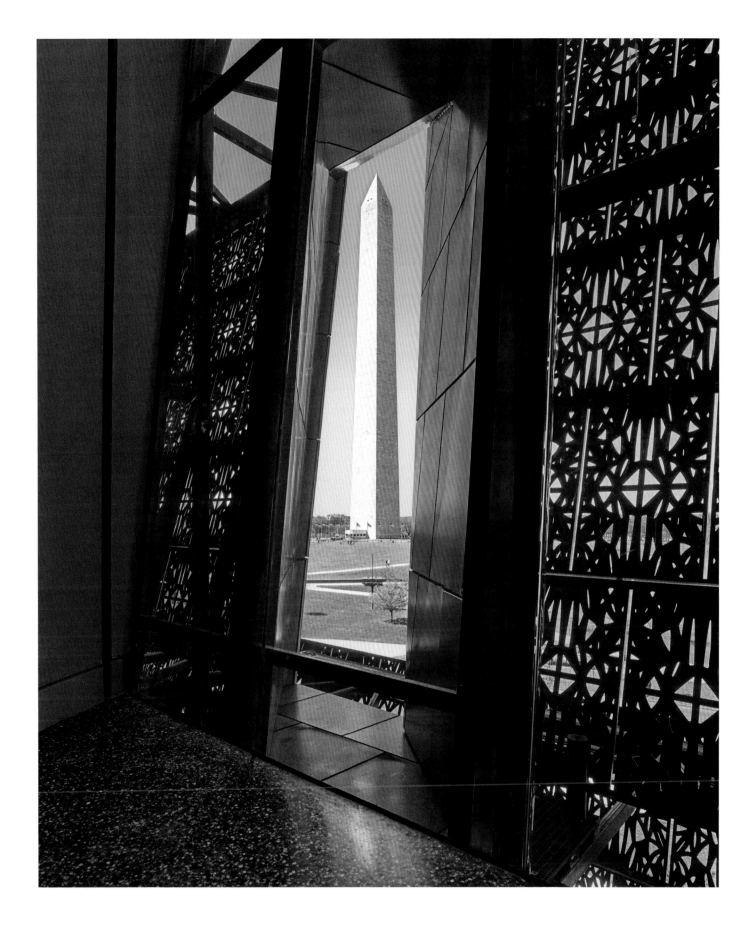

ABOVE THE FACADE CLOSELY (AND INTENTIONALLY) MATCHES THE 17-DEGREE ANGLE OF THE WASHINGTON MONUMENT'S CAPSTONE.

OPPOSITE NATURAL LIGHT FILTERS INSIDE IN A POETIC WAY, CREATING VISUALLY ARRESTING SHADOWPLAY THROUGHOUT THE ATRIUM.

HOPE
STRENGTH
GRIEF
LOSS
FEAR

When walking through memorials, especially those depicting war and mass violence, fear can kick in. At Holocaust memorials in particular, fear is a constant. The reality is that the events being interpreted could happen again. Combined with designs intentionally built to evoke visceral emotion, these spaces and places can induce dread.

At Elmgreen & Dragset's 2008 Memorial to the Homosexuals Persecuted Under the National Socialist Regime (page 82) in Berlin's Tiergarten, for example, the somber concrete block with a viewfinder—standing in stark contrast to the surrounding park—draws visitorsin. I'd already read about the memorial, so I vaguely knew what I'd see when I looked inside the aperture: a black-and-white film of two men kissing with gruesome images of Nazi horrors scrolling behind them. What I wasn't prepared for was the jarring clash between love and brutality. Watching it elicited anxiousness, discomfort, and fear. The video work is meant to be hopeful somehow, but the inhumanity of the Holocaust images is hard to shake—especially when juxtaposed with the two men kissing.

Across the street, at the rigid grid of concrete slabs that is Peter Eisenman's 2005 Memorial to the Murdered Jews of Europe (page 28), a similar sense of discomfort came over me. At moments, I would even describe what I felt as fear—an abstract sense of how disorienting being Jewish during the Holocaust was. The terror they must have felt was, like the memorial's rows and rows of columns, mysterious, incomprehensible, imposing, and seemingly unending. Spend enough time at the Eisenman memorial,

though, and fear will quickly dissipate: I overheard a giggling twenty-something scream, "Work it!" as another, who was in high heels, posed for a photograph. I saw several selfie-takers, too. Clearly, any sense of fear was lost on them. Their interactions with it changed my experience as well. In its abstraction, the memorial, for some, serves as a serene Minimalist backdrop, and for others, a solemn setting.

Other fear-laden sites in Berlin include Ursula Wilms and Heinz W. Hallmann's 2010 Topography of Terror (page 152), situated on a property that was once home to the Nazis' secret police headquarters, and Micha Ullman's 1995 The Empty Library (page 204), a memorial to a 1933 book-burning by the Nazis, located underground in the middle of a public square and visible through a thick pane of glass.

At Latz + Partner's 2018 Memorial Place (page 62), on what was the second-largest satellite camp of Dachau, in the Bavarian town of Mühldorf, Germany, a particular sense of despair and unease is articulated through nature. At the site of a former mass grave there, the firm created a clearing, leaving only the stumps of trees, cut exactly to 5.5 feet (1.7 meters). Humanlike in scale, the stumps manage to arouse the fear that those in the camps went through, making it chillingly comprehensible.

BOLOGNA SHOAH MEMORIAL

Installed on a square next to Bologna's railway station, the city's memorial to the Holocaust stands on the site of a 1980 neo-fascist terrorist attack that killed eighty-five people. The Bologna Shoah Memorial comprises a symbolic CorTen-steel structure of two symmetrical 32 x 32-foot (10 x 10-meter) blocks. Beginning at a width of 5.2 feet (1.6 meters) on one end, the memorial's walls converge on the other end, narrowing to just 31 inches (80 centimeters); this design recalls the discomfiting feeling of walking through the towering concrete blocks of Peter Eisenman's 2005 Berlin memorial (page 28) or Daniel Libeskind's 2001 Garden of Exile at Berlin's Jewish Museum (page 224). On the interior, a grid of horizontal and vertical metal sheets forms "boxes" that reference the geometries of the beds found at concentration camps. The facade, which overlooks the city, resembles a blank page. The path itself is laid with black basalt stone chippings common in roadbeds—representative of the *Judenrampe,* the railroad siding between the two Auschwitz camps where the Jews disembarked from trains. During the day, dim natural light filters in; at night, lamps placed along the interior path dramatically illuminate the volumes inside.

Designed by the Rome-based firm SET Architects, the project, which was constructed in just two months, was the nascent studio's first commission. Selected in an international competition chaired by Eisenman and held by the Jewish Community of Bologna, the memorial, in the architects' words, "abandons rhetorical and didactic conventions in order to emphasize the importance of emotions." The incorporation of CorTen steel connects to this idea: the material naturally rusts in open-air environments, thus corroding and displaying the various subtle traces of time. The result is a quiet design that invites reflection, a place that evokes—in a weighty, abstract way—anguish over the dark past of the Holocaust.

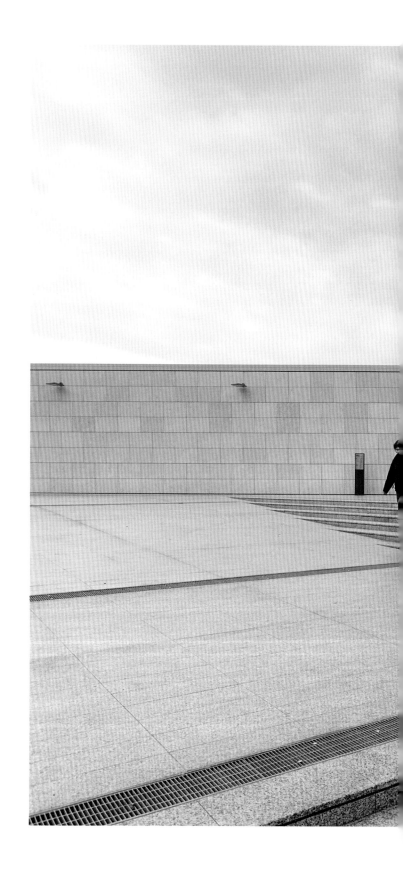

RIGHT LOCATED NEXT TO BOLOGNA'S RAILWAY STATION AND OVERLOOKING THE CITY, THE MEMORIAL RESEMBLES A BLANK PAGE.

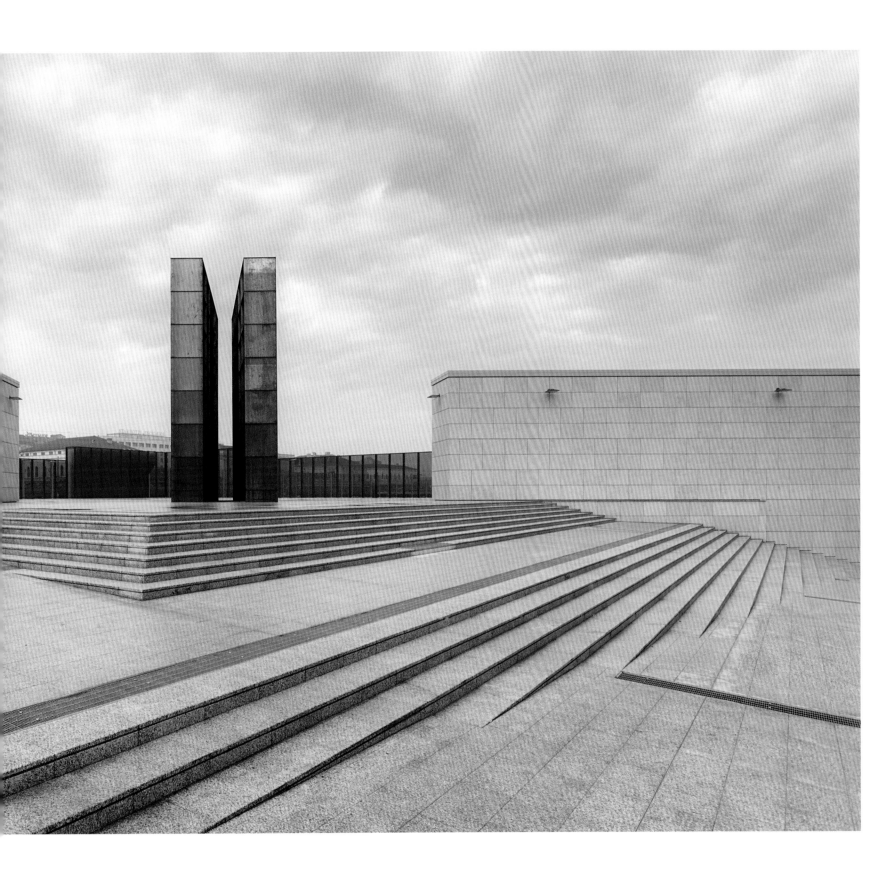

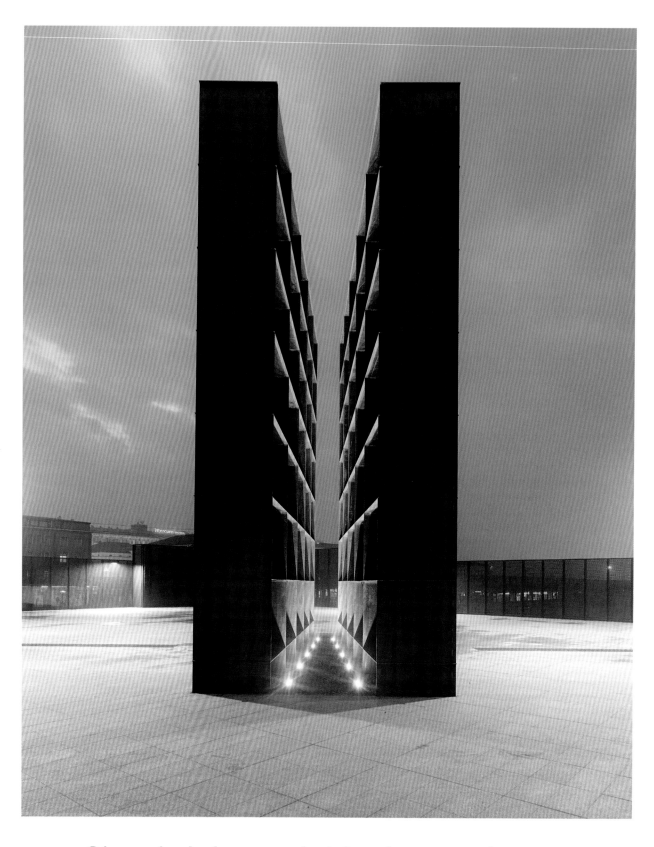

The Bologna Shoah Memorial invites quiet reflection and evokes—in a weighty, abstract way—anguish over the dark past of the Holocaust.

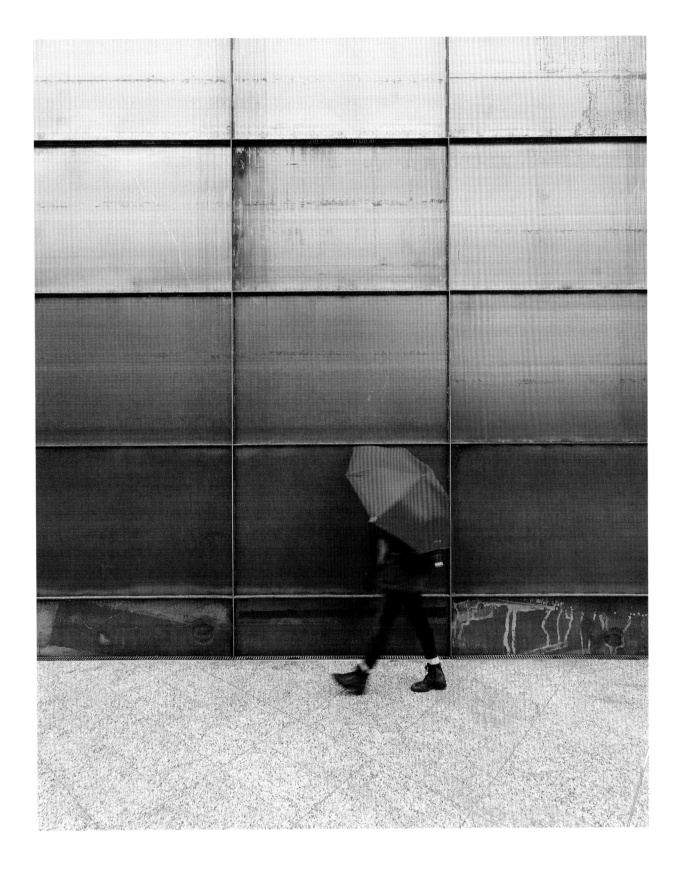

ABOVE THE CORTEN–STEEL STRUCTURE
RISES FROM 5.2 FEET (1.6 METERS)
AT ONE END TO 31 INCHES
(80 CENTIMETERS) AT THE OTHER.

OPPOSITE THE MEMORIAL FORMS
"BOXES" THAT REFERENCE THE
GEOMETRIES OF CONCENTRATION
CAMP BEDS.

THE EMPTY LIBRARY

Situated underground in the center of Bebelplatz, a historic public square in Berlin's Mitte neighborhood, through a thick plane of glass, is a memorial to an infamous book burning that took place on May 10, 1933. Around 70,000 members of the National Socialist Students' Union and professors at Friedrich Wilhelm University (now Humboldt University), as well as figures from the SA and SS, burned roughly 20,000 books that they deemed "against the German spirit." Titles by Jewish, communist, liberal, and socially minded authors, journalists, philosophers, and academics—including August Bebel, Sigmund Freud, Karl Marx, Bertha von Suttner, and Stefan Zweig—were among those destroyed, selected according to blacklists made by the librarian Wolfgang Herrmann.

A visually arresting, heartbreaking work by Israeli sculptor Micha Ullman, the installation is harrowing in its simplicity, exacting in its messaging, and timeless in its aesthetic. The 16 x 16 x 16–foot (5 x 5 x 5–meter) underground space depicts a towering, white-walled, empty-shelved library built of concrete cases to house those 20,000 books that went up in flames. Because of its subterranean location, the memorial, unveiled on March 20, 1995, calls little attention to itself: a quiet but potent reminder of the loss.

Two bronze plaques nearby, also set into the ground, elaborate with a quote from Heinrich Heine's 1820 tragedy *Almansor*:

> *That was but a prelude;*
> *where they burn books,*
> *they will ultimately burn people as well.*

Illuminated at night, the memorial becomes all the more powerful in darkness. Unlike Peter Eisenman's nearby 2005 Memorial to the Murdered Jews of Europe (page 28), which immediately strikes passersby with its gargantuan grid of gray columns, Ullman's humble book-burning memorial carries significant weight for the opposite reason: it's underfoot and behind glass, and therefore inaccessible. Onlookers can't touch it or walk through it. They can only stare in wonder at the absence and emptiness.

Micha Ullman's memorial to an infamous Nazi book burning is harrowing in its simplicity, exacting in its messaging, and timeless in its aesthetic.

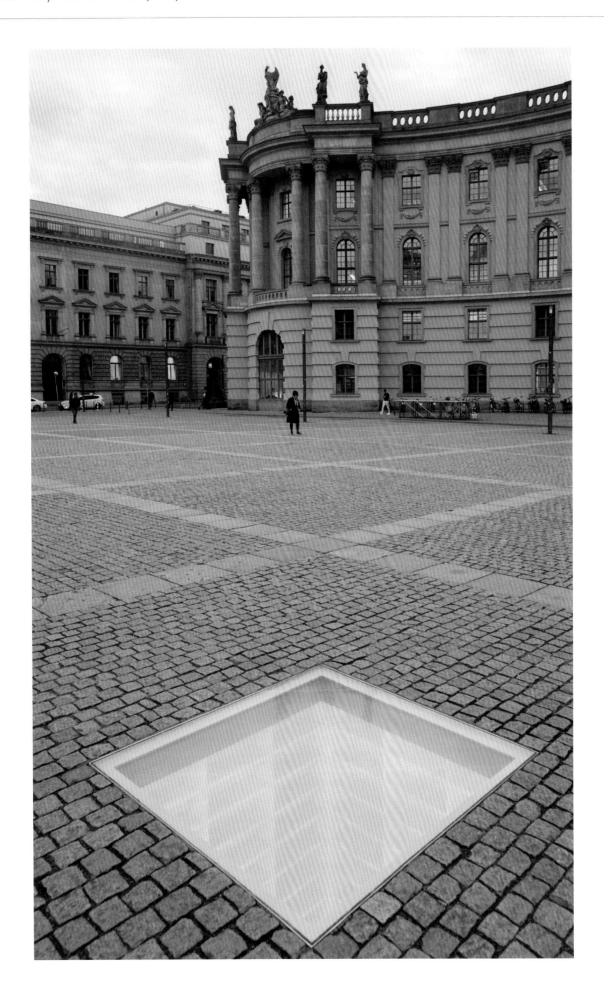

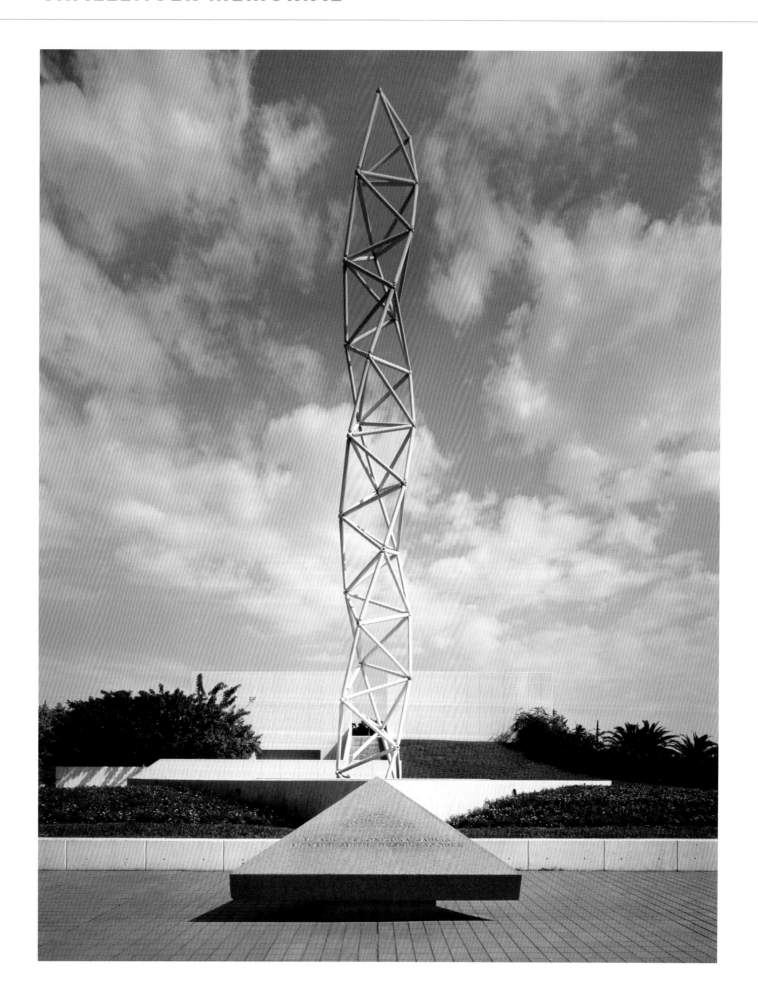

Located in the southwest corner of Miami's Bayfront Park, the Challenger Memorial reaches 100 feet (30.5 meters) high in the form of a tetrahelix. One could easily mistake the spiraling steel, white-painted sculpture, made of thirty-one tetrahedrons, as the work of Buckminster Fuller. It is actually by his longtime friend and creative compatriot, Isamu Noguchi, who was inspired by both Fuller as well as by Vladimir Tatlin's unbuilt design for the Monument to the Third International (1919—20). A tribute to the seven astronauts who died in the 1986 Challenger space shuttle explosion, it was built to resemble a DNA molecule—Noguchi's way of suggesting a continuity of nature. At the base is a granite triangle engraved with the names of the astronauts.

One of Noguchi's final works, it was his last public monument to be built before his death on December 30, 1988. The memorial was officially unveiled at a ceremony in January 1989. Shoji Sadao, an architect and longtime friend of both Noguchi and Fuller, oversaw the completion of the sculpture, which was part of a larger Bayfront Park plan for which Noguchi was commissioned by the city of Miami in 1978. Despite a slew of bureaucratic obstacles over the decade to come, Noguchi and Sadao saw through about three-quarters of the park plan.

One notable element of the memorial faltered: an expensive 40-foot (12-meter) wall. Mayor Xavier Suarez, who considered scrapping the project altogether just three months before its unveiling, opposed the wall, resulting in a sort of stalemate between him and Noguchi. The two decided they would return in January 1989 to determine if it was needed. Noguchi's death decided for them, though Suarez told *The Miami Herald* at the dedication, "Maybe Noguchi inspired me from above, but I now think it needs a wall. I think Noguchi might have had a point." The wall was never built.

A quiet tribute to the astronauts who died in the 1986 Challenger space shuttle explosion, Isamu Noguchi's memorial carries a calming, graceful presence.

OPPOSITE LOCATED IN MIAMI'S BAYFRONT PARK, THE TOWERING, TETRAHELIX-SHAPED MEMORIAL REACHES 100 FEET (30.5 METERS).

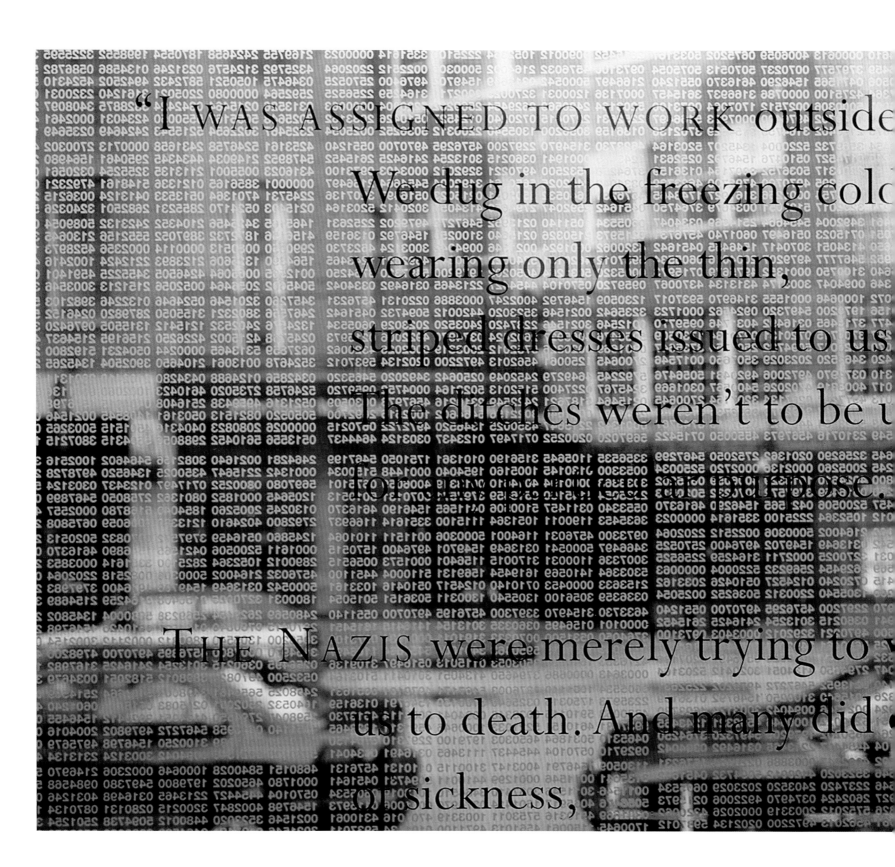

"I WAS ASSIGNED TO WORK outside. We dug in the freezing cold wearing only the thin, striped dresses issued to us. The ditches weren't to be used. THE NAZIS were merely trying to work us to death. And many did of sickness,

Boston, Massachusetts, USA. Stanley Saitowitz (1995)

Stanley Saitowitz's elegant proposal for the New England Holocaust Memorial, next to Boston's City Hall, a hulking Brutalist landmark, rose above roughly 560 other submissions. The memorial was designed around the number six—as in, six million Jews killed, the six-pointed star, the six death camps (Auschwitz–Birkenau, Belzec, Chelmno, Sobibor, Treblinka, and Majdanek), and the six years (1939—45) that the mass extermination took place. Saitowitz dug six pits, lining them with black concrete and arranging six 54-foot-high (16-meter-high) glass-paneled towers in a row, a reference to *yahrzeit* candles, lit in memory of the dead in Judaism, and more loosely to the menorah multibranched candelabra. In total, the towers are etched with 2,280,960 flickering numbers—another subtle reference, to the tattoos found on the arms of Holocaust prisoners.

The fragility of making a memorial in glass—each tower hosts twenty-four panels—was exactly the point. In part, the material choice references *Kristallnacht*, the smashing of Jewish-owned stores, buildings, and synagogues, which took place in November 1938 and resulted in broken glass littering the streets of Nazi Germany. The idea, in the architect's mind, was that the structure be frail enough that if anyone ever damaged it, it would create the same kind of memory as Kristallnacht. The glass is effectively a covenant not to touch it.

For the first twenty-two years of its existence, the memorial remained respected and unscathed, though it had been targeted for destruction in a 2002 white supremacist terror plot. Then, in the summer of 2017, around the same time as a mass-mediated neo-Nazi rally in Charlottesville, Virginia, the memorial was vandalized, twice. The strength and resilient spirit of the memorial—a fitting metaphor for Jewish people—was on full display. Replacement glass panels were soon installed. More remain in storage, at the ready.

LEFT A QUOTE FROM HOLOCAUST SURVIVOR SALLY SANDER, A DRESSMAKER WHO WAS FORCED TO MAKE UNIFORMS FOR GERMAN FLYERS.

209

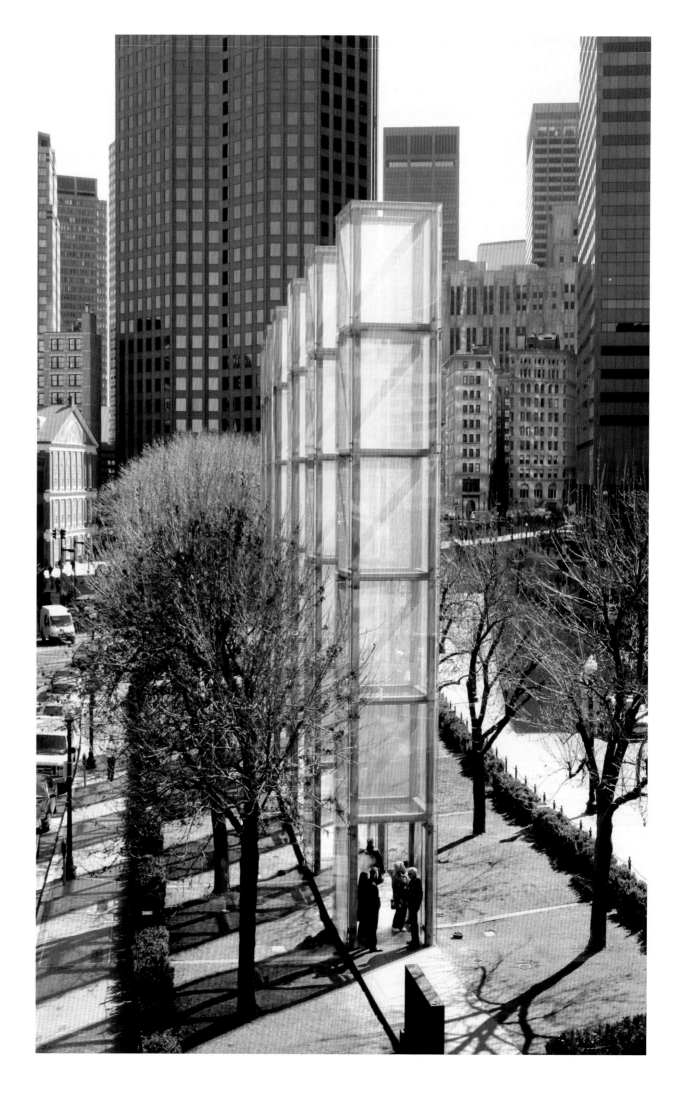

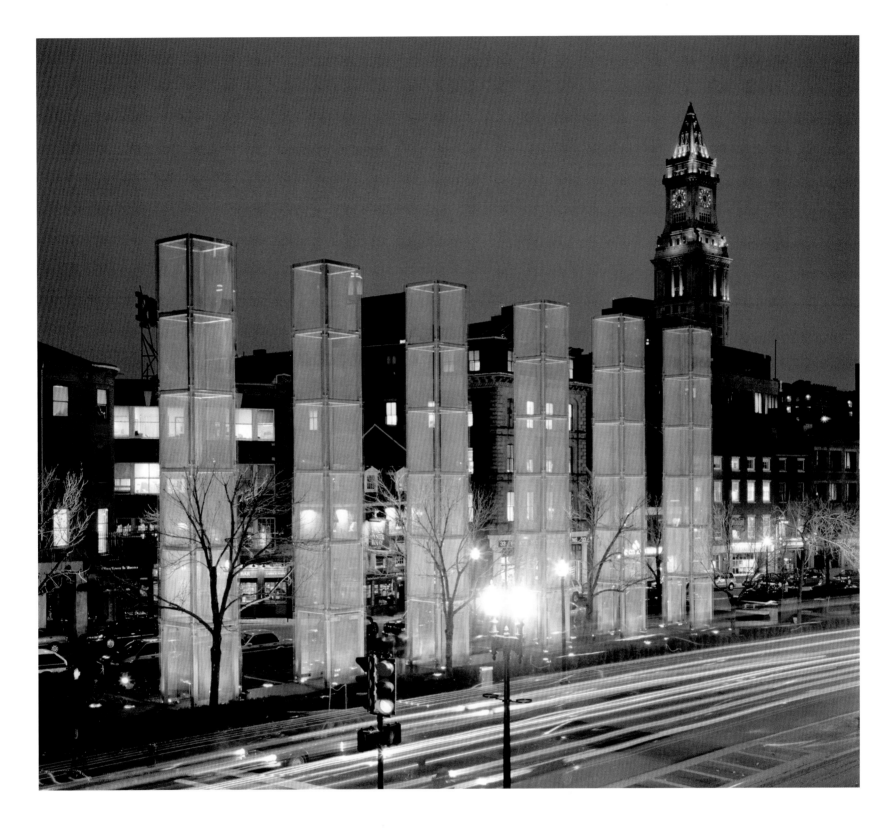

ABOVE ARRANGED IN A ROW, THE SIX
TOWERS REFERENCE YAHRZEIT CANDLES
AND, MORE LOOSELY, THE MENORAH.

OPPOSITE EACH TOWER HOSTS
TWENTY-FOUR GLASS PANELS—
A MATERIAL THE ARCHITECT CHOSE
AS A LINK TO KRISTALLNACHT.

NEW ENGLAND HOLOCAUST MEMORIAL

HIROSHIMA NATIONAL PEACE MEMORIAL HALL FOR THE ATOMIC BOMB VICTIMS

Designing the the Hiroshima National Peace Memorial Hall for the Atomic Bomb Victims—the sister project of a similar 2003 memorial by Akira Kuryu in Nagasaki (page 106)—was a full-circle moment for architect Kenzo Tange. On the same site, in 1949, a group headed by Tange, then an assistant professor at the University of Tokyo, won a competition to design the master plan for Hiroshima Peace Memorial Park, a sprawling, future-oriented complex that came to include the Atomic Bomb Dome, the Cenotaph for the Atomic Bomb Victims (originally to be designed by Isamu Noguchi, but ultimately awarded to Tange), a plaza, a Peace Memorial Museum, Peace Memorial Hall, and Hiroshima City Auditorium. Over the decades, the park would be considered by many critics and historians a Modernist beacon—an exemplar of postwar globalism, merging Western Modernism and traditional Japanese architecture. (In 1991, the museum was repaired, and in 1994 Tange renovated the Peace Memorial Hall; the

two structures now make up the principal buildings of the Hiroshima Peace Memorial Museum.)

For the Memorial Hall—completed in 2002, just three years before Tange's death—the architect was hired by the national government to design a space to "deepen the people's understanding of the calamity of the A-bombing, to hand down the experiences to future generations, and to pay tribute to the deceased victims." Inside the underground 32,300-square-foot (3,000-square-meter) concrete building, a softly lit entrance leads to the circular Hall of Remembrance presenting a panorama of the bombed city. The room's roughly 140,000 roof tiles reference the number of people estimated to have died from the bomb by the end of 1945. An adjacent space features memoirs and photos of those who died—survivor testimonies that add greater context and weight. Above ground, surrounded by water and denoting the time the bomb was dropped on Hiroshima, is the "Monument to 8:15."

Kenzo Tange's Memorial Hall gracefully brings a sense of solace to the incomprehensible violence and loss of the 1945 atomic bombing of Hiroshima.

OPPOSITE (TOP) VISITORS VIEWING BLACK-AND-WHITE PORTRAITS OF THE ATOMIC BOMB VICTIMS IN HIROSHIMA.

OPPOSITE (BOTTOM) INSIDE THE CIRCULAR HALL OF REMEMBRANCE, WHICH PRESENTS A PANORAMIC VIEW OF THE BOMBED CITY.

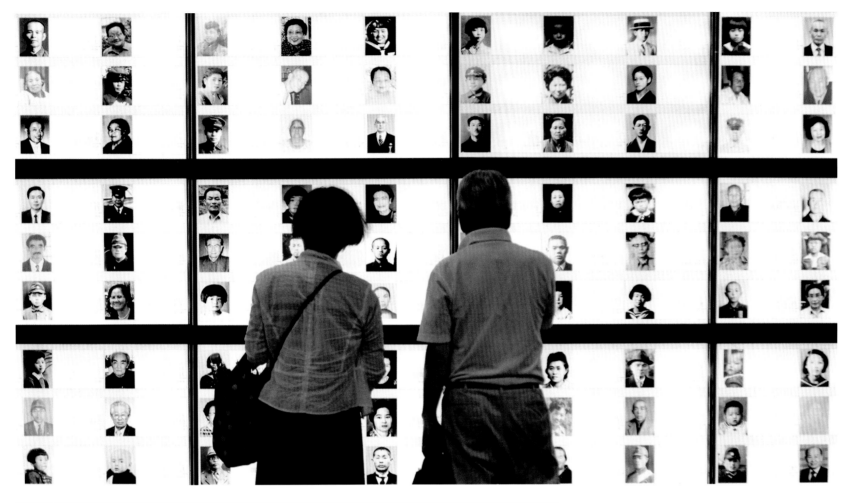

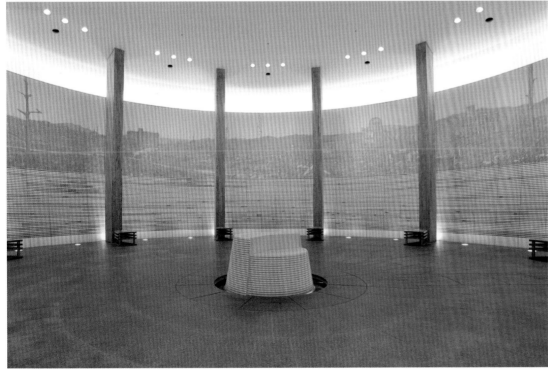

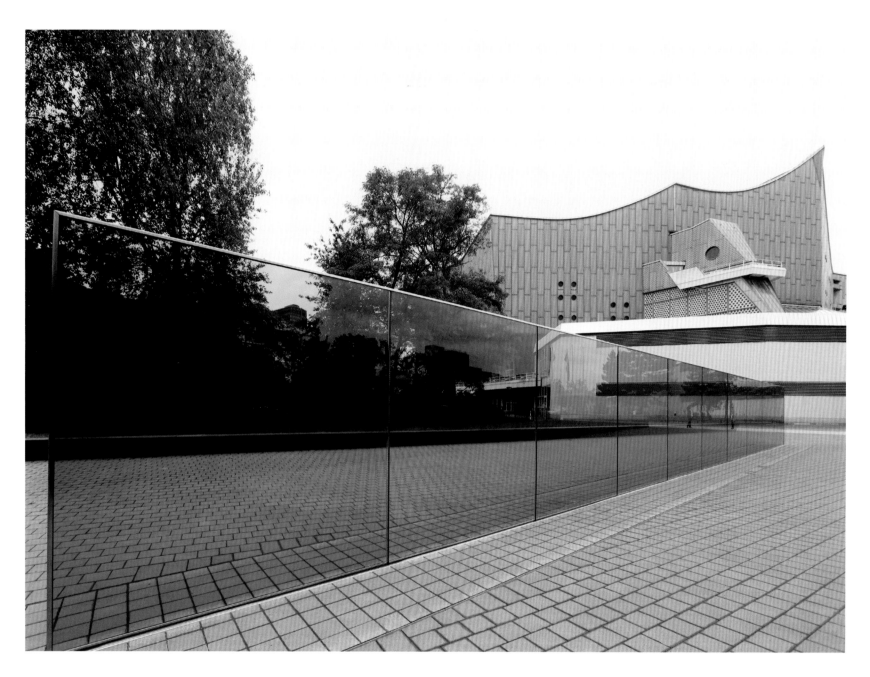

This simple memorial testifies to a stark,
heartbreaking reality: the Nazis' effort
to exterminate those deemed sick,
handicapped, or "misfits."

The Memorial to the Victims of the National Socialist "Euthanasia" Killings commemorates an estimated 300,000 people who, either psychotherapy patients or physically disabled, were deemed "unworthy for life" by the Nazis and then gassed or starved. Designed by architect Ursula Wilms, landscape architect Heinz W. Hallmann, and artist Nikolaus Koliusis, the memorial recalls the jarring atrocities that were planned at a facility on its site on Tiergartenstrasse, next to the city's philharmonic orchestra hall and Richard Serra's *Berlin Junction* (1987) sculpture. Under the codenamed "operation T4" program, more than 70,000 people were killed at six gas chambers in Germany from January 1940 to August 1941. Dozens of Nazi bureaucrats and doctors had worked at the Berlin location, in secret, to commit the mass murder.

This stark reality is given current-world awareness through an open-air installation in the form of an 80-foot (24-meter) blue glass wall set into gridded, gently sloping concrete. A display of information panels with direct, easy-to-read text—an intentional move, so that those with learning disabilities can understand it—testifies the Nazis' effort to exterminate those deemed sick, handicapped, or "misfits." Wheelchair accessibility is another notable facet of the design.

Organized following a vote by the German Parliament in November 2011—which came about after petitioning by surviving family members, including Sigrid Falkenstein—and resulting from a competition, the winning memorial replaced what was long just a bus stop, with only a plaque attesting to the agony that had transpired there. The memorial functions beyond reflection—it is, like so many Holocaust-related memorials, political and, not so surprisingly, government-funded. And necessary. Without it, the Nazis' medical killings could very well be forgotten. Not anymore.

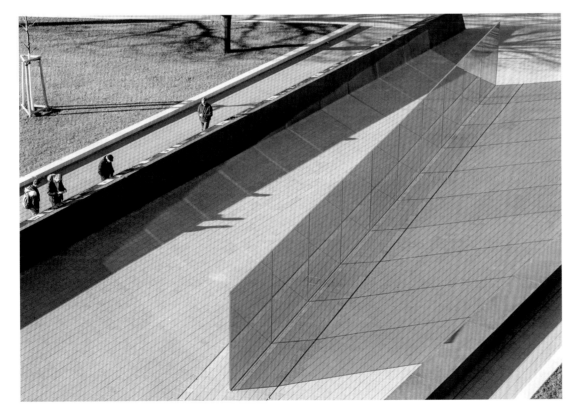

LEFT AN 80-FOOT (24-METER) BLUE GLASS WALL, THE MEMORIAL IS SET INTO GRIDDED, GENTLY SLOPING CONCRETE.

OPPOSITE LOCATED NEXT TO BERLIN'S PHILHARMONIC HALL, THE MEMORIAL IS ON A SITE WHERE NAZIS ONCE PLANNED THEIR "EUTHANASIA" KILLINGS.

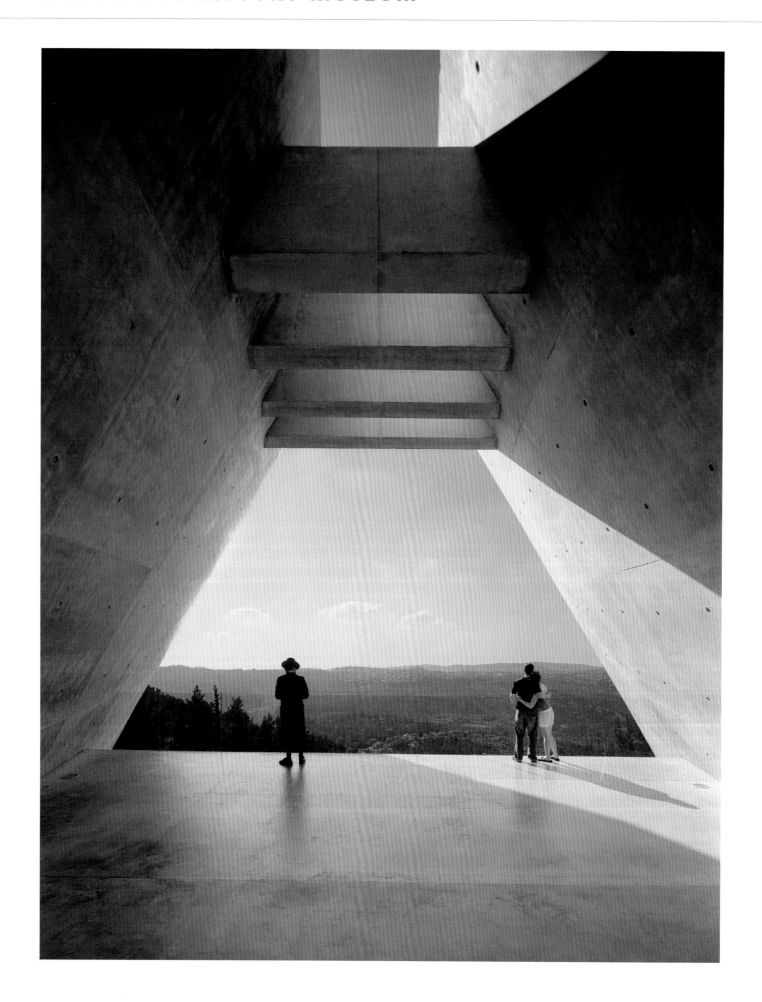

Following the 1993 opening of the United States Holocaust Memorial Museum, which set a new standard for Holocaust memorialization, a major overhaul of Jerusalem's Yad Vashem got under way in the form a new, Moshe Safdie–designed Holocaust History Museum. Established in 1953, soon after the birth of the state of Israel, and formerly known as the Holocaust Martyrs' and Heroes' Remembrance Authority, Yad Vashem organized an exceptional archive, with a library and study center, and built a museum that opened in 1973 (it was among the first of its kind in the world dedicated to the Holocaust). Safdie himself considered it a "sacred site." But within a few decades the program had become, as *The New York Times* described it, "fusty" and "didactic and flat: strictly chronological, like a lesson plan." Safdie's bold building, which took ten years to construct and replaced the existing 1957 building, changed that, creating a space of profound weight, clarity, and meaning.

Mostly underground and arranged into a 200-yard-long (182-meter-long) concrete triangle that cuts through Mount Herzl, the prismatic structure is topped by a skylight that runs along its spine, washing its network of galleries in light. The layout includes a reception building, a hall of names, an exhibitions pavilion, galleries for Holocaust art, a learning center, and a synagogue. On the north side of the site, the building emerges toward Jerusalem, as if it is reaching out. Visitors go down into darkness in the galleries, which slowly reveal themselves, and then rise back up into the light, standing on an open-air cantilevered platform comprising arching, wing-like curves. Originally, Safdie had created a more figurative design: two protruding hands reaching over the valley. The authorities at Yad Vashem found it too figurative and even, potentially, fascist, and after some debate settled on the more abstract option.

Ten years in the making, Moshe Safdie's bold Holocaust History Museum at Yad Vashem carries profound weight, clarity, and meaning.

OPPOSITE ON THE NORTH SIDE OF THE SITE, THE MEMORIAL OPENS TOWARD JERUSALEM, WITH VIEWS OF THE CITY.

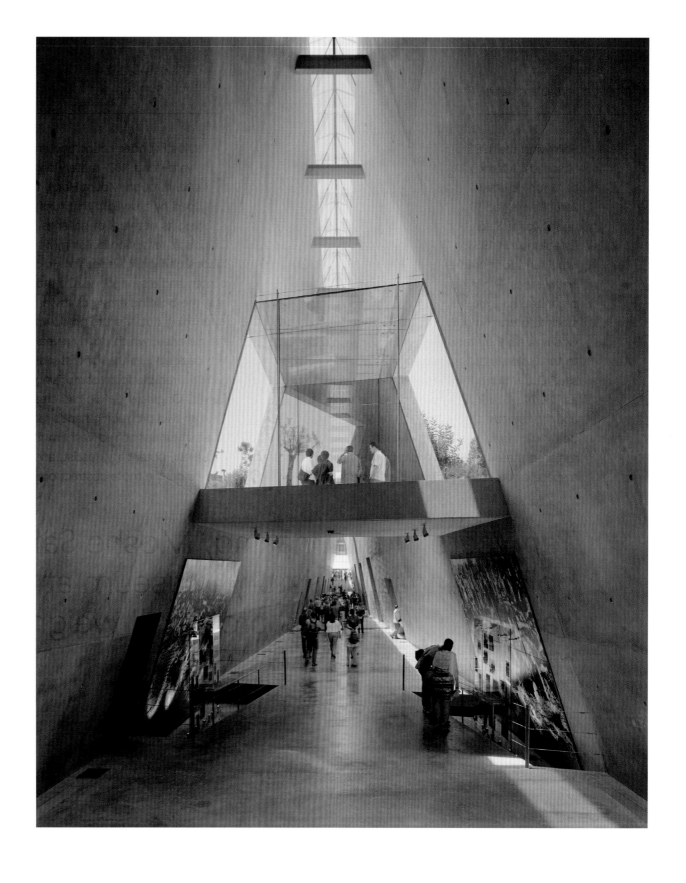

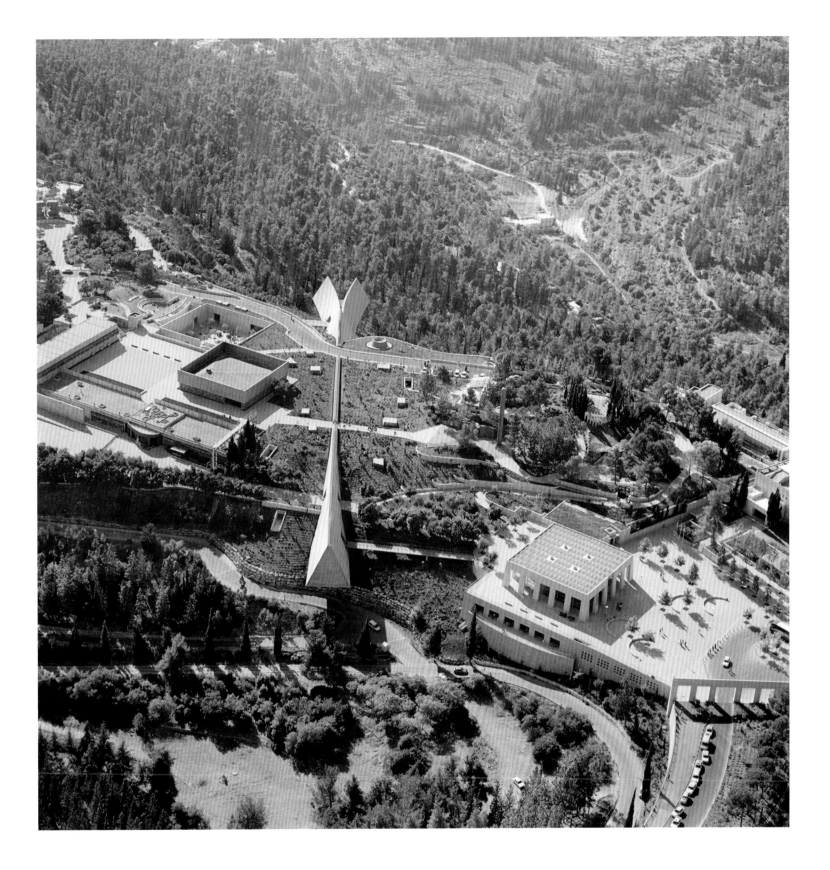

TOP THE MEMORIAL'S 200-YARD-LONG
(182-METER-LONG) CONCRETE TRIANGLE
CUTS THROUGH MOUNT HERZL.

OPPOSITE THE PRISMATIC STRUCTURE
IS TOPPED BY A SKYLIGHT THAT RUNS
ALONG ITS SPINE, WASHING ITS
GALLERIES IN LIGHT.

HOLOCAUST HISTORY MUSEUM

THE INVISIBLE MONUMENT: 2146 STONES— MONUMENT AGAINST RACISM

Beginning in April 1990—together with his students at the School of Fine Arts in Saarbrücken, Germany, where he was a guest lecturer—artist Jochen Gerz undertook what was, at first, a clandestine, guerrilla–style, borderline illegal memorial project. In the dark of night, several of his students would pull out stones from the cobblestone square in front of the Saarbrücken Schloss, the former home of the Gestapo during the Third Reich, and temporarily replace them. The plan: to inscribe the names of all the Jewish cemeteries in Germany that existed prior to the Third Reich on the removed stones and then return them all, installing them face down and thus creating a literal and figurative underground memorial. Its abstraction and void would be its invisibility. As scholar James E. Young writes in his book *Humanity at the Limit*, "The memorial would be invisible, itself only a memory, out of sight and therefore, Gerz hoped, *in mind*." (Through research, and with the help of more than sixty Jewish communities across Germany, the class determined there were 2,146 cemeteries, many that had been destroyed or abandoned.)

As the project was underway, Gerz eventually decided to get official state permission and wrote to the minister–president of Saarland, telling him what he was up to and asking for parliamentary approval and aid. The public soon became aware through media coverage and a furore broke out, with many decrying the work as vandalism. After addressing the Stadtverband Saarbrücken himself, though, Gerz was able to not only get public approval for the work, but the parliament even renamed the site *Platz des unsichtbaren Mahnmals*, or Square of the Invisible Monument—the only visible sign of the memorial's existence. Of 8,000 stones in the square, 2,146 were inscribed. "The invisibility of our monument was like a cure," Gerz once said.

RIGHT THE SQUARE AT THE SAARBRÜCKEN SCHLOSS, HOME TO 2,146 STONES EACH INSCRIBED WITH THE NAMES OF JEWISH CEMETERIES ON THEIR UNDERSIDES.

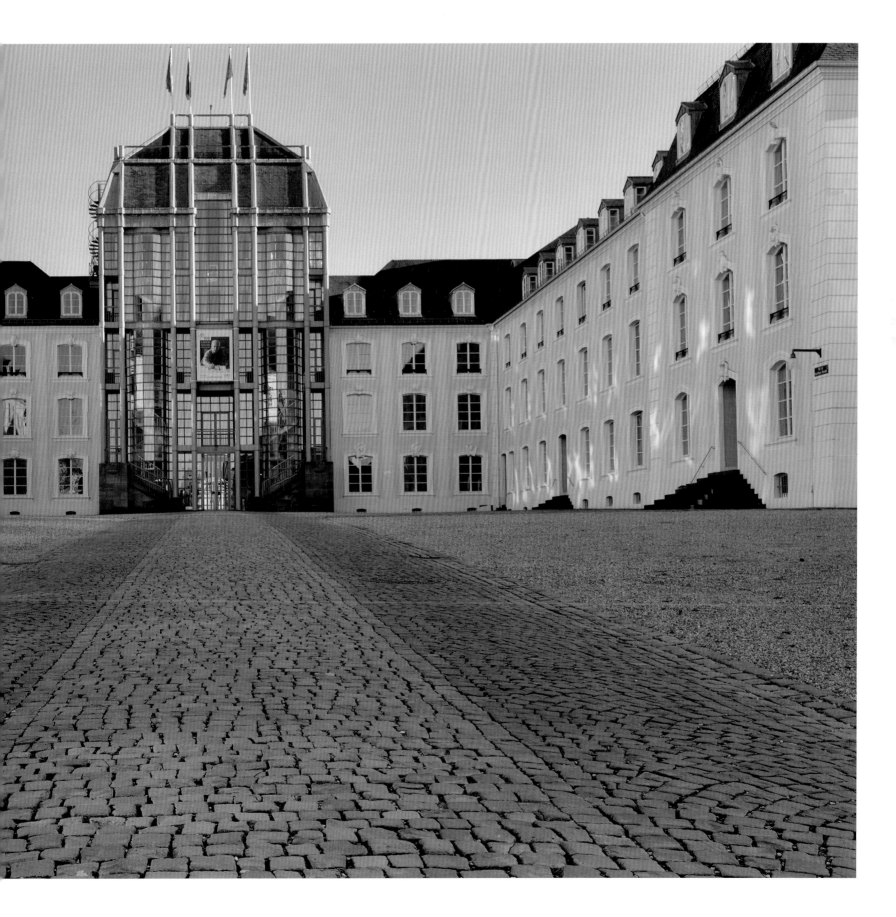

Saarbrücken, Germany. Jochen Gerz (1993)

ALLMANNAJUVET ZINC MINE MUSEUM

The process of constructing the Allmannajuvet Zinc Mine Museum near the town of Sauda, Norway, was not rapid, taking nearly a decade and a half to complete. This is typical of the methodical work of the Swiss architect Peter Zumthor. The site became a kind of archeological dig of the surrounding ravine and the mine that operated there from 1881—99. Zumthor was commissioned by the Norwegian Public Roads Administration to design a tourist-route intervention in 2002; years of site planning and foundation work were required to ensure the buildings would be properly supported on the site's rocky hillside. Comprising a gallery, a café, and a service building—all perched on creosote-coated laminated pine supports, bolted down to steel plates—the site memorializes the 168 miners who strenuously labored away, blasting and excavating the ore out. It also metaphorically mines the place's past, evoking its vanished history through an industrial aesthetic that recalls the structures that were once there.

Similar to Zumthor's 2011 Steilneset Memorial to the victims of the seventeenth century witch trials in Vardø (page 148), which also explores darkness and light, Allmannajuvet establishes a profoundly poetic sense of atmosphere through materiality. Coated in a weather-proofing material called PMMA that was layered over jute mesh, the plywood walls of the structures create an engaging texture and contrast with the surrounding countryside. Zumthor also used zinc throughout, from the engraved site map and the corrugated roof panels, to the heavy doors and the rough-forged door handles—a symbolic link to the site's origins. In the cramped, dimly lit gallery, several of the mine's surviving artifacts, including the head of a pick axe, a lamp, and a shovel, are on display alongside oversized books detailing the site's history, architecture, geology, and vegetation. A narrow 2,600-foot-long (792-meter-long) path leads visitors to the mine itself.

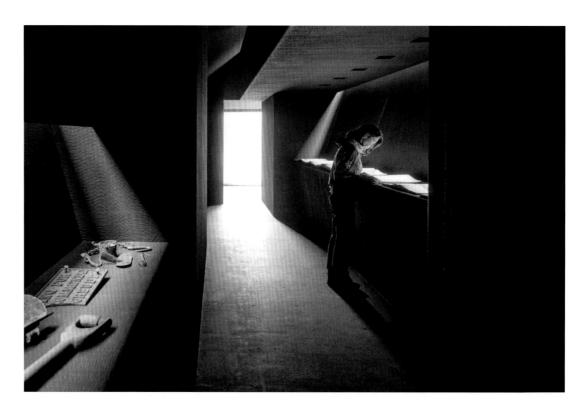

RIGHT A VISITOR LOOKS AT ONE OF THE OVERSIZED BOOKS IN THE MUSEUM'S CRAMPED, DIMLY LIT GALLERY.

OPPOSITE THE GALLERY BUILDING, SEEN FROM THE OUTSIDE, PERCHED ON CREOSOTE-COATED SUPPORTS OF LAMINATED PINE.

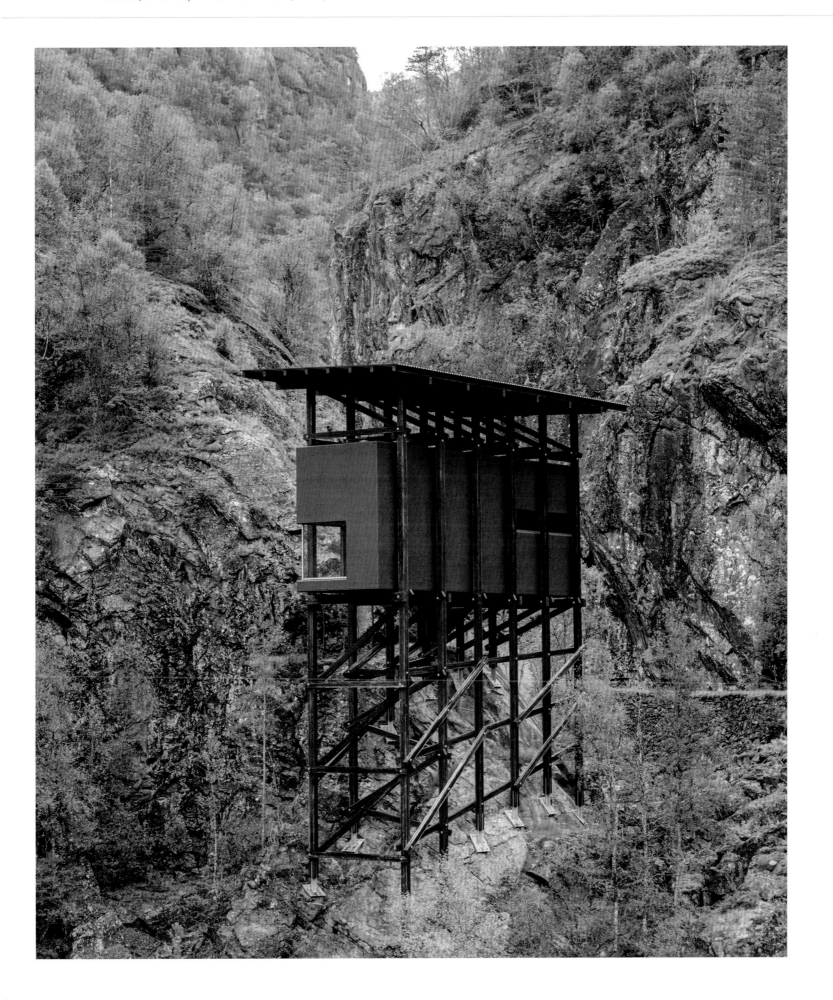

JEWISH MUSEUM BERLIN

In 1989, just five months before the Berlin Wall came down, Daniel Libeskind was named the victor of a design competition—chosen out of 165 submissions—for a new wing of what was then the West Berlin city museum. (The exact brief was for a "Jewish Museum Department" extension, an idea that riled Libeskind.) Already well-known for his bold theoretical drawings, writings, and teachings (his work was featured in the famed 1988 *Deconstructivist Architecture* exhibition at New York's Museum of Modern Art), Libeskind at the time had yet to complete a single building. So it was an especially big win for the Polish-born architect, then in his early forties.

Libeskind's concept was in fact not a wing to the museum's former eighteenth-century Baroque court-house building, but rather a freestanding extension connected through an underground passageway. To actually build the unusual design, which *The New York Times* panned as "bizarre," required tremendous willpower and agile political maneuvering, thanks in no small part to Libeskind's wife, Nina, a shrewd negotiator and stealthy force in the studio. Five Berlin governments would pass through during its construction; one of them, in 1991, even briefly cancelled the project. Construction started in 1992, and in 1999, to wide praise, it finally opened—but as a completely empty building. (The architecture was, after all, chosen before it was decided what to fill it with.) By the time of its official opening in September 2001, with a permanent display covering nearly 2,000 years of German-Jewish history, 350,000 people had already visited the space despite no exhibition having been installed.

When first visualizing the expressive design, Libeskind looked to several references beyond architecture: composer Arnold Schönberg's unfinished opera *Moses and Aaron,* the German Federal Archive's *The Memorial Book for the Victims of the Nazi Persecution of Jews in Germany,* and Walter Benjamin's essay "One-Way Street." The resulting zigzagging zinc-clad building—which Libeskind named "Between the Lines," as if the architecture were a poem or a song—resembles a lightning bolt and has been described as a fractured Star of David. Its skewed geometries and suture-like slashes express the complexity and diversity of the Jewish experience while also evoking a sense of wreckage. Though the museum is, of course, not a Holocaust memorial, its architecture captures the lingering scars and tortured world that the Holocaust left behind—a traumatic landscape of memory and loss. That was the architect's intention, anyway, especially with the "voids," five concrete shafts without heating or air-conditioning that cut through the building's vertical axis. Some critics have come to feel differently: Writing in *The Times* in 2004, Michael Kimmelman bitingly referred to the design as "the epitome of kitsch."

Once underground, visitors are confronted with three crisscrossing corridors: the Axis of Exile, the Axis of the Holocaust, and the Axis of Continuity. At the end of the Axis of Exile, which features artifacts of Jews who fled in the 1930s, is the Garden of Exile, a disorienting space—strikingly similar to Peter Eisenman's 2005 Holocaust memorial (page 28), completed four years later in 2005—comprising forty-nine concrete pillars arranged in a seven-by-seven configuration on a sloping ground (forty-eight of them are filled with dirt from Berlin, the forty-ninth, in the middle, with dirt from Jerusalem); oleaster plants, symbolizing hope, grow on the top of each.

Situated at the end of the Axis of the Holocaust, which features a range of donated letters, photographs, and historical objects, is "Voided Void," or Holocaust Tower, a concrete silo with a sliver of light coming in. The Axis of Continuity leads to a steep eighty-two-step staircase, where visitors continue on, two stories up, to the permanent exhibition. At the very top, after the final eight steps, there's simply a white-walled dead end.

OPPOSITE AT THE END OF THE AXIS OF THE HOLOCAUST, "VOIDED VOID" COMPRISES A CONCRETE SILO WITH A SLIVER OF LIGHT COMING IN.

Berlin, Germany. Daniel Libeskind / Studio Libeskind (2001)

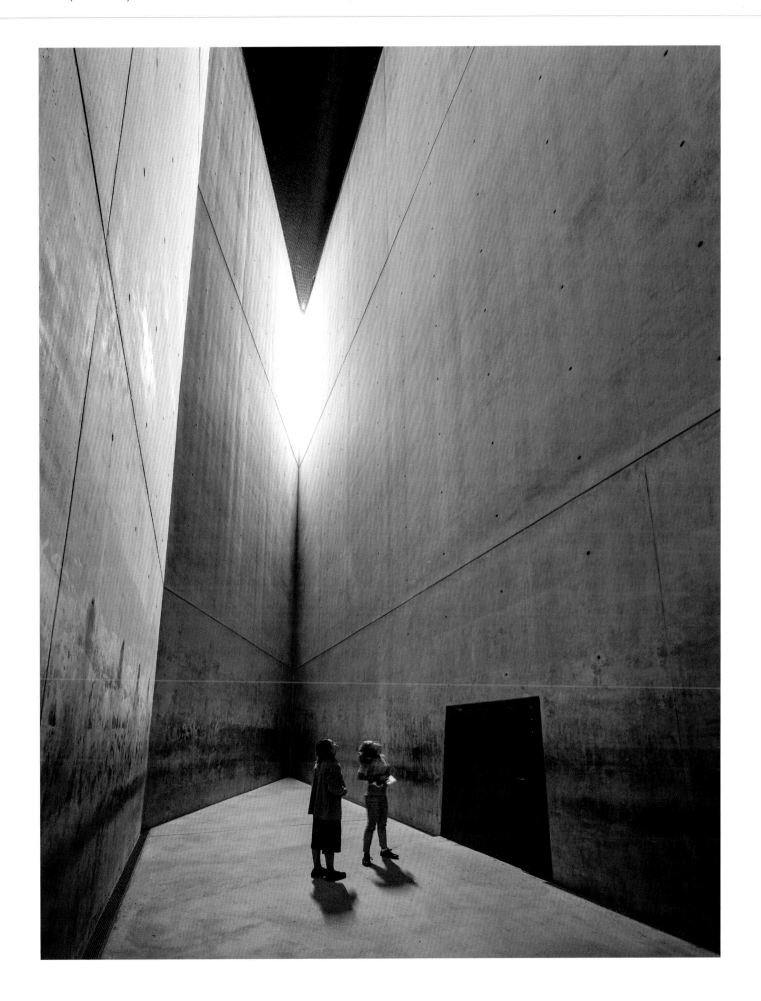

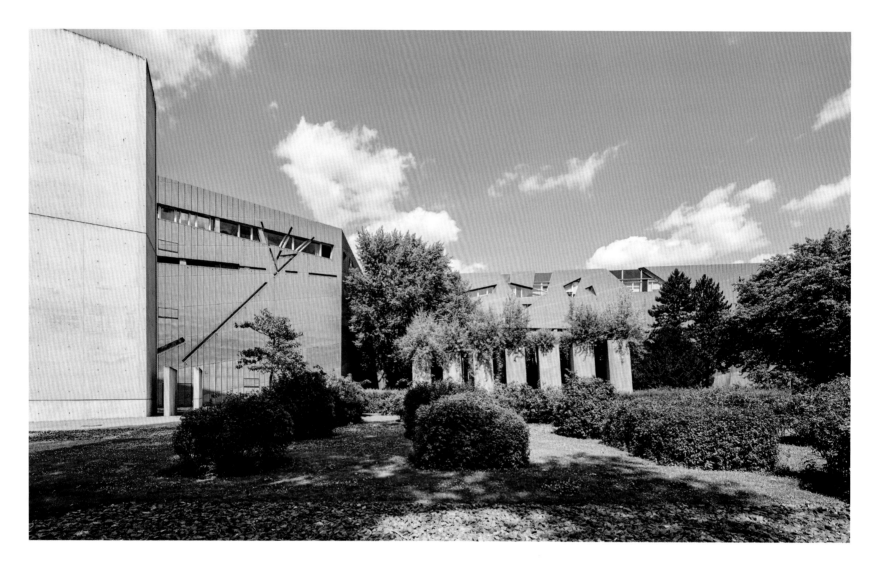

The Jewish Museum's architecture captures
the lingering scars and tortured world
that the Holocaust left behind—a traumatic
landscape of memory and loss.

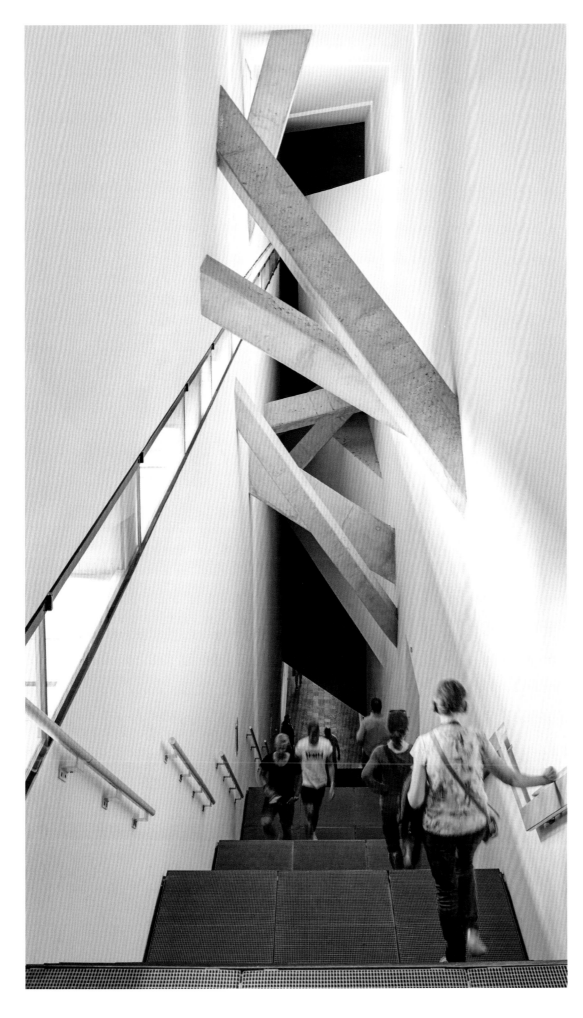

LEFT THE AXIS OF CONTINUITY LEADS TO THIS EIGHTY-TWO-STEP STAIRCASE THAT DELIVERS VISITORS TO A GALLERY AND FINISHES WITH A DEAD END.

OPPOSITE SEEN FROM THE STREET, THE GARDEN OF EXILE FEATURES FORTY-NINE CONCRETE PILLARS ARRANGED IN A SEVEN-BY-SEVEN GRID.

JEWISH MUSEUM BERLIN

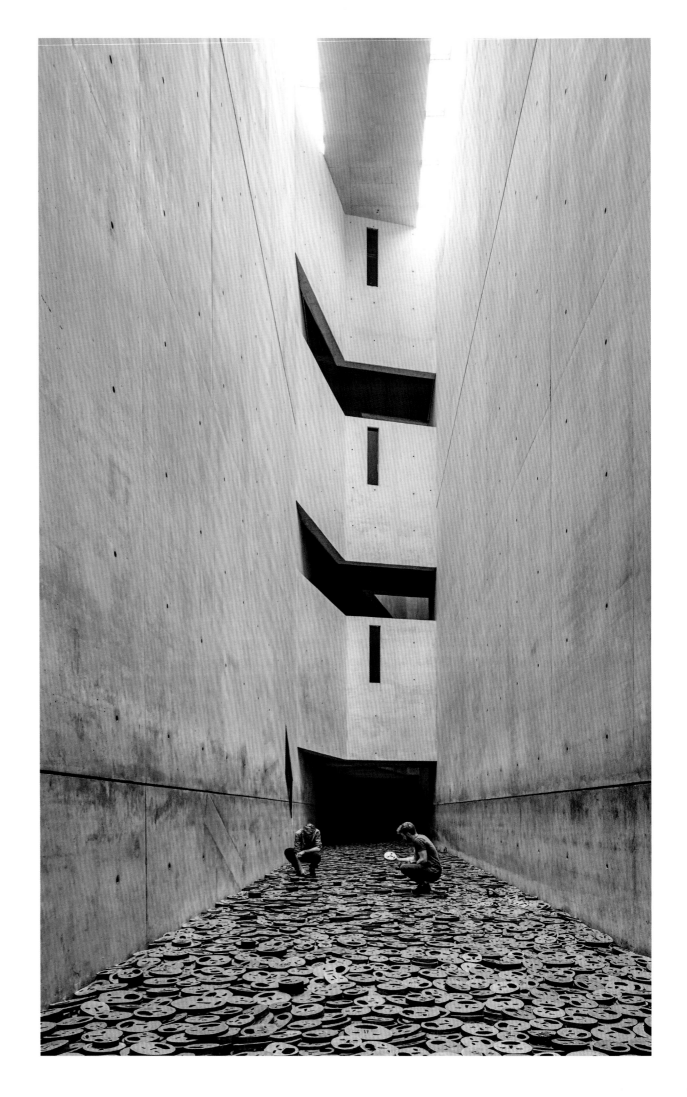

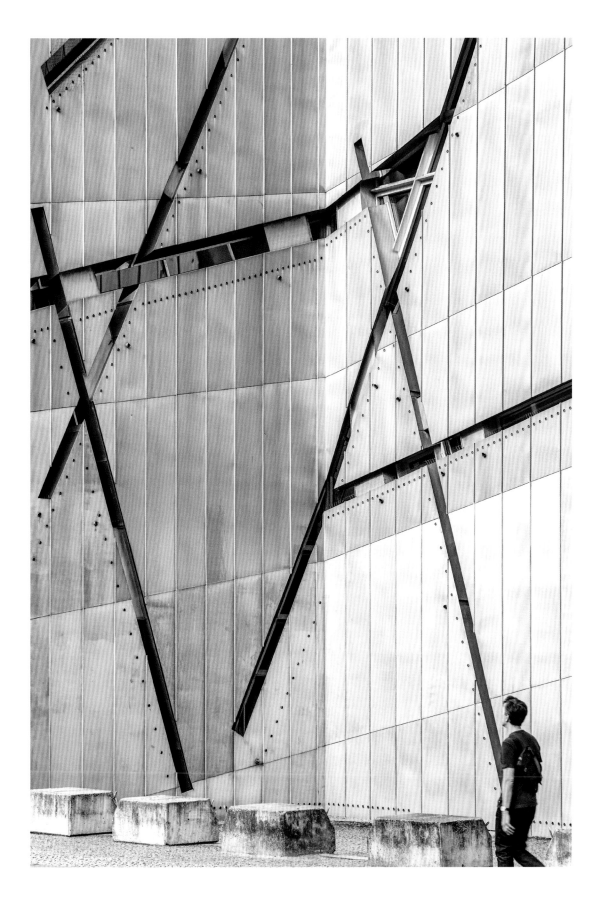

OPPOSITE VISITORS AT MENASCHE
KADISHMAN'S "SHALEKHET"
INSTALLATION INSIDE THE THREE-STORY
"MEMORY VOID."

ABOVE THE BUILDING'S ZIGZAGGING
FACADE IS COMPOSED OF TITANIUM-
ZINC PANELS THAT ADD TO A JARRING
SENSE OF DISORIENTATION.

JEWISH MUSEUM BERLIN

INDEX

Page numbers in *italic* refer to the illustrations

ACKNOWLEDGEMENTS

Due to the emotional weight of the subject matter, this book has been, by far, the most challenging project of my career. It has also been incredibly cathartic.

For thirty years, I mostly kept the story of the crash-landing of Flight 232 to myself, only sharing it with close friends. Largely, this was because I felt like I hadn't processed it fully enough, nor did I want to simply be labeled a "survivor." But in July 2019, following three years of therapy and plenty of reflection—and after building a career as an editor and journalist over the course of a decade—that changed: on the Time Sensitive podcast I co-host with Andrew Zuckerman, he interviewed me about what had happened. I finally felt ready to talk about it openly and with greater perspective. During this period, I had begun work on this book, too, selecting the memorials to be included, conducting the research, and, in time, writing the texts. All of this is to say that it was a complex, nearly lifelong process.

This book would not have been possible without many key people. First, and most importantly, my mom, to whom the book is dedicated and whose creative spirit I hope lives in these pages, and my family: Dad, Brandon, and Trent, thank you—your love and support means more to me than I can put into words.

I'm especially indebted to Captain Al Haynes. Were it not for his actions on July 19, 1989, I would not be here typing this sentence.

And I'm deeply grateful to Andrew, who remained patient and encouraging as I undertook this complicated, at times daunting and draining project—especially in the midst of getting The Slowdown going.

Thank you to Dakin Hart, Brett Littman, and Jennifer Lorch at the Noguchi Museum. And to the museum's former director, Jenny Dixon. Your enthusiasm for Noguchi is contagious.

Thank you to David Adjaye, whose Foreword is an invaluable addition to this book and whose conversations with me over the years have helped reshape my understanding of both memorialization and architecture. And to the various architects and artists who took the time to speak with me for this book: Cheryl Barton, Craig Dykers, Brad Cloepfil, Wes Jones, Daniel Libeskind, Paul Murdoch, Michael Murphy, David Piscuskas, Stanley Saitowitz, Maryann Thompson, and Elyn Zimmerman. And to those whose work is featured from whom I have learned so much during various conversations over the years: Tadao Ando, Elizabeth Diller, David Rockwell, Shohei Shigematsu, and Peter Zumthor.

I'm also deeply appreciative of the various writers, journalists, and scholars whose texts served as a foundation from which to build this book, including Edward S. Casey, Erika Doss, Karen A. Franck, Michael Kimmelman, Sanford Levinson, Edward T. Linenthal, Kendall R. Phillips, Rebecca Solnit, Susan Sontag, Quentin Stevens, Marita Sturken, and James E. Young.

Thank you to Bessel van der Kolk, whose transformational book The Body Keeps the Score I read while writing this one. It completely changed my perspective on trauma. And thank you to Susanna Stephens for helping me as I continue to unpack the layers of my own loss and grief.

Thank you to Stephanie Goto, who helped me come up with the Hope, Strength, Grief, Loss, and Fear themes of this book's essays.

Thank you to Fallon, an incredible mother who is among the strongest, most gracious people I know. I hope you know how much your guidance through this emotionally intense writing process has meant to me.

I'd like to extend my deep appreciation to Elizabeth Beers and Brian Janusiak for introducing me to Louis Bickford, whose wealth of knowledge about memorials and memory helped me know I was on the right track.

And thank you to Sarah Arison, Diana Budds, Alexandra Cunningham Cameron, Julia Cooke, Mary Corman, Casey Fremont, Shruti Ganguly, Cena Jackson, Blanca Guerrero, Tiffany Jow, Mitchell Joachim, Monica Nelson, James Matschulat, Dung Ngo, Ingrid Moe, Clare Connor, James O'Reilly, Jeanine Celeste Pang, Aaron Schiller, Daphne Seybold, Sina Sohrab, Robert Stadler, and Marlies Verhoeven and Lily Wan for your enthusiasm, insight, and inspiration.

Last but not least, I want to thank the team involved in the realization of this beautiful book: Michael Bierut at Pentagram and Laitsz Ho for the exquisite layout design; Rebecca Roke for her thoughtful editing; Anthony Naughton for his spot-on copy edits; Jenny Meredith on sourcing all of the photography; and Keith Fox, Virginia McLeod, and Emilia Terragni at Phaidon for welcoming me into the fold and believing in my vision for this book.

Picture Credits

Every reasonable attempt has been made to identify owners of copyright. Errors and omissions notified to the publisher will be corrected in subsequent editions. T—top, B—bottom, L—left and R—right.

View Pictures / David Borland / akg-images 168—169; Architect's Eye / Alamy Stock Photo 40B; Arco Images GmbH / Alamy Stock Photo 155; Ian Dagnall / Alamy Stock Photo 56—57; Val Duncan / Kenebec Images / Alamy Stock Photo 185; EB Images / Alamy Stock Photo 38—39; Reiner Elsen / Alamy Stock Photo 40T; Giulio Ercolani / Alamy Stock Photo 46—47; GFC Collection / Alamy Stock Photo 59B; Blaine Harrington III / Alamy Stock Photo 122; Icona / Alamy Stock Photo 41; Patti McConville / Alamy Stock Photo 142T, 142B; Iain Masterton / Alamy Stock Photo 154T; Newscom / Alamy Stock Photo 213T; Christopher Penler / Alamy Stock Photo 124—125; Ferdinando Piezzi / Alamy Stock Photo 24R; robertharding / Alamy Stock Photo 53B; Special View / Alamy Stock Photo 23R; Steve Tulley / Alamy Stock Photo 59T; David Vilaplana / Alamy Stock Photo 50—51; Edd Westmacott / Alamy Stock Photo 123; Zoonar GmbH / Alamy Stock Photo 154B; Spencer Bailey 20R; Blandon Belushin 116—117; © Nikolai Benner 10—11, 62—65; © Ron Blunt 113; Simone Bossi 8, 200—203; © Bitter Bredt 12, 66—67; Prof. Yongjie Cai 86—87; Are Carlsen 179T; Edward Caruso Photography 32—33; Chuck Choi 9, 188—189; Alon Cohen 205; Rodrigo Davila 108—111; Kevin Dolmaire 166—167; © Doublespace 144—147; Photo Roger Ellingsen 223; Elmgreen & Dragset *Memorial to the Homosexuals Persecuted under the National Socialist Regime*, 2008, Concrete, glass, film projection, 366 x 190 x 491 cm, Permanent installation Tiergarten, Berlin, Photo: Elmar Vestner, Anja Schiller 83; Sebastian Errazuriz, *The Tree—Memorial of a concentration camp*, Santiago, Chili, 2006 26B; Sergio Gustavo Esmoris 36; © Brad Feinknopf 182—183; Shao Feng 85; © Ian Walker / FotoLibra 70; photo: Marko Priske / Foundation Memorial 44—45; GION 114T, 114BR; Gaeta Springall Arquitectos 73; Amit Geron 78—81; Photographer Credit: Historisches Museum Saar, Thomas Roessler / © Jochen Gerz, VG Bild-Kunst, Bonn 2020 Image Courtesy of: Gerz studio 220—221; Adam Berry / Stringer / Getty Images 214; Jason Hawkes / Getty Images 139; Keith Sherwood / Getty Images 99T; Image courtesy of Gustafson Porter + Bowman 138; Roland Halbe (www.rolandhalbe. eu) 28—31; © M Hedelin 165; Hiroshima National Peace Memorial Hall for the Atomic Bomb Victims 213B; © Hufton & Crow 225—229; © Tim Hursley 216—219; Infinite Impact 132—133; © The Isamu Noguchi Foundation and Garden Museum, New York / ARS—DACS 23L, 206; Jeremy Bittermann / JBSA 134T; KBAS 112; Photo © Werner Kaligofsky 48—49; Nikolaus Koliusi 215; Matthias Könsgen 152—153; © Naho Kubota 190—191; Christopher Lark 55, 58; © Alan Ricks / MASS Design Group 42—43, 89—93; Mémorial international de Notre-Dame-de-Lorette Philippe Prost, architect / AAPP © adagp-2014 © Pierre di Sciullo, graphiste © Aitor Ortiz 34B; Mémorial international de Notre-Dame-de-Lorette Philippe Prost, architect / AAPP © adagp-2014 © Aitor Ortiz 34T, 35; Suisho Moriguchi 114BL; NAARO 13, 129—131; Alan Karchmer / © NMAAHC 194—197; Luther Bailey / NPS 68; Nacasa & Partners 106—107; courtesy Stanley Saitowitz / Natoma Architects Inc. 14—15, 208—211; © Peter Aaron / OTTO 140—141; © Brad Feinknopf / OTTO 134B, 135, 193; Lisa O'Connor / AFF / PA Images 53T; Sebastian Zachariah / PHX India and Mindspace 74—77; PWP Landscape Architecture 118—119; Eric Staudenmeier Photography / Paul Murdoch Architect 156—161; Sandra Pereznieto 72; Shannon Kosaber Petrunak 6—7; Sergio Pirrone 102—104, 105T; Propapanda 172—173; Bjarne Riesto 148—151; Philippe Ruault 170—171; Roberto Sáez 105B; Nicolas Saieh 100—101, 136—137; Andre Scarpa 176—178, 179B; Takuji Shimmura 174—175; Kyungsub Shin 187; Yingna Cai / Shutterstock. com 184; EQRoy / Shutterstock.com 143; Gobmetha / Shutterstock.com 180—181; Tony Gutierrez / AP / Shutterstock 52; Pit Stock / Shutterstock.com 121; planet5D LLC / Shutterstock.com 24L; Photo Tonje Tjernet 222; Paul Warchol Photography 96—98, 99B; Photography by Lewis Watts 69; Elyn Zimmerman 26T; Gary Anderson / Sioux City Journal / Zumapress.com 20L

About the Author

Spencer Bailey is the co-founder of The Slowdown, co-host of the Time Sensitive podcast, and editor-at-large of Phaidon. He has written at length about architecture, art, culture, design, and technology for publications such as *The New York Times Magazine, Fortune, Newsweek, Town & Country,* and *Bloomberg Businessweek.* From mid-2013 to mid-2018, Bailey was the editor-in-chief of *Surface* magazine. He lives in New York City.

Phaidon Press Limited
2 Cooperage Yard
London E15 2QR

Phaidon Press Inc.
65 Bleecker Street
New York, NY 10012

phaidon.com

First published 2020
© 2020 Phaidon Press Limited

ISBN 978 1 83866 144 1

A CIP catalogue record for this book is available from the British Library and the Library of Congress.

Commissioning Editor: Emilia Terragni
Project Editor: Rebecca Roke
Production Controller: Jane Harman
Design: Pentagram / Michael Bierut, Laitsz Ho

Printed in China